D1142291

) 593 ⸮

100593547

# Utopia and Monument

Springer Wien New York

WITHDRAWN
FROM THE LIBRARY OF
UNIVERSITY OF ULSTER

Exhibition *for* the Public Space
steirischer herbst 2009–2010

# Utopia and Monument

Edited by
Sabine Breitwieser and steirischer herbst

io 0593547

700.
103
BRE

# Contents

**Utopia and Monument I, 2009
On the Validity of Art between
Privatization and the Public Sphere**

## Utopia and Monument II, 2010
## On Virtuosity and the Public Sphere

# True Love Leaves No Traces

Despite assertions to the contrary, it is not necessary to create a public for art and culture. A public already exists. It is merely a question of how it is structured, and which spaces it grants art on the terrain normally described — in terms more general than specific — as "public space." The public is what one would describe, if located on the human body, as the skin, with all of its sensual and perceptual faculties, and all of its states of being exposed and concealed. And it is always interesting to note what this skin, be it thick, thin, or however, allows to come close to it. How much contact does it permit — and what kind? Which signs are inscribed on it? What "remains"? And what disappears again, like a fleeting fingerprint? "True love leaves no traces… " (Leonard Cohen).

The steirischer herbst can look back on a long tradition of art in public space — a tradition not infrequently accompanied by a longing for some scandal or other — or fears of one occurring. In this regard, it struck us during the course of our co-operation with Sabine Breitwieser that it would be particularly interesting and appropriate now, in particular (where art in public space is almost as compromising as art at roundabouts and on/in buildings), and especially in Graz (where public space is permanently cluttered up everywhere with events), to develop and allow signal affects and points of contact between the two negotiable concepts: "utopia" and "monument."

It is essentially the question as to how much public space and attention we delegate to political and economic interests nowadays. And how little space we have left: public space for our most fundamental interests, needs and experiences. I associate very personal perceptions with this exhibition: and this is almost certainly due to its nature and specific form. One of these perceptions is as follows: A group of children in Graz's Stadtpark, on a school trip to *Utopia and Monument*, learn what it means to mark out terrain with caution tape in order to privatize and demarcate public space. And to find out, in the process, how scarce and endangered public space is.

The essential point about Sabine Breitwieser's exhibition project for the steirischer herbst was her idea of creating space for new works by international and local artists in and for Graz: temporary and rapid interventions that consciously deal and argue with the ephemeral nature of these works. Projects that provide critical commentaries on the place where we live: such as Andreas Siekmann's highly political work, which was shown in the courtyard of the Landhaus in 2009; Dorlores Zinny and Juan Maidagan's curtain installation at the Town Hall of Graz; and Ayse Erkmen's sculptural interventions, which were spread all over Graz's urban space that same year; Andrea Fraser's sociological-artistic study; Isa Genzken's sculptures at Mariahilfer Platz; Michael Schuster and John Knight's project, which unceremoniously robs the steirischer herbst of its "customary" advertising space. No one notices this at first sight, or they overlook it amidst the city's clutter of "street furnishings" by all kinds of advertising spaces. In the long run, however, people really do notice that something would be missing if there were no "steirischer herbst" in Graz. Public space: sometimes it is just a trigger point.

Veronica Kaup-Hasler
Artistic director, steirischer herbst.

# Introduction and Acknowledgement

This publication documents and reflects upon the two-year exhibition project *Utopia and Monument* at the steirischer herbst 2009 and 2010 in Graz. Focusing on two special themes — "The Privatization of Public Sphere" (2009), and "Virtuosity and Public Sphere" (2010) — ten artworks each year, making a total of 20 new works (installed for the duration of the respective exhibition) were commissioned for Graz. As a point of departure, two concepts were provocatively presented for discussion that had disappeared from the debate on public space: "utopia" as a space of thought, and the "monument" as a space of memory. The monument, utopia and the work of art have been analyzed very critically during the past few decades, and their validity has been contested and questioned. Responding to this critique, contemporary art, which has now turned its attention to the public sphere, is increasingly replacing the work of art with objects of communication and action, thus establishing a form of public practice that seeks to transcend — tendentially at least — the antagonism between art and the public sphere.

However, it is precisely this public space that has changed so radically over the past twenty years and become a plaything of economic interests. Consequently, all conflicts that give rise to public space and are fought out (or suppressed) in this sphere must be formulated anew — and this includes the possibility of their being accessed by art. The question is then: what validity does art have? Is it still a vital terrain for engaging in social controversy? Can public space still be reclaimed as an arena for debates of equal validity, and for gossip, exchanging opinions and expressing interests, when it is ruled above all by commercial considerations? *Utopia and Monument I* examines the question of the validity of value systems and provocatively puts these two concepts up for discussion. Indeed, they both form portals in different, possible organizational forms within the public sphere that allow us to pose the question again and again: Who actually owns public space?

Artworks in public space seldom arise from artists' own initiative. Rather, they generally arise in connection with various kinds of commissions in which the reciprocal interests are negotiated with varying degrees of success. The development of art in public space is thus determined as much by the history of exhibitions and the reception accorded artworks as it is by the diverse clients and their intentions. How do artists respond to both the expectations

placed on them and the different interests they have to deal with? Which skills do they contribute? For, in actual fact, what urban planners now promote as "creative industries," because of the promise they hold for the future, has long been part of everyday reality for many artists: the ability to convincingly present and successfully communicate their own work, which they have developed independently in their own respective fields. In the process, well-functioning networks and tried-and-tested forms of co-operation are used, occasionally in conjunction with brilliant, and also quite shrewd, PR strategies — all of which basically belong to the tools of the trade of the successful artist. The "virtuosity" with which artistic capital operates in urban space extends from exhibits without artworks to artworks that are exhibited by others.

My thanks go, first and foremost, to Veronica Kaup-Hasler, who spontaneously invited me to prepare an art exhibition for the steirischer herbst and supported the project in every respect when it was evolving to its full complexity. With Reinhard Braun as curator for visual arts at the steirischer herbst, I had a competent sparring partner at my side, whose advice and suggestions on content made an indispensable contribution to the project. I could not have done without him. Christine Sbaschnigg, project director in 2009, and Annika Strassmair, project director, with Maximilian Lechler as curatorial assistant in 2010, together with the entire team of the steirischer herbstand supported by the external production team eeza, with Barbara Sommerer and Jakob Pock, all did an excellent job, especially considering the challenging projects and the scarce resources. I can only take off my hat to them.

Without the artists and their fervent project proposals for *Utopia and Monument* this exhibition would have never materialized. For this, they deserve my very special thanks.

Countless other co-operation partners were involved in the exhibition: Graz city library accommodated our reference library in 2009; Hans Kupelwieser and Ruby Sircar from the Institute of Contemporary Art at Graz University of Technology co-operated with students to erect the *Pavilions* again in 2010, as well as the interventions at Tummelplatz; and Sabine Haring and Anja Eder from the Center for Social Research, Department of Sociology at the University of Graz conducted a sociological study for Andrea Fraser's project.

I would also like to thank the authors of the present publication, for which over twenty new contributions were especially written as a parallel project to the commissioning of twenty newly created artworks. Last but not least, I should like to thank the team that produced the two exhibition guides and the publication, which served the task of documenting, as well as possible, projects that were still running and being continuously revised.

Sabine Breitwieser
Curator and editor

Sabine Breitwieser

# Utopia and Monument: An Exhibition *for* Public Space in Two Stages at steirischer herbst in Graz in 2009 and 2010

*In their very essence, and sometimes at the very heart of a space in which the characteristics of a society are most recognizable and commonplace, monuments embody a sense of transcendence, a sense of being elsewhere. They have always been utopic. Throughout their height and depth, along a dimension that was alien to urban trajectories, they proclaimed duty, power, knowledge, joy, hope.* — Henri Lefebvre[1]

It is a well-known fact that in Austria revolution did not take place in the form of radical social upheaval or the mobilization of the masses on the streets, as in other countries, but rather in the form of public art actions. For his *Wiener Spaziergang* (Vienna Walk) — one of the first and most internationally renowned actions in public space ever staged by an Austrian artist — Günter Brus, a native of Styria, was sentenced to pay a fine of 80 Austrian schillings in 1965. In his *8th Action* Brus walked through the center of Vienna as a white living painting until, at some point, a policeman arrested him. The complaint stated: "By painting yourself in white paint, you displayed a form of behavior that was liable to cause a public nuisance and did indeed cause such a nuisance among passersby, whereby order was disrupted at a public place."[2]

In 1969 VALIE EXPORT and Peter Weibel staged an action for their project *Aus der Mappe der Hundigkeit* (From the Portfolio of Doggishness) where the artist and her colleague — who was on a leash and followed her on all fours — went for a walk along the Kärntner Strasse in Vienna. This "case study on sociology and human behavior," as EXPORT called it, followed an Actionist tradition that had already reached its recurring climax with the performances of the *Tapp- und Tastkino* (Tap and Touch Cinema) in Vienna, Munich, and other cities in 1968. Already in June of the same year, the most notorious provocation triggered by an art action had taken place in lecture hall 1 at the Neues Institutsgebäude (NIG) at the University of Vienna: *Art and Revolution* led to pretrial detention for some of the participants and the conviction of two others, Günter Brus and Otto Muehl. This reaction ultimately drove some of the artists into "exile" in Berlin.

In 1970, five years after Brus's conviction, EXPORT and Weibel had to appear in court for transgressing the law on pornography with the publication of their *Bildkompendium Wiener Aktionsimus und Film* (Image Compendium of Viennese Actionism and Film). Despite their absurdity and premeditated search for areas of social friction, the extent to which these actions were inspired by an awareness and the desire to create long-lasting impressions is evident in the following statement by Brus, some forty years after his *8th Aktion*: "I wanted to walk from Heldenplatz to St. Stephen's Cathedral, but I was stopped at Bräunerstrasse. I was warned that I faced either the madhouse or prison. The action was certainly nerve-wracking. But even so, I still felt very good about it. I knew I was making art history."[3]

As an multidisciplinary festival for avant-garde art without a fixed location, which has been held annually since 1968, steirischer herbst can look back on a variety of innovative urban art projects known for occasionally sparking controversy, including many works with sustained resonance in the public sphere. One might recall, for instance, Richard Kriesche's appearance in an inventive Humanic TV spot in the 1970s, which was accompanied by the slogan: "Art means intervention. Intervention means to organize." Kriesche stuck corn grains to his suit and was covered from head to foot with pigeons pecking at them. Then there was Hans Haacke's "Victory Column" on the Platz am Eisernen Tor in 1988, which bore the inscription *Und ihr habt doch gesiegt* (And You Were Victorious After All); it became a fire-gutted ruin following an arson attack by someone associated with the "right-wing scene." Or one of the bookshelves from Clegg & Guttmann's *The Open Public Library* in 1991, which was situated on a green space beside an anonymous traffic intersection in Graz. But likely one of the most radical exhibitions at steirischer herbst was the *trigon* series,[4] which showcased art from the border countries Italy, former Yugoslavia, and Austria. One of the first editions on the topic *ambiente/environment* (1967) clearly illustrated that a highly dedicated program was being pursued in the cityspace of Graz. The following year's exhibition *Architektur und Freiheit* (Architecture and Freedom), as well as the 1971 edition titled *Intermedia Urbana*, are still astonishing to this day given their innovative yet largely unrealized project proposals.[5] A glance at the various outdoor manifestations in Graz reveals that they went through practically all of the developmental phases one nowadays associates with art in public space: from autonomous sculptures in the city and the countryside (or grouped in sculpture parks) to public actions and performances, site-specific works with historical references, poster projects, as well as activist and interventionist art practices. The latter are frequently accompanied by a desire to draw attention to marginalized groups, or to even help improve their social standing.[6] "An uncompromising art form that emerges in the living environments of the people, unprotected by the white cube of art centers, never fails to cause a stir, when not massive resistance."[7] With these words a specially designed website on the topic of art in public space begins its introduction to a major part of the permanent and temporary public art realized "off-site" in Graz since 1945.

Following many years of trench warfare about artistic manifestations in public space, political and economic decision-makers have discovered the potential of contemporary art as a tourist magnet and economic factor, and they have become very adept at using it as a marketing instrument. The artists themselves as producers — like those local citizens called upon to *play*

a part (Teil*habe*) or those groups invited to even *take* part (Teil*nahme*) — are not always comfortable in the roles assigned to them. In his analysis of the different linguistic usages in museum exhibitions ("having an exhibition") and in works in public space ("getting a public commission"), Daniel Buren speculates as to whether "there is some truth in this common parlance, in this coupled, guaranteed label,"[8] namely, whether "[i]n an exhibition it is agreed that expression is free, uncommanded"[9] and if a public art commission isn't more like carrying out an order. "The street," according to Buren — who argues that one should rather speak in this context of "public 'demand' than 'commissions'"[10] or a "permanent exhibition in the street"[11] — "is not home territory, [a]t best it is a territory to be tamed."[12] He goes on to assert that "To work for the street is to challenge more than a hundred years of the production of art for museum. It also means the artist coming down from his pedestal."[13]

Parallel to the developments in art, public space itself has undergone significant trans-formation. The almost unrestrained, progressive privatization and commercialization of public space and its subjection to spectacle culture and state control was already criticized in the mid-1970s by the philosopher Henri Lefebvre, who described space as a social product and medium. In his thesis on the *Production of Space*,[14] Lefebvre points to the conflict "between a space that increasingly becomes an exchange value and a yet inhabited space that only has use value to the extent that the exchange value could not succeed in totally destroying it or making it disappear."[15] According to Lefebvre, "capitalist space" is for the perspectival space, as we know it from the Renaissance, the "place of decay." The buildings lack alignment, have been divested of façades, and "are situated in an indifferent space and are indifferent to this space, which is moving toward total quantification."[16]

Alongside this much-discussed scenario of urban spaces, a no less radical shift in private and public property becomes apparent: one that is dominated by the effects of global, neoliberal finance. Several years ago, many municipal authorities — including those in Austria — heavily criticized the sale of public facilities to foreign investors, which yielded high tax benefits and conversely entailed high rental payments for the use of the same facilities (so-called "cross-border leasing"). The fact that many purely private companies are recently being run with government involvement due to the current financial crisis — albeit without the new partner having a say — is causing many to wonder how this hybrid form of ownership should be dealt with in the future. Here the paradoxical situation may arise where companies that have hitherto been involved in public art institutions as private-sector sponsors suddenly find themselves predominantly state-owned, and the dogma of "public-private partnership" — proclaimed for Austrian federal museums to relieve the burden on tax payers — mutates into a multiplication of partnerships with the state, whose share had actually been intended to be kept at a minimum.[17]

In fact, we are being confronted with a paradigm shift in all areas of society. The question is: How do we respond? In the past years, there has been much talk about civil society and about the population *as a whole* — in its full cultural and social multifariousness — assuming respon-sibility and actively participating in the country's art and culture.[18] How can the public, or

moreover, how can *diverse* publics be addressed in artworks? Or do such considerations show that we have already completely succumbed to a strive for "diversity" like politicians fixated on quotas? Are we forced to helplessly give in to an occupation by both the public and the private spheres? Or is all this just "talk" with no direct consequence on our real, everyday lives?

At times, the view expressed is that public space is now merely the product of communication and negotiations between diverse — public and private — interests. In this context, one is entitled to ask: Who holds these talks and negotiations, and on which basis and values are decisions made? Or can we really — as so graphically proclaimed in the business world — strive for a win-win situation, a conflict solution where all the participants benefit? How can the potentials in accessing public space also be reformulated by art?

### Utopia and Monument

Against the backdrop of these developments and debates, *Utopia and Monument* was developed as a temporary exhibition *for* public space. It was conceived as a two-year project within steirischer herbst 2009 and 2010 with a focus on the respective annual leitmotif of the festival. Based on previous experience in similar projects, we selected an exhibition format with a discursive approach, but one that would also set a clear tone for the public. In contrast to institutions with their own facilities, the exhibition was designed on the premise that steirischer herbst possessed not only the need but also the access and opportunities necessary to be able to physically realize such projects. The aim was to effectively use this potential during these two years. Resources being scarce, we decided in favor of two stages with different thematic focuses each year. In this manner, the festival was also investigated in terms of its actual capacities and competences in the city, too.

As points of departure, two concepts that had largely vanished from the debate on the public sphere were provocatively put up for discussion: "utopia" as a space of thought and the "monument" as a space of memory. The former circumscribes a desired future state that, while often arising from an individual's projection, refers to society as a whole. The monument, in contrast, is a distinctive, permanently objectified site for a collective community that relates to a past event: two contradictory concepts in dialogue, each the subject of tough critical analysis in recent years, challenging and questioning their validity. With this antagonism in mind, the exhibition project pursued the reciprocal interplay between autonomy, aesthetics, and politics.

The modernist paradigm of an art that is emancipated from various tutelages, and thereby an autonomous, "thematically cleansed," and "functionally specialized" art,[19] was criticized as being devoid of meaning because it lacks any purpose and is not related to anything. Lately, many artists have therefore turned their attention from art *in* public space to art *of* the public sphere,[20] setting out to dispel the contradiction between art and the public sphere with the aid of a changed artistic practice. In the process, the aesthetic expertise ascribed to art was often deliberately neglected in favor of action and communication strategies that set out to tackle new tasks in the form of direct interventions in the city and in sociopolitical issues.

### On the Validity of Art between Privatization and the Public Sphere

*[…] before it is the exercise of power or the struggle for this power, politics is the dividing up of a specific space of "common affairs"; it is the conflict determining which objects will enter and which will not enter this space, the conflict determining who will participate in this space and who will not.* — Jacques Rancière[21]

Industrious projects have repeatedly investigated whether art can function as an instrument for the concrete shaping of our environment and as a vehicle for attaining necessary insight into societal relationships. But what if the desired aim — namely, art becoming engaged in tangible societal circumstances — is not achieved, rather it perhaps becomes even positioned in competition thereto? With artistic practices mirroring their own logic in public space and ending up generating a conflicting relationship? And with artists not necessarily working toward making a fragment of the injustice in the world visible (but that they themselves are perhaps a result of this injustice)? How can the validity of visual arts as an important cultural field be asserted in such a project? Can the public as a space for debates, opinions, and interests even be reclaimed after having been commercially "governed" to such an extent?

Lefebvre indicates that "a much too common image of space is to be corrected, namely, the concept or the notion that space is an empty container and indifferent to its material content. […] Between the containing and the contained, between the form and its contents, there is a much more strict and deep relationship than that of mutual indifference."[22] The utopian potential addressed here is further elaborated by Rancière: "Art is political foremost in the way in which it configures a spatiotemporal *sensorium* through determining the different ways of being together or apart, inside or outside, in front of or in the midst of. […] If art is political, then only to the extent that the spaces and temporalities that it divides up and the forms of occupation of this temporality and these spaces that it determines interfere with the division of spaces and temporalities, subjects and objects, the private and the public, the competent and the incompetent, which defines a political community."[23]

"All the Same – What is Valid if Everything is Valid?," which was set as the leitmotif for the 2009 steirischer herbst festival questioning our society's value systems, showcased pertinent explorations of public and private space in the realm of visual arts. The first stage of *Utopia and Monument* focused on a frequently asked question in recent years — "Who owns public space?" — and reflected upon the rhetoric of the loss of this public space. This question was pursued in the projects of the ten participating artists, who strove for a (re)appropriation of the public sphere through individually commissioned works and those produced for the exhibition in downtown Graz.

### On the Virtuosity of the Public Sphere

Artworks in public space rarely come into being on the artists' own initiative. They are more often associated with diverse types of commissions in which reciprocal interests are negotiated

with varying degrees of success. Thus, the development of art in public space is determined as much by the diverse clients and their intentions as it is by the history of exhibitions and the reception of artworks. First and foremost, however, come the expectations to address — by means of art — a specific and, to the same degree, unintended public and, in a way, to represent them as well.

How do artists deal with this situation of their exposure, with the experience of being exposed to the gaze of others; how do they react to the expectations and the various interests that confront them? What specific abilities and skills do they possess with regard to the design of memorials, sculptures, and monuments — that is to say, interventions intended to create public effect, a political terrain of 'common affairs'? The fact is that what urban planners nowadays promote as forward-looking 'creative industries' has long since become part of artists' daily lives: the ability to convincingly present and successfully communicate their own works, which they have developed independently, based on their own fields of interest. What networks and proven cooperations do they avail themselves of? And to what extent do they need cunning PR strategies to make their own work visible in public space in the first place? Are we really dealing with a "political act" as Paolo Virno states in diametrical opposition to Hannah Arendt? Because, from his point of view, politics has not adapted to work, rather work has "absorbed into itself many of the typical characteristics of political action."[24] And which transfers take place in exposure to the "presence of others"?[25]

For the second stage of the exhibition in 2010, with the leitmotif "Masters, Tricksters, Bricoleurs. Virtuosity as a Strategy for Art and Survival," once again ten artists were commissioned to generate projects on the theme of the exhibition for the public space in Graz. It became an experiment that explored whether the "public realm" can still actually offer "the presence of others," this "space of appearance" as described by Hannah Arendt[26] — a "politically organized space." The "virtuosity" of the artistic capital that was at work in Graz's public spaces ranged from collective models and changes in the psychogeographical sphere to work in which artistic authorship was reduced to a script, and the work was realized by others.

Two projects, one from each year, accompany this publication in their original form: the exhibition guides, which, in addition to their communication function, were also designed as artistic contributions. In his *Discursive City Tour* (2009) with its meaningful title *The City Speaks!*, Michael Zinganel guides us through Graz, staging a fictitious dialogue between a person familiar with the place and an urban theorist. The interdisciplinary project *You Are Here* (2010), conceived by Andrea Fraser as an institutional cartography of the exhibition locations, was realized in cooperation with sozYAH — a group specially formed for this project — Sabine Haring and Anja Eder from the Center for Social Research at the Institute of Sociology at Karl Franzens University, and the information designers Wolfgang Gosch and Georg Liebergesell.

These two "guides," along with the *Pavilion* conceived by the Kooperative für Darstellungspolitik, were commissioned in connection with concrete functions and content, which were translated in a specific manner by these three artists/collectives. The *Pavilion* was mounted on

a scaffolding construction at the Platz der freiwilligen Schützen beside the Bad zur Sonne spa in 2009, and fulfilled a number of purposes — initially as a meeting place and information center. With its thematic exhibition, a genealogy of art and public space printed on the inner walls, it was as much a (necessarily incomplete) collage of exemplary artworks from the past as it was a space for experimentation. The following year, the *Pavilion* was realized once again, but in a modified form and at a different location: this time directly on Tummelplatz where it unfolded into a stage. Students from the Institute for Contemporary Art (IZK) of the Graz University of Technology contributed with interventions and in events around the exhibition theme.

*Utopia and Monument* traces the genealogy of art in public space, while placing the focus on public space itself and its transformation. Indeed, the realization of the works was invariably determined in the negotiations with the various interest groups: by exploring the possibilities both in terms of financial and human resources, and the ambitions and interests of the diverse stakeholders and shareholders among the population and in the city administration. Not all of the "negotiations" were immediately successful, and some artists even had to elaborate new proposals several times over. Some works remained in the project status and could not be realized — when, only partially or in a different form.

Many thanks to Reinhard Braun for the discussion and countless tips.
The project is devoted to the memory of Hartmut Skerbisch (1945–2009).

1   Henri Lefebvre, *The Urban Revolution* (University of Minnesota Press: Minneapolis, 2003): 22.

2   E. Znaymer, "Das Denken ist ein Unfall," http://www.datum.at/0505/stories/782980, 2010-09-15. Here translated from German: "Sie haben, indem Sie mit weißer Farbe bemalt waren, ein Verhalten gesetzt, welches geeignet war, Ärgernis zu erregen, und bei den Passanten auch tatsächlich erregt hat, wodurch die Ordnung an einem öffentlichen Orte gestört war."

3   Ibid. Here translated from German: "Ich wollte vom Heldenplatz bis zum Stephansdom gehen, doch schon in der Bräunerstraße wurde ich aufgehalten. Man hat mich gewarnt, das gebe entweder Irrenhaus oder Gefängnis. Die Aktion war freilich von Nervosität begleitet, trotzdem hatte ich ein sehr gutes Gefühl. Ich wusste, ich mache Kunstgeschichte."

4   The *trigon* three-country biennial was held from 1963 to 1995 with the aim of transcending the borders of Austria's socialist neighbors.

5   One of the best-known exhibitions in the *trigon* series took place in 1973: *Audiovisuelle Botschaften* (Audio-Visual Messages) on international video art.

6   Since 1999, the artists' association < rotor > in Graz's so-called Annenviertel has been involved in "artistic productions that explicitly deal with current social, political, economic, and ecological questions." Among other things, they are preoccupied with projects in public space and, above all, questions raised by migration processes. Parallel with *Utopie und Monument*, the two members Margarethe Makovec and Anton Lederer launched their own two-year project *Annenviertel! The Art of Urban Intervention*. (cf. http://rotor.mur.at).

7   Werner Fenz, "OFFSITE_GRAZ," http://offsite.kulturserver-graz.at, 2010-09-16. Fenz, who as curator of the exhibition *Bezugspunkte 38/88* also initiated Hans Haacke's project *Und ihr habt doch gesiegt*, has been the director of the Institute for Art in Public Space, Styria since 2006. Here translated from German: "Eine kompromisslose Kunst, die im Lebensraum der Menschen auftaucht, nicht geschützt durch den White Cube von Kunstorten, sorgt immer wieder für Aufregung, wenn nicht sogar für massiven Widerstand."

8   Daniel Buren, "Can art get down from its pedestal and rise to street level?" in: Klaus Bußmann, Kasper König, and Florian Matzner (eds.), *Contemporary sculpture: projects in Münster 1997* (König: Cologne, 1997): 484.

9   Ibid.: 485.

10  Ibid.: 495.

11  Ibid.: 499.

12  Ibid.: 492.

13  Ibid.: 499.

14  Cf. Henri Lefebvre, *The Production of Space*, trans. Donald Nicholson-Smith (Basil Blackwell Publishing: Oxford, 1991).

15  Henri Lefebvre, "Die Produktion des städtischen Raums," in: *An Architektur*, no. 01, 2002: 4. Here translated from German: "[…] zwischen einem Raum, der immer mehr zum Tauschwert wird, und einem noch bewohnten Raum, der nur noch in dem Maße Gebrauchswert hat, wie ihn der Tauschwert nicht völlig zerstören konnte oder zum Verschwinden bringt."

16  Ibid., p. 12. Here translated from German: "[…] stehen in einem gleichgültigen Raum und sind selbst diesem Raum gegenüber, der sich auf dem Weg zur totalen Quantifizierung befindet, gleichgültig."

17  This happened to the Albertina in Vienna when one of its prime sponsors, the Kommunalkredit Bank, was abruptly "compulsorily nationalized" after its collapse in the wake of the 2008 economic crisis. Thus, the supposed private-sector host of a dinner officially held to raise funds suddenly became identical with the public sector.

18  See the so-called Museumspolitische Initiative 2007/2008 (Museum Policy Initiative) by the Austrian Federal Ministry for Education, Arts and Culture under Claudia Schmied, in which I was also involved as a 'moderator' along with Dieter Bogner and Martin Fritz. See: bm:ukk, "Die Sammlung Österreich – Museumspolitische Initiative," http://www.bmukk.gv.at/kultur/museumsreform/index.xml, 2010-11-10.

19  See: Cornelia Klinger, "Autonomy – Authenticity – Alterity: On the Aesthetic Ideology of Modernity," in: Sabine Breitwieser (ed.), *Modernologies. Contemporary Artists Researching Modernity and Modernism* (Museu d'Art Contemporani de Barcelona: Barcelona, 2009): 25–38. Here translated from German.

20  See: Marius Babias and Achim Könneke (eds.), *Die Kunst des Öffentlichen. Projekte, Ideen, Stadtplanungsprozesse im politischen, sozialen, öffentlichen Raum* (Verlag der Kunst: Dresden, 1998).

21  Jacques Rancière, "The Politics of Art and its Paradoxes," trans. David Quigley, in: *Brumaria*, vol. 9 (fall 2007): 331–332.

22  Ibid., Henri Lefebvre, "Die Produktion des städtischen Raums," p. 4. Here translated from German: "[…] ein viel zu gängiges Bild des Raumes zu korrigieren, nämlich das Konzept oder die Vorstellung, der Raum sei ein leerer Behälter und seinem materiellen Inhalt gegenüber gleichgültig. […] zwischen dem Enthaltenden und dem Enthaltenen, zwischen der Form und ihrem Inhalt, eine viel strengere und tiefere Beziehung als die einer gegenseitigen Gleichgültigkeit."

23  Ibid., Jacques Rancière, "The Politics of Art and its Paradoxes."

24  Paolo Virno, *Grammatik der Multitude. Die Engel und der General Intellect* (Turia und Kant Verlag: Vienna, 2008): 64. Here translation from German: "[…] die Arbeit die traditionellen Eigenschaften des politischen Handelns angenommen."

25  Cf. Hannah Arendt, *Vita activa oder Vom tätigen Leben* (Piper & Co.: Stuttgart, 1960). Here translation from German.

26  Ibid.

Simone Hain

# The End of Appeasement:
# Art Alone Will Not Suffice

If one believes the people involved, the turn of the 1990s saw a euphorically welcomed paradigm shift in the advanced cultural sector. Art was suddenly part of life again. "Art went public" — but not in the form of a colorful art-for-all caravan, rather as a strict methodological research campaign and militant political agency.

## The End of the Commune

The timing of this paradigm shift could not have been better: the spaces relentlessly dumped onto an unscrupulous global market after the fall of the Iron Curtain were not surrendered to the "urbanites" entirely without resistance. Public space seemed all the more precious, the more it began to monotonously adjust itself to the pursuit of purely economic goals: everywhere, worldwide, always the same program, historical amnesia and the white noise of information instead of communication. Wherever governments created Urban Task Forces[1] — special operations units promoting the "renaissance of the city" — it was a matter of resistance to show an interest in the ordinary side of life, the everyday, and the genuine needs of the inhabitants. The second impetus was to protest and take sides, because urban renewal policies with a "zero tolerance" tone went hand-in-hand with surveillance, human rights violations, displacement, marginalization, the theft of public property, and municipal corruption. Particularly symbolic was the revisionist attack on modern industrial society, which was to be dabbed away from the cityscape as with a stain. Rotterdam, for example, invented the argument of "poor architecture," while Berlin spoke of "rubbish-strewn spaces"[2] and "Asian voids." In particular, monument protection issues and the defense of monuments that disrupted the smooth running of operations had great potential for mobilizing the middle class. Rampant privatization and aesthetic speculation in "modernist wastelands," which were discredited for their lack of architectural expression and their association with public welfare, inspired involvement in municipal decision-making and public protests in many places. Pure profit interests adorned in neoconservative and, at times, cyber-futuristic glitter had long since become an insidious process that undermined community-oriented urban development policy. This masquerade was

well-known as a strategy to "stage the everyday world" or the spectacular commodification of public property and had been unmasked with considerable public attention.[3] The fact that public life only takes place as a simulation had been common knowledge in critical social theory since the 1970s. However, with progressive deindustrialization, the working class, which had hitherto still presented the greatest challenge to capitalism, was not only assimilated politically but also destroyed economically. Wherever automatons had not yet assumed these functions, production was transferred to China, India, or Romania: to low-wage countries. And once the towns and cities — now deserted by industry — were compelled to start marketing themselves in municipal beauty pageants as well-packaged service centers, a start was made on the successive surgical removal of normal everyday life, the banal architectural motifs, and — preferably — their "plebby" youth cultures and petty criminal lower-class mycelia.

In Central and Eastern Europe one could witness the severe transformation of urban space after the fall of the Iron Curtain in fast forward. Not only did the nation-state social institutions of workers' power (as flawed as they were) disappear like snow in the sun, so did the informal flipside of excessive regulation and control: the celebrated niches with their relatively free, critical, and ultimately rebellious milieus. Notably, the pacifist and libertarian revolutions of the twentieth century took place in the East — neither as a rule nor by chance — because the one-sided politicization of all public (and private) affairs could only be opposed with political means. Now the nests of subversion and their media, the uncontrollable "dark" sides of the city, the courtyards and the neighbors with their well-rehearsed gestures, had disappeared. With them the cluttered workshops of the shadow economy, the unanticipated rabbit hutches in the back courtyards, the coal dealers. Where thousands of people had been claiming their right to shape their communities, on these huge central squares, building pits were now being industriously excavated, eliminating existing landmarks of cultural identification. Whether in Vilnius, Erfurt, or Zagreb, it was the same story everywhere: cinemas, public squares, and cultural centers were being destroyed by development projects. "Proper" people moved into the immaculately renovated streets of the inner cities, where law firms, real estate offices, bank branches, pharmacies, and mobile phone outlets now alternate in a relentless rhythm. Amidst the lively hum and hissing of espresso machines celebrating their victorious advance, people soon forgot the melodic harmonies of coal shoveling. And where foreign-language construction workers just recently vanished, labor now bore a new mask: "What can I do for you?" Here and there, the sunny side of the street had already been renovated and occupied by cafés. Across the road, you could still see the morbid bricolage of lovingly-tended cyclamens in front of antediluvian curtains, nicotine-stained local pubs, and flower shops furnished in the 1950s. Here, the doors and driveways were always open. For years, construction waste containers overflowed with pure history: First the bizarre flower stalls and office equipment from suddenly abolished authorities, then the forsaken workers' lockers along with their complete contents, then propaganda leaflets, school books and atlases, old wallpaper mixed together with new packaging and wrapping from tax law software, PlayStations, intercoms, and electronic security systems. Once this equipment had been installed, the courtyards ceased to be common property. People had to pay far higher entrance fees for everything — ten or twenty times the price — for public swimming pools, the tram, the cinema, and mini-golf. And if it wasn't enough that the depth of space was increasingly

receding and that the colors and shapes of the house façades — and even the once vast sky — had changed, it also became impossible to keep a clear picture of the city in mind. Ho-Chi-Minh-Allee was renamed Kröllweiner Weg; the Magistrale der Arbeit was changed to Brückenstraße. Loss of orientation, utterly displaced bodies, and radically overwritten memories: such were the visible and tangible signs of this major epochal change in the development of the European city, which for 200 years had been characterized by industry, and for 800 years by labor.[4] Albeit with different parameters and processes, a regime had prevailed in these cities for an entire century, which now — at the very latest — lost its basis: local politics as social democracy.[5] In the European city, the long epoch of the commune had come to an end.

### Real Time: History Again — At Last

"The post-war period ends here, today," a Leipzig urban planner used to say in the old days. In reunited Germany in particular, there was repeated talk of a return to normality — to the days before the Weimar Republic — especially in a military sense. The global safeguarding of interests was directly linked to preventing immigration. Already in 1993, the Social Democrats had to accept that the most valuable asylum law in the world from a constitutional standpoint — a law paid for in millions of human lives — was changed by the government. That was the first breach of taboo. Unbelievably, this was even topped by a left-wing government when the promise was broken with the bombing of Belgrade: "A war should never be launched from German soil again." The lessons of the Second World War had evidently been forgotten. Hence, 1989 not only marked the end of the supremacy of the commune, but also a 40-year state of emergency: the Cold War.

The epoch that had thus ended was met with great scientific interest.[6] Recently, however, the term "Cold War Culture" is used to palimpsest attempts to investigate that time period which evoked, in the onerously balanced rivalry between the systems, the most gravely threatening scenarios and, even more, utopias in which both sides sought to outdo one another. "No violence" and "Everyone is an artist" are but two examples of this. Mahatma Gandhi's "Satyagraha," the idea of "converting" opponents and winning them over as allies and friends to one's own cause, was not the only thing that ushered in decolonization. The related concept of "living in truth" extends from the Prague Spring to the "Velvet Revolution," and also comprises Mikhail Gorbachev's Glasnost. The list of the moral heroes of the (not only) Cold War is long: There was also Tito's ethnically peaceful, hedonistic Yugoslavia — communism with a passport; Kwame Nkrumah's African path to socialism via village democracy; and Black consciousness — self-respect. To these must be added Fidel Castro's literacy campaign, the Prague Spring and May '68 in Paris, the Algerian liberation struggle and the victory celebrations in Saigon, the Declaration of Helsinki, the Danzig workers' councils and round tables — all pearls in a chain of historical events that demonstrate the primacy of responsibly exercised political will, a trace of the potential success of collective endeavors. The Cold War, that age of beautiful fears, which basically sought consensus and dialogue, drew its life spirit from the pathos of the absolute counter-model. "I have a dream…" But sit-ins and flower power gave up in the end, under the banner of punk, when Maggie Thatcher issued her ice cold statement:

"There is no alternative." If "one world" was only possible in capitalist form, then chaos days are still better than *Give Peace a Chance*. Or, in the words of a song by Gerhard Gundermann: "So, brother, that's why there's war, we've now laid it at our feet,"[7] commenting on the ultimately liberating release from the doctrine of appeasement that prevailed throughout the decades of the Cold War.

The end of the post-war period, lacking any alternative but the re-creation of world unity under the sign of capital, also gave rise to clear positions in art. The world clock suddenly showed the same time everywhere. "Now I remember what I'm supposed to be doing," concluded the art-producing Frithof Bergmann in Lusatia, reaffirming his ecological militancy. With their texts, Bergmann and the far better-known Indian woman Arundhati Roy have become the artistic-political trailblazers of a micro-social partisan army, growing in a "bottom up" process across the globe since the mid-1990s to counter this lack of alternatives.[8] Gunderman once argued that "one has to be as confident as a virus. No matter how tiny one might be, the following day the whole town will be ill." Others speak of "Do-It-Yourself Geo-Politics."[9] Now that the confrontation of systems has ended, and the blocks and embattled political camps have disintegrated, the question arises: "Who does the world belong to?" Instead of being at an end, as some claim, history is now demanding a new beginning.

- **Buy Milk**
- **Phone Mom**
- **Save the World**
  **or**
  **Art as a Trojan Horse**

"Is there anything more wonderful than experiencing a paradigm shift close up? […] The importance of one's own role in the historical process seems assured," says Viennese curator Stella Rollig, recalling the resurgence of political activism in the early 1990s, which made critical intervention in society a guiding principle of advanced artistic practice.[10] Almost as before in the so-called Eastern Block countries, art now became — as if prearranged — the favored means for creating surrogate publics for both reflexive needs and social interests that had been steamrollered amidst all the neoliberal furor, and for decisively employing the symbolic capital accumulated in the art world for political purposes. While the old forms of social struggle and political education seemed to be exhausted, new movements appeared on the scene, often with manifestations of artistic provenance. It simply made sense to use the established rituals of games, dramatization, and masquerade to smuggle viruses into the hegemonic programs of the rulers. Artists call this strategy "camouflage."

With the aid of dramatized imagery, the cry of the Zapatistas, the WTO protests in Seattle, and the first World Social Forum reached the public media they so urgently needed. They borrowed from the spectacle. One need only recall the black masks of the Zapatistas and the carnivalesque processions of the globalization critics. Under the laws of media democracy, the new political forces achieved greater visibility as "social sculptures" — through their united

bodies — than they would have with classical political propaganda. In this way, they were able to get round the news blackouts.[11]

It is now generally agreed that in German-speaking regions, in particular, neoliberal mobilization has ushered in an increasingly community-oriented era of public art production. This change stems from the insight that social space is constituted not so much by the people present, or by their potential communication, as by the quality of a myriad of overlapping activities. Consequently, action-oriented projects replaced sculptural urban embellishments. They are now empirically site-specific, socially-embedded, networked, and communicative interventions. Barely identifiable as art, they serve the production and mediation of knowledge as "research," the direct exploration of reality as open-source newspaper projects, and as "archives" of social narration — not to mention breakfasting and cooking in public, which combined the eating houses of the Third World with the plein airs of the fin-de-siècle bohemians. Often, such projects simply meant social work, providing care for people quickly and unbureaucratically, social experiments, or bitter satires about the new conventions. Especially in places where the post-industrial transformation of space simply cannot succeed, and where — because the promise of tertiarization was totally ideological from the start — all established political and disciplinary procedures evidently fail, this new art based on urban activity has become a binding force with far-reaching consequences. Hence, some theater people now participate in the urban planning of shrinking cities. And in forsaken landscapes, "space pioneers" fight to establish new modi operandi for precarious existences. In the past twenty years, the procedural and social operatives have at any rate prevailed over a more traditional concept of property and put the self-centered art scene in its place for good. Ultimately, this change was sanctioned by the pertinent institutions, too.[12]

WochenKlausur, atelier d'architecture autogérée, evolutionäre zellen, Spacewalk, anschlaege.de, raumlaborberlin, Liisa Roberts' work in Wyborg, pro-test lab in Vilnius, Critical Art in Poland, Chto delat? in Saint Petersburg, Peter Watkins' *La Commune* project, Christoph Schlingensief and Pravo na grad in Zagreb, Leipziger Experimentale, bankleer, and the Thalia-Jugendtheater in Halle — in the past two decades, various groups of artists, networks, and working platforms have achieved an incredible amount, responding to the loss of social coherence and the absence of social alternatives with very concrete and powerful political projects. Contemporary art has meanwhile permeated all spheres of society, displaying every single shade of theoretical profundity and anti-capitalist intransigence. Above all, it has gone through all states of precariousness.

### The Example of Berlin: The City of Surprises

Hardly any other city has been so well researched, contested, and valiantly staged as Berlin, the Cold War's former frontline city that was transformed into an arena for neoliberal urban experimentation during the 1990s. In this case, a few novel features were added to the standard procedures: brainwashing and daily loyalty tests, psychological pressure, tempo, techno, Berlin's anachronistic development into a capital city, a truly marginal middle class and distinct

left-wing majorities, "East-ness" as the felt experience of living on the border to Mongolia. And last but not least: the long, affectionate process of "saying goodbye to Lenin" and the thousands of Red Army graves, Russian soil where the little children play. The average Berliner does not have a great fear of loss: Berliners have always been at the bottom of the pile and have never wanted anything different. In addition to this comes genuine passions and a biting sense of humor (the big heart and mouth) as well as the well-rehearsed languidness. Berliners are not particularly obliging and love to remain in their seats when others would wave their hats in excitement. And then there is decentrality as an urban form and social experience. No other German city has witnessed so much urban anger, revolt, rebellion, and revolution. And yet Berlin was the largest garrison city in Europe from the time of the Great Elector on, virtually occupied by the army for almost 400 years. Controlled by the four victorious powers after the Second World War, encircled and infiltrated by all the secret services in the world, nothing really surprising ought to have happened there. But it did.

### What Kind of Economy? Does the State Pay the Dissidents?

"For God's sake, what kind of economy is that?" During the past few years, new artistic movements — especially in Berlin — have succeeded in eliciting astonishing gestures of rejection: the funky media façade of the Chaos Computer Club at the squatted "Haus des Lehrers"; the *Berg* (The Mountain) in the skeleton frame of the former Palace of the Republic; Lars Ramberg's disturbing installation *Zweifel* (Doubt), which was the talk of the town for weeks; the *Rollende Road Show* (Rolling Road Show) by the Volksbühne theater on the real peripheries of the city; and the Camp for Oppositional Architecture in an abandoned factory. Berlin evidently possesses the kind of creative, socially critical potential that other capital cities do not tolerate (anymore). What kind of economy forms the basis of this highly concentrated spatial production of dissidence? What do artists and innercity activists survive on when they no longer manage to sell their works? The question cannot be answered simply by referring to a city's symbolic function between epochs. Since the fall of the Berlin Wall, the city has not succeeded in putting its economy right. Although the city displays the very finest design, it has been spared life-stifling wealth. Berlin is shrinking. As a result, social relations still remain fairly stable, relations that bring about remarkable things. Nowhere, according to Yugoslav deserters in hiding, can you survive so easily without money and papers as you can in Berlin. Bakers and greengrocers place their unsold wares in front of the door in the evenings, as if it were normal in Berlin to live in the underground or to be utterly penniless. "They'll find takers…" So what kind of economy allows people to live a cheerful life in Berlin, enjoying widespread sympathy as a "Polish failure" or a "Hängematte" ("hammock" cf. sponger) or as a member of the "happily unemployed"?[13] How does this hard-up city, yet bursting with life, function? A city in which people wish themselves "good projects" in the New Year?

Well, all of the success stories in Berlin's art economy[14] ought to end with the words: "And when they are not dead…" Running a project means business until further notice. Those who arrived first are totally exhausted twenty years on, like the *scheinschlag*, Berlin's version of the *Village Voice*. More than a few of them have died. And at least one was murdered.[15]

The "scene," which enjoys widespread sympathy but receives only meager support from its social network, lives off allowances from the Employment Office and is supported by the Künstlersozialkasse (artists' social fund). Not insubstantial remains of the German social welfare system and a few art colleges and theaters support its precarious job structure. Artists can do many different things, and they do bread-and-butter jobs to finance "their" interests. Since the Bundeskulturstiftung (German Cultural Foundation) was founded in 2002, some things have become easier. A number of demanding projects — above all, alternative social concepts that go far beyond transcending artistic genres — have been realized in the meantime. At times, the list of project initiators from the fields of mediation art, socio-culture, cultures of economies, and sustainability reads like a Who's Who of urban activists. The strange thing about all this is that the state funds the dissidents.

The existence of creative spatial production subsidized by social welfare and cultural stimulation funds is not without its problems and is, indeed, the subject of lively debate in international networks. "As a politically moral person, you are quite free in this big game of democracy to publicly condemn the political and economic structures as long as you are obliged, as an economic subject, to obey them to the letter."[16] The only way to escape this degrading situation is to withdraw as much as possible from the system of support — with all the risks this entails. From the standpoint of the rulers, self-exploitation is, in turn, *the* subtle manner in which an efficient political system shifts responsibility for welfare and happiness onto the individual. Artists who adopt this approach ultimately heroize the neoliberal concept of "Me Inc." Far more serious, however, is the feeling of becoming like an extended arm of established cultural policy through integration into project support schemes and having to operate according to rules and routines that are neither appropriate for the place nor for the particular needs of the local people involved. All the same, the sponsors expect dynamic projects with well-filled press portfolios and preferably international appeal, meeting their own — artistic — standards. This usually prevents laypeople from participating on an equal basis as they are naturally not very well-versed in art, thus excluding sustainable local impulses. In the process, artists end up either as bureaucrats in enterprises driven by spectacular quotas, very likely having to betray their true partners in order to maintain the pace, or they play fair and accept money only after their main communicative work has led to mutual understandings and trust, once they know what the situation demands of them. In other words, they must prefinance the research, the communication, and the brainwork at their own risk. And that means a lot of unpaid work.

### Mapping, Claiming, and Science as Avant-Garde

Because new art thrives on knowledge. One might be tempted to think that it primarily arose in prerequisite courses at universities and in reading rooms, before finally making it from the ivory towers to the street. Never before, at least not since the sixteenth century — the age of religious wars — have artists been so well endowed with cognitive functions. Consciousness raising is the precondition for success. As in the days of Leonardo and Dürer, it is a question of constructing a self that does everything in its power and acts on its own initiative. Michael Foucault, especially in his cultural studies and critiques of power, has contributed to a related

shift from describing the world "as God created it" to the question of the position one assumes in it. The new scientific paradigm is informed by social research on worker culture and is based on the revolutionary discourses in the 1960s of Lefebvre, Lacan, and Debord. In the mid-1980s, "struggle" once again became a scientifically interesting concept, albeit one far removed from the Marxist concept of classes. Like the moral doctrines in the time of the religious wars, current debates in the realm of social theory have to do with the high art of differentiation. The humanism of the Renaissance, and particularly that of the Reformation, had its roots in the radical discourses on order and the masterfully conducted public disputations on theses; the paradigm shift in contemporary art is similar with regard to its way of seeing reality, places, things, and persons as concrete, clearly distinguishable, yet highly contextual entities. Just as the artists and heretical theologians of the sixteenth century used their eyes and the word to perceive and order the world anew, a contemporary movement is once again addressing societal values and the establishment of the truth. Precisely because the old constellations of power and forms of government have been shaken to their foundations — be it due to the powerlessness of the communes or to the collapse of social democracy, or because the bipolar rivalry between camps and systems dissolved — it is again necessary to survey the world anew. If there is a problem then put it on the map! One of the goals of artistic work entails what is commonly known as mapping: the attempt to render complex interrelationships visually intelligible and thus communicable. Mapping is accompanied by a participatory form of staking claims, of mapping out interests in a concrete urban space. Concerned about the privatization of endangered common goods, the 6th Werkleitz Biennale in 2004 in Halle, Germany, gave members of the public yellow barrier tape and asked them to mark the inalienable in the city. Here, too, incidentally, there are parallels to the conflicts in values that arose in the Early Modern Age. During the peasants' revolts, it was ultimately the "old rights" that the peasants defended: the freedom to hunt and fish, and the preservation of their common land. Today, one must ask who has the right of disposal over a picture, a gene, or certain plants. Will people one day have to pay Bill Gates royalties for photographs of the November Revolution of 1918 — for the memory of a social act?

The theme of the Biennale was an extremely good choice for it clearly demonstrated with artistic means the actual extent of privatization, but also paid homage both to historical systems of recording data and to public institutions of knowledge production, those that protect towns and cities from the loss of their memories: museums and collections, archives and libraries. Previously, rarely anyone had consciously reflected upon all the things that had been collected, recorded, and archived over the centuries in the Middle German city of Halle, the former center of pietism. Also the question as to how much community humans really need was single-mindedly raised. Can they survive as a species if they do not associate or barely communicate, if they even cease to view themselves as a global community? And how can social experience prevail if human beings lose sight of the time and space with which they are familiar? Again, we owe it to the analytical sciences that we can clearly name the greatest threats to coherent activity, overcoming crises, and collective learning processes. Ever since the 1920s, the time when philosophical *Zeitdiagnostik* (the diagnosis of contemporary time) arose, there have existed critical instruments for distinguishing and understanding how power

functions. Confronted with a new type of regime and the failure of the middle-class way of life, Ernst Bloch, Siegfried Kracauer, Jean-Paul Sartre, Antonio Gramsci, Hannah Arendt, the Russian Formalists, and the philosophers of the Vienna Circle such as Moritz Schlick began to "sharpen their weapons" in art and philosophy. The idea that the truth can be found in the profane, that even the lowliest of cultural phenomena provides insights into the laws of the whole, is a realization from those decades in which, according to Guy Debord, the "dominance of the spectacle" began. Kracauer fervidly studied the Berlin scenes formed by the reality of the world economic crisis and exposed in them the codes of the time. He was among the first to anticipate the approaching commodification and monopolization of collective passions. By the 1930s, the essential shifts were already apparent: diversion from former well-focused interest; the eradication of historical depth and dissonance, of dissimultaneity through identity-systemic conformity; the ensuing expansion of an eternal present that was as ahistorical as it was blind to the future; the standardization and elimination of otherness; the theft — and hence devaluation — of positive symbols; the increasing control of political measures with regard to their effectiveness; and the shaping of society in accordance with an authoritarian state plan. The dispositive first diagnosed in the interwar period has crystallized — most recently through the digital reproducibility and dissemination speed of forgeries — into a present in which individuals make themselves seem ridiculous when they say they have a dream. Ha, Lieschen Müller* imagines the world! A world so damn impervious to wishes, hopes, and love.

## The Return of Space

The new art set itself the task of making Luise Miller the mistress of her words again, not abandoning her in the world of intrigue, but underlining her political competence. Knowledge-based art provides individuals not only a courageous counter-blueprint, it also organizes responses. The systematic location for this operation is space. By nature, individuals are nowhere more competent than in the space immediately surrounding them in their daily lives: they bear witness to its physical and atmospheric qualities, a space in which they can place a flower pot or invest with personal meaning. They are more independent here than they are in a digital network; they can verify their perception in their contact with others.

The great surprise of the overwhelming year 1989 and the ensuing events was that the niche population spontaneously seized the space they needed to overthrow the rulers: mighty demonstrations, human chains extending hundreds of kilometers, and later — as a gesture — the airplane attacks on the World Trade Center. The renewed employment of bodies in concrete space — in all its qualities, meanings, and phantasmagorias as the objective of action — refuted all predictions made by the theoreticians of the information age. For about twenty years, good old physical space had been considered an atavistic relic. Electric currents, interfaces, networks, and pixels defined a completely new world, inspiring splendid debates over its blessings and curses. And then, instead of hacking into the virtual world or causing digital systems to crash, people went on the streets. So simple, so effective. It was possible to manipulate everything: the writing of history, the news, making undesirable persons disappear — or even entire peoples. Urban space — historically shaped from nature by different generations and cultures, a material

witness to their endeavors to realize their dreams of the good life, their projections and aims — still persistently resists the assimilation and automation of emotions. No matter what may be asserted about past epochs or a societal group, their legacy as embodied in buildings and space repeatedly confronts the present with awkward questions. Not only that this legacy must be judged against the past in terms of the functionality and aesthetics of its spatial production, the character of the inherited spaces is — in comparison to historiographies written down under surveillance — by far the more reliable source of knowledge. The wealth of structures, typologies, materials, building styles, and physical manifestations of institutions can be seen and appropriated by anyone.

It is hardly surprising that during the 1990s "Reclaim the Streets" was the first mass expression of a "return of space." It started in England in 1991 as an environmental initiative, but soon took a fundamentally anti-capitalist turn. On the occasion of an International Monetary Fund and World Bank summit, the network attacked the bank districts of thirty metropolises in a "global carnival against capital" and took over the CCTV controlled city of London by staging a political street party. Not only did the jubilant actions held under the motto "tactical frivolity" mobilize, above all, the youth, the movement itself also learned a lot in terms of theory. Incidentally, a cultural historian, Marshall Berman, is considered to be the stooge. He evoked Baudelaire's poetry and the Paris revolutions, and also employed the phrase[17] that was to become a material force globally ten years later. It is a superb example of the political relevance of knowledge and of the memory.

The dialogue with space inevitably leads to a temporal claim, to a fight over the right to define history. It was not only in England that the demands "Reclaim Your Brain" and "Reclaim the Future" emerged during the occupation of the streets following the world financial crisis. Incidentally, the mobilizing power of Reclaim the Streets spawned considerable urban competence within the youth culture, which precipitated in the development of its own communication system with "tags" and "street art." Quite a number of the activists have meanwhile become professional artists, working in communication design and studying media science or architecture. Regrettably, as professionals they import dissident strategies into the world of advertising. At the same time, the experience of the playful urban guerillas seeps rather unpredictably into the economy, where open source concepts have become an explosive force. "Cultures of Economy" is the name of a new field sponsored by the German Federal Culture Foundation in which economists are looking for economic utopias.

## Tactical Utopias

In addition to Reclaim the Streets, innercity activist events revealed how integral the political impetus was. Although they were prepared by artists on the fringes of art fairs such as Art Cologne, they were carried out jointly with political activists and their scene. While playful street blockades in the fashion of "Pop" and "Critical Mass" rapidly evolved into fixed rituals in many places throughout Europe — Budapest had the highest mobilization rate, by the way — political art activists who practiced the art of "aggressive, non-accumulative urban activity"[18]

could not attract as many supporters as they anticipated. Once the format's activation potential was sounded out, they increasingly refocused their attention on the institutional milieus. Now, more than ever, they concentrate on the production of theory, the politics of representation, and "information arts."[19]

Within the domain of political art, various directions have emerged. Interventionist art as a form of *realpolitik* is particularly important in this context. It involves the genuine, long-term integration of political themes and marginalized strangers to art into the institutional world of art: AIDS patients are assisted at galleries; people with disabilities perform in theater productions; and current political issues are made accessible through artistic reflection. Striking examples of this are Christoph Schlingensief's theater projects and actions, especially *Passion Impossible: 7 Day Emergency Call for Germany. A Train Station Mission*, which actually made a sustainable change to a social injustice. Schlingensief's "prototypes" for reality-changing rule infringements exploit the fact that the constitutionally guaranteed freedom of art legitimates gestures that are subject to restrictions — or even illegal — in the political domain. Another pioneer in art as social trouble shooting is the Viennese group WochenKlausur, whose projects have brought about lasting improvements in hitherto unbearable conditions. Their approach is to precisely research the structure of a given problem, devise unusual measures, and employ art's authority as a media to compel solutions. In every single case, no matter if it involves providing medical care for homeless people or drug addicts, the press — as a form of public sphere — plays a catalytic role. WochenKlausur attaches great importance to defining its sociopolitical work with marginalized people as a form of art. The group translates what it does as fantasy "applied to society." They are convinced that the challenge presented by the new concept of art they practice will also inspire the liberal arts.

## Gegenfeuer and Attac

Political art reached a climax in 1995 when a scientist left the institutional realm of the academy to distribute his own texts as pamphlets on the street. Pierre Bourdieu expressed his solidarity with railway workers, the unemployed, and "illegal" immigrants, and triggered a new social movement across the globe with his new pamphlet *Gegenfeuer*. Attac. The way he significantly transgressed boundaries and redefined science as a militant struggle for human rights and freedom also gave art movements something they could latch on to. At documenta X in Kassel, the anti-racist network "Kein Mensch ist Illegal" (No One is Illegal) was created within the framework of "Hybrid Workspace." Hybrid projects are characterized by the systematic overlapping of political, social, artistic, and economic fields.

Shortly before the year 2000, Attac announced its slogan "Another World is Possible" and a sensitive messianic discourse began, enhanced by the coming of the new millennium. In addition to the radical question of who owns the city, concrete alternatives were also elaborated. And, for the first time in a while, people again began to think constructively about utopias in a micro-sociological sense.

## Utopia, Utopia: Paper Models instead of Grand Opera

In the realm of art, a comprehensive discussion on this theme most recently took place in Harald Szeemann's legendary exhibition at the Kunsthaus Zurich. With his culturally critical, philosophical, and religiously contextualized show *Der Hang zum Gesamtkunstwerk. Europäische Utopien seit 1800* (The Inclination toward the Total Artwork: European Utopias since 1800), the curator visualized the tendency towards the total work of art in all its ramifications, thus illuminating a profound current within modern art that had always sought to take aesthetic operations to their ultimate socially transformative consequences. The exhibition and the corresponding catalog were both enlightening and sobering, especially with regard to artistic positions that systematically interlock the identities of art and life with one another. Historical material revealed how the total overlapping of the two fields contributed to the creation of the most terrifying social nightmares. Faced with this collection of artistic hysteria, one was well placed to learn what fear was all about: from Wagner's concept of the total work of art — the great, all-embracing opera — to the furious battle cries of the Italian Futurists. The tendency to completely aestheticize life was identified as a diabolical concept of totalitarianism; the emphasis was placed on difference, deviation as a precondition for emancipatory, imaginary global production. "Only through a difference to the existing and a difference to the completely impossible"[20] does the production of utopias become really interesting on a societal level. Instead of religiously embedding the best of all possible worlds in the hereafter or in an ideology, it should first be established along the temporal axis, either as a different future or as a relay station in real time — invent concrete, different, valuable rules for the exchange of goods in the here and now.[21]

For twenty years, it thus seemed as if everything that needed to be said about utopia had been said. Szeemann had, in a certain sense, condemned the idea of "integrating art into life." It was only after the threshold to the new millennium had been crossed that the concept of utopia in art experienced a striking renaissance. At the Venice Biennale, curator Hans Ulrich Obrist presented the *Utopia Station* project. He cited Buckminster Fuller when explaining his reasons for doing so: "The world is now too dangerous for anything less than utopia." From the hands-off imperative of the Zurich exhibition, which underlined the affirmative character of an art with no boundaries whatsoever and its tendencies to aestheticize politics and everyday life, and create a dream factory, the impulse shifted from utopia's consolatory sides to its redemptive aspects. At the beginning of a row of similar projects came Thomas Hirschhorn's rather dystopian parody on a new world under mono-polar rule: a world reunited under the sign of the new "empire." Everything was associatively covered with militaristic camouflage patterns, with each and every sign serving as camouflage. *Utopia, Utopia – One World, One War, One Army, One Dress* illustrated the total rule of mimicry, the uniform design of globalization, and the literal conquest of all forms of difference with military means.

The description of the real imperialist utopia of global recruitment and uniformization served as a starting point for sounding out, little by little, the potential of a subjectivity that deviates from the norm. Which people are least likely to be deprived of their energy and

authenticity? Where do we find resistance nowadays? Hirschhorn's next project was to establish the *Musée Précaire Albinet* in a rough district in the Parisian *banlieues* in 2004. There, with the aid of some unemployed youth, he constructed an exhibition room and succeeded in showing eight auratic, autonomous modern artworks in succession in the very last milieu where one would expect to find anyone interested in art. He was not interested in communicating art pedagogically, rather to find out which impulses and reflections the works — as expressions of deviation — provoked among people who would otherwise be unlikely to see them due to their "apartheid" situation and marginalization. Hirschhorn did not conceive his activity as "political art" but as "art done in a political way," and fully respected the lessons learned from the Zurich exhibition. He carefully preserved the contrast to the daily gloom in Aubervilliers. And during the course of the eight-week exhibition, he created a utopian configuration that deviated from every conceivable reality — as all of the participants were fully aware. Hirschhorn gave exhibition visitors background information on the artworks so that they could personally get a picture of each image. The precarious museum was a kind of paper model for sharpening people's powers of judgment: encouragement training for Luise Miller. For twelve hours each day, the artist was present as a conversation partner, host, and resonance booster. The results of the undertaking remained completely open: It served both as a field for experimentation and as an exploratory movement that advanced in a certain direction, depending on whether and how the motley audience responded, spontaneously and without bias, to the diverse works. Here, the artist was more the recipient. Tell me what you see. Was this a new form of mimesis? Empathy for the community of outsiders or collective handicraft in the lifestyle of the multitude?

## Without Monuments, the World Will Fall Apart

In general, new artistic manifestations of utopian spaces are highly influenced by the concepts of Antonio Negri and Michael Hardt. Departing from the idea that a world reunited under the banner of capital is dominated in every respect by commodification and global uniformity, the production of utopia is now understood as a process of breaking chains. The point is to generate situational states of emergency that deviate from the norm, such as Hirschhorn's "precarious museum" or the pneumatic *Kitchen Monument* created by the Berlin group raumlabor. The German architects have shown in passing that it is still possible to splendidly pitch tent at any "non-place" on the global periphery. Celebrating a dream wedding under a city motorway? No problem!

Dissident art is more likely to create utopian moments than clearly defined spaces. It is still too early to say which long-lasting values will arise from this. When the utopian is defined as an open process, however, it raises serious questions about the continued existence and memorability of the interventions. How can the stage victories and defeats of a "multitude," which consists of good deeds and fine gestures, a tactile concert of acts of protest and of gestures of rejection, enter the collective memory? Which forms and, above all, formats provide suitable testimonies, for instance, to the societal work done by artists over the past twenty years? Without monuments, even "art done in a political way" will not be effective enough. To paint a graphic picture of the great moments and states of collective happiness has been a

basic human need ever since the time human beings lived in caves. Anyone who despises the power of images, and bans them, inevitably falls victim to the Counter Reformation.

It was Ernst Bloch who, in his *Bequest of this Time*, written during his early days of emigration, poignantly contested that the combatants of the New Objectivity had tried "to achieve transcendence by means of abstraction." This book warns against the historical avant-garde's error of pushing pure functionality into societal vacuums. Instead, concrete interventions of the "most material kind" are needed if one wants to avoid losing political initiative because of disregard for emotions. The very people who want to change the world need a well-positioned "revolutionary tradition army" that does not show contempt for the magical quality of the image. In addition to the coldness of analysis, the theoretical excess baggage, some reassurance in the world of affects was urgently necessary, respect for the archetypes of collective memory. Bloch firmly believed that the triumphal progress of the Nazis was also a consequence of the previous blunders and deficits of an avant-garde that had adopted an all too scientific approach. By disregarding people's inner needs, it had allowed the enemy to steal its most valuable symbols: the aesthetic of the street, the red of the flag, the eschatological dream of the Kingdom of God on Earth. All this had served the marching terror as a weapon for mobilizing the masses. Bloch identified the re-appropriation of traditions as an urgently needed corrective. "For there are only red secrets."

The world is currently engaged in a civil war over resources, a war in which information and symbols have played a role for quite some time now. It is still being fought out with spiraling, unrivaled acts of destruction. Where is the counter pole? Football alone will not succeed in satisfying people's desire for miracles and moments of magic.

In all likelihood, setting the right example will be the hardest task of all. Although the programmatic reorientation toward the public was consummated some time ago, and the opposi-tional nature of art as the thematization of the other and the creation of resonance rooms have been largely defined, the question of the form, the style, and the appropriate media for the collective memory, mutual recognition and embrace, still remains open. We know that the monument and power form a unity. Monuments require not only unhindered access to the claimed space and the necessary resources; monuments devoted to veneration and commemora tion and which dominate public space can also release powerful psychic energy. They are sustained interventions — especially when their form and content have an impact on their urban surroundings — in the emotional sphere of the collective and the individual. Monuments in the form of protected historical sites and buildings, on the other hand, require constant care and explicit public protection. The creation of mementos, their discovery and their preservation, is a particularly important political task in the cultivation of the public sphere.

How, then, should identity-reinforcing symbols, energy-laden gestures, durable sculptures, architectural forms, or moving pictures be made so that they serve large collectives as symbols of their shared aspirations? How can the memory of courageous acts of deviation and defining moments of collective action be passed on? How can one prevent new movements — which are,

in fact, a social miracle — from collapsing in the end because of a lack of passion and symbols? It seems that we now face a new chapter in the development of art. We can only wait for these novel works — and more "good projects" — with great impatience. Without monuments it won't really be possible to save the world.

1    "The Urban Task Force (UTF) was a working group commissioned by the deputy prime minister of the United Kingdom, John Prescott, to develop strategies for the revitalization of urban centers. It was called into being by the British government in 1998 and concluded its work in 2005." Here translated from German: Wikipedia, "Urban Task Force," http://de.wikipedia.org/wiki/Urban_Task_Force, 2009-12-29. There have been similar programs in many other countries, aiming to bring about an "urban renaissance." Problematically, they coincided with police measures, privatization, and tighter controls.

2    The Christian Democrat politician Klaus-Rüdiger Landowsky provided a drastic example in a demagogic speech before the Berlin House of Representatives in which he said: "I am also very grateful for the fact that the Senate is now proceeding intensively against Berlin's urban decay, against sprayers, against rubbish, and the total neglect of, among other things, the city's fountains. It is a fact that wherever there is rubbish, there are rats, and that wherever there is decay, there is vermin. This must be eliminated." Here translated from German: n-tv.de, "Der Fall: Klaus-Landowsky," http://www.n-tv.de/politik/Klaus-Landowsky-article140945.html, 2001-10-04.

3    The speculative nature of New Urbanism – its self-description notwithstanding – was revealed in the film *The Truman Show* (Peter Weir, 1998), which received several Oscar nominations.

4    Cf. Jacques Le Goff, *Die Liebe zur Stadt. Eine Erkundung vom Mittelalter bis zur Jahrtausendwende* (Campus: Frankfurt am Main, 1998).

5    The fact that social interests in the state socialist countries were implemented bureaucratically and in a despotic form does not mean that state rule in Central and East Europe didn't have the character of a hegemonic labor-based political order. Social and community-oriented values were habitually encoded in the "working class" (Wolfgang Engler). Although conflicts were all too rarely fought out publicly, the political elites were constantly confronted with the pressure of mass interests. This hegemony collapsed together with the "Second World" in 1989.

6    Cf. David Crowley and Jane Pavitt (eds.), *Cold War Modern. Design 1945–1970* (V&A: London, 2008).

7    Gerhard Gundermann (born 1955) can be seen an example of an artistically active worker and, vice versa, as an artist with an uninterrupted biography as a mine worker. Cf. Simone Hain, "Unsereins. Gerhard Gundermann und das wahre Leben," in: Franziska Becker, Ina Merkel, and Simone Tippach-Schneider (eds.), *Das Kollektiv bin ich. Utopie und Alltag in der DDR* (Böhlau Verlag: Cologne 2000): 98–125; and Simone Hain, "Gundermanns post mortem: Über das Ende der Arbeit, den Kampf gegen das Empire und die notwendige Erziehung der Gefühle," in: *Utopie kreativ*, no. 177/178, 2005: 688–692.

8    Roy, who grew up in a tin hut in the communist Indian state of Kerala during the 1960s, studied architecture and subsequently started working in the field of film. Her novel *The God of Small Things* was published in 1997. It served as an artistic metaphor for the activities of new social movements. During the Iraq war, Roy called for concerted, worldwide activities to ruin companies that were making money out of genocide. "I suggest that […] we choose, by some means, two of the major corporations that are profiting from the destruction of Iraq. We could then list every project they are involved in. We could locate their offices in every city and every country across the world. We could go after them. We could shut them down. It's a question of bringing our collective wisdom and experience of past struggles to bear on a single target. It's a question of the desire to win." Marxsite, "Arundhati Roy: 'We have to become the global resistance'," http://www.marxsite.com/aroy11.htm, 4 February 2004. Tellingly, Gandhi's fellow compatriot thinks very little of the idea of making friends with the enemy. The propensity to genocide is just as much engrained in human beings as "love, art, and agriculture."

9    See: B. Brian Holmes, "Do-It-Yourself Geopolitics, or the Map of the World Upside-Down," in: atelier d'architecture autogérée (ed.), *Urban/Act. A Handbook for Alternative Practice* (aaa-Peprav: Paris, 2007).

10   Stella Rollig, "Das wahre Leben. Projektorientierte Kunst in den neunziger Jahren," in: Marius Babias and Achim Könneke (eds.), *Die Kunst des Öffentlichen* (Verlag der Kunst: Dresden, 1998): 12–27.

11   Against this background it seems more than consequent that the attack on the World Trade Center adopted a Hollywood-style approach. The daily deaths in the colonies of the 'Empire', which no one seriously takes notice of, were transformed in the most shocking way imaginable into a spectacle in accordance with the laws of the eponymous "Society of the Spectacle." Was this politics or pop?

12   Cf. *Walter Stach and Martin Sturm, "Vorwort," in: Stella Rollig and Eva Sturm (eds.), Dürfen die das? Kunst als sozialer Raum* (Turia & Kant: Vienna, 2002): 7–9.

13   All of them were anarchist clubs and networks involved in developing friendship and assistance between the peoples or among the people.

14   Cf. anschlaege.de (ed.), *Plan B. Kulturwirtschaft in Berlin* (REGIOVERLAG: Berlin, 2008).

15    See: Umbruch Bildarchiv, "Silvio Meier Gedenken 2007," http://www.umbruch bildarchiv.de/bildarchiv/ereignis/ silvio_meier_2007.html, 2007-11-28.

16    Tina Leisch, "Nächste Ausfahrt Wirklichkeit," http://www.malmoe.org/preview/artikel/widersprechen/167/58, 2002-01-02.

17    Translator's Note: In German, Lieschen Müller is commonly used as a placeholder for an average or typical person. See "Jane Doe." In the following paragraph, the author draws a connection with Luise Miller, the daughter of a middle-class musician in Friedrich Schiller's *Kabale und Liebe* (Intrigue and Love), who believes that pure love can overcome class differences.

18    Cf. Marshall Berman, *All That Is Solid Melts Into Air. The Experience of Modernity* (Simon and Schuster: New York, 1982). Title is taken from the *Communist Manifesto* as a definition of modernity: "All that is solid melts into air, all that is holy is profaned, and man is at last compelled to face with sober senses the real conditions of his life and his relations with his kind." Karl Marx and Friedrich Engels, *Manifest der Kommunistischen Partei* (Dietz Verlag: Berlin, 1970): 46.

19    Cf. the exhibition *Baustop.randstadt* realized in Berlin in 1998 at the Neue Gesellschaft für bildende Kunst (NGBK).

20    Cf. Nicole Grothe, *InnenStadtAktion – Kunst oder Politik? Künstlerische Praxis in der neoliberalen Stadt* (transcript: Bielefeld, 2005).

21    Philipp Stoellger, "Das Imaginäre zwischen Eschatologie und Utopie. Zur Genealogie der Utopie aus dem Geist der Eschatologie, und das Beispiel der 'Hoffnung auf Ruhe'," in: Beat Sitter-Liver (ed.), *Utopie heute II* (edition text + kritik: Stuttgart, 2008): 59–99.

22    Cf. Christoph Links and Kristina Volke (eds.), *Zukunft erfinden. Kreative Projekte in Ostdeutschland* (Links Verlag: Berlin, 2009); and Ulrich Brand, Bettina Lösch, and Stefan Thimmel (eds.), *ABC der Alternativen. Von "Ästhetik des Widerstands" bis "Ziviler Ungehorsam"* (VSA: Hamburg, 2007).

# Possiblilites for institutional actions, when such institutions act as their own audience, and when Vienna, and before something like Berlin, existed ...

A conversation between Christine Frisinghelli and Diedrich Diederichsen, moderated by Sabine Breitwieser, on the network of the art scenes in Cologne and in Graz during the 1980s and 1990s.

**Sabine Breitwieser** This year's steirischer herbst festival is being held under the leitmotif: "Masters, Tricksters, Bricoleurs." The second part of the exhibition *Utopia and Monument* is, therefore, especially devoted to virtuosity in public space. Artists commissioned to create works in public space are faced, above all, with the question of how art reveals itself to the gaze of the others and, at the same time, with the extent to which the presence of the others is necessary. What do artists contribute to such a situation in the way of communicative, mediatory and even provocative gestures? How do they render their works "visible"? How are public debates — a common space — staged? In this context, I'm reminded of that story about the link between the art scenes in Graz and Cologne, and particularly of the legends about some of the protagonists of these scenes, such as Martin Kippenberger and other brilliant masters of communication and self-presentation.

I would like to start with Christine, because you — like Diedrich, too — were part of the scene from the very start. How do you view it all in retrospect? How did this network actually come about? And who were the most important partners, in your opinion? How did it work in the first place? And what's left?

**Christine Frisinghelli** For me, it all started with those who were actively involved. Just as important, though, was the institutional framework that Graz offered them. This made it possible for artists to pursue their own artistic strategies — also with regard to the situation that Graz represented institutionally. Important criteria were the friendships between the artists. And I think that Wolfgang Bauer and Jörg Schlick were central figures in all of this — certainly when viewed from Graz. Schlick acquainted the Galerie Bleich-Rossi with Martin Kippenberger and

Albert Oehlen. In 1985, the four artists had their first joint exhibition here. Peter Pakesch, who exhibited Kippenberger's and Oehlen's works at his gallery in Vienna, invited Albert Oehlen — as Grazer Kunstverein's first "artist in residence" — to Graz. After all, Forum Stadtpark was important in this connection as an institution: as an association of artists who were per se on the side of production, of doing artistic work, and not so much as an institution with a public mission to mediate. For Kippenberger and Oehlen, Wolfgang Bauer was an interesting figure. His theater plays regularly polarized people in the political and societal milieu in Graz. They rapidly exposed the limits of acceptance of contemporary art, and influenced discussions in the media and among the public on the steirischer herbst festival and Forum Stadtpark in Graz in the 1970s. Wolfgang Bauer continues to be connected with the exhibition projects, both as a participant and as a text author. Also worth mentioning is the interrelationship between the institutions in Graz: between Forum Stadtpark, which, as an association of artists, provided a free space for artists and consequently found itself competing with, say, the Neue Galerie and the Kulturhaus der Stadt Graz. We — and I include myself in this "we" — were able to operate as an open, hospitable house; we could invite artists on equal terms without the hierarchical structure typical of the other institutions. Here, there was a different relationship between production and representation from the very start. Jörg Schlick was able to use this situation for his projects, too, when he ran the department of fine art at the Forum from 1987 on. He used it as a base for making offers, as one that made it possible for people to view their own artwork in relation to that of other artists. This attitude and these opportunities were certainly also important for the joint exhibitions, such as *Broken Neon*,[1] curated by Kippenberger. For these exhibitions showed that an exchange was taking place, and a utopia of mutual activity. I think these were important developments for both the artists involved and for Graz.

**Breitwieser** Diedrich, you were one of the import factors from Cologne at the time. You started curating exhibitions at Forum Stadtpark quite early on. Who got you to come to Graz?

**Diedrich Diederichsen** In my memory, it was even earlier. But that's right: it was 1985. At this exhibition Albert Oehlen, Martin Kippenberger, Wolfgang Bauer and Jörg Schlick jointly exhibited their works at Bleich-Rossi.[2] I was there, too. And that's when I got to know the Graz crowd. I had something going on in Vienna at the time and then I went to Graz. Lots of things were developing in Graz even before this exhibition happened, which I later curated in Forum Stadtpark in 1987. Readings, exhibitions of works by Jutta Koether, Michael Krebber, Martin Kippenberger — and various other reasons for me to go there. Actually, it was Jörg Schlick who took the initiative, though not always. But you would often see the Graz artists in Cologne. Galerie Nagel was another important factor: Christian Nagel, who established close contact with Bleich-Rossi, and then, of course, Kippenberger. People saw one another pretty often. Kippenberger staged something in Cologne, and Wolfgang Bauer read or played something. But I established my first contacts in Graz, which were very differently organized, even earlier — before I got to know Bauer, Schlick and Bleich-Rossi in 1985. It had more to do with the New German music of the late 1970s and early 1980s, in which I was involved. There was an entire group of people from Graz there. There was this guy who called — or calls — himself Xao Seffcheque. He now writes screenplays. He turned up with a group called padlt noidlt, which

had come into existence about ten years earlier through another Graz-Cologne connection around the Cologne drummer Frank Köllges, who called himself Adam Noidlt and studied in Graz. Graz had been for many years one of the few places where you could study jazz. In any case, Seffcheque came from Graz and then — via padlt noidlt — to the Rhineland, where he got really involved in this German New Wave world in Düsseldorf. He also operated labels and had bands. Above all, though, he wrote for the magazine[3] that I was editing at the time. In the milieu around padlt noidlt there were others like Chrislo Haas, who ended up with D.A.F. and later became successful with Liaisons Dangereuses. I think he died about two years ago. And then there was also Mike Hentz and Minus Delta t: and although he wasn't from Graz, he also hung around there, around padlt noidlt. There was a padlt noidlt record on the Forum-Stadtpark label. Peter Glaser should also be mentioned, a friend of Seffcheque, who went from Graz to Düsseldorf, where there was a connection with the Forum-Stadtpark scene. He had more of a background in experimental literature, and later became interested in Neue Deutsche music around 1980. And that's when I first became acquainted with Graz and the people from there. And then this second phase started around 1985, and after that there was, above all, Jörg Schlick's influence and the relationship between Jörg Schlick and Martin Kippenberger. That was followed by a third wave, which was actually the founding of the magazine *Texte zur Kunst*: the symposium *What is Social History?*, which Elisabeth Printschitz, Isabelle Graw, and Helmut Draxler, another person from Graz, jointly organized, and where very different people appeared on the scene. These things gradually began to overlap. Although the 1985 exhibition, and the connections that resulted directly from it, came about through very different people than the 1990 generation, there were lots of connections that subsequently crisscrossed in every which way during the 1990s.

**Breitwieser** So it wasn't homogenous. Even in our preliminary discussion, you spoke of a number of waves with very different protagonists. Alexander Bleich once told me that the two cities were similar in size and similar in structure. But then how do you explain this connection now — which no longer exists in this form? Some of the people are still in contact, but these contacts are no longer that strong that the art scene in Graz is involved in intensive exchanges with Cologne. Didn't Forum Stadtpark even have an apartment in Cologne, as well?

**Frisinghelli** Jörg Schlick rented a studio apartment in Cologne. It was available to artists from Graz until around the late 1980s. In the early 1990s, an apartment was fitted out in Prague, so that it could also be used for exhibitions.

**Breitwieser** Who actually was the engine of this communication — was it really Kippenberger? Or were a number of people also involved in this? Who had the strongest impact? When I was doing research, the role of rowan berry schnapps was sometimes also mentioned. According to Isabelle Graw, the intensive meetings always ended with drinking this schnapps.

**Frisinghelli** I think that our mutual perceptions and our discussions were very intense. The things that were happening in Cologne/Düsseldorf in the fine arts and on the music scene — particularly through these friendships — were consequently, I think, often more interesting when you were viewing them from Graz than things happening in Vienna.

**Breitwieser** Elisabeth Fiedler, for example, who took over as fine arts correspondent at Forum Stadtpark after Schlick, and was also involved in the Graz-Cologne clique, told me, for instance, how impressed she was. But she also noted that very informal exchanges took place at the Grünes Eck.[4] So she would always travel to the Messe in Cologne for an entire week and spend the evenings in the Grünes Eck to find out which theory was "in."

**Frisinghelli** The symposium *What is Social History?* mentioned by Diedrich, was very important for the theoretical discussions in Graz. I wouldn't have necessarily associated that with our subject this evening — the relationship between artists in Graz and Cologne — although, of course, Isabelle Graw was one of the participants. Looking back, I'd say that for me the symposium was more closely tied to Graz, thanks to Elisabeth Printschitz, whose background was in literary studies (she also directed the Grazer Kunstverein) and Helmut Draxler, whose background was in art history. The contributions were supposed to be published in the journal *Durch*, if I remember correctly.

What made Cologne so attractive? In Graz, you often heard criticism of Forum Stadtpark. One of the accusations was that the exchange between artists was a one-way street. But in many respects, I simply don't believe that this was the case. At the time, thanks to the Cologne art fair and the individuals involved and the galleries there, Cologne was one of the most interesting cities for contemporary visual arts in the German-speaking area. For the artists in Graz, I think that the artistic gesture was decisive: playing with the public sphere and with themes that were clearly polarizing. I think, that was more decisive than the exchange between the two cities.

**Diederichsen** Well, I think that there were certain things you couldn't do in Cologne. This was because the scene in Cologne, inasmuch as it was interesting, was like that because it was more than merely the staff of the most important fine arts center in Europe. There was much in the way of self-organized projects going on in Cologne, in any case. And this included the music magazine (*Spex*), which I was involved in at the time. But some of these self-organized projects had partners, and these were galleries, or partners that tended to be more in the private sector. They had absolutely no access to things that are now perfectly normal in a city like Berlin, for instance: working with state or institutional money. There weren't any institutional budgets or institutional links. Even someone who was right at the center of things, like Kippenberger, had hardly any contact with institutions. And the new German museums, which were appearing everywhere at the time — in Stuttgart, Frankfurt and Cologne — didn't initially have anything to do with the entire world we were involved in. What was novel was the fact that in Graz — interesting that it was always Graz — there were people who either had institutions or were in contact with them. And this made it possible to produce things in a different way. In other words, there was something we'd never experienced: things like Forum Stadtpark and, later on, the Kunstverein in Graz, and so on. We were pretty cut off from this at the time. It took a while before anyone from this generation made an impact on the world of institutions, and before German institutions deigned to acknowledge the young generation. They are quicker off the mark these days.

That was one aspect. The other, of course, was that there was a parallel at the level of the famous 750-meter radius of a psychogeographical center that was said to exist in Cologne. Although Cologne is bigger than Graz population-wise, life there (then; it's different nowadays) — took place within a 750-meter circle around Friesenplatz. And that, in turn, is what you found in Graz: this structure. People always going the same ways, encountering the same people again and again, the concentration that it produced. But the modes of co-operation that arose in the process varied considerably. What I mean is that the core relationship, for example, between Kippenberger and Schlick was completely different from the one that, say, brought Elisabeth Printschitz, Helmut Draxler, and Isabelle Graw together — and perhaps a few more very different connections than between you, Christine, and Christoph Gurk, again five or ten years later.

**Frisinghelli** One thing in particular that I really appreciate about Graz is that many of the institutions there were created by the base: the idea of Forum Stadtpark as an association of artists. It's not easy to preserve the continuity of a structure like that. That's why some of the Forum's departments developed in a very professional direction, whereas others were more base-oriented and had an impact locally by presenting artists' works. But for the artists we were working with it was always a matter of creating a common basis on which to present their works in public. This was true of the exhibitions, the literature, the music events and the magazines that appeared there, such as *manuskripte* and *Camera Austria*.[5] Later on, there was also a film magazine called *Blimp*, as well as a series of art books that Schlick (together with Martin Kippenberger, among others) edited, like the symposia on literature, photography and film, which also formed part of the program. To our way of thinking, the events had a different character from those staged by a public or asademic institution. In other words, we had an institution that focused on the co-operation between the various artists and was self-organized. The program was presented on the basis of this self-conception.

**Breitwieser** So it was about working together on an equal basis, directly and quickly, the chance of being able to develop things relatively fast and to actually realize them. And these joint works, with people directly exchanging ideas, clearly created this close, temporary relationship between those involved. In such a situation, you get something back, unless you part on bad terms, which clearly wasn't the case.

**Frisinghelli** This principle was important to me, as it was when I was director of the steirischer herbst:[6] being at a place where something can also develop, that's being worked on; the festival not only as a place of representation, with an event character, but one that tries to create, in every single discipline — temporarily, within the time-frame of the festival — a basis for the events taking place here. And these were the projects you mentioned: in 1998, for instance, presenting *4 Record Stores from Graz and Music from Cologne* in co-operation with Christoph Gurk; setting up a store for each of these labels in Graz for a week; and arranging a concert evening for the same time. That same year there would also be an exhibition by Cosima von Bonin.[7] There were certain transfers from existing networks, between one scene and other, which challenged the local scene. Maybe things were done here that weren't yet useful for the scene I think that exactly these projects at the steirischer herbst, which were often small in

scale, have contributed towards Graz's extremely diversified contemporary music scene, which sometimes reaches very high theoretical and political standards, and sometimes holds the big-event character.

**Breitwieser** This kind of relationship between the art scenes in Graz and Cologne is well known and important to the degree that its protagonists have also attained recognition or will be recognized in the future, and that is what actually happened in some cases. It's certainly right, though, that Graz was a forerunner in some things. Andrea Fraser pointed out to me that in an edition of *Durch* magazine[8] from Graz the manuscript of her performance *Museums Highlights*, which was staged in 1989, was published just one year later in a German translation (as a first publication). It was evidently a very productive and stimulating scene.

**Diederichsen** Yes, that too. You know, when I start recounting the various contacts, and the longer we sit here, the more all these tiny details occur to me. For example: the fact that Albert Oehlen had a residence in Graz for a long time and that a number of contacts came about as a result. Among other things, they resulted in the production of another important issue of *Durch* magazine: the double-issue *3/4* with Albert as the guest editor and me as his collaborator. And there was also Roberto Ohrt, whom we got to know then; and Mayo Thompson participated. This was the first time, Albert and I sat down in writing our debate with Cobra and the Situationists. As a result, this contact was always there, but obviously the precondition for all this was not only the preconditions that existed in Graz, but those that existed in Cologne, too, which probably changed far more dramatically and no longer exist in this sense in Cologne. And, the preconditions changed on the other hand, precisely because the protagonists in Cologne at the time were far more cut off and far less clearly defined via a normal art scene. Nowadays, people become part of the art scene relatively quickly, but then the status you have is generally not worth so much, because there are too many contenders at the same level, and because it's also so highly differentiated. This relatively constant "off" world on the fringes no longer exists nowadays, or has declined in importance. And then again, Graz, in contrast to Cologne, had to deal very consciously with its being the smaller of the two towns alongside the center. After all, there was a city called Vienna, whereas Germany didn't have a Berlin at that time. So Cologne didn't know where it stood. And the fine arts as such were not so hegemonial as they are today, and were consequently more experimental in general. In Graz, in contrast, there was a stable relationship between what people wanted to distinguish themselves from, or create a counter-balance to, and the places where they could also develop the kinds of coalitions, connections or networks, as it were, that were opposed to the other, more obvious network. You didn't really have such a clear-cut situation in Cologne. At the height of these exchanges, I never really understood why. But now I think that it had a certain logic, which has to do with the history of the 1980s and 1990s and, above all, with this transition.

**Frisinghelli** An interesting point in time was reached during the phase when the leading figures at Forum Stadtpark changed. Do you remember? That was after 1995, when I decided to take over the steirischer herbst festial and left Forum Stadtpark. Walter Grond became the new director, because Alfred Kolleritsch retired. Around 1996–97, the idea of starting an academy

arose (Graz had, after all, the great disadvantage of not being able to provide an art school or college for the visual arts). The idea was based on the conception that Forum Stadtpark — as a multidisciplinary association of artists — could, with its entire program, serve as a basis and location for an academy, with links to the universities, and integrate all existing networks. During this period, a lot of people were thinking along these lines. You were involved, so was Helmut Draxler and Stephan Dillemuth of Friesenwall.[9] The next step was to create a situation, on top of Forum Stadtpark's program, in which you could reflect upon the main points of content. This was very interesting for Graz and the province of Styria, as far as cultural policy was concerned. And after the province's leading figures in the field of cultural policy changed, also political interest was expressed in taking charge. I believe that this would have meant Forum Stadtpark giving up a lot of its autonomy, but the project foundered pretty quickly anyway. Although it must be said that its failure was due to internal conflicts, and particularly from the perspective of its own self-conception as an institution.

**Diederichsen** In the meantime, something had happened in Cologne that was, for a time, referred to as "repolitizication." After reunification — not immediately afterwards, but after a certain period of being paralyzed with shock — there was a return to political positions that would not have been formulated in this way again in the 1980s, or rather were now being formulated and articulated differently, partly by different protagonists than those who'd been the protagonists in different constellations and contexts in Cologne in the 1980s. But this was relatively important in the entire history of this academy project in Graz. People from Cologne and, in the meantime, from Berlin, too, who had been watching this project, now did so in the light of this new development. Because after this phase of repoliticization started (the rediscovery of "institutional critique" and so on), where it was less a case of individual expression and individual anarchy, but more of acting collectively now, in groups and in new situations — the "academy" was now one of the concepts chosen for these new, temporary forms of organization; and it was also one thing, among others, that was projected onto this development, but where those involved could not really reach any agreement. I was not, as it were, very closely involved in the entire development of the academy project, but I do remember a symposium, in which I participated, that focused more on literature, which also occurred in 1995 where the academy was a sub-theme; Sabeth Buchmann was also there, for instance.

**Breitwieser** Isabelle Graw told me that Graz was also the place where she practiced giving her first lectures, and the place she received her first invitation to visit. It was similar for me, too. I wasn't involved until the late 1980s, early 1990s. When we look at this network and the way the protagonists acted, it was very much a case of publicizing (advertising) oneself, and of how to appear in public as a group or as a conglomeration of these two cities. That seemed to be very fundamental. How did you experience celebrating yourself in public? I personally experienced it as someone who never belonged to this group; I was there as a sort of onlooker at the various venues in Graz and Cologne. There were these social get-togethers in the evening for meals and openings. And I always had the impression that presenting yourself, as well as celebrating among, and in front of, a certain group of people in public was very important.

**Frisinghelli** We were able to define the framework ourselves: providing a hospitable venue, which also included celebrating, of course. And this, I think, contributed a great deal towards making an informal exchange possible, so that we did not get caught up in the customary hierarchy of speakers and listeners. Instead, there were lots of talks that took us further and didn't obey a formal structure.

There was also a great tradition of symposia in Graz, which was especially cultivated by Forum Stadtpark — often within the framework of the steirischer herbst festival. Apart from the artistic work, it was important to us to create a platform for theoretical and historical debate and to link up positions that were important for local discussions with international ones. Let me cite just one example that concerns photography: the annual photography symposia were something like art academies in the 1980s, as there had never been any educational courses in this field in Austria until then, neither in the area of art history nor that of art education. The form these symposia assumed was most certainly influenced by the literature symposia, which had a legendary reputation going back to the early 1970s. For many years, people often talked of these meetings of writers. At Forum Stadtpark, we diligently cultivated the role of hosts.

**Breitwieser** It was evidently crucial to have resources so that you could get this published, in a professional sense going beyond the framework of the discussion rounds. What was this like for you? Publishing things you had been involved in? Presenting your self as a group or a network in various cities? How open was all this? To what extent were the people there allowed to join in? How much power did this give to people who played a gatekeeper role?

**Diederichsen** What I find interesting is the fact that the participants were their own audience, in both Graz and Cologne — and this is also true, amusingly enough, for the various groups: for the more expressive artists of the 1980s, and also for — how shall I put it? — the reflective discourse-producers of the 1990s. So you could say in a way that they hardly had an external audience in either city. The people who listened were the same ones who saw themselves — potentially, at least — on the stage. And often they were not only potentially there, but in reality, too. And that no longer happens these days, because you can now find audiences for everything, strangely enough, even for the things that we were doing back then. And the people who are doing things experimentally, as it were, really do have an audience now. So the interest in all things associated with the arts has grown enormously. And it obviously has a very intensifying quality to it, if you are your own audience. Especially if there is enough mutual interest within the group and an exciting atmosphere, because you want to win over this audience, which happens to be you yourself. And I found this aspect relatively important. Apart from that, there were obviously other times when you didn't know what had actually happened in Graz in the meantime. So you did something or other and returned to Graz eighteen months later. There were the same people, the same institutions, everything was quasi-familiar but there was something that was different, too, and that remained unknown: what happened in illusory continuity in the meantime. That, I think, is a problem — like the way everything ran so smoothly.

**Frisinghelli** Although there was certainly some political tension there, too. That's what I was trying to say at the beginning: the atmosphere would sometimes take a sudden turn for the worse. The ominous trip to Singapore by the "Lord Jim Loge"[10] is a good example of this. It was a complete scandal there and resulted in a rift between Forum Stadtpark and the steirischer herbst festival. It even triggered sharp conflicts within Forum Stadtpark. It all started over the question of whether ten members of Loge 1988 should travel to the *Council of the Lord Jim Loge*, which was taking place in Singapore, at the festival's expense — as a contribution to the steirischer herbst. This festival contribution had already been presented as a concept to the director and — as it is customary among contractual partners — had been approved by him. Later on, however, when the departure date drew near, Horst Gerhard Haberl, then director of the festival, unilaterally cancelled the contract and the flights, arguing that such a waste of public funds simply went too far and that the festival would be cast in a bad light in subsequent media discussions. Faced with this situation, Forum Stadtpark yielded to the festival. The board refused to support Jörg Schlick, the curator of the project. Perhaps outsiders underestimated the conflict and were able to understand the project as a playful, provocative gesture. In Graz, however, this development caused a deep rift between the two institutions, Forum Stadtpark and the steirischer herbst, and put in question our own conception of autonomous work.

**Diederichsen** And I think that Jörg explained very clearly what it was all about. He explained it to everyone in great detail. But even so, it obviously looked as if it had been planned just as a gag right from the start anyway. And then it didn't materialize. Who cares? It was the idea that mattered. And that this wasn't the case is a good example of precisely what I am trying to say. Because it really was connected with something — it wasn't just a funny idea. And that is precisely the point.

**Breitwieser** This Cologne-Graz scene also comes in a portable form, as it were. There was a series of exhibitions in which the Graz and Cologne scenes presented themselves: Kippenberger had done a large number of exhibitions, such as *Broken Neon*, which I've already mentioned. It showed his collection, which reflects this particular scene's network. There were other private collections, too, which also mirror these relationships and exchanges. How do the works that were generated at that time come across when someone looks at them now. The entire system functions very differently these days. Whereas in those days, it was all-important to have acknowledgement from your own audience and these informal, non-institutional, direct links at eye level, in the meantime, professionalization and institutionalization have established themselves. Artistic works have a different objective now and are aimed at what people readily refer to as the "international art business." I personally feel that you can see this communicative, networking approach in the works themselves. In the works we are talking about, you always have the feeling that the artist is addressing someone, and we have a pretty good idea whom, but we have that distinct feeling that it isn't us. These works engage in a kind of artistic insider talk.

**Diederichsen** That is certainly true for the entire period between 1985 and '90 — a phase in which I'd say that this entire exchange was dominated by figures such as Kippenberger, Krebber, and Schlick. But the institutional level, or the level of familiarity, or of the size of the audience was not all that different five years later; but the protagonists and the content had certainly changed. Although this Kippenberger-Schlick-Krebber-and-so-on-network still existed, there was something else that was very different too, and this was happening between Cologne and Graz. And these are the very things we've already mentioned: the symposium in 1990, the Academy developments, and a few other things, too. And the content of artistic work and artists' self-conception changed considerably. But even so, the frequency, size, scale and structure remained the same. I find that very interesting. And in this case the works don't make it look as if members of a clique have been communicating with one another. Although that's basically the way it was. But very different concepts and very different strategic conceptions appeared, and they responded very differently, as it were, to the historical circumstances, which had changed in the meantime. And although Berlin was still far, far away on the horizon, the content was now very different.

**Breitwieser** Let's take Berlin now as a topical example. One thing I keep on hearing is that everyone lives there, but they never meet one another — or only occasionally. The structures for a real exchange don't exist. Do you also see a marked contrast with Graz and Cologne? Is it simply the size, or is it really different?

**Diederichsen** It's also something to do with the people's age and way of life. In Berlin, too, there are obviously opportunities for frequent encounters. On the whole, their scale has become bigger, much much bigger, and not only in Berlin, however, but basically across the globe. Nowadays, twenty to thirty times the number of people are interested and participating in this form of artistic production. Accordingly, there is no longer only one type of structure, but various overlapping ones. But even today, you still can live out a kind of intensive, psycho-geographical, pub-art existence just as they did in the 1980s.

**Frisinghelli** I should like to say something to that. We were on the periphery; we were working at Forum Stadtpark; we also planned joint exhibitions with them; but we then didn't count among Schlick's and Kippenberger's close circle of friends. And it didn't only depend on the nature of the projects: there was also this group consensus that was based very much on inclusion and exclusion. So the kind of participation was also always a challenge, too. As far as I can see, Kippenberger defined himself very much in terms of exclusion: in terms of who or what belonged to the inner circle, and what was right. That might be very productive as a game, but it probably excluded many people, in fact. […] A second aspect is related to the fact that the position of the artist as the director of an institution or as an organizer also changed the reception accorded his or her work. Forum Stadtpark, as an association of artists, enabled artists to define their own institutional context, however, they simultaneously began competing with other institutions. What was an advantage in terms of co-operation between artists could be a disadvantage when it came to the reception of their own works, particularly in a local context.

**Breitwieser** Although this scene is characterized precisely by the fact that the protagonists engaged in hybrid activities. Kippenberger, of all people, was always arranging things, organizing exhibitions and collecting things, and was very versatile in what he did. And consciously so.

**Diederichsen** I wouldn't like to see this Kippenberger-Schlick axis as being representative of the whole. It's one aspect.

And, of course, what you have said about all this inclusion and exclusion is, for me, really a leitmotif. As far as I was concerned, it started with the first work I ever saw by Wolfgang Bauer with his play *Change*. I knew that it dealt with precisely this kind of figure in the social life of artists, and with an attempt to create intensity and commitment — by means of inclusion/exclusion — within a group of artists. That is, of course, precisely what many artists obviously did — quite independently of Graz — during the 1980s, at a time in which there was simply no other anchor, no immediately identifiable links with political movements or anything like that, but where the construction of social tensions determined everything. And that it constantly reappeared in this scene precisely then: both as a theme and as social practice. And then, in the end, you also found it in the sharp criticism directed at the "Lord Jim Loge" by so many people, for instance by Stephan Geene and Sabeth Buchmann and others from the former b_books milieu, and it became an issue again. I also remember being at a symposium on the occasion of Wolfgang Bauer's fiftieth birthday and that I gave there a lecture entitled *Avant-garde and Human Sacrifice* which had this as its theme again. In fact it really is a theme that is linked, I think, with the history of self-organization: a form of self-organization that justifies itself not on the basis of a certain external discourse that legitimates it, but through its own self-generated intensity. That's where it belongs. In any case, I find it in the sequence of events we are talking about now; it really is a recurrent theme, just as it is obviously also a structuring, productive social practice.

**Breitwieser** I should like to conclude with a question: How do you both find Graz now? And the Cologne-Graz connection nowadays? It has often been the subject of debate that the steirischer herbst no longer has the same significance because this entire area is now witnessing a proliferation of exhibitions, artists and debates.

**Frisinghelli** From within? From without?

**Breitwieser** That is the idea of the question: a view from within and from without.

**Diederichsen** Only last year, I spent very, very much time in Graz, but I always approached it from Vienna. And that's a completely different story. Viewed from Vienna, Graz looks very different than it does from Cologne. And there is also this process of getting there. I mean first of all it's a fact that it's easier to fly somewhere these days than it was in the 1980s and 1990s, simply because you couldn't afford it then. And traveling to Graz by train was always rather awkward, even from Cologne. I remember these night-train journeys when you got out at Linz in the morning and were completely wrecked, and then you first had to travel to Selzthal and

change trains there. And then, four hours after you'd arrived in Linz, you'd finally be in Graz. It's not only that cheap flights connect towns and cities in different ways these days, but also the trip from Vienna: you've only just finished reading the newspaper and you notice you're already there. That's another angle. The other one, of course, is that the protagonists are no longer there. So in this case, the personal level plays a decisive role. Too many of the protagonists have simply disappeared.

**Breitwieser** But haven't any new faces appeared on the scene? Do you know anyone who acts in a similar way today?

**Diederichsen** Not necessarily between the cities of Cologne and Graz. Well, now that I've been at the Akademie in Vienna for four years now, I've got to know a lot of people who are studying here at the academy that are linked with Graz in one way or another. Which has probably always been the case. But I've never really noticed it, because I've never spent so much time in Vienna without a break as I have now. Now I see it from Vienna, and there it is, so to speak, one of the cultural crystallization points in the catchment area of the Akademie and other Viennese institutions. That's a very different perspective. And I'm also a lot older now, of course, and have a different attitude towards a certain mode of producing sociality, in the way it's now being generated by young people. I see it with different eyes, too. But I don't really think there is any new blood for all this. Not like that.

**Frisinghelli** I think the institutional situation in Graz has grown far more varied during the past decade. One important factor is that, since the late 1990s, Forum Stadtpark has ceased playing the role of a catalyst within the context of institutions and as a result, the public institutions are no longer challenged in the same way as they used to be. And in the form of the Kunsthaus, a very large player, which is integrated into the Landesmuseum Joanneum, has appeared on the local scene: in terms of its weight alone it is a major challenge for everyone involved. On the other hand, Graz hasn't made much progress in cultural-political terms since 2003, when it was the Cultural Capital of Europe. It seems that the identity of the city as a cultural center is again and again put into question. City marketing ideas tend to point in the direction of "creative industries," which cover all forms of cultural production: from fashion to design. Graz is apparently going to become the design capital, as a UNESCO City of Design. This shift in context is the diametrical opposite of what we've been talking about. This raises new questions about the way institutions see themselves. How can we support artistic production? I believe that cultural policy must increasingly examine the conditions under which art is produced, and how distribution works. I don't think that Graz finds itself in a particularly different situation than other cities. All in all, a strange and vague concept of culture has superseded a stricter attitude towards art. People will have to continue working on generating content, no matter whether this involves exhibitions, publications, or other products of the artistic processes.

**Diederichsen** On the whole, I think that the fine arts no longer generate the same kinds of social contexts that they used to. These social contexts still arise — I would say that they have shifted, changed a little — even today. Maybe in different structures, and in a different way, too,

connected with different kinds of networks; but they exist, and when they include the fine arts, it's always in connection with something else that holds the social component together; in other words, either a political idea or a different kind of cultural practice. These are, as it were, still co-determined by something else. It is only due to the fact that people produce fine art independently, just as they fancy, and want some resonance, as it were: the only thing is that by acting with this intention people no longer create such structures.

**Breitwieser** And it has probably always been the case that they've wanted to rise above established structures or other scenes, that there's been this striving for differentiation.

**Diederichsen** Yes, but what has changed, in fact, is that this alone used to be enough if you wanted to diversify and become more and more sophisticated. No matter whether it was successful or not. But it worked for everyone who wanted to observe it. And it is no longer possible to do this with the strength of your own desire to diversify, as it were, but only by doing something else at the same time. Or if you justify it with other arguments, or you are involved in other things.

> Interview conducted on June 24, 2010 in Vienna
> Transcribed by Karin Lederer
> Edited by the interviewees

1    *Broken Neon*, exhibition of the Martin Kippenberger Collection, Forum Stadtpark, 1985
2    *Kritische Orangen für Verdauungsdorf*, Wolfgang Bauer, Martin Kippenberger, Albert Oehlen, Jörg Schlick, Galerie Bleich-Rossi, Graz, 1985.
3    Diedrich Diederichsen was editor of the music and pop culture magazine *Spex*, Cologne, from 1985 to 1991.
4    Zur Grünen Eck was a legendary meeting place in Cologne during the early 1990s.
5    *manuskripte*, magazine for literature, founded in 1960 for the opening of Forum Stadtpark in Graz (http://www.manuskripte.at); *Camera Austria*, photography magazine, founded in 1980 by Manfred Willmann, Christine Frisinghelli and Seiichi Furuya (http://www.camera-austria.at).
6    Christine Frisinghelli was director of the multidisciplinary festival steirischer herbst, which was founded in 1968, from 1996 to 1999.
7    Cosima von Bonin, *Löwe im Bonsaiwald*, Palais Attems steirischer herbst, 1998.
8    The art magazine *Durch*, commissioned by the Grazer Kunstverein, was published from 1986 to 1993 by various editorial boards. Altogether, the following editions were published: 1, 2, 3/4, 5, 6, 8/9, and 10.
9    Friesenwall 190 was a project room in Cologne operated jointly by the two artists Stephan Dillemuth and Josef Strau from 1990 to 1994.
10   The "Lord Jim Loge" was an association of a number of artists, including Jörg Schlick, Martin Kippenberger, Albert Oehlen, Max Gad, Walter Grond, and the writer Wolfgang Bauer. Their motto was: "Nobody helps anyone." Schlick was the publisher of the magazine *Sonne Busen Hammer*, the association's central organ. The name of the loge was taken from a novel by Joseph Conrad, whose main character is Lord Jim, the eternal loser, who nevertheless remains an idealist. The "Lord Jim Loge" viewed itself as a "male association of genuine resistance to thought and behavioral patterns."

# Utopia and Monument I
# 2009

## On the Validity of Art between Privatization and the Public Sphere

- Lara Almarcegui
- Nairy Baghramian
- Ayse Erkmen
- David Maljkovic
- Heather & Ivan Morison
- Nils Norman
- Andreas Siekmann
- Michael Zinganel
- Dolores Zinny & Juan Maidagan
- Kooperative für Darstellungspolitik
  (Jesko Fezer, Anita Kaspar, Andreas Müller)

# Lara Almarcegui
# Hidden Terrain with Abandoned Allotments

**Körösistraße 30**

**Emiliano Gandolfi**
**Under the City's Skin**

Lara Almarcegui's look into the urban environment is constantly drawn to those often imperceptible incongruities that reveal how the contemporary city truly operates politically, socially and economically. The opening to the public of land temporarily left behind in the process of urban development, the manifestation of the construction materials of a building and the preservation under contract of a wasteland are all actions that contribute to consolidating a fragmentary documentation of episodes that express an unofficial chronicle of the city. These places are the plots of a parallel historiography, antithetical to the rigid, imposing account of the political cabinets and the technical bureaus. They are the places from which that capillary narrative emerges which is composed of the slow stratification of thousands of small daily actions, of the inexorable succession of laws, and in which the development of the official image of the city inevitably comes undone.

In Graz — Cultural Capital of Europe in 2003, registered in the World Cultural Heritage Sites of UNESCO and 2008 City of Culinary Delights — the work of Lara Almarcegui was to find, among the dense mesh of restorations and the packaging of the image so totally controlled as to be apparently handled by the Tourism Office, an open space capable of rendering obvious the true nature of the city. Her first attempt was to open an empty lot to the public, to show the citizens and the tourists a place inaccessible until that moment and, even more significant, provide access to a place that was not yet planned out. The residual, the non-designed, the "what's-to-come," have an eminently political quality in Lara Almarcegui's work. This is the possibility of being able to access a site in which visitors can exercise something rare in the "over-designed" contemporary urban context, such as the ability to use their imagination. That ability which Henri Lefebvre previously quoted in clear opposition to the "subjective" space designed by the architect, a space too loaded with objective significance: "It is a visual space, a space reduced to blueprints, to mere images — to that 'world of the image' which is the enemy of the imagination."[1]

But the empty lot in Graz remained closed due to the impossibility of obtaining the required permits and Lara Almarcegui continued her search until she unearthed another city fragment that caught her attention. A hidden place in which to encounter a dimension totally different from the rest of the old town, one of those parallel conditions in which the reality emerges with intensity, just before disappearing once again. *Hidden terrain with abandoned allotments* is a work that goes beyond appearances, to retrace in the interstices of the city's urban evolution an inexorable source of stories, of human interlacement, of interests and possible imagination. It is a work that disregards the representation or the concept of space to expand a much more complex main theme — that of space experienced. What emerges is the contraposition between the abstract space of the experts (architects, town planners, planners) and that of "everyday life," a subjective dimension created by the decades-long venturing of citizens, of relationships, of dreams, and inevitably also clashes and negotiations.

The *hidden terrain* space experienced, with its abandoned allotment gardens, the pre-eminent vegetation, the unguarded huts, brings with it stories, dreams and conflicts that Lara Almarcegui brings back to our memory. The economic interests, the imminent plans of transformation of this area and the cancellation of these memories allow the transience and the inevitable failure to retain these stories to emerge. Lara Almarcegui's work has concentrated several times on the allotment gardens. In order to learn how to read these marginal territories and to decipher the fragility of the tracks that they leave on the area, Lara Almarcegui worked between 1999 and 2002 on the project

*Becoming an Allotment Gardener*, in which she took care of an allotment garden in Rotterdam. This scrap of land, next to a small wood, gave her the opportunity to understand the real implications of this condition of urban self-determination and to be part of a community of people who define a free space outside the rigid mesh of the city. In an urban setting in which the spaces for living, working and free time are strictly planned, the allotment gardens, because of their unique and distinguishing state as self-built and self-managed spaces, offer a dimension of obvious opposition to the rest of the city. Lara Almarcegui's goal in *Becoming an Allotment Gardener* was to "make a garden, build a shed, and spend hours working there, with all the implications this might have."[2] With this performance stretching over several years, Lara Almarcegui has had the opportunity to test an urban condition, with the only instrument possible: everyday life.

Lara Almarcegui's allotment garden never had exceptional yield. Too close to the trees, it did not have enough light to flourish. In addition, in the last year of the project, the artist's frequent absences to pursue projects abroad heaped on her a litany of criticism from the community of market gardeners, not to mention a lack of understanding and negative opinion from the art world. But, in a certain way, the project's failure from the formal point of view was a fundamental experience for understanding the nature of the city, its hidden qualities, and the subtle social plots that hide behind the physical manifestation of the area.

From the point of view of the perception of the urban context, the work of Lara Almarcegui fits into the definition of "psychogeography" as Guy-Ernest Debord

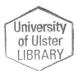
University of Ulster LIBRARY

and the Situationalists intended it: the study of the precise laws and specific effects of the geographical environment, consciously organized or not, on the emotions and behavior of individuals.[3] This new awareness of the urban landscape casts an alternative look at our urban landscape, traces new priorities, and redirects the glance. In her work, Lara Almarcegui tests firsthand the limits of our definition of city and construction. She gives us documentation — as in the case of the maps of the wastelands of Amsterdam, Liverpool, and São Paulo — from which we can reconstruct parallel geographies. Her experiences and observations leave opinion open; they define simply a frame of the places of interest and leave us free to identify their qualities, their possibilities and their consequences. It is thanks to the opening of this new urban imagination that we collect these oppositional spaces, through which we can see under the city's skin.

1    Henri Lefebvre, *The Production of Space*, trans. David Nicholson-Smith (Oxford: Blackwell Publishers, 1991): 361.
2    Lara Almarcegui, "Becoming an allotment gardener" in *Lara Almarcegui* (Brussels: Etablissement d'en face projects, 2003).
3    Guy-Ernest Debord, *Introduction to a Critique of Urban Geography* 1955, from http://library.nothingness.org/articles/SI/en/display/2, website visited in May 2010.

Unrealized project proposals by Lara Almarcegui, pp. 53–55

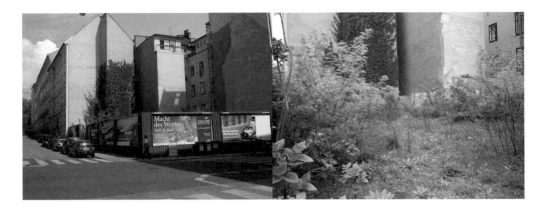

**First Project for Graz**
**Open Terrain**

**The project consists of removing the fence that encloses and surrounds an empty lot so that the land and the vegetation become visible from the street; the public can also access the terrain.**

The terrain is a small one. What happens inside is not visible from the street. It has lots of vegetation surrounded by a big fence that hides it. Removing the fence will significantly transform the site. Letting the vegetation be open will produce a strong image. But the project will also be an action to enlarge public space.
Additionally, I expect the project will generate a discussion on the empty terrain itself. The conversation about what used to stand on the land, its demolition, what happened meanwhile, and the future development project. In this way it could further the discussion of urban change and development.

**Location**

The best terrain is at the corner between Einspinnergasse and Burggasse.
It is within the historical centre; this makes it easy for visitors to access. Such a location underlines the content of a "negative monument" by the contrast to its surroundings.

This small corner in the city centre seems to represent well what Graz is and wants to become: a monumental city. A historical building was demolished there around 10 years ago, very loved by the inhabitants not just for its architectural value but because it housed popular bars such as the "Kommod"-house and "Triangle." People still remember that demolition. The future building is designed by Zaha Hadid. The lot is controversial.

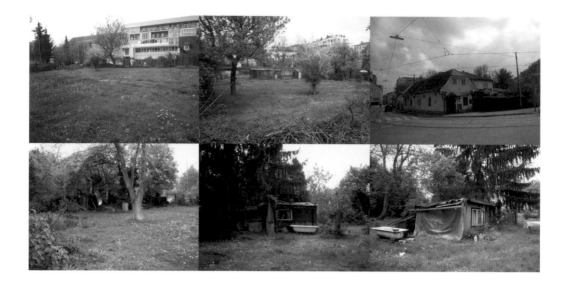

**Second Project**

**Study and presentation of block with empty allotment gardens**

The project consists of finding out the history, the present situation and the future of each construction on the block of the allotment gardens. The detailed description of the entire area would be published in a local newspaper.

This would include each shed in the gardens but also the empty terrain in the area with its squatters' history, eviction, demolition, new owner's plans, the existing bar and the small houses.

The block is very interesting because it contains different housing typologies in a small area surrounded by upscale housing; the city wants to relocate everything in the block area. The construction hasn't started because the owners of the bar do not want to leave; the gardeners officially left the area but some remain. Near that site, along the river, many expensive trendy flats are being built in stark contrast with the half-abandoned site.

I still have to decide on details such as which newspaper to use, which date, etc.

| | | |
|---|---:|---|
| Gneiss | 400 000 | tons |
| Limestone | 150 000 | tons |
| Clay | 40 000 | tons |
| Loam | 20 000 | tons |
| Basalt | 12 000 | tons |
| Talc | 3 000 | tons |
| Schist | 2 000 | tons |
| Lime | 500 | tons |
| | | |
| Total | 660 000 | tons |

**Third Project
Material Componenents Schloßberg**

**The project consists of finding out the materials that are part of the Schloßberg mountain and elaborating a list that says how much there is of each material, ending with the total weight of the mountain.**

**Location:** The list would be placed on a wall of a cave within the mountain, so that the viewer can experience the materials and feel how it is to be inside the mountain while reading it. Since there is or may be too much underground space, I suggest it would be stronger and less obvious to use a space on the top of the mountain; for example the entrance to the prison or the cave of the clock tower, etc.

Some underlying ideas: With this work the mountain is analyzed and "put in pieces." The mountain is presented in a detailed, careful way but at the same time, its destruction is suggested. The mountain becomes very physical when presented as so many tons of limestone, in contrast with the image—which can be idealized—of the mountain that can be seen from the city. Presenting the rock weight in tons runs counter to "images" or "views." The mountain is itself an iconic monument in Graz; therefore I like the idea of putting it in pieces.

How to calculate: I had planned a similar work in Linz for a show which was ultimately cancelled, but I can apply my experience. We will need the digital geological map of the mountain and the result of wheels done by the city.

There is something a bit obvious about those locations, that makes me hesitate about the project.

# Verborgenes Terrain mit aufgelassenen Schrebergärten

Versteckt hinter den Häusern der Grazer Körösistraße, Lange Gasse und Muchargasse sehen die Schrebergärten, die einst im Besitz der Stadt waren, ihrer Zukunft entgegen. Sie wurden von einem Bauunternehmen aufgekauft, doch obwohl die Gartenpächter die Anlage bereits räumen mussten, steht der Beginn der Bauarbeiten noch aus. Aus diesem Grund verwildern die Gärten zusehends, zwischen den Obstbäumen, Blumen und Hütten wuchert das Unkraut. Verborgen vor den Augen der Öffentlichkeit hat sich die Anlage zu einem gleichermaßen verwahrlosten wie faszinierenden Ort entwickelt. Ziel des Projekts ist es, einige der Geschichten, die mit ihm verbunden sind, und einige der Pläne, die für seine Zukunft geschmiedet wurden, vorzustellen.

## Die Schrebergärten

Als der Besitzer dieses Schrebergartens vor acht Jahren starb, begann sich einer der Nachbarn um die Anlage zu kümmern. Einstmals waren alle Gärten durch Zäune getrennt, von denen die meisten jedoch mittlerweile entfernt wurden, häufig, weil zwei oder drei Anlagen zusammengelegt wurden, wie auch in diesem Beispiel hier.

Diese Anlage besteht aus drei zusammengelegten kleinen Schrebergärten. Früher befand sich hier ein großes Zelt mit Teppichen und einer Gasheizung, an der sich die Gartenbesitzer im Winter wärmen konnten. Auch eine Pergola aus Holz gibt es, die über und über mit Wein bewachsen ist, sowie eine Hütte, die in den 1950er Jahren, als Pläne für den Bau einer Straßenbahnlinie diesen Abschnitt der Anlage bedrohten, abgebaut und ein paar Meter weiter entfernt wieder aufgebaut wurde.

Während des Zweiten Weltkriegs fiel eine Bombe auf diesen Schrebergarten, die neben einem Zwetschkenbaum und einem Kaninchenstall explodierte. Sowohl der Baum als auch die Kaninchen überlebten, aber der Baum steht heute noch schief. In den 1960er Jahren pflanzte der Besitzer eine große Fichte, unter der er zu sitzen pflegte, direkt neben seinen beiden Vogelhäuschen. Dort fütterte er dann seine Vögel mit den frischen Nüssen des benachbarten Walnussbaums. Wie viele andere auch hatte er Hühner und Kaninchen in seinem Garten, obwohl das Halten von Tieren in den Schrebergärten eigentlich verboten war.

Im 15. Jahrhundert wurde an dieser Stelle ein Zoo für Kaiser Friedrich III. errichtet, der jedoch nur bis 1664 Bestand hatte. Auch danach blieb die Anlage kaiserliches Eigentum. Ab dem 17. Jahrhundert wurden entlang der umliegenden Straßenzüge Häuser errichtet. Dennoch bewahrte das Areal bis in die Mitte des 19. Jahrhunderts, als immer mehr bürgerliche Vorstadthäuser gebaut wurden, weitgehend seine ländliche Atmosphäre.

Entlang der Lange Gasse findet sich so manches Vorstadthaus aus der ersten Hälfte des 19. Jahrhunderts. Im Jahr 1820 wurden die nahe gelegenen Jäkl'schen Gründe in kleinere Parzellen aufgeteilt, auf denen kleinere Arbeiterhäuser im Biedermeierstil gebaut wurden. 1870 wurde die Laimburggasse in die Laimburggasse, die Muchargasse und die Wartingergasse unterteilt, wobei dieser Bereich für Gärten vorgesehen war. Die Bebauung entlang der Muchargasse begann 1889 und erfolgte im Jugendstil nach Josef Hötzl. 1892 waren die Gärten bereits vollständig von Häusern umgeben.

Um das Jahr 1901 herum wurde die Straßenbahnlinie gebaut, die Andritz mit Graz verband und die in der Theodor-Körner-Straße, ganz in der Nähe der Schrebergärten, verlief. In den 1950er Jahren erwarb die Stadtverwaltung Teile des Geländes einschließlich der Gärten, da eine Begradigung der Straßenbahnlinie geplant war. Verschiedenste Pläne wurden entworfen, darunter auch einer, der den Verlauf der Gleise mitten durch die Gartenanlage vorsah. Das Projekt sorgte für große Bestürzung unter den Schrebergärtnern, wurde jedoch nie verwirklicht, da sich die Firma Lipowec und das Gasthaus Körösistubn weigerten, ihre Grundstücke zu verkaufen. Die Firma Lipowec produziert und verkauft in der Lange Gasse 39 seit nahezu hundert Jahren Rollläden. Die Eigentümer fürchteten, im Falle eines Umzugs Kunden zu verlieren. Die Frau wiederum, der das Gasthaus Körösistubn gehörte, hatte das Gebäude von ihren Eltern geerbt. Sie lebt heute noch in dem Haus in der Körösistraße 36. Bis in die 1990er Jahre versuchte die Stadtverwaltung ihre Pläne für die neue Straßenbahnlinie

durchzusetzen. Das Scheitern des Projekts führte letztendlich dazu, dass das Areal an ein Bauunternehmen verkauft wurde.

Während des Zweiten Weltkriegs diente die alte Switzermühle in der Körösistraße 17 als Kriegsgefangenenlager. Etwa 100 russische Gefangene wurden hier getötet. Bis 1960 stand auf dem Gelände eine Militärbaracke, im Jahr 1977 wurde der Sportplatz fertiggestellt. Nach dem Krieg wurden die Schrebergärten an Bedienstete der Stadtverwaltung und Staatsangestellte verpachtet. Insgesamt gab es etwa zehn Gärten mit jeweils ca. 200 m².

Im Frühjahr 1989 wurden die Gebäude Körösistraße 26-28 von Hausbesetzern in Beschlag genommen, die dort mit stillschweigender Duldung der Grazer Stadtverwaltung mehrere Monate lang lebten. Da die Häuser in den Wintermonaten nicht bewohnbar waren, wurden sie Ende 1989 geräumt. Eines der Gebäude wurde abgerissen, das andere mit Brettern vernagelt.

Im aktuellen Flächenwidmungsplan der Stadt Graz aus dem Jahr 2002 wird die Gegend als „allgemeines Wohngebiet" ausgewiesen. Der Plan sieht

eine Verbreiterung der Lange Gasse vor, dazu müssten einige Häuser im Süden abgerissen werden, darunter auch das Gasthaus. Der Sportplatz bleibt erhalten.

Im Frühjahr 2008 teilte die Stadtverwaltung den Schrebergärtnern mit, dass ihre Pachtverträge nicht verlängert würden und dass sie ihre Habseligkeiten bis zum Oktober desselben Jahres zu entfernen hätten. Sie wurden angewiesen, keine neuen Pflanzen zu setzen, erhielten jedoch die Erlaubnis, sich bis zum Beginn der Bauarbeiten in den Gärten aufzuhalten.

Neuer Eigentümer des Areals ist das Unternehmen Jauk Baumanagement GesmbH, das im Stadtgebiet von Graz Wohnhäuser errichtet: Reihenhäuser, Einfamilienhäuser, mehrgeschoßige Gebäude mit Mischnutzung und Objekte im Loftstil. Die Firma arbeitet mit der Grazer Altstadt-Sachverständigenkommission zusammen und prüft verschiedene Vorschläge für die Erschließung des Geländes. Für den Herbst dieses Jahres plant sie einen Ideenwettbewerb und hofft, bis Jänner 2010 über ein klares Nutzungskonzept zu verfügen.

Dieser Schrebergarten gehörte ursprünglich einer Frau, die in der Lange Gasse wohnte. Ihr Ehemann war bei der Stadtverwaltung beschäftigt und durfte den Garten als Lohn für seine Dienste pachten. Die Frau konnte die Anlage direkt von ihrem eigenen Garten aus betreten. Irgendwann war sie zu alt, um den Schrebergarten weiter zu pflegen, und so begann in den 1980er Jahren eine Familie aus der Gegend, hier ihr Gemüse zu ziehen. Als sie im Oktober 2009 die Anlage räumen mussten, grub der Sohn die Rosensträucher aus und pflanzte sie bei sich zu Hause im Garten ein.

Dieser Schrebergarten ist sehr sonnig gelegen, und die letzte Pächterin baute hier Gemüse an, das sie an ihre Gartennachbarn verschenkte. Insbesondere ihre köstlichen Kartoffeln sind nach wie vor unvergessen.

Diese Anlage besteht aus zwei ursprünglich getrennten Schrebergärten und hat deshalb Eingänge zu den Gärten in der Körösistraße 30 und 32. Die Hütte verfügte über einen Wasser- und einen Stromanschluss und war mit einer Küche sowie mit einem Bett und einem Sofa ausgestattet. Wie viele Schrebergärtner schlief der Besitzer im Sommer manchmal in seinem Garten, entweder in der Hütte oder im Freien auf einer Luftmatratze.

Ein Projekt von Lara Almarcegui, beauftragt und produziert im Rahmen der Ausstellung „Utopie und Monument I. Über die Gültigkeit von Kunst zwischen Privatisierung und Öffentlichkeit", kuratiert von Sabine Breitwieser für den steirischen herbst 2009. www.steirischerherbst.at

# Nairy Baghramian
# Construction Helper

**Foyer Kunsthaus Graz and "Südtiroler Platz" tram stop**

**Beate Söntgen**
**"Misfits"**

The *Construction Helper* is a divided figure. One part, a "base enframing" installed in public space in front of the Kunsthaus, next to a tram stop, is chained up like the furniture of an outdoor café; the other part, the "platform," is located inside the protective space of the museum. For even within an institutional framework, art literally has to be supported: in defiance of the artwork's title, the platform is curved and leans against one of the columns supporting the Kunsthaus. The sculpture, which stands near a window in the transitional zone created by the foyer, is reminiscent of an early work by Nairy Baghramian: she leaned two flexed panels against one another (optically at least), on each side of the glass wall at the National Gallery in Berlin. Her aim was to illustrate vividly the fact that art belongs to both spheres: to the institution and to public space.[1] The *Construction Helper* sets out to show the ambiguous interrelationship between these two spheres. The "enframing's" two interconnected curved forms are beautiful and as delicate as they are powerful, lying unmotivated on the chain. The weight of the material alone — dark lacquered steel — is

enough to prevent them from being stolen. The chain transforms the "enframing" into a "misfit,"[2] into a thing which, contrary to the promise offered by Heidegger's expression,[3] does not find a place where it belongs.

This is not the first time that Baghramian has created a sculpture in public space to serve as a disruptive element. When she did her *skulptur projekte münster 07*, she installed a kind of screen — an "enframing" covered with fabric — on one of the few prized carparks.[4] Her traverser lacks the powerful presence of Richard Serra's steel sculptures, whose disruptive potential lies precisely in the way they presumptuously appropriate their entire surroundings, whether as obstacles on familiar paths or as visual barriers, blocking oversight and control.[5] Somewhat more modest, but equally effective is *Entr'acte*, a bulky object that seems to have no place. It is also a "misfit" that exhibits its own functionlessness, without allowing it to change dramatically, and without any resistance, into an aesthetic entity: into the free play of the imagination.

The screen exposes the paradoxes of conceptual art: of its not only having the capacity to be more than an idea, but of having to be a material, too — if it is to be at all visible and effective; and it does so with "sprezzatura," with the lightness of a material that pokes fun at "weighty" works in public space. The "enframing" – according to Heidegger – of the *Construction Helper* makes a very different point. The shape of the elegant steel forms calls to mind post-war sculptures that alternated between abstraction and figuration: like those of Henry Moore, with which he optically and semantically enhanced the representational buildings of the Federal Republic of Germany: the organic, interweaving forms of — primarily — female figures naturalizing ethical principles based on harmony, protection and openness; principles, which, in turn, drew their strength from their being abstractions of an individual form. [6] The image of reciprocal support, although lacking distinct, unequivocal semantics, also appears in *Construction Helper*. The free play of forms is hindered by the chain, causing the sculpture to degenerate into an endangered exemplar of furniture in public space. Art in public space competes with other objects that are standing around there, without even having to justify themselves, despite their being dysfunctional and ugly. Beautiful forms and ornamentality are — as Nairy Baghramian suggests in her text on *Entr'acte* — the prostheses of art in public space,[7] a claim that the "enframing" of the *Construction Helper* now makes for itself.

The silent conversation partner of the "enframing," has no need of such prostheses. The platform occupies its place within the space of the institution. The peacefully flowing form transforms the aggressive "splashings" that Serra started producing in the late 1960s into an almost contemplative gesture. Whereas Serra marks out the specific location of a contemporary artwork made for museum space or galleries, Baghramian emphasizes the delicate interplay between the artistic creation and the institutional framework. The rubber that leans against a column, as if seeking support, appears to be soft and incapable of fulfilling the function that the sculpture's title assigns it: to serve as a platform, offering others a stage, and providing a venue for communication. A second layer, poured onto the semi-erected quadrangle, flows out beyond the geometrical form, transforming it into the bearer of what appears to be an organically growing sculpture. Relying on supports, the platform is both the very picture of support and of rendering possible: an image of unregulated growth beyond the limits of a measured form. Reciprocal dependency is a leitmotif in Baghramian's work. It is rooted in architecture and theatre; it is also effective in art and in the image of society that art conveys and engenders, and which is, on the other hand — ideally — shaped by art. Supporting, backing and loading — the basic figures of architectural design that are always guided by use — are not hierarchized figures, as the differentiation between active and passive elements suggests. Otherwise there would be no load — nothing that would have to be borne; it would be as if the support had lost its function and had therefore become superfluous. And the theatre (at least in its modern variety) is also the product of an ensemble-playing, which only reaches its full power of expression when directed at someone vis-a-vis — not at the public, but at a vis-a-vis standing on the same stage.[8]

In the works executed jointly by Nairy Baghramian and Janette Laverrière (one of

the grand dames of design), the structures of the two forms of arrangement — of architecture and theatre — merge. Baghramian accorded Laverrière a place within art, where she was able to show both utility and uselessness to their full advantage, with dysfunctional mirrors that replicate the world in surreal splinters.[9] In the "reenactment" of Laverrière's Garderobe einer Schauspielerin,[10] also executed within the context of art, the accent shifts from design to the function and impact of a space that provides the actress with a retreat between acts. But she is not the only one to have had her semi-public performance here, as an absentee who is present, and is made present by the space alone.[11] It is also the designer's encounter with a female artist half her age that is staged in the installation. This work, too, is dedicated to communication, to a transgenerational dialogue, and to an exchange between the private and public spheres. The Construction Helper in Graz presents the exchange between the institution and public space with the aid of a platform inside the Kunsthaus, whose "enframing" is literally connected with the outside world. Situated in public space, supported by publicity, art can reveal its properties only as a commentary, and as a model worthy of emulation. The Construction Helper is a figure connected with exhibition stand construction, with the erection of ephemeral, highly efficient, wellfunctioning, and effective works of architecture. This figure still contains a touch of those utopias which, throughout the entire period they served as capitalist product exhibitions, also inspired the world exhibitions, namely: to construct, for a short time, a new world, a world that assembles heterogeneity under one roof.[12] It is the "misfit" that demonstrates the need for the ensemble.

1    Nairy Baghramian, La colonne cassée (1871) (2008) at Neue Nationalgalerie Berlin during the 5. Berlin Biennale für zeitgenössische Kunst (5 April to 15 June 2008) in: Adam Szynczyk, Elena Filipovic (ed.) When Things Cast No Shadow (Zürich: JRP / Ringier, 2008).

2    I am indebted to Katharina Sykora for her inaugural speech at the Hochschule für Bildende Künste Braunschweig in 2002, which inspired me to reflect upon the "misfit."

3    See Juliane Rebentisch, Ästhetik der Installation (Frankfurt/M.: Suhrkamp, 2003): 241–251, on the suitability of Heidegger's terminology for a theory of installations.

4    Nairy Baghramian, Entr'acte (2007), skulptur projekte münster 07, Münster (2007-06-16–2007-09-30).

5    As in the case of Serras Tilted Arc, 1981 installed in Federal Plaza in New York.

6    Such as Moore's Large Two Forms, 1979, erected in front of the former Federal Chancellery in Bonn.

7    In: Brigitte Franzen, Kasper König, Carina Plath (eds.), skulptur projekte münster 07 (Cologne: König, 2007): 35.

8    It was Denis Diderot who called for the ensemble in his design for a new theatre, particularly in his pithy reply (1758-11-27) to Madame Riccoboni's critique of his ideas on the theatre in: Denis Diderot, Ästhetische Schriften, vol. 1, (Berlin: Das Europäische Buch, 1984): 338.

9    Nairy Baghramian, La Lampe dans l'horloge (2008), Schinkel Pavillon, 5. Berlin Biennale (see note 1).

10   Entre deux actes. Loge de comédienne, Kunsthalle Baden-Baden (2009-07-25 – 2009-11-08).

11   See also Baghramian's work Vierte Wand/Zwei Protagonistinnen (2005), which also deals with the framework and conditions for performances that are articulated through spatial structures alone.

12   In a conversation with Oliver Tepel on her participation in skulptur projekte münster 07, Nairy Baghramian uses the concept "real utopia" in her relation to the dialogue between citizens and art ("Dahinter/Davor/Daneben," in: skulptur projekte münster 07: Das Magazin zur Ausstellung, 2 (Münster: 2007): 13.

# Ayse Erkmen
# Pleasant Corners

**Karmeliterplatz, Burggasse/Dom, Underground car park ventilation Künstlerhaus, Jakominiplatz, Schloßbergplatz, Schloßberg clocktower, Südtiroler Platz, Mariahilferplatz, Esperantoplatz, Volksgarten**

**Silvia Eiblmayr**
**Pleasant Corners in Graz — A Contradiction**

The artist's profound aim is already expressed in the title of her work *Pleasant Corners*, which Ayse Erkmen inserted in the city space of Graz for the *Utopie und Monument I* (2009) project. Her interventions contain a promise that is intentionally double-edged, because the "corners" are not "pleasant." Erkmen conceived ten formally different plaque-like objects, each of which was painted in a bright color. These aluminum "plaques," which are anything up to 250 centimetres long, lean unintentionally, or so it seems, against streetlamps, traffic signs, bollards and trees, awakening the impression that someone has simply put them there for a moment and forgotten them.

The "uncomfortable" (and somewhat discon- certing) thing about her objects is partly due to the fact that they seem to appear by chance and with no apparent motivation, as it were, at the spots where they are positioned throughout the city. And this impression is certainly created by the fact that Erkmen assigned them a formal code that is not easily deciphered. With their schematic-geometri- cally cut-out contours and smooth, perfect

surfaces, the plaques look as if they have been punched according to predefined patterns, although the system underlying this formalisation remains unclear. Their banal exemplary character awakens associations with designs for chip- and punch-cards that have, however, grown way out of proportion. But the elements, which were cut to shape with the aid of numerical control, could equally stem from a computer-controlled carpenter's workshop, making it impossible to determine their function or affiliation. Nothing — and this is the crucial point regarding this particular work by Erkmen — lends these objects even the slightest touch of a romantic secret worth discovering. In their seemingly contextless presence, they have a very literal quality, and are, initially self-referential.

Ayse Erkmen is a sculptress. She always conceives her works as sculptures, although it is important to her to note that she has no "visual style." And this is precisely where she sees her freedom to deal with things, spaces, and situations, and, therefore, related contexts of meaning, which she makes into her theme.

Her strategy involves creating a metaform, as it were, which allows her to develop systematic structures that characterize and define a location, a work of architecture, an urban or museum space, or — in the broadest sense — a cultural space, without its having been previously rooted in public consciousness. Erkmen seeks to render the invisible visible, and to trigger an aesthetic, poetic and culturally critically cognitive process.

In the artistic realization of an urban experience, or one specific to a certain location, as a sculptural experience, Erkmen applies the means of functional and/or formal abstraction, whose plausibility is, however, based on a concrete empiricism. She condenses — in an act of apparent simplification — complex interrelationships and processes, no matter whether they are, for example, political, socioeconomic, institutional, logistic, technical or craft-occupational in nature. In her striving to create new realities, she shifts and transfers contexts, creates, finds and invents poetic cross connections, and intervenes in spaces.

Sometimes, Erkmen's material interventions are minimal; sometimes they are monumental. Two examples illustrate this well: minimal yet effective was her removal of a few panes of glass in the entrance area to the Künstlerhaus Graz for the exhibition *Inklusion : Exklusion* (1996); monumental, in contrast, was her project *Shipped Ships* (2001), in which she had public ferries and their crews shipped in from three cities, namely Istanbul, Shingu (Japan), and Venice, to Frankfurt, where they traveled along the Main River for the population's benefit for an entire month. *Hohentwiel* (2000) and *Stoned* (2003) also deserve mention here as two more examples of Erkmen's great artistic resourcefulness in using unorthodox cross connections. Take, for example, the distinctive rock, overgrown with trees, of Hohentwiel Castle near Singen: Erkmen discovered that the rock, seen from a certain perspective, had exactly the same silhouette as the snake that swallowed an elephant in Antoine de Saint-Exupéry's drawing in *The Little Prince*. Erkmen used gigantic photos of an African elephant in the savannah to enrich the town of Singen (on the occasion of the regional garden show *hier, da und dort*) with this poetic reference. *Stoned* consisted of a two-and-a-half-ton stone (suspended by the artist from a beam) hanging like a Damocles sword above the transparent glass roof of an exhibition room situated beneath a courtyard. The room itself remained empty. For the audience looking upwards, this space was transformed into an aesthetic-psychic experience, the compacted consummation of the architectural and cultural history of Innsbruck and the mountainous landscape of Tirol.[1]

Erkmen's work *Pleasant Corners* draws together several problem areas facing cities, especially those with a historical fabric, namely: the proliferation of city design, furnishings and embellishments pushed by a variety of interest groups, and the attendant increase in commercialization and surveillance in urban spaces. Erkmen notes their increase in Graz since her first stay in the city thirteen years earlier, and reacts in her own manner.[2] She responds ambivalently to the many different offers of direct and practical use by the urban population, as well as the countless messages of a tourist-informative, commercial, and an artistic nature addressing this same population. On the one hand, she refuses to increase this profusion by adding more objects designed to "create meaning," or ones available for immediate use; on the other hand, she laconically places her

colorful symbols in the various spots, corners, and squares of the city. The *Gemütlichen Ecken* certainly play a positive role as "beautification"; at the same time, however, they formulate — as an aesthetic appeal — a subtle metatext on the conditions and structure of the urban space itself. The constructive formalism of the ten plaques refers implicitly to the constantly changing constructs themselves, upon which "urban space" and "public space" (which is by no means identical with the former) are based. Among the important parameters of these constructs are the political-institutional context, property relations and spheres of influence that determine what happens in "public space," and the potential which that public space contains. It should be noted that its extension into the virtual space of the media is an important factor, too.[3] In the *Gemütlichen Ecken* a contradiction materializes, which urban designers and furnishers try to cover up.

Ayse Erkmen's art is never tied down — and never can be tied down — to one single statement. Her great quality lies in her conceptual openness, which permits complex associations and inspires interpretations. To quote the artist herself: "I would like to confront visitors with a situation they do not expect. I don't want them to know in advance what it's all about. It is supposed to look like the work of chance, as if something has happened."[4]

1    *Stoned* was a project she did for the exhibition *Gegeben sind … Konstruktion und Situation*, Galerie im Taxispalais, Innsbruck, 2003. The exhibition was part of an overall project *Performative Installation*, Siemens Arts Program, Munich, 2003.

2    See Sabine Breitwieser's short text on Ayse Erkmen's *Pleasant Corners* in: *Utopie und Monument I*, exhibition guide (Graz: steirischer herbst, 2009): 14f.

3    See: Brigitte Franzen, Kasper König, Carina Plath (ed.), *skulptur projekte münster 07* (Cologne: König, 2007): 396. Here translated from German.

4    Quoted from Hannelore Kersting, "Ayse Erkmen im Museum Abteiberg," in: cat. *Gebunden an. Bound to. Ayse Erkmen* (Mönchengladbach: Städtisches Museum Abteiberg, 2004).

# David Maljkovic
# Untitled

**Karmeliterplatz**

**Søren Grammel**
**Monument and Actualization**

Soviet Union: early post-revolutionary era. Everything is subject to re-evaluation, also its monuments. The country's statues shall be replaced by new sculptural figures. A catalogue of revolutionary personalities worthy of portrayal is created. It does not disturb the Bolsheviks that this is not a re-evaluation of the concept of the monument but merely an exchange of old faces with new ones: using the same authoritarian communication format. Seizing the historical opportunity in contrast would have meant reinventing the communicative modes of remembrance as such, as several artists had proposed through their works at that time. But it was only the depictions of the power constellations that were changed, not the social and aesthetic power relations.

Consequently, Tatlin's *Monument to the Third International 0 10*, a model for a 400 meter-high tower consisting of revolving conference and exhibition centers, radio transmitters, restaurants and projection machines, ended up in a depot — too revolutionary for everyday revolution. Unlike the concept behind Lenin's statues, Tatlin's concept for a

monument was essentially based on new principles. It was to modify, first, the face and structure of the city; secondly, the public conception of what art actually is; and, thirdly, the relationship between the artist, the architect, and the engineer. This monument revolves around imagining the future — a monument as a communicative platform, as a venue for exhibitions and conferences, and as a workshop for ideas. The aim is to involve others in the production of content. Its character lies in its communicative, "relational" aesthetics, in which the object is regarded not as something finished, but as something to be negotiated and contextualized. It is not a place of commemoration, but of actualization. It constitutes this purpose by provoking interpretations and appropriation, rendering it "concrete," step by step.

Within this conception of the monument, I can also place the memorial site realized by Vojin Bakic between 1972 and 1981 for the Yugoslavian partisans in Petrova Gora. It encompasses rooms for exhibitions and seminars, presentations and communication,

Alvar Aalto, Savoy Vase, 1936
Manufactured by Karhula Lasitehtaala, Karhula/FN
© V&A Images/Victoria and Albert Museum

whilst its formal appearance not only embodies a visual event, but also serves as an experiment for providing an interface of art, design, architecture, and construction. In the contemporary political context of Croatia, Bakic's building is deliberately left dilapidated. Its original form is characterized by layered and interlocking cylindrical rooms, whose biomorphic ground plan recalls the lake-like curved vases designed by Alvar Aalto in the 1930s. The speculative and dynamic impression created by the exterior corresponds to the concept of the open monument as sketched out above.

In David Maljkovic's work, the motif of the memorial museum in Petrova Gora appears regularly and in many different formats: for example, as photo(copy) and drawing in numerous collages. One sheet shows, among other things, a view from above into a multi-storey atrium, whose vertical plane is dissected by elegantly curving bridges. Light enters wherever decay has completely destroyed the covering of the external walls. The floor is still covered with debris. A small illustration of a modern interior is mounted on the photo. It depicts a kind of lobby: seductive with its bouquet of flowers, designer furniture and carpets. How do these two pictorial layers relate to one another? The assumption that the small illustration shows how the interior of Petrova Gora was designed in the days when it was still open would be far too obvious for Maljkovic's way of thinking. Furthermore, with its organically styled seat shells, it calls to mind a rather postmodernist design ensemble in Western Europe or the USA. What is and what was — and how the two conflicting concepts of design and architecture relate to one another — are questions that remain unanswered. Precisely this "gap," however, allows room for manifold

speculation about design, occupation and the use of space in general. It is these suggestive cracks between realities and fictions that Maljkovic repeatedly creates with his work. In an interview with Natasa Ilic, Maljkovic expressed his desire to use these works to create platforms that would allow for a new, futuristic use of the location: "... the question of how I recreate the energy that is already there, and how I can give it a new color."[2] Here, too, he used the motif of Petrova Gora as a setting for videos in his trilogy *Scene for a New Heritage* (2004–2006). The artificial scenes, such as those using cars wrapped in silver foil, do not reflect a documentary approach: they transform the location by adding scenic and visual elements, and by carefully applied reductions and focusing. The self-made futuristic setting seems to locate the fragmentary action in an as-yet-undefined future. Maljkovic's works act here as appropriations which transform the location into a projection machine — for speculating about the possibility of a future and the desire of actively producing it. The following comment points in this direction: "I use the space of the future as an element of openness, a subdued reference to potential optimism, ...

of what could be, and … to explore what could happen."[3] A third way in which Maljkovic treats Petrova Gora lies in his contextualizing of his works with the models that Bakic made for the building. In his constant repetition, in testing diverse media, and in his involving actors and friends during the happening-like filming, Maljkovic's way of dealing with Petrova Gora is an active form of exactly the kind of "actualization" in the future-oriented sense of a revolutionary monument à la Tatlin. In dealing with Petrova Gora, Maljkovic realizes an offer that was already immanent to the site. The consistency and the creativity with which he does so is without equal.

Maljkovic's idea of erecting a construction site at the Karmeliterplatz in Graz, right in front of the disused Pfauengarten, which claims in a photo-collage that the monument is intended to fill the empty space between the remains of the city wall and some buildings to the side of the disused land, is, therefore, just one way among many of dealing with Bakic's legacy. The site sign shows the building in its present condition: somewhat of a ruin, but also as if it were a construction project in the planning stage. The picture shows the futuristically designed Peugot 4002 (the winner of the 2002 Peugeot design competition) parked in front of the building. This car appears in countless collages in the series *Scene for a New Heritage*. Just like the traces of decay on the building, the car's presence intervenes in the perception of the ostensible building project, since it undermines the latter's claim to be real as asserted on the first level, giving Maljkovic, in return, additional space for another, imaginative dimension.

Few passers-by will probably remember that the so-called Trigon Museum was once supposed to open on the same site in 1995 to provide space for the purchases and donations made during the thirty years of the Graz Biennale with three nearby countries — former Yugoslavia, Italy, and Hungary. In this regard, the square provides a good analogy for the way cultural heritage is treated and for the inability of contemporary actors to realize future visions with this in mind. The fact that Maljkovic's ostensible construction-site sign was stolen during the exhibition — please note: removed, but not destroyed — is a positive sign, as someone evidently liked it and probably took it because they had a different use for it. Maybe it will turn up again soon as a set in some play or other, or in a concert with new electronic music, or just as a backdrop for a bar — in short: somehow actualized.

1    Ulrich Wienbruch, "Die Funktion der schematisierten Ansicht im literarischen Kunstwerk (nach Roman Ingarden). Problemkritik der Alternative Darstellungs- oder Wirkungsästhetik," in: Ulrich Claesges, Klaus Held (ed.) *Perspektiven transzendental-phänomenologischer Forschung* (Den Haag: Martinus Nijhoff, 1972): 262.

2    "Der leere Raum der Zukunft. Natasa Ilic, im Gespräch mit David Maljkovic," in: cat. *David Maljkovic. Almost Here* (Cologne/Hamburg: DuMont/Kunstverein, 2007): 177.

3    *David Maljkovic. Almost Here*, (Cologne/Hamburg: DuMont/Kunstverein, 2007): 179.

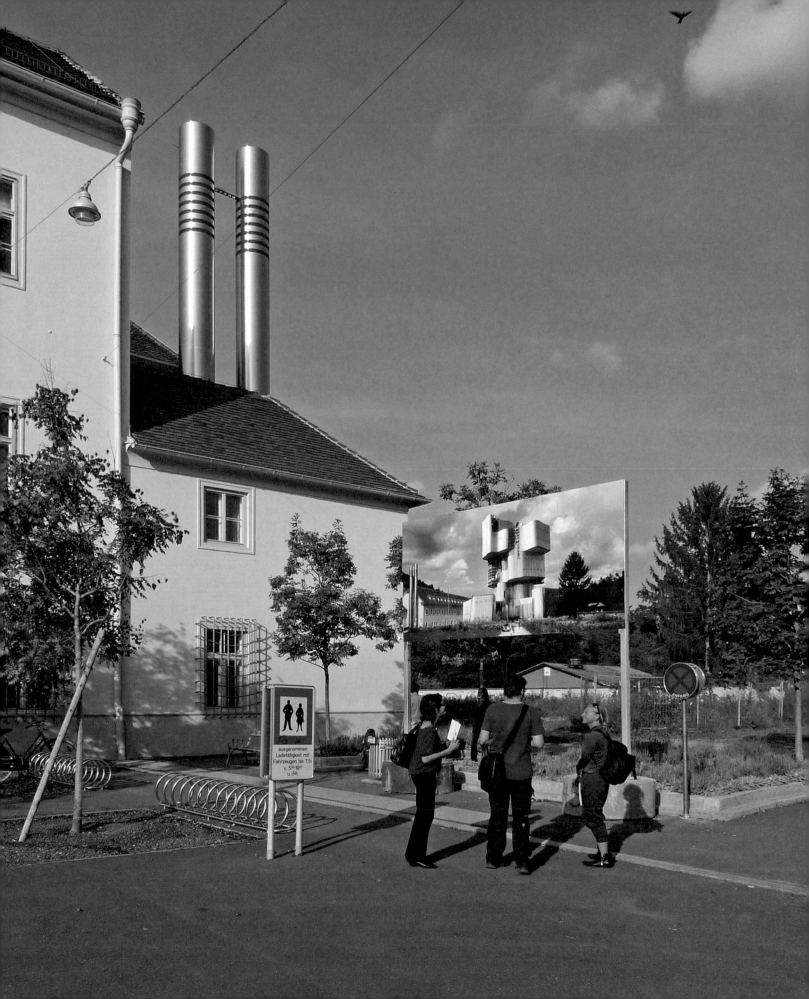

# Heather & Ivan Morison
# Du vergisst Dinge (You forget things)

**Mailing of 2000 printed cards**

## Claire Doherty
## The Unreliable Witness

*Whoever assumes the charge of bearing witness in their name knows that he or she must bear witness in the name of the impossibility of bearing witness.* Giorgio Agamben[1]

A recently published novella acts as an unreliable witness to the work of Heather and Ivan Morison. *Falling into Place*[2] weaves an apocalyptic narrative around the artists' most recent work, *Escape Vehicles*, a series of remarkable structures, buildings and vehicles which explore desires to escape the modern world and our subconscious appetite for the cataclysmic. The unfolding narrative of this book provides just one possible imagining of the past and potential futures of the Morisons' artworks — including an ex-military Green Goddess fire engine converted into a survivalist house truck (*Tales of Space and Time*, 2008), a scorched wooden shelter structure raised into place through a community barn-raising (*The Black Cloud*, 2009) and a 16 meter-tall dinosaur Ultrasauros occupying an area of common land (*Luna Park*, 2010). These works are the pivotal characters on which the post-apocalyptic plot of *Falling into Place* turns —

an unspecified, high impact event that has led to the displacement and precarious existence of survivors. The story emerges through fragments of the characters' endeavours to survive and whilst certain intimate details — the visceral quality of mud, the smell of dried fennel, the quality of light as it fractures through a wooden, slatted roof — are vividly described. An omnipotent view of this post-apocalyptic world is never offered. The story remains partial and inconclusive, as if certain things must be forgotten and never passed on.

The Morisons' mailed cards are similarly fragments of this complex and accumulative series of events, partial histories and fictions. Printed using a thermographic technique on square white card measuring 135 x 135 mm, and sealed in white envelopes, the cards have been mailed anonymously to a growing number of recipients worldwide since 2001. The artists' consistent use of the same printed card has always seemed incongruous with the event to which they refer. For example, the location of the first regular series of cards was the artists' allotment —

Garden 114 in Edgbaston, Birmingham, UK — hardly a place from which one would expect to receive an elegantly embossed note-card. Though the texts were initially received as horticultural reports, the precious format should have been an indication of the deeper significance of the cards — in this case, an intimate portrayal of the emotional toll of maintaining a garden: "Slugs are tunnelling Ivan Morison's Picasso tubers … Ivan admits things may have got out of control."

The ritualistic associations of these cards — formal announcements which mark life events — jar with the temporality and informality of the texts themselves. Those sent from the artists' epic expedition *Global Survey* (2003) have been compared to On Kawara's *I Got Up* postcard series (1968–1979) and yet in their formal simplicity and avoidance of touristic imagery or contextual information, the cards bear closer resemblance to Kawara's telegrams sent intermittently to friends and professional colleagues which declared, "I am still alive."[3]

Imbued with humour and pathos, both the Morisons' cards and Kawara's telegraphic missives are a form of gift which does not require or request acknowledgement and which are designed to be held in the hand and read by an individual recipient. Conceptually they operate in a collective consciousness, however, accumulating temporary communities. Of course, both the printed invitation and telegram are now anachronistic as forms of communication — with Twitter offering the closest contemporary correlation to this form of daily, mundane reportage and Twitter subscribers forming a similar temporary community around a protagonist's endeavours.

As the Morisons' practice has developed through the Escape Vehicles, however, the printed texts have become less reportage than a combination of narrative fragments and, what J. L. Austin calls, "illocutionary acts" — which involve an affirmation or promise, a threat, a warning or command for which the public is continuously reformed and readdressed. So we see highly specific events such as: "African Grey Parrot, grey with red tail feathers. I lost her near Fantasy Island. Life has not been the same." received prior to the apparent crash of a white articulated lorry shedding its load of 25,000 flowers across the city centre of Bristol and "I used to love her, but look what she's done. I hate her. I hate her. Tasmania" postmarked Tasmania, as *Journée des Barricades*, a monumental barricade, comprising materials accrued from second-hand garages and the city dump, blocks off Stout Street in the City of Wellington, New Zealand; combined with the instructive *Let's Pretend We're From the Future* (Margate Rocks, 2008) and *Du vergisst Dinge. Du vergisst Dinge. Du musst.* (which translates as "You forget things. You forget things. You must.") produced undated and unsigned for steirischer herbst, Graz, Austria in 2009.

The urgency of the instruction from Graz contains, like much of the Morisons' work, a dark and melancholic tone. Within the performative context of steirischer herbst, the card clearly indicates the impossibility of performing an intentional process of forgetting. Slavoj Zizek's reading of Deleuze's essay "What is an Event?" is particularly useful here.[4] Zizek suggests that "the proper Deleuzian paradox is that something truly new can *only* emerge through repetition. What repetition repeats is not the way the past effectively was, but the virtuality inherent to the past [...] In this

precise sense, the emergence of the New changes the past itself, that is, it retroactively changes... the balance between actuality and virtuality in the past."[5] In this sense, the event of reading the printed words "You forget things" twice along with an instruction that "You must" is activated across numerous times and places, and mobilizes a complicit public by summoning them to perform a particular action which then changes their perception of the past. Set within the complex web of interconnecting narratives which surround the Morisons' *Escape Vehicles* and remarkable sculptural interventions, *Du vergisst Dinge. Du vergisst Dinge. Du musst.*, like *Falling into Place*, embodies then the possibility of the unreliable witness to bring into being the event of art through a process of attempted forgetting.

1    Giorgio Agamben, *Remnants of Auschwitz: The Witness and the Archive* translated by D Heller-Roazen (New York: Zone Books, 1999) 34.

2    *Falling Into Place* (London: Book Works, 2009).

3    These telegrams followed three he sent for the "18 Paris IV.70" exhibition: "I am not going to commit suicide – don't worry" (1969-12-05); "I am not going to commit suicide – worry" (1969-12-08); and "I am going to sleep – forget it" (1969-12-11).

4    See Gilles Deleuze, "What is an Event?" in *The Fold: Leibniz and the Baroque*, trans. Tom Conley (University of Minnesota Press, 1992).

5    Slavoj Zizek, "On Alain Badiou and *Logiques des Mondes*," accessed at http://www.lacan.com/zizbadman.htm.

You forget things. You forget things. You must.

Du vergisst Dinge. Du vergisst Dinge. Du musst.

Graz, Austria

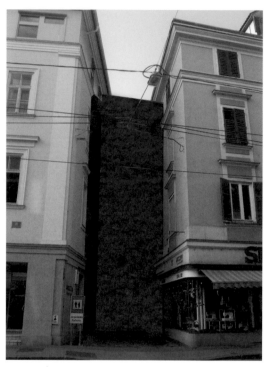

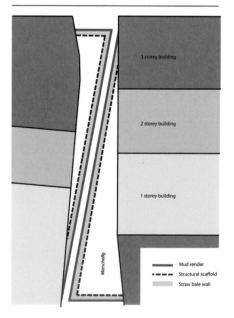

SIDE ELEVATION

Proposal *Mud Blockage*, 2009
Marschallgasse, Graz

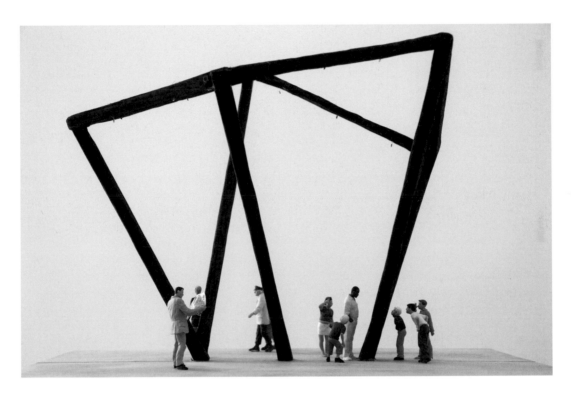

Proposal for a construction at Volksgarten, 2010

# Nils Norman
# Public Workplace Playground
# Sculpture for Graz

**Volksgarten**

### T. J. Demos
### Designs for a New Economy

Nils Norman's *Public Workplace Playground Sculpture for Graz*, 2009, jumbles our expectations of what public sculpture can be today. Its title and look immediately announce the piece's contradictory status as a workplace design, combined with the look of a roughshod playground for children, categorized as a sculpture, situated in the midst of a park! What appears striking is the project's mind-boggling merging of functions (work and play), typological categories (artistic sculpture, office furniture, DIY-construction), intended users (children, business people, recreational visitors), and spaces (public and private). By joining these paradoxical qualities together in a bizarre, composite and interactive object, the work enters a utopian dimension by momentarily suspending all social and political contradictions implied by those qualities. But like all good uses of utopia — in contrast to the regressive, nostalgic, escapist versions — Norman's piece rebounds reflexively and critically on reality by literalizing and exaggerating its ideals.[1]

One important point of departure for Norman's work — which informs the artist's ongoing research — is the recent recon-ceptualization of office design within the New Economy (the post-manufacture financial system of globalization based on services and information technology). Unlike older plans for offices, based on cubicles, hierarchical layouts, and privileged zones of access, recent designs of the 1990s and 2000s aim to inspire fluid social interaction amongst workers, engendering cross-disciplinary communication in the name of creative innovation, efficiency, and of course the maximization of profit.[2] The resulting commercial design aesthetic typically emphasizes the flexible open plan (as in loft architecture), which combines uses of space and strategically situates social areas to facilitate exchanges within and between office members that will lead to collaborative solutions to business problems.

That same logic rules Norman's adaptable and interconnecting construction, which merges areas for heterogeneous functions — desks for laptops, ramps and holes for play or sleep, plants for meditation, a composting unit and rocket oven for recycling and eco-awareness — thereby creating a mixed-use

structure that joins disparate social systems. In other words, Norman adopts the aesthetics of the New Economy's office design in order to model an equivalent form of public art on that basis.

Such design ideas have also guided recent mainstream proposals for the reinvention of public space, as advanced by urban studies theorist Richard Florida and his notion of the "creative class" — a further reference, and frequent target, in Norman's work. According to Florida, successful cities — those that demonstrate consistent economic growth — possess a high "diversity index," one that measures dense concentrations of "high bohemians," comprised of high-tech workers, artists, musicians, lesbian and gay men, whose culture correlates with an open, energetic, and professional environment that promotes long-term urban prosperity.[3] Rather than invest in costly and unsightly infrastructure, such as sports stadiums, spectacular buildings, and shopping malls, urban planers with ambition, in Florida's view, should make their cities attractive to the creative class; economic success will then follow.

Norman's sculpture mirrors these imperatives too, proposing a kind of monument to the current-day utopian vision of entrepreneurial capitalism, referencing its ideals of social creativity, ecological consciousness, and knowledge exchange. One fundamental aspect of this contemporary ideology is its belief in profiting from every second, which the *Public Workplace Playground Sculpture* anticipates: When an idea arises on the walk home, for instance, why not sit down at the "hot desk," discuss with others, and work out a creative solution on your laptop? And when you're tired, why not take a power nap in the crawl space? There's room for kids if necessary.

Norman's sculpture thereby images the ultimate all-in-one activity center that maximizes productivity and potentializes the moments otherwise lost to travel and disorganization. In this sense, given its resemblance as well to the constructivist forms of Soviet avant-garde kiosks and theatrical platforms, Norman's sculpture suggests a current-day equivalent to Tatlin's *Monument to the Third International*, 1917, recalling such exemplary Soviet utopian models dedicated to communism. Only now, in Norman's version, it has been appropriately reformatted to the needs of neoliberal capitalism, which has already appropriated the communist principals of social participation for its own purposes, just as Soviet aesthetics were co-opted in turn by minimalism and post-minimalist design — further contradictions visible in Norman's work.[4]

Yet the sculpture's redeployment of these capitalist ideals soon takes on critical tones, as its utopian elements begin to unravel and to backfire subversively. First, the incongruity of the design's intended functions quickly becomes apparent. To combine children's play with office work, for instance, is in fact far from the corporate ideal of labor (even if the proposal is nevertheless an interesting one, particularly for those able or needing to concentrate on work while children play independently). Second, insofar as the rocket oven and worm composting unit — the presence of which are suggested in Norman's Graz prototype — reference the cultures of homelessness and DIY environmentalism, they clearly contradict capitalist interests. Of course, capitalism thrives on the appropriation of the non-productive, which is clear in corporate greenwashing campaigns that adapt ecological commitments to market imperatives. But homelessness is a particularly

intransigent predicament for the current economy. It defines as well a longstanding problem for urban planning, leading to "defensive architecture" that seeks to minimize the presence of undesirables via creative design solutions (e.g., benches that physically forbid sleeping) — indeed the *Public Workplace Playground Sculpture*'s "play lean" references precisely this element.[5]

That said, to join these elements directly, without mediation, is to invite consideration of the strategy's dubiousness — as if urban planning can really resolve social conflicts and economic inequality, as much as social engineering or interior design can guarantee a city's or business's success. In this regard, Norman exposes the grotesqueness of the New Economy's appropriation of sub-cultures — whether environmentalist, gay, bohemian, or artistic — for by co-opting and internalizing their styles and forms, the creative class neglects, or violently eliminates, the oppositional energies attached to them.

A further contradiction is the sculpture's location in public space, a siting that defies the recent trend of the privatization of urban design by corporate architecture. Once, urban theorists like Jane Jacobs celebrated social diversity and connectivity in dense, tightly-knit areas as the qualities of the ideal city — as evidenced in her native Greenwich Village neighborhood of New York City during the 1950s. But today those very conditions have been instrumentalized by corporate culture, given over to their demands for social creativity in corporate office spaces, whereas public space has succumbed to banal commercialism surveilled and disciplined by high-tech security and defensive architecture.[6] If the New Economy's office layout has appropriated the dynamism once obtained cooperatively and freely in the public realm, it has drained that social energy from the commonwealth only to turn it into a private resource and commodity.

By situating his *Public Workplace Playground Sculpture* in a public park — the Volksgarten, or People's Garden, no less — Norman's deeply ironic gesture thereby makes an urgent and radical demand: to rethink and re-appropriate the creative and collaborative potential of recent economic transformations as a public resource outside of and beyond neoliberalism. Or is that demand the real utopian aspect of his work?

1    For a critical positioning of utopia, which informs my own views on the subject, see Louis Marin, *Utopics: Spatial Play*, trans. Robert A. Vollrath (New York: Humanity Books, 1984).

2    For his 2009 exhibition at Raven Row in London, which presented a structure similar to the one in Graz, Nils Norman included several books that served as references for his project, such as: Alexi Ferster Marmot and Joanna Eley, *Office Space Planning: Designs for Tomorrow's Workplace* (New York: McGraw-Hill, 2000) and Jeremy Myerson and Philip Ross, *Space to Work: New Office Design* (London: Laurence King, 2006).

3    See Richard Florida, *The Rise of the Creative Class: And How It's Transforming Work, Leisure, Community and Everyday Life* (New York: Basic Books, 2002), also included in Norman's Raven Row library.

4    For elaboration on this aspect of Norman's work, see T. J. Demos, "The Cruel Dialectic: On the Work of Nils Norman," *Grey Room* no. 13 (Fall 2003): 33–50.

5    See Ted Kitchen and Richard H Schneider, *Planning for Crime Prevention: Trans-Atlantic Perspectives on Defensible Space* (London: Routledge, 2001).

6    Jane Jacobs, *The Death and Life of Great American Cities* (London: Jonathan Cape, 1962), and Malcolm Gladwell, "Designs for Working," *The New Yorker* (2000-12-11): 60–69, which was important for Norman's research (based on email correspondence with author, June 2010).

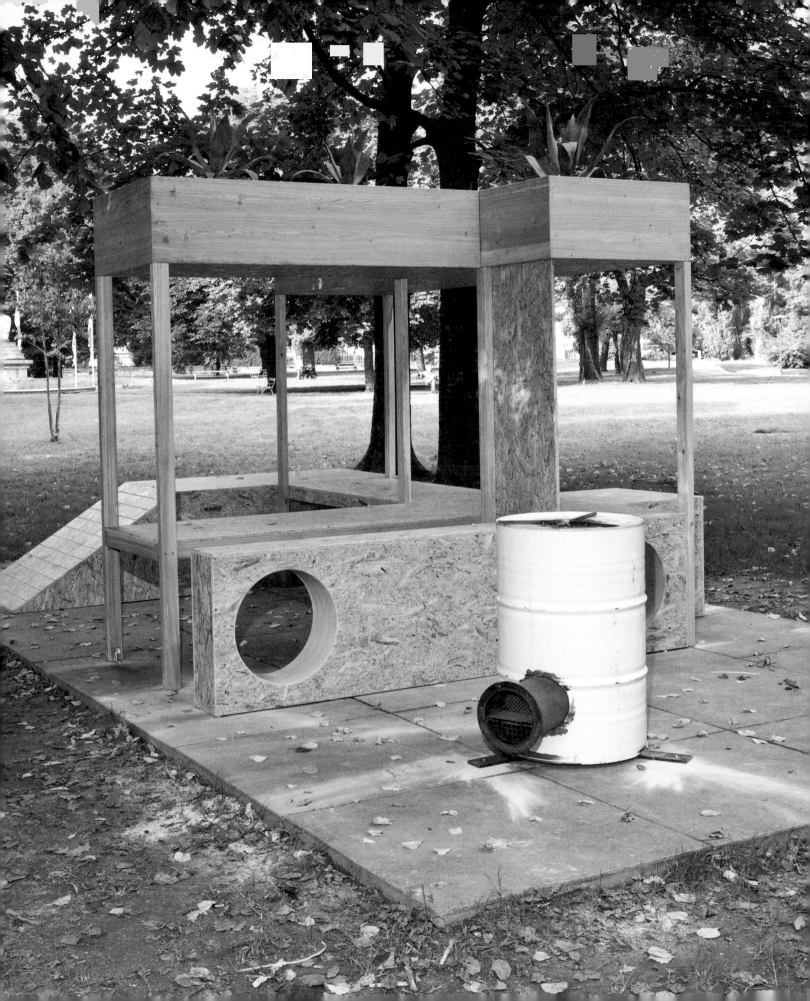

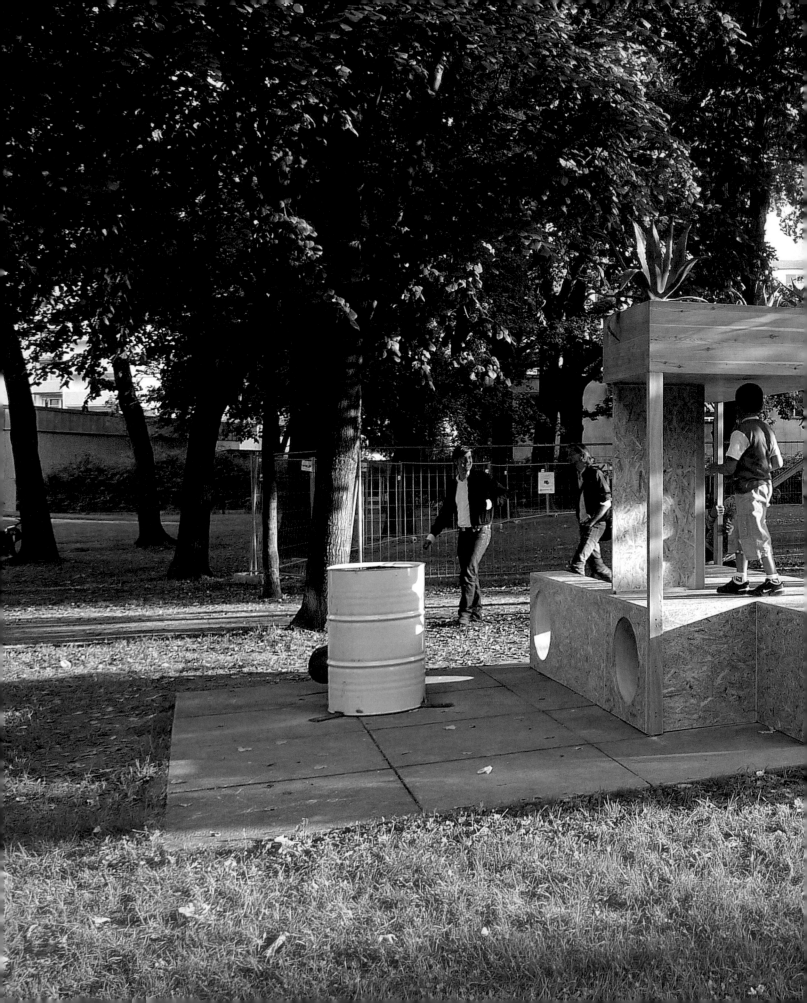

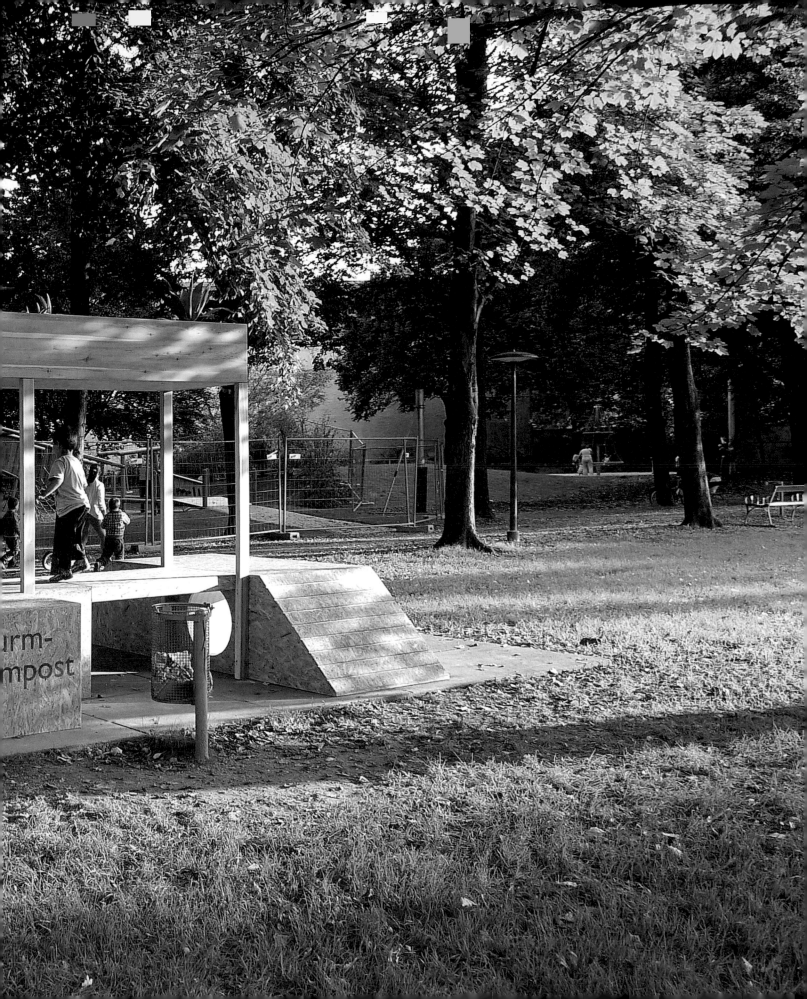

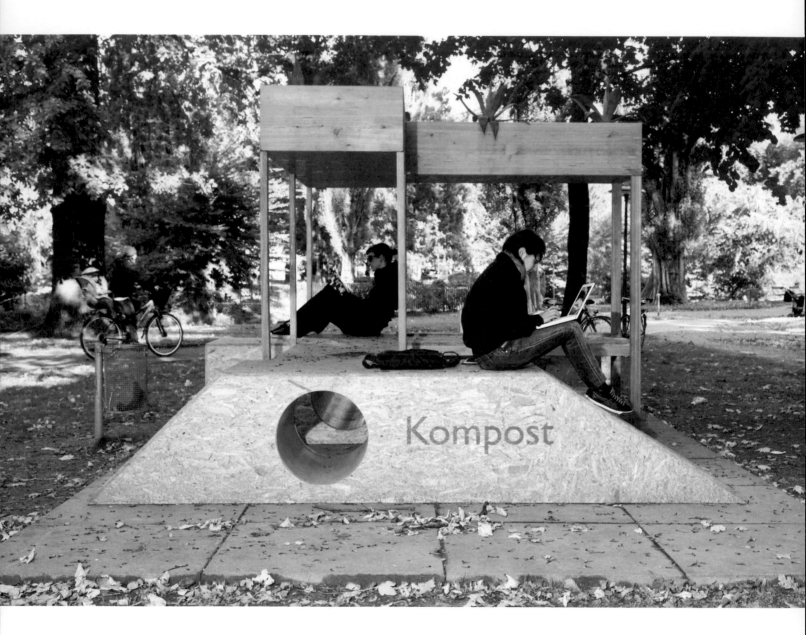

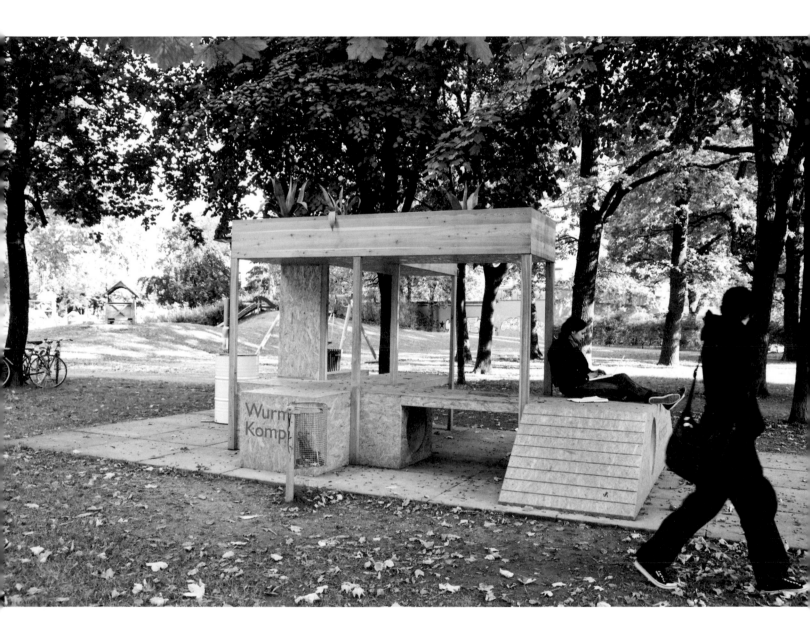

# Andreas Siekmann
# Trickle Down. The Public Space
# in the Age of Its Privatization

**Landhaushof, Herrengasse 16**

**Werner Rügemer in Conversation with Alice Creischer and Andreas Siekmann, June 2009**
**The Financial Crisis is Causing Public Sector Liability to Grow Exponentially**

**Alice Creischer** In our first interview with you, in March 2007, we discussed the way in which municipalities privatize their public sectors and examined which new financial products play a role in this. Have these business relationships changed in any way?

**Werner Rügemer** They are still the same. However, their impact, which nobody believed possible for quite some time, has now hit the municipalities very hard because of cross-border-leasing agreements. In the contracts, the municipalities' liabilities, which become due when a crisis sets in, were defined very precisely in advance. Since the financial crisis started, fierce negotiations have been taking place behind the scenes with both the investors and the participant banks. Under the terms of these contracts, the public sector has to guarantee that the circulation of capital between the banks involved (always five in number), which is calculated for a period of thirty years, will continue undisturbed. And that this capital continues to flow, even during a crisis. A lot of munici- palities are now affected by this, because one or more of the participant banks is now in crisis and threatened with insolvency. When that happens, the public sector assumes liability.

**Andreas Siekmann** Does that mean that the crisis is now being managed partly by the same protagonists who caused it?

**Rügemer** If, for example, the laws on managing financial crises have been made in Germany, the minister of finance directly contacts Freshfields, the law firm. Law firms such as Freshfields, Linklaters, and Hengeler Mueller have prepared draft legislation for the ministry of finance designed to stabilize the financial markets. Freshfields drew up the draft bill to take Hypo Real Estate into public ownership. They prepared the cross- border leasing contracts and continue to advise the municipalities and the federal government. Unfortunately, we have to assume that the same interests continue to prevail as those that were there before the financial crises began. The legislator and the financial lobby have become increasingly chummy with

each other during the past twenty years of neo-liberal economic policies. The politicians who make pertinent laws on the basis of this preparatory lobbying are now evidently finding it incredibly difficult to extricate themselves from all this chumminess.

**Creischer** In her recent book *The Shock Doctrine* Naomi Klein, citing various historical examples, describes how crises are played up to create pressure to act, thereby giving the respective governments and their financial agents absolute authority to act. Do you see any parallels here?

**Rügemer** It's one of the old worldly wisdoms of rulers: apply cruel policies quickly, immediately and right across the board, because then the majority of the population will be so stunned that they will no longer know what's hit them. The population is not informed precisely about what the money is being spent on, nor, for instance, about who the creditors of these bankrupt banks are, what exactly their demands are, how they are justified, and whether these justifications can be taken seriously. On the contrary, they exploit the opportunity to blackmail people: If the banks aren't saved, the entire economy will collapse. However, because the banks' actual obligations are never discussed in detail, people — and this includes the trade unions, too — believe this argument. In actual fact, the crisis argument is used to make further demands on the state — demands that are not based on any sensible economic arguments.

**Creischer** There is a perceived discrepancy between the news in the media about the big crisis and everyday perceptions of it. You don't really know exactly what other consequences the crisis might have. On the

other hand, however, you learn indirectly that the world's biggest famine has started, yet there's no attempt to explain the relationship between the financial crisis and the famine …

**Siekmann** … as if "Fortress Europe" had built itself a roof of banknotes. We can't even begin to see the economic effects this is having on other countries.

**Rügemer** The neo-liberal doctrine that has dictated economic activity over the past two or three decades is not interested in the development of the real economy. The crisis was not triggered by the banks, the hedge funds, and the private equity funds granting the real economy — the consumers, craftspeople, and so on — too much credit. It came about because over ninety per cent of all financial transactions were in speculative products.
Another reason for the crisis lies in the deregulation of jobs and social relations: falling wages, unpaid overtime, terminable employment contracts, the erosion of the entire institutional environment in which employees find themselves. All these things have given the financial operators even more freedom of manoeuvre than before. It is a very banal fact that the income gap has widened considerably over the past twenty years. One of the extreme consequences of global impoverishment is famine, because foodstuffs have become the target of speculative deals.
At the moment, the social impact of the crisis does not seem to be particularly serious here. There hasn't been much of a change as far as welfare payments and low wages are concerned. The financial crisis is a crisis of the rich and their agents for the time being. But managing the crisis by recourse to explosive state indebtedness will reduce

social transfers. The material constraints of privatization will appear like a god out of the machine and make them appear to be the only real solution — which will mean an increase in the cost of essential services.

**Siekmann** Can the Finanzmarkt Stabilisierungsanstalt (FMSA, Financial Market Stabilizing Agency) in Frankfurt, with its steering and management committee — and its remoteness from political controls — be compared with the former trust organization and privatization agency: the Treuhandanstalt? Are we seeing a repeat of the property privatizing policy that was implemented in East Germany in 1990, but with a greater level of indebtedness?

**Rügemer** Yes. This Sonderfonds Finanzmarktstabilisierung (SoFFin, Financial Market Stabilisation Fund) is a new version of the Treuhand. But with a fundamental difference: It was possible to use the Treuhand in East Germany at the time the political and economic system was undergoing changes. What is dramatic now, though, is that this new version of the Treuhand is being applied to an established market economy. This is tantamount to saving banks in full secrecy, completely shielded from parliamentary controls, and responding to the demands of private investors only; but those of us who are from the Treuhand know all about the

extreme secrecy and the excessive role played by the advisors. And this entails the far-reaching disempowerment of politicians. One result of this is that ever more citizens become aware that politicians are not interested in representing their interests. And this is the collateral damage caused by the self-disempowerment of politicians and parliament.

**Siekmann** Is there such a thing as an independent discussion on the crisis?

**Rügemer** I am glad to see that among various smaller groups such as attac and diverse groups from ver.di and the other unions, as well as in salons of citizens and independent cultural groups, people are increasingly interested in seriously discussing the real backgrounds, as well as the causes of and alternatives to the financial crisis. But the political and economic elite suppresses all reflection and discussion on guilt or responsibility — because it wants to manage the crisis without naming, penalizing, or recalling those responsible. When East Germany collapsed, the state had debts of about 30 billion Deutschmark. As a result, the entire elite was replaced. The western elite, which has presented us with global bankruptcy and a thousand times as much debt, will not be replaced. The arsonists are being put in charge of the fire department!

The above text is an abbreviated version of an interview conducted in 2007 and continued in 2009.

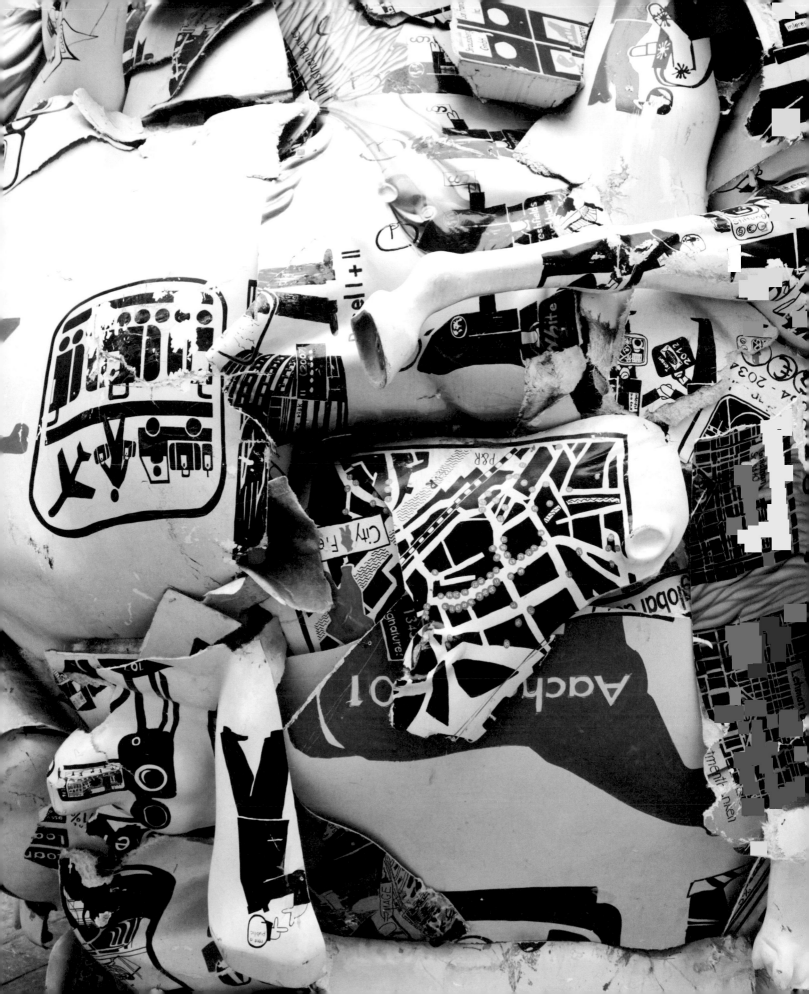

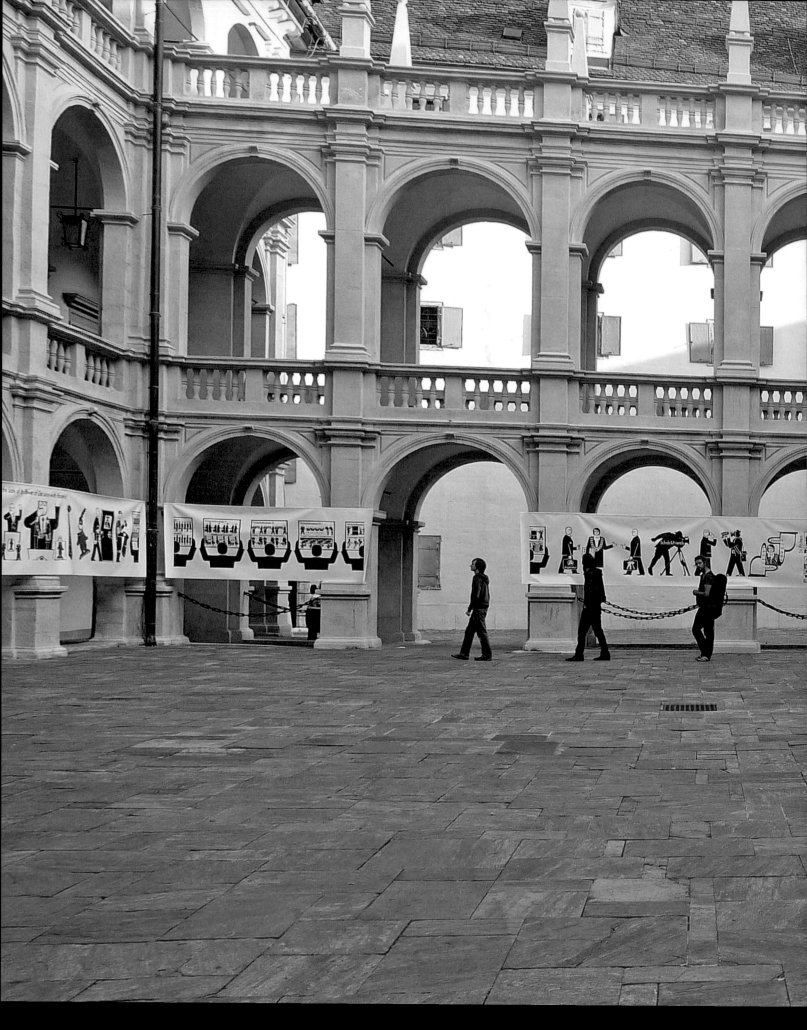

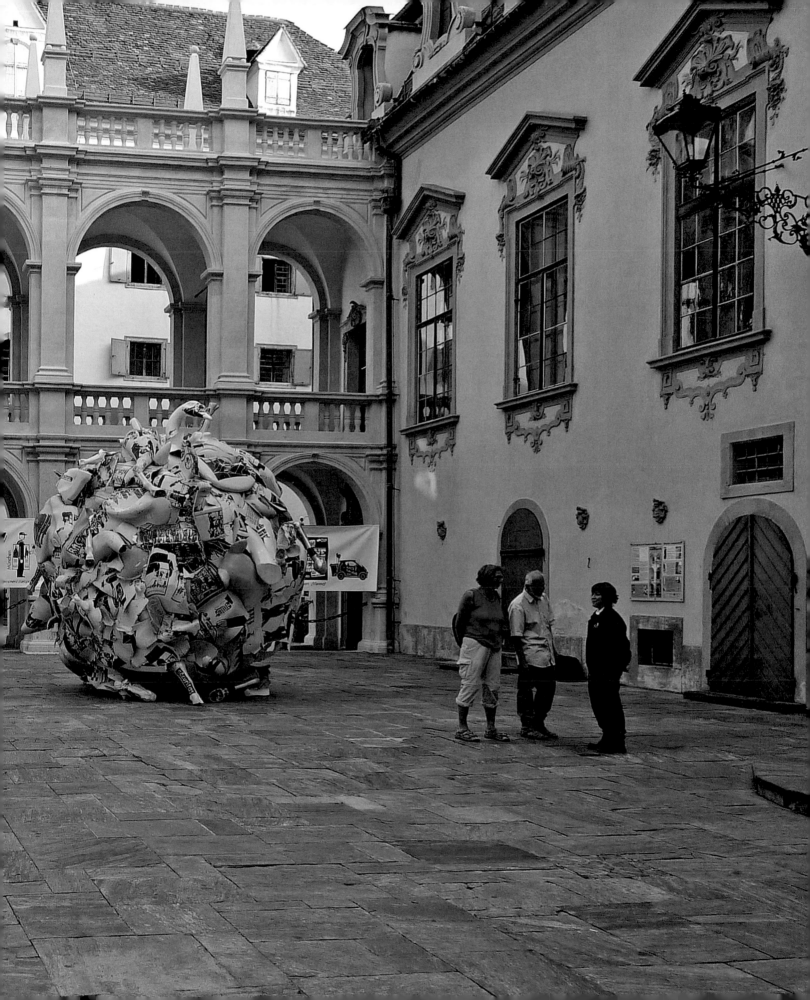

# Dolores Zinny & Juan Maidagan
# Curtain Call for Graz

**City Hall, Hauptplatz 1**

**Juli Carson**
**Hang Fire: Curtain Call**

*In classical theatre, the curtain … is the bearer of the function of theatre time … When the curtain falls between two acts, it has a double role. On the one hand, it promises that we won't miss anything in the interval should we leave the hall …. The lowered curtain "freezes" and "petrifies" the figures of the story and halts their time. It is only the presence of the gaze that makes the images (the figures on the stage) come to life, and it seems these images stand still the moment the curtain cuts into the field of vision.*
Alenka Zupancic, "A Perfect Place to Die."[1]

By lowering a curtain onto the portico of Graz's city hall, Juan Maidagan and Dolores Zinny set into motion a game. The stage is set up. In the square facing the portico — Graz's "public space" — spectators are metaphorically transformed into actors. On the other side of the curtain, administrators within city hall become the attendant audience. However, as the artists point out, this stage is simultaneously "upset" by the curtain's ambivalent position. Perhaps it is the "public" that functions as the audience to the actors "within" city hall? In reality, *Curtain Call*'s demarcation anamorphically cuts across the field of our gaze. In the process, our quotidian actions are frozen and something ordinarily repressed is revealed: the paradoxical nature of public space.

Maidagan and Zinny's gesture at once continues and negates another historic "curtain" that (unwittingly) set a similar game into motion. In that other instance, however, the game ends in the project's demise. Richard Serra's *Tilted Arc*, mounted in New York City's Federal Plaza, was destroyed in 1989 after the infamous trail that pitted the so-called "art world" public and the non-art world public against each other. What Serra, in his utopian vision of site-specificity, failed to understand was the manner in which the administrators within the US Federal Building would transform themselves from a passive audience of Serra's work to actors on the public stage determined to tear down what they called the "Berlin Wall of Foley Square." When *Tilted Arc* was destroyed — an act that took place at midnight under cover of darkness — Serra saw it as a public execution. Actor/Audience. Audience/Actor.

The relationship endlessly shifts the way the pronouns You/I shift endlessly in conversation. Just who is addressing whom? It depends, of course, on the situation. Back to *Curtain Call*.

In conceiving the work, Maidagan and Zinny were influenced by Borges's short story, *The Secret Miracle*. In it, the protagonist, Jaromir Hladík, is a playwright living in Nazi-occupied Prague arrested for being Jewish and opposing the Anschluss. Sentenced to die by firing squad, his only concern is his unfinished tragedy, *The Enemies*. The night before his death, Hladík prays to God that he be granted a year to finish his play. A voice speaks to him, promising: "The time for your labor has been granted." The next day, at the moment of his execution, a "hang-fire" occurs — a delay between the executioners' triggering of their firearms and the ignition of the powder that would expel the bullets that would eventually kill Hladík. In that frozen second, spread out in his mind over the span of a year, Hladík reflects upon and completes his play. Once it is done, Hladík is struck dead by the once-delayed volley. The reader is left asking: What is an audience? What is a production? In Borges's tale, the playwright is both audience and producer, meaning the play has no incidence in the real (political) world. If *Curtain Call* freezes a moment in which audience and actor are similarly conflated, it does so with the intention of making something in the world "happen" — something entirely eclipsed in Hladík's fictional case or repressed by Serra's *Titled Arc*. What is this thing? It is the dual commitment to avant-garde aesthetics and contemporary discourses of public space — wherein the artist's intentionality is but one factor in a game of infinitely exchangeable, contingent subject positions.

*Curtain Call*'s color and dimensionality mime the city hall's architecture. Neither frame nor negation, the work is a monument to the tactics of avant-garde site-specificity — "the scale, size and location of the work being determined by the typography of the site." At the same time, *Curtain Call* solicits opposing meanings that arise (from its ambiguous position in the square) as an "instance" of public space. This is what Serra failed to see — that the *babble of voices* that define the public sphere was just as much *Tilted Arc*'s site as was its physical space. The more Serra defied these voices, the more threatening *Tilted Arc* became. Some detractors even feared it would become a "blast wall for terrorists." Ironically, when avant-garde tactics of abstraction maintain utopian ideals of a singular public sphere, dystopian politics ensue. Like Borges's Hladík, the homogeneous site of *Titled Arc*'s specificity had no incidence in the real world.

*Curtain Call* conjures up an infinite number of disparate, real "curtains" that came before it. The memory of these curtains "appear" in Graz's public square as we recall them in our mind's eye. As in a "curtain call" — "the appearance of one or more performers on stage after a performance" — the likes of Daniel Buren, Dan Graham, Michael Asher, Francis Alys or Renee Green come to life on this global stage of critical aesthetics. For it is "here" that we negotiate the relationship between abstraction and politics, history and memory, vis-à-vis a curtain that is at once metaphorically lowered and drawn. An effect is produced like the final second of Hladík's life — "a second composed of a thousand seconds, frozen into action" — wherein infinite combinations of avant-garde strategies take place. This time a public audience, who are also actors, plays the game, producing

a type of public Happening. And if this game follows Kaprow's mandate that "Happenings can only happen once," it does so by encouraging the simultaneous — and infinitely contradictory — experience of the game that we hold in our minds while walking in real time. This is *Curtain Call*'s performative "picture" of public space.

1    Alenka Zupancic, "A Perfect Place to Die: Theatre in Hitchcock's Films," in: ed. Slavoj Zizek, *Everything You Always Wanted to Know About Lacan, But Were Afraid to Ask Hitchcock* (New York: Verso, 1992).

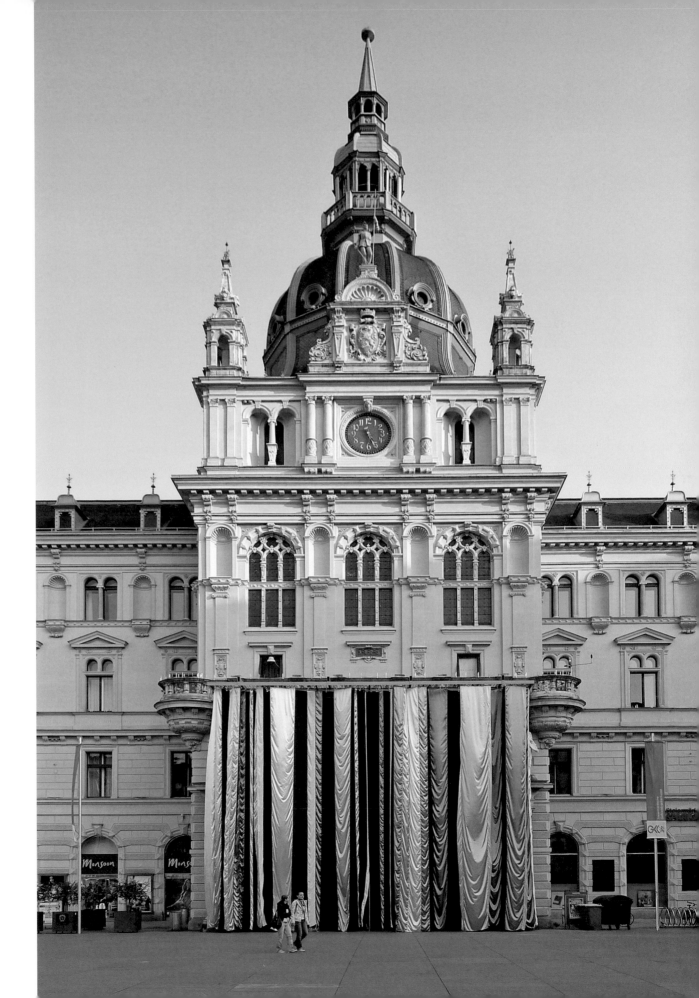

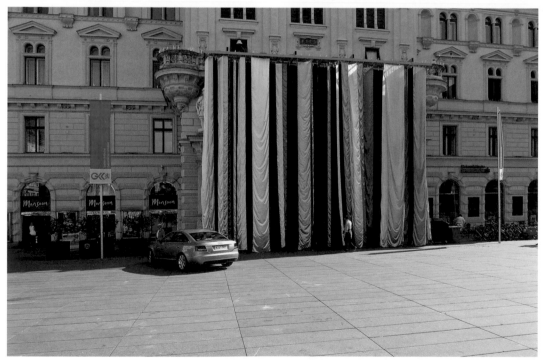

# Michael Zinganel
# The City Speaks! A Fictitious Dialogue

**Discursive city tour as part of the exhibition guide**

## Martin Fritz
### A Multi-voiced Dialogue with Himself

The very first paragraph of the introduction to Merlin Coverly's book *Psychogeography*[1] contains a demand, in the form of the simplest plan imaginable for a psycho-geographic stroll through the city: to explore the city by following a circle drawn with a compass. When, in the mid-1980s, two students of architecture took a map, placed the point of a compass in the center of an Austrian district capital and decided to take a stroll together through the rural-townscape along the line of the circle thus created, they unconsciously[2] and intuitively succeeded in interconnecting land art, conceptual walks (in spiritual affinity with Richard Long), Hamish Fulton and Lucius Burckhardt's "strollology," and the Situationist "dérive," which has now become a central reference for artistic interventions in urban spaces. From today's perspective it is clear that not only does the dialogue partner refer to the work for Graz, but that the circular nature of the enterprise also contains a prophecy: for Michael Zinganel happens to be one of those interdisciplinary artists who repeatedly returns to their original discipline's conceptual and methodical points of departure, despite the manifold

ways in which they have extended their horizons and getaway patterns in order to draw new circles and spirals starting at this very point.

For Zinganel, however, the tour and, therefore, the related textual and material developments serve not only metaphorically as methods with which he bundles the multifarious developmental threads of site specific art of the past few decades while, at the same time, pushing ahead with his mediatory work on town planning, architecture and social history.[3] At quite an early stage, he developed a preference for polyphonic dialogue and a format that one could designate "documentary fictionalization." One of his research projects on shared facilities in buildings in the "Rotes Wien" (Red Vienna) residential housing construction scheme (*Freiraum Superblock — Leerstellen im Roten Wien*, 1995; *Free Space Super-Block - Empty Spaces in Red Vienna*) included excursions on which he himself was the guide, to the now disused facilities in Vienna's municipal housing projects, as well as a video project presented by a fictitious "architecture guide." This guide,

played by an art mediator, read in situ from a standard work on the architectural history of the location and, therefore, as one of the authoritative voices who, in the exhibition, was supplemented and challenged with various positions, such as that of the caretaker or of students making suggestions for new uses. Co-operation projects and the continual inclusion of dialogue partners in his thematic tours thus constitute the methodological constants that enable Zinganel to do justice to his subject matter without falling into the trap of over-specialization, egomaniacal super-expertise or ideological reductionism. On his *Real Crime Tours* on "Architecture, the city and crime," for instance, which he has been running for several years now, he is accompanied by, among others, plain-clothes policemen, feminist urban-planners, and historians. With their contributions, they have introduced a multi-perspective approach that is still not very common among the various disciplines: although its potential, thanks to the mediatory and participatory tendencies of the 1990s, is finding ever greater acceptance within the arts. Parallel to this, so-called post-dramatic theatre has developed its interests in documentaries and urban space, thus adding further lines of development that crossed in 2007, for instance, when Zinganel, accompanied musically by a police band, presented a special version of his *Real Crime Tours* for a project by the Wiener Tanzquartier.

Michael Zinganel's art has thus always played a mediatory role. And his contribution to *Utopie und Monument I*, (part of? in? forming part of) the "official" exhibition guide, was the perfect supplement. There, in addition to the customary information on the artists and their projects, [4] he introduced a "multi-layered narration" comprising texts and drawings, producing, in the artist's own words: "not a complete or historically correct cartography of the city, but the author's overlapping memories, experiences and knowledge spaces." [5] The media he used comprised additional plans drawn especially for the exhibition, [6] supplementing the information on the artworks with factual information on historical and contemporary Graz. [7] There was also a long, fictitious dialogue between a "local urban historian, who knew his way about the city, and a theoretician well versed in international discourse on urban centres and the arts." Together, they visited the exhibition sites without explicitly referring to the artworks. It may have been in response to the meanwhile ubiquitous — and often performative — "use" of various experts within the context of art projects[8] that prompted Zinganel to do without an opposite number on this project, or rather to find one in himself, as he is not at all difficult to identify in his two protagonists. The dialogue, which equally combines the sometimes contradictory perspectives of a local standpoint with a theoretical bird's-eye view, created an opportunity for interpreting urban space in a variety of ways, without the other contributions hindering one another in terms of space or content. As a result of Zinganel's decision to trust the text and, by way of an exception, not to do any guided tours, the exhibition visitors were assigned a self-defined role that could consist in their contributing their own — and even contradictory — interpretations and perceptions as they conducted their own personal tours.

For urbanity — to cut a long story short — is a product of the existence of a sufficient number of contradictions — and voices articulating them. However, they do not

combine to form harmony in urban space, but leave their mark on public space as a polyphonic choir. It is to this opportunity to work polyphonically that the city's outdoor space owes its historical role as a center of encounters and dialogue: a matter of significance which must, however, first be renegotiated or secured for the future, as it could fall victim to all those developments which, for contemporary site-specific art practice, have become sources of friction associated with the catchwords "privatization," "surveillance," "festivalization," and "commodification," and are, therefore, lamented by Zinganel's fictitious urban theoretician, too. Michael Zinganel knows more about these developments than many others and never hesitates to reflect upon his *own* involvement in these processes. In dialogue with himself — if need be.

1    Merlin Coverley, *Psychogeography* (London: Pocket Essentials, 2006).

2    During a personal talk, Michael Zinganel, who went on the walk with Manfred Lindorfer, referred to it as "an attempt by frustrated architecture students to flee into land art."

3    For the artist's own detailed comments see: Michael Zinganel, "Vor lauter Thema verschwindet die Stadt! Stadtwanderungen zwischen Bildungsauftrag und widerständigen Lesarten," in: Elke Krasny, Irene Niehaus (eds.), *Urbanografien der Stadtforschung in Kunst, Architektur und Theorie* (Berlin: Dietrich Reimer Verlag, 2008): 45–58.

4    Corresponding with the dual nature of the 58-page booklet, the inside cover of the uniformly designed publication contains separate credits for the exhibition guide and the project by Michael Zinganel.

5    Michael Zinganel, "Die Stadt spricht! Ein fiktiver Dialog," in: the exhibition guide *Utopie und Monument I. Über die Gültigkeit von Kunst zwischen Privatisierung und Öffentlichkeit* (Graz: steirischer herbst, 2009): 6.

6    The illustrations for the exhibition guide were provided by Barbara Heier.

7    A plan illustrates historical "architectures of control" and the displacement of "undesired" social groups within the city area; the other shows the highly frequent use of central city squares for events.

8    At the steirischer herbst, for instance, at the *Schwarzmarkt des nützlichen Wissens* by Hannah Hurtzig (2007) or the projects by Rimini Protokoll (the last being in 2009).

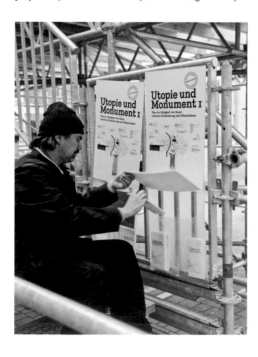

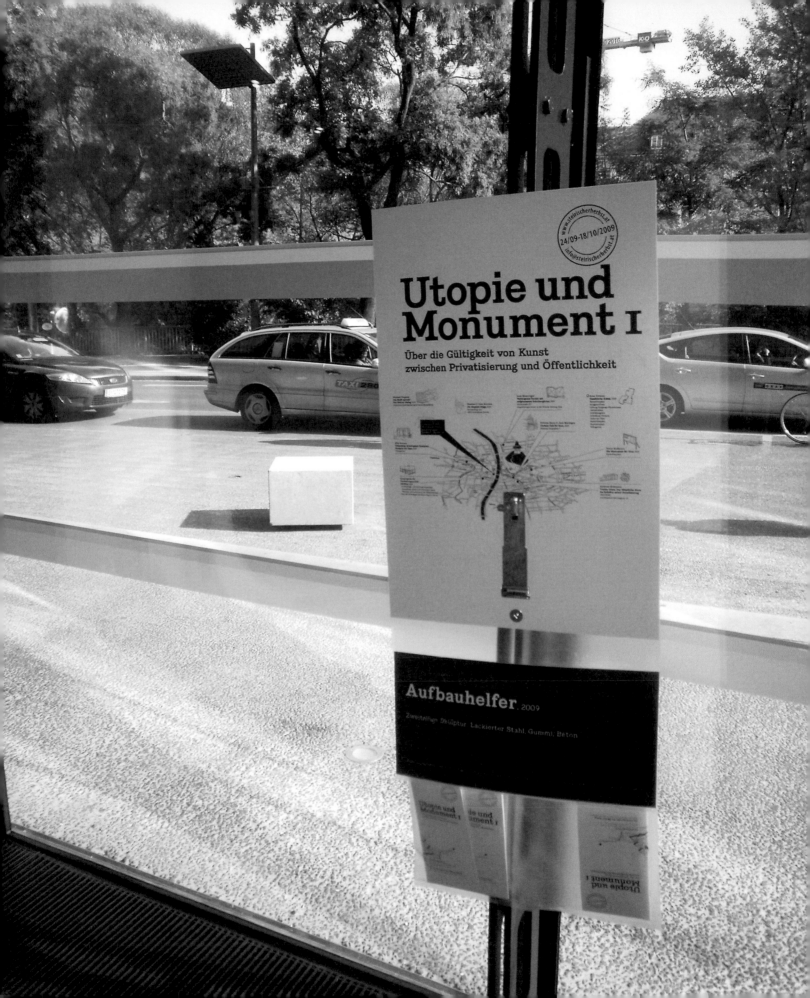

# Kooperative für Darstellungspolitik Pavilion

**Platz der Freiwilligen Schützen / Bad zur Sonne**

**Doreen Mende**
**Pavilion: Kooperative für Darstellungspolitik**

### Interior Space Outdoors

Perhaps it was not unlike the way in which the beatnik Rolf Dieter Brinkmann strolled around the streets of Cologne in the late 1960s, audio taping his descriptions of all that he found, that the *Pavilion* of the Kooperative für Darstellungspolitik (KDP) was preceded by a walking tour of the city aimed at preparing a "spatial recording" of the streets and squares of Graz. The co-operative noted the existing infrastructure, the distinctive urban features in the center and the surrounding area, the existing social uses, and the requirements placed on temporary architecture. They used standard sheathing of the kind often employed on building sites so that they could finally start building the *Pavilion*. However, the KDP inverts the visual and spatial imperatives for making building site reinforcements. The supporting structure Things that are normally concealed are not kept from us, but openly displayed. Created by integrating found objects (such as a streetlamp that no longer serves to illuminate the street) and inverting standards, the roofless *Pavilion* generates an interior outdoor space in the open air. Seen from the outside, the structure resembles a film set, while the visibility of structure transforms the interior into a performance venue. At this point, the boundary folds in and out like an accordion book, advertising an exhibition on art and public space that consists of pictures and texts, presenting forty-six projects on a gallery of yellow wallboards. Furthermore, the *Pavilion* provides a setting for artists' talks, film shows, and discussions: fleeting events which, catering to topical interests, are planned for the new construction in 2010. Whereas the "as-found," created by the intervention at the square identifies itself as a "site," the enclosed space forms a set for staging curatorial ideas and events. Hence, the *Pavilion* does not function as an infobox. On the set, people rehearse, take photographs, and film — the audience is imagined, designated, and programmed. The folding in and out — at the square — of both space and the public creates a role play in which both the guests and the actors move between the stage and the backstage, the exterior and the interior, between the real and the staged.

## Ad Hoc

Yellow sheathing, scaffolding, a prefabricated staircase, an inkjet print on wood — the KDP regards the selected materials and technologies not as a means to an end, but as elements constituting the *Pavilion* itself. One of the yellow wall panels on the interior displays a text on Matha Rosler's project *Housing is a Human Right* (1990–1992), which was realized in Saint Louis, Missouri (US), among other places. In 1972, to mark the demolition (with explosives) of the Pruitt-Igoe residential complex, architecture critic Charles Jencks proclaimed the failure of the Modernists in this very Saint Louis, in order to ring in the age of the *Language of Post-Modern Architecture*. At around the same time, he published another book *Adhocism: The Case for Improvisation*. This ad-hoc practice divests existing objects of their bureaucratic purpose in order to make them available for the immediate needs of each specific user for an infinite variety of usages. Depending on the particular need and not the norm. Although the KDP's spatial concept certainly strives, in many ways, to move towards the "unitary urbanism" of the radical International Situationists of the 1950s-1960s, in the case of the *Pavilion* the use of the above-mentioned standards for unintended purposes is more apt. These standards, corresponding to an acute, on-the-spot need, annul systems and spatial codes of behavior that are regulated from the outside. Hence, the outdoor interior also provides an environment for everyday personal needs outside the framework of officially planned agendas. However, we know that even the steirischer herbst operates through the supervision of the authorities and institutions. And the continuing practice of art in public space — including its ability to express and deal with criticism — has meanwhile transformed some unintended uses into standard responses. Hence, when curator Sabine Breitwieser's introductory text declares that the *Pavilion* contains a historical-chronological survey not only of projects in public space but also, and above all, of the commissioning policy thereof, then ad-hoc practice has reached its limitations as far as the *Pavilion* is concerned. "Using according to need," therefore, can only be a suggestion that might help us to distinguish different spaces and states of institutionalization.

## Performance of Space

The *Pavilion*, which was first constructed in 2009 at the Platz der Freiwilligen Schützen in Graz, is now being erected at Tummelplatz within the framework of the steirischer herbst 2010. The first time round, the *Pavilion* stood on scaffolding, as if it were on a rostrum. Its reading table was relocated to the city library. At Tummelplatz, it is on ground level and opens out in a less formal manner onto the street, Hans-Sachs-Gasse. There is one important difference, though: the second exhibition accompanies a co-operation project undertaken with the students of the Institute for Contemporary Art at Graz Technical University. In the workshops, a series of events on art in public space is being prepared. The form of presentation will change in line with requirements: In the *Pavilion* there will be a lecture, discussion and a film in the room niches administered by the students. The niches loosen up the structure of the space planned for the events. Although the *Pavilion* assumes different forms, the spatial concept nonetheless corresponds in its realization like a music score to a performance, or a film script to the filming. Not unlike the performance practices of Group

Material, Clegg & Guttmann, and Dan Graham, whom we can read about in *Pavilion*, the KDP's design is intended as a sort of concept paper that can activate centers of activity at other places, too, in relation to alternating conditions. In other words: a political zone is activated not at the moment the *Pavilion* is erected, but only via interaction with its performance. Hence, a certain space can only be politicized once its politicization is linked to the duration of social processes.

## Document / Monument

In marked contrast to all the other contributions to *Utopia and Monument*, the interaction — in the *Pavilion* — of the exhibiting system ("the display") will be rigorously connected with that which is exhibited ("on display"). Sabine Breitwieser compiled the texts and the images, which document a chronology of projects in public space and are exhibited as an "incomplete collage" in the *Pavilion*. In co-operation with graphic designer Matthias Görlich, Berlin, a layout has been prepared for the "exhibition" in the *Pavilion* that generates the tangible dynamics of spatial visual perception. The sheathing not only forms the architectural wall and floor elements, but is itself transformed — by virtue of the specific qualities of the material — into an object, while simultaneously serving as a display for texts and images. Display strategies render the curatorial idea legible in relation to the various elements configuring the exhibition space. The concep-

tion and production process weaves the curator's documents, the specific local spatial conditions and the architectural and design practice of the KDP into a relational system. If curating primarily entails activating a network in order to create both space and a public, then the KDP's practice can be described as curatorial. Similar overlaps in various forms of exhibiting can be found in other KDP projects, too, as in the exhibition architecture for *In der Wüste der Moderne* (2008) at the Haus der Kulturen der Welt in Berlin and the *Berlin Documentary Forum I* (2010) — including the interconnection of the roles of architect and curator: A member of the KDP served as a co-curator of the exhibition *Soziale Diagramme* (2008) at the Künstlerhaus Stuttgart.

Considered from an institutional point of view, the *Pavilion* is an architectural body with an exhibition display and, therefore, not an exhibit. Considered from a curatorial point of view, however, the architecture conceptualizes a space for events, which becomes public and becomes an exhibit by being displayed. With respect to the exhibition (projected to last two years), which coincides with the steirischer herbst and bears the title "Monument," the event, the temporality, and the unpredictability of the process of exhibiting transmogrify the *Pavilion* into a form of monument. Even so, the monument is to be sought, as a public site, in the temporally restricted, plural staging of an interior space outdoors.

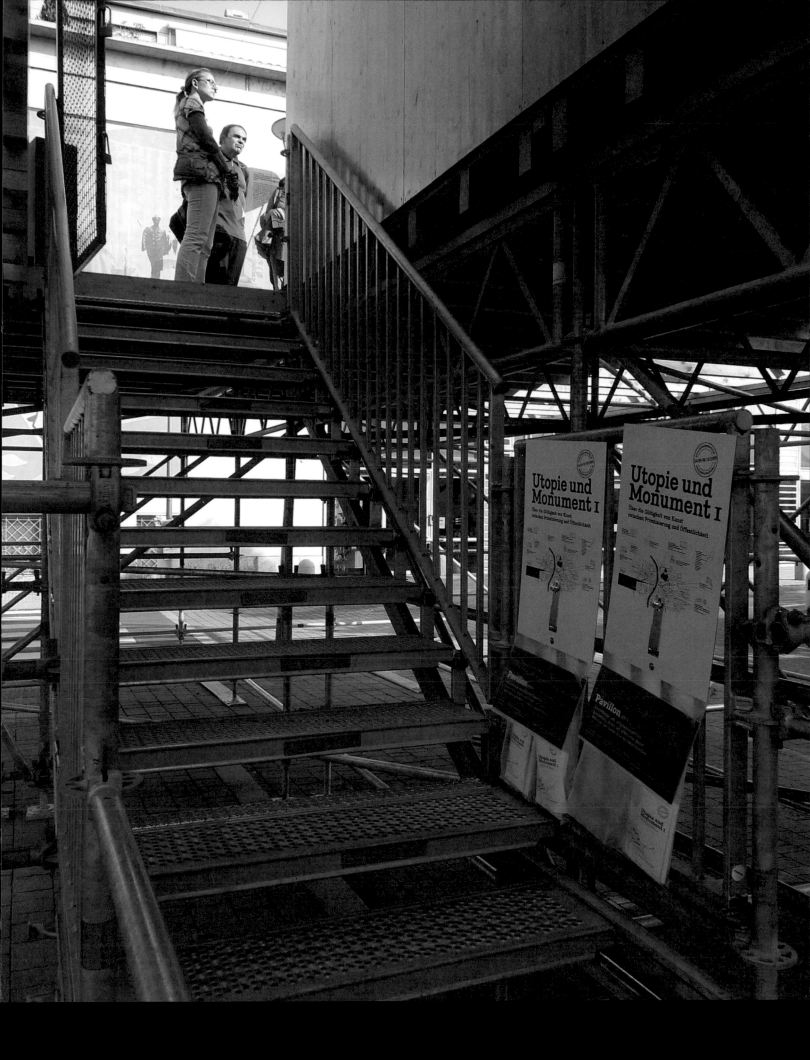

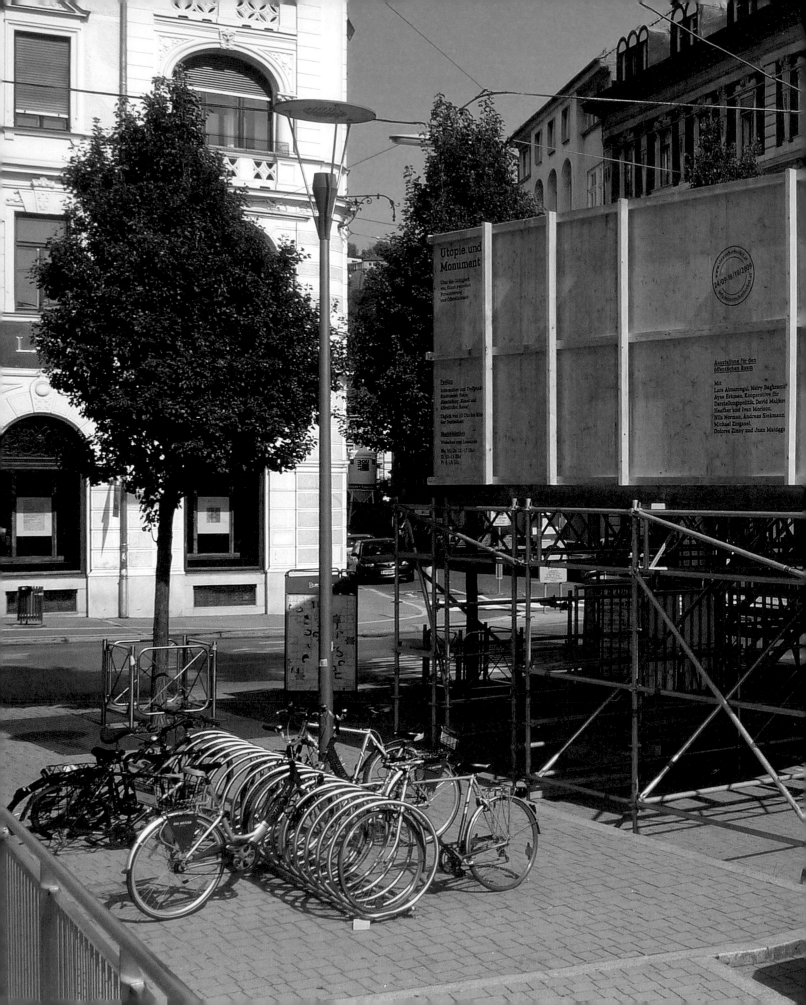

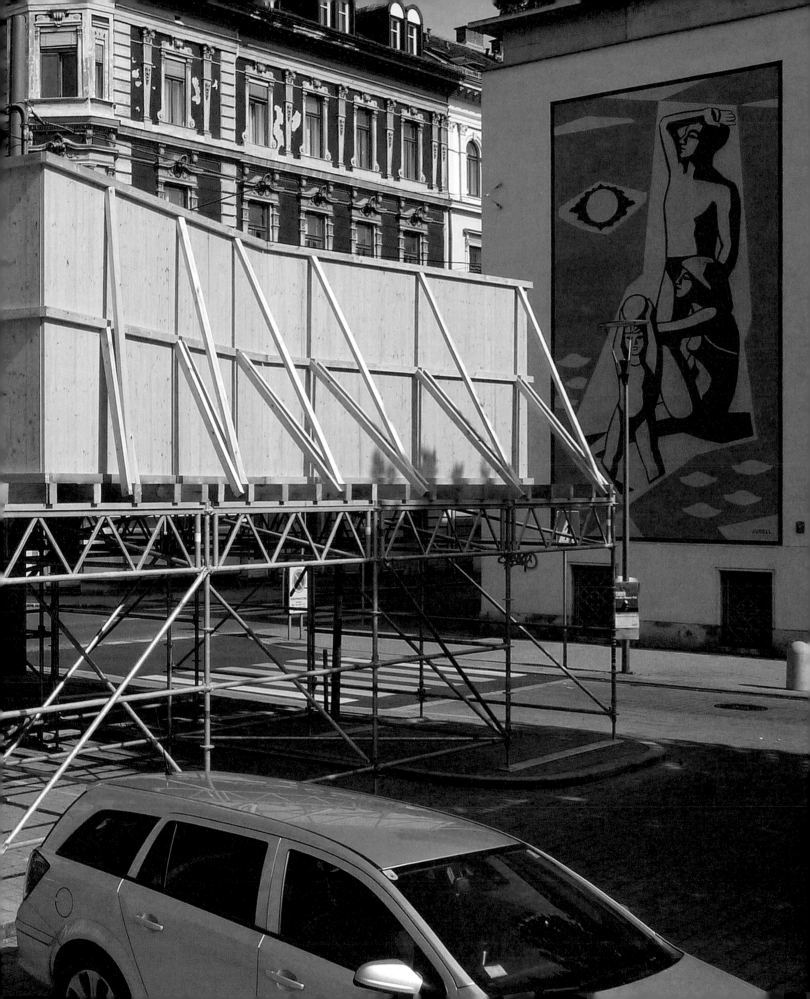

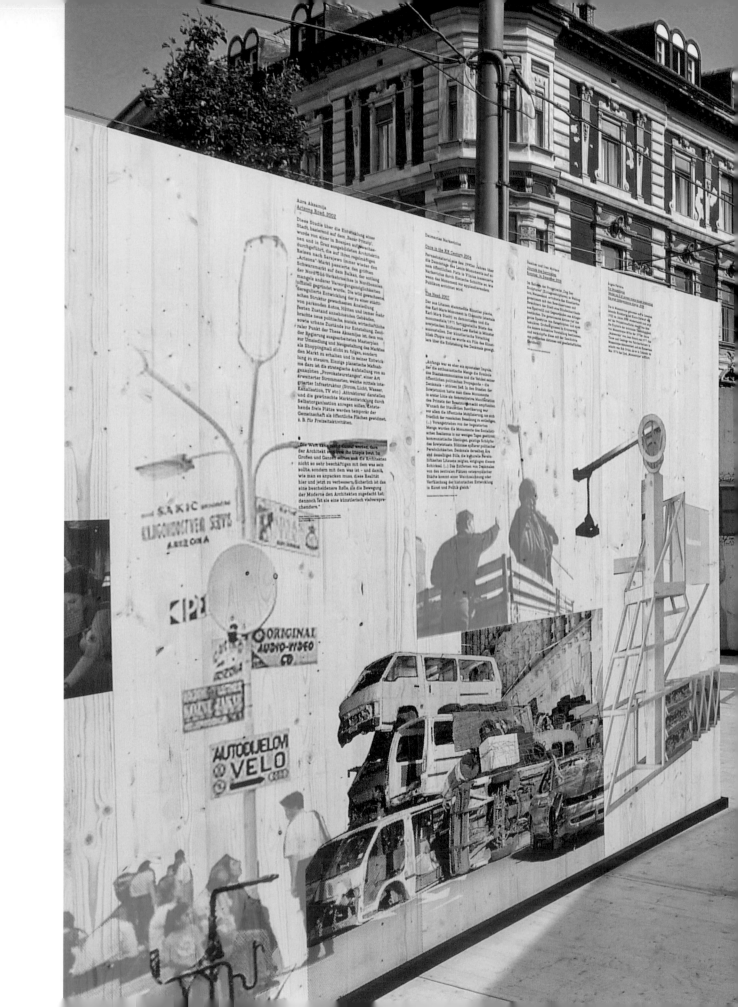

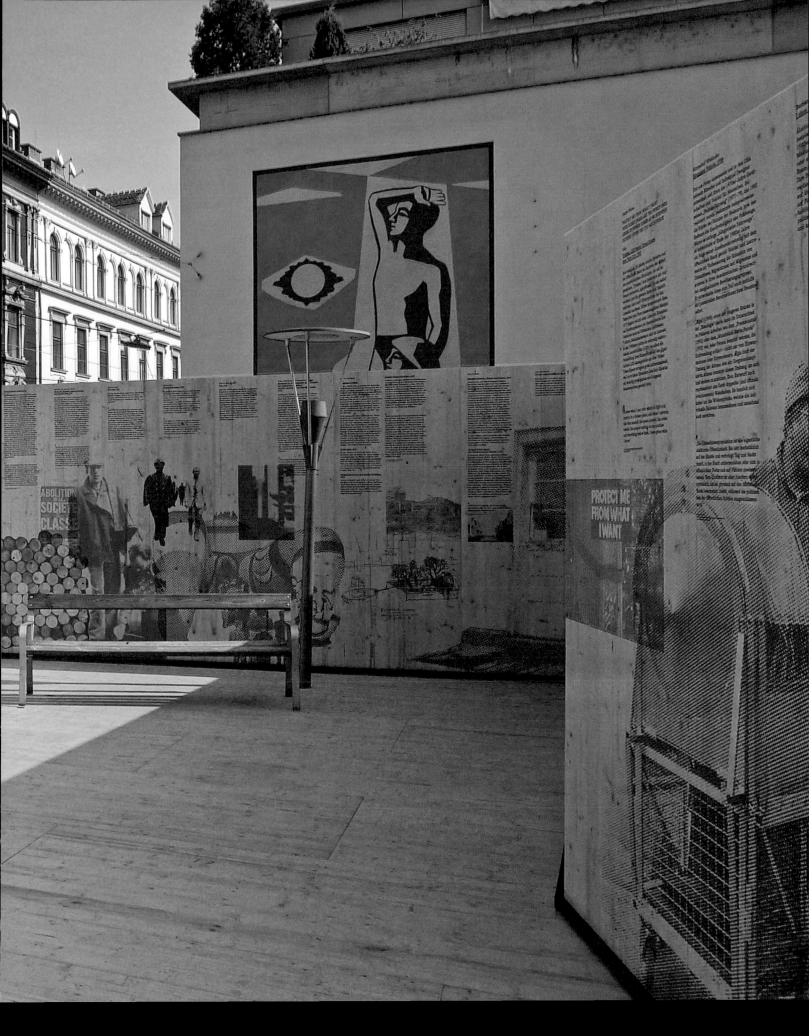

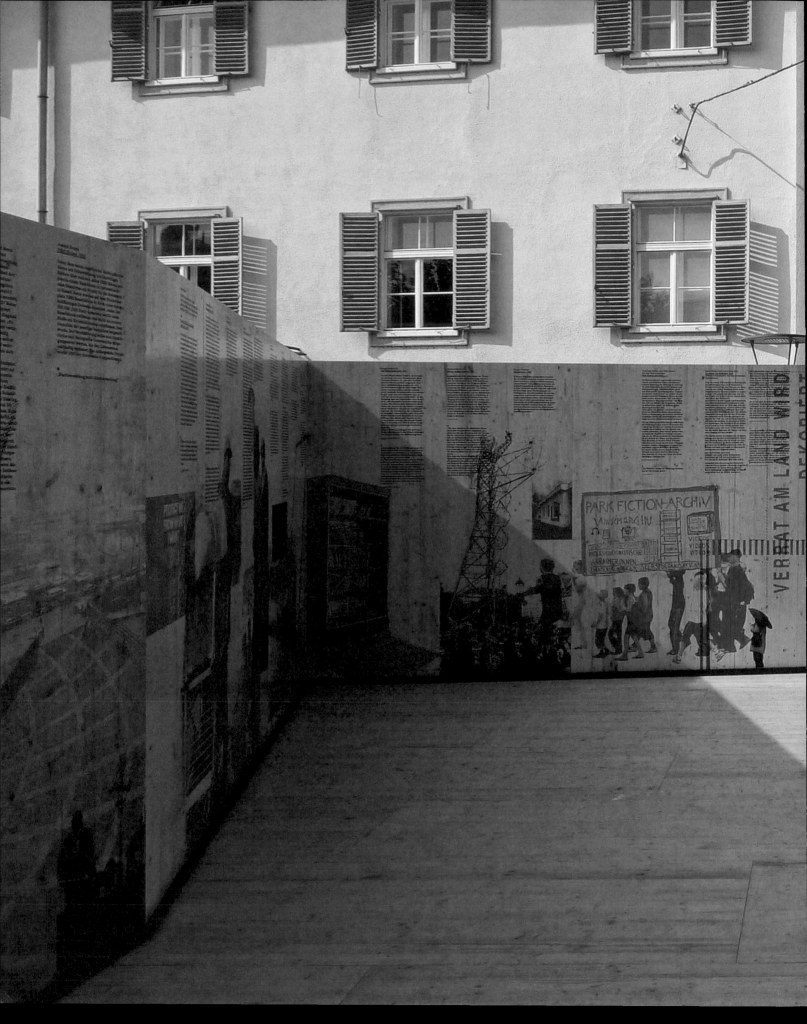

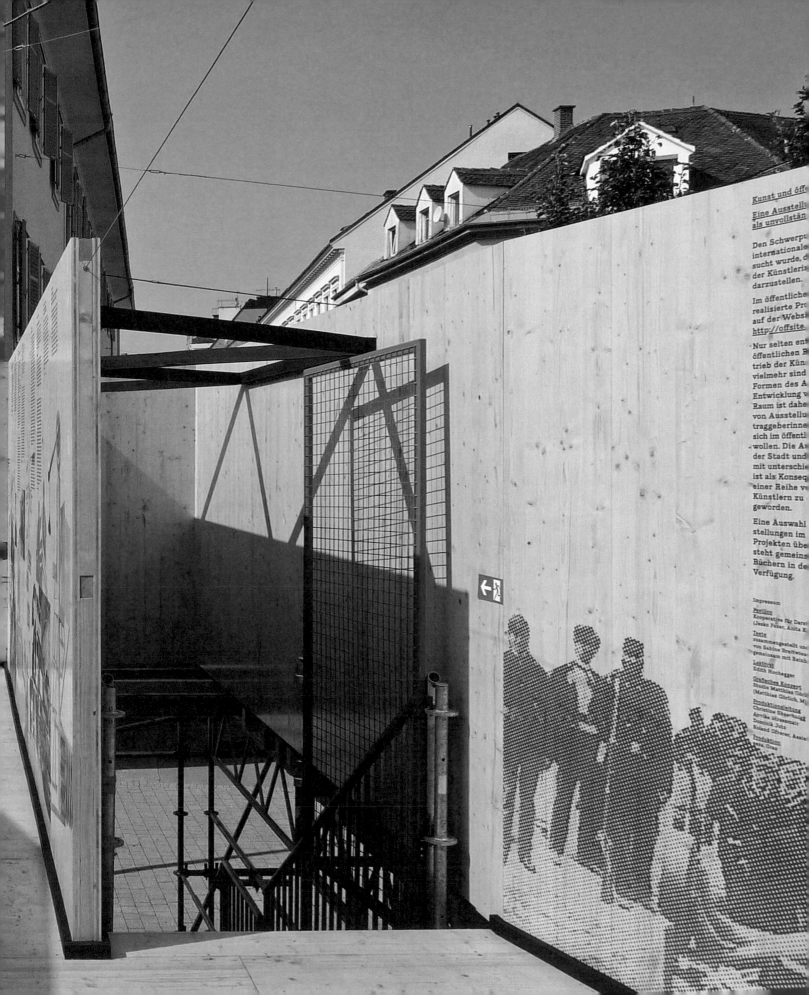

Kunst und öff
Eine Ausstell
als unvollstän

Den Schwerpu
internationale
sucht wurde, c
der Künstlerin
darzustellen.

Im öffentliche
realisierte Pro
auf der Webs
http://offsite.

Nur selten ent
öffentlichen P
trieb der Kün
vielmehr sind
Formen des A
Entwicklung v
Raum ist dahe
von Ausstellu
traggeberinne
sich im öffentl
wollen. Die A
der Stadt und
mit unterschie
ist als Konseq
einer Reihe v
Künstlern zu
geworden.

Eine Auswahl
stellungen im
Projekten übe
steht gemeins
Büchern in de
Verfügung.

Impressum
Pavillon
Kooperative für Dar
(Jesko Fezer, Anita E
Texte
zusammengestellt und
von Sabine Breitweise
gemeinsam mit Reinh
Lektorat
Edith Hochegger
Grafisches Konzept
Studio Matthias Gö
(Matthias Görlich, M
Produktionsleitung
Christine Ebenthal
Agnika Strau...
Produktion
Roland Jitz
Roland Oltern... Annie
...Graz

# Utopia and Monument II
# 2010

## On Virtuosity and the Public Sphere

- Kooperative für Darstellungspolitik
  (Jesko Fezer, Anita Kaspar, Andreas Müller)
  IZK, Institute for Contemporary Art,
  Graz University of Technology
- Armando Andrade Tudela
- Kader Attia
- Angela Ferreira
- Andrea Fraser
  sozYAH, Center for Social Research
  Institute for Sociology, University of Graz
  (Sabine Haring, Anja Eder)
- Isa Genzken
- John Knight
- Jutta Koether
- Paulina Olowska
- Michael Schuster

# Kooperative für Darstellungspolitik & IZK, Institute for Contemporary Art, Graz University of Technology
# Pavilion

---

**Tummelplatz**

### Ruby Sircar
### Space Dream – Contribution from the Institute for Contemporary Art at Graz Technical University, at the New *Pavilion* Installation for *Utopia and Monument II*

In the class on "Designing specialized themes," architecture students seize the opportunity — within the framework of the exhibition *Utopia and Monument II* — to examine questions on art and public space with the aim of developing artistic, space-creating strategies, analyzing private and public space, or subverting specific conceptions of these spaces. The studies here focus on (among other things) the translation mechanisms operating between these different spaces: Do we read content in different ways? Are the images of perception and representation contingent upon the type of space — urban, rural, private, or public? What are the points of translation at which images become legible for a group or mass of people? Can a culturally translatable utopia and a collectively co-ordinated consciousness develop on this basis? Which codes are needed for this to happen? Students examine these questions on the imagined creation of space, and on the basic patterns, symbols and images, from an artistic and architectural perspective.

The projects developed have assumed artistic and architectural forms and encompass the most diverse media: starting with the projects that augment the *Pavilion* as an installation and transport it, in the form of fragmented sculptures, into the square's surroundings. Examples of how this can be achieved include using wooden steles that rise like exploding advertisements from the material forming the *Pavilion's* walls; beanbags in the same striking color as the *Pavilion*, which are placed at various points in the steirischer herbst and the Pavilion itself and, last but not least, the markings on the asphalt, which are intended to encourage people, themselves elements of collective everyday life, to reconsider their own positions in urban space.

The *Pavilion* itself has also been extended to include the most diverse functions. It aims to encourage and broaden discussion on the overall project *Utopia and Monument II* both artistically and at the level of content. The same applies to the furniture for sitting, climbing, lingering, and conversing alongside the outer skin of the *Pavilion* at Tummelplatz,

all of which invite people to use it as it is, or to find novel uses: such as allowing people to leave small notes and comments there on a sheet of plastic film. A roof comprising floating, interweaving ropes has also been stretched across the *Pavilion*. The roof is movable, so that visitors can push it along rails. In this way, the structure creates intertwined levels on which dancing light reflections and projections form.

As the *Pavilion* allows for diverse — and unplanned — uses, a stage has been designed with the aim of catering for as many different uses as possible, including short breaks and periods of contemplation, crash pads for the homeless, and a stage for performative interventions. A photographic documentation of the development of the various installations in the *Pavilion* will be prepared, showing who uses the *Pavilion* and how. And asking what will remain afterwards. The documentation will be created in, among other places, the container in the *Pavilion*. The container can be used as both a camera obscura and a supervised assembly box, inviting visitors to comment and join in the debates.

In addition to the installations, there is also a performative central thread that examines questions on the theme of *Utopia and Monument II*, rendering these visible in a celebrated, imagined community. Various strategies will be presented in three different performances at the three sites of intervention with the aim of rendering (public) social space visible. For two weeks in October, the *Pavilion*, as a useful setting for minimal-temporary installations, as well as for performances for perceiving space, will also stage a seminar entitled "Tuck and Fray - Art and Public Space." Rapid interventions in public space will also take place. The approaches we shall adopt to examine the fundamental questions underlying the overall project on imagined space are to be realized as direct reactions on Tummelplatz. The question is to be cut into, scratched up, and rendered visible, like the existing materials and traces left behind in the *Pavilion*. *Raumtraum* and *Tuck and Fray* are two discussion contributions on the realization of an imagined and not necessarily utopian society and its everyday spaces — what contribution can we make towards this?

Project participants: Kathrin Bart, Peter Rudolf Franz Baumann, Johanna Doris Binder, Julius Coutandin, Theresa Götzfried, Andrea Kalcher, Alexander Kampits, Sarah Kandlhofer, Stefan Kral, Georges Majer, Pia Pöllauer, Emmy Anna Rauscher, Martina Ribic, Andreas Rogala, Paul Rossi, Carina Stabel, Lisa Thrainer, Elisabeth Maria Weber, Mario Weisböck, Karl Zrunek, and Lisa Zvetolec
Project collaborators: Claudia Genger, Lisa Obermayer, and Maurice Rigaud
Project director: Ruby Sircar

The Institute for Contemporary Art wishes to thank Sabine Breitwieser for her invitation and support, Annika Strassmair and the steirischer herbst for their guidance throughout the project and Andreas Müller and the Kooperative für Darstellungspolitik (Co-operative for Representational Politics), and John Knight for occupying himself so intensively with both the content and implementation of the project.

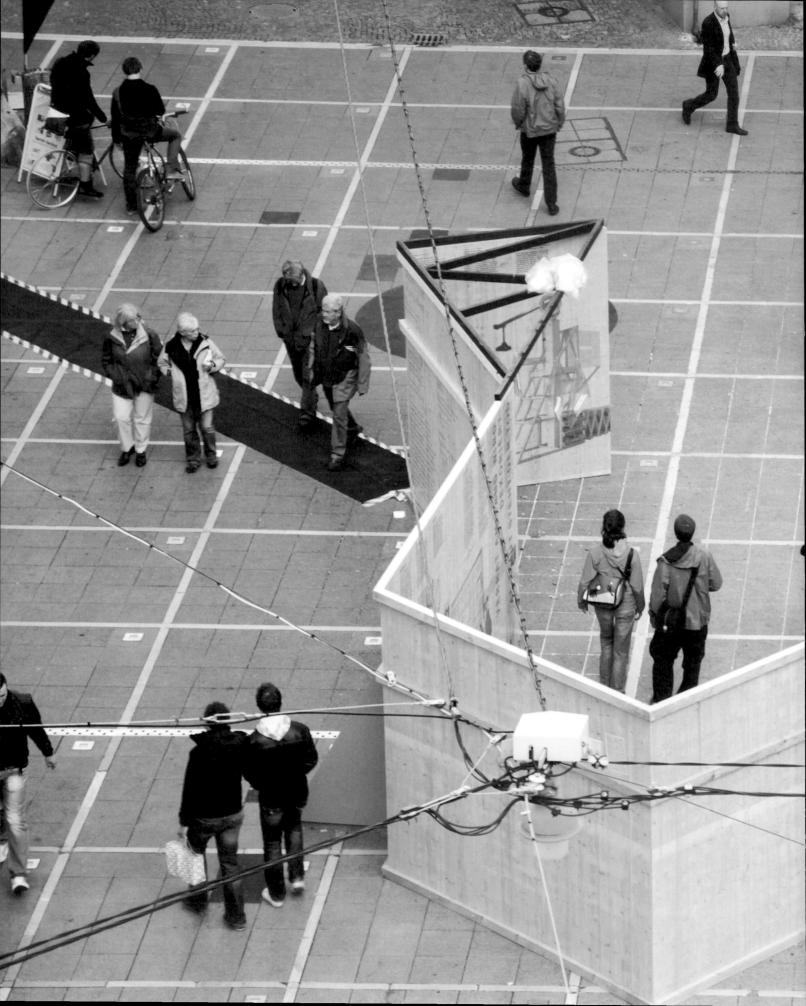

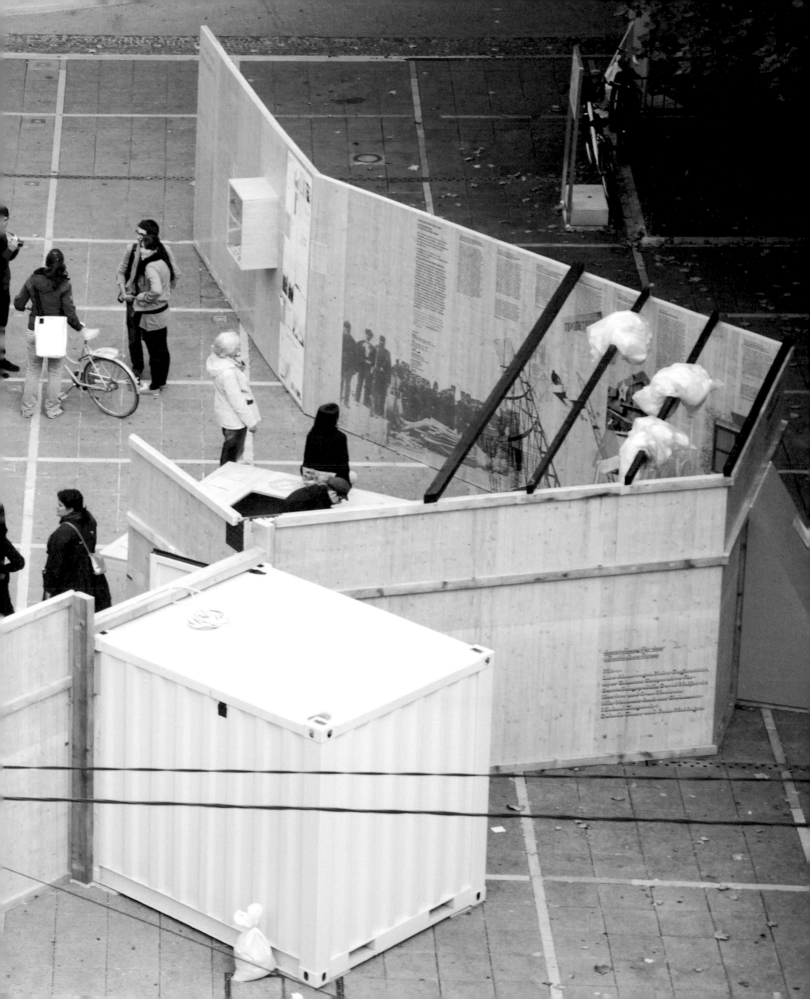

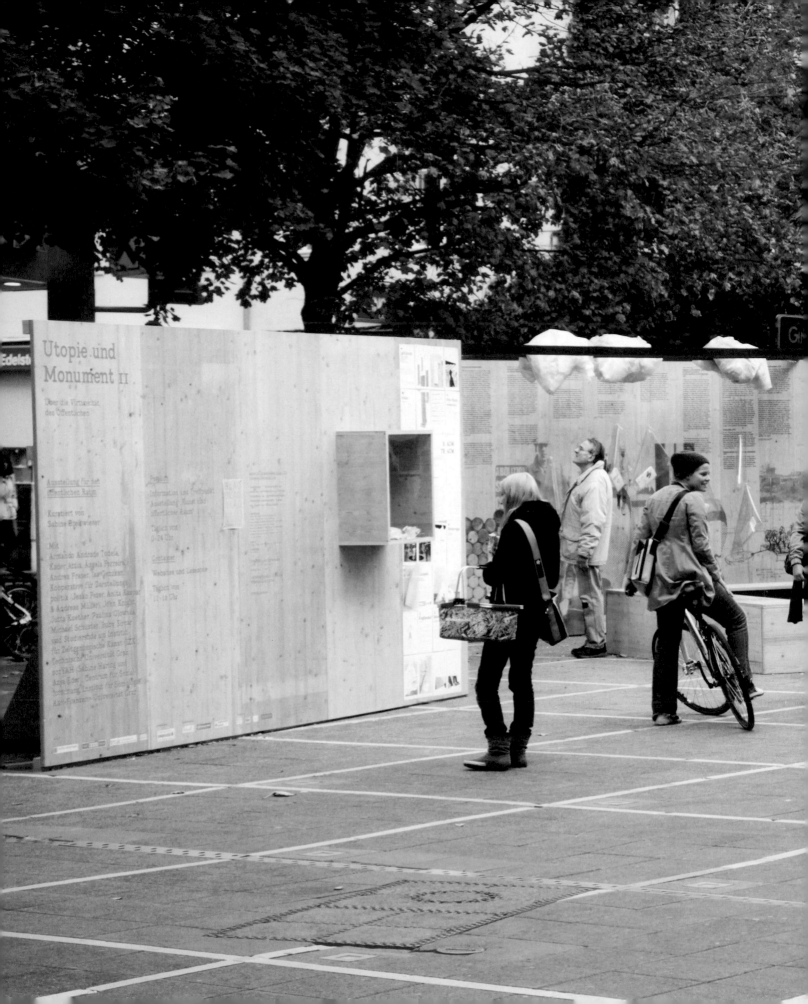

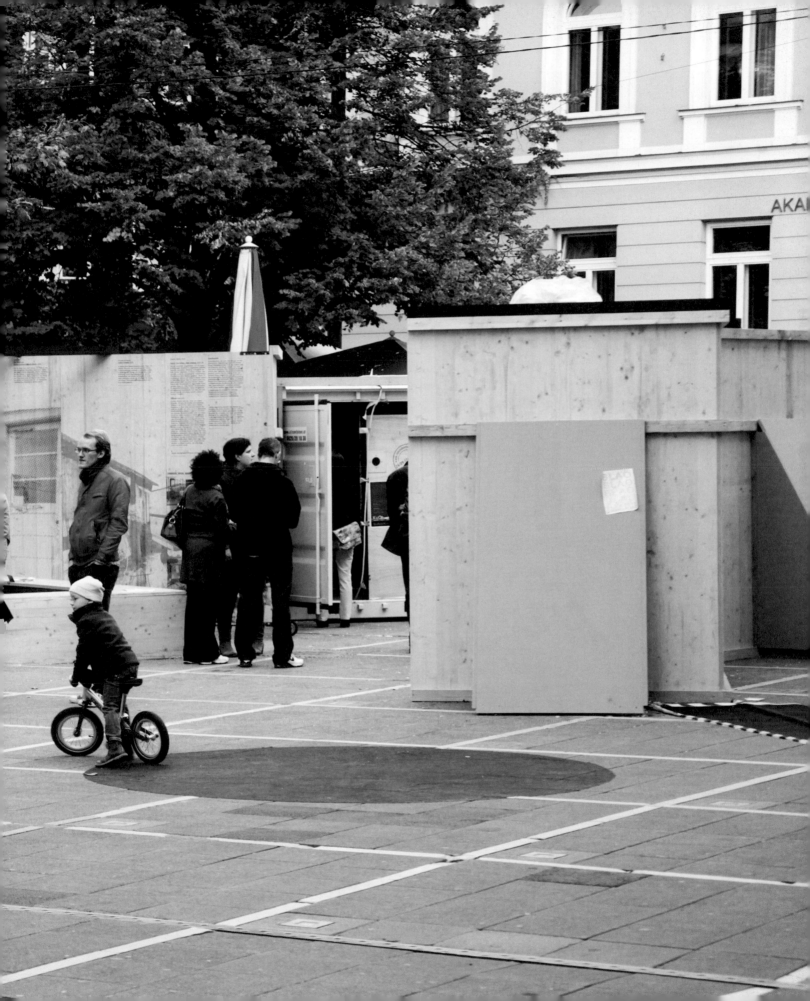

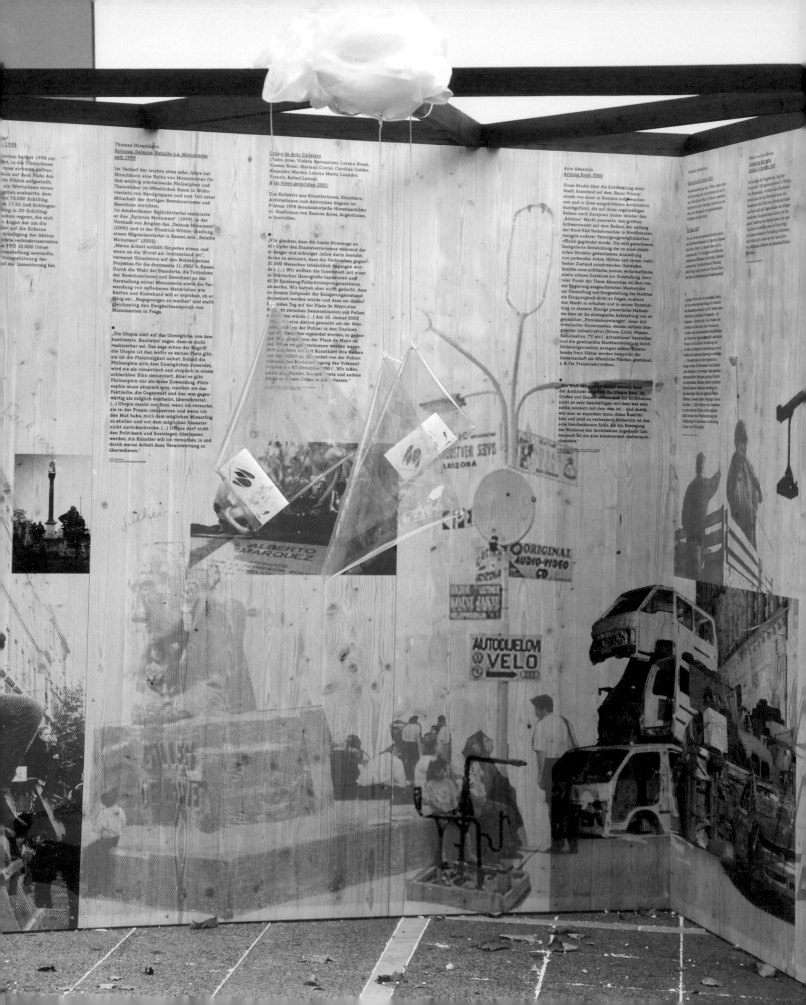

Thomas Hirschhorn
Spinoza, Deleuze, Bataille u.a. Monumente,
seit 1999

Im Verlauf der letzten etwa zehn Jahre hat
Hirschhorn eine Reihe von Monumenten für
ihm wichtig erscheinende Philosophen und
Theoretiker im öffentlichen Raum in Wohn-
vierteln von Randgruppen und zum Teil unter
Mitarbeit der dortigen Bewohnerinnen und
Bewohner errichtet.
Im Amsterdamer Rotlichtviertel realisierte
er das „Spinoza Monument" (1999), in der
Vorstadt von Avignon das „Deleuze Monument"
(2000) und in der Friedrich-Wöhler-Siedlung,
einem Migrantenviertel in Kassel, sein „Bataille
Monument" (2002).
„Meine Arbeit enthält für jeden etwas, und
wenn es die Wurst am Imbissstand ist",
verweist Hirschhorn auf den Nutzen seines
Projektes für die documenta 11, 2002 in Kassel.
Durch die Wahl der Standorte, die Teilnahme
der Bewohnerinnen und Bewohner an der
Herstellung seiner Monumente sowie die Ver-
wendung von ephemeren Materialien wie
Karton und Klebeband will er erproben, ob er
fähig sei, „Begegnungen zu machen" und stellt
gleichzeitig den Ewigkeitsanspruch von
Monumenten in Frage.

„Die Utopie zielt auf das Unmögliche, von dem
bestimmte ‚Realisten' sagen, dass es sich nicht
realisierbar sei. Das sage schon der Begriff:
die Utopie ist das, wofür es keinen Platz gibt,
sie ist die Platzlosigkeit selbst. Sobald die
Philosophie sich dem Unmöglichen zuwendet,
wird sie als romantisch und utopisch in einem
schlechten Sinn denunziert. Aber es gibt
Philosophie nur als diese Zuwendung. Philo-
sophie muss utopisch sein, insofern sie das
Faktische, die Gegenwart und das, was gegen-
wärtig als möglich erscheint, überschreitet.
(...) Utopie macht nur Sinn, wenn ich versuche,
sie in der Praxis umzusetzen und wenn ich
den Mut habe, mich dem möglichen Misserfolg
zu stellen und vor dem möglichen Desaster
nicht zurückschrecke. (...) Utopie darf nicht
den Politikern und Soziologen überlassen
werden. Als Künstler will ich versuchen, in und
durch meine Arbeit dazu Verantwortung zu
übernehmen."

Grupo de Arte Callejero
(Pablo Ares, Violeta Bernasconi, Lorena Bossi,
Vanesa Bossi, Mariana Corral, Carolina Golder,
Alejandro Merino, Lorena Merlo, Leandro
Yuturlo, Rafael Leona)
A rui viven genocidas, 2001

Das Kollektiv aus Künstlerinnen, Künstlern,
Aktivistinnen und Aktivisten begann im
Februar 1998 denunziatorische Hinweisschilder
im Stadtraum von Buenos Aires, Argentinien,
zu erstellen.

„Wir glauben, dass die beste Hommage an
die Opfer des Staatsterrorismus während der
siebziger und achtziger Jahre darin besteht:
daran zu erinnern, dass die Verbrechen gegen
30.000 Menschen tatsächlich begangen wur-
den. (...) Wir wollten die Innenstadt mit einer
militärischen Ikonografie tapezieren und
6030 Spielzeug-Fallschirmspringersoldaten
abwerfen. Wir hatten aber nicht gedacht, dass
zu diesem Zeitpunkt der Belagerungszustand
dekretiert werden würde und dass am darauf
folgenden Tag auf der Plaza de Mayo eine
Schlacht zwischen Demonstranten und Polizei
stattfinden würde. (...) Am 10. Januar 2002
machten wir eine Aktion um der Men-
schen zu gedenken, die von der Plaza de Mayo
..."

Azra Aksamija
Arizona Road, 2002

Diese Studie über die Entwicklung einer
Stadt, basierend auf dem ‚Bazar-Prinzip',
wurde von einer in Bosnien aufgewach-
senen und in Graz ausgebildeten Architektin
durchgeführt, die auf ihren regelmäßigen
Reisen nach Sarajevo immer wieder den
‚Arizona'-Markt passierte: den größten
Schwarzmarkt auf dem Balkan, der entlang
der Nord-Süd-Verkehrsachse in Nordbosnien
mangels anderer Versorgungsmöglichkeiten
offiziell gegründet wurde.

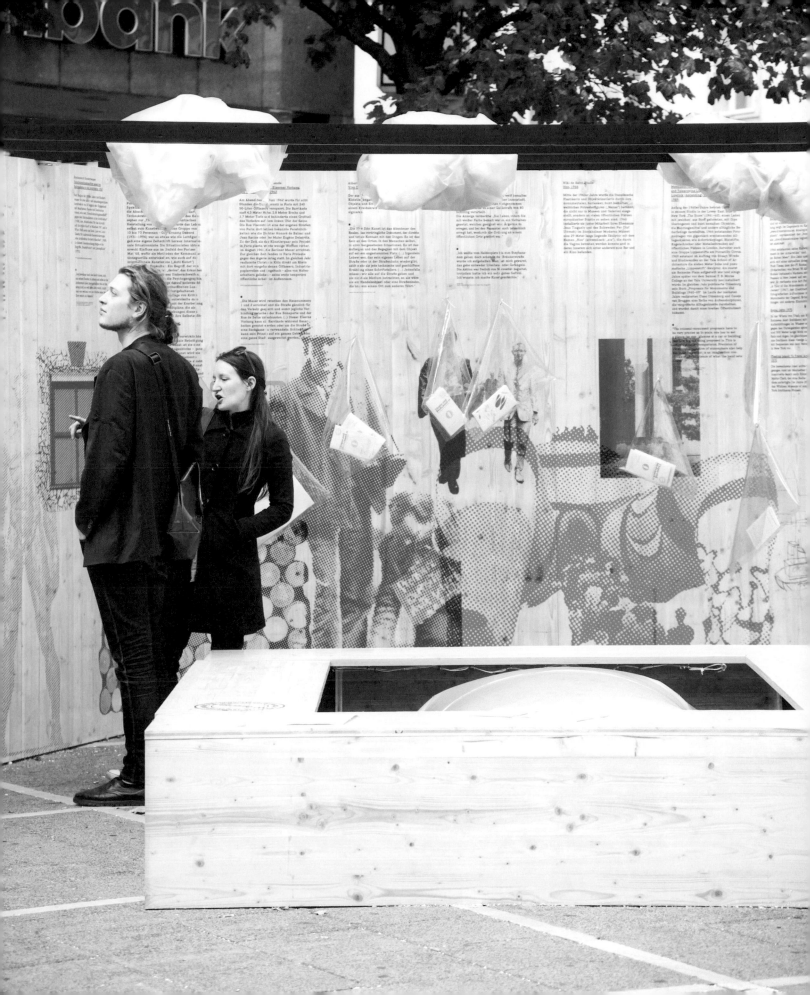

# Armando Andrade Tudela
# Project for Pergola

**Roseggergarten, Pergola**

**Francesco Manacorda**
**The Public and Its Private**

The nature of Armando Andrade's work involves the subversion, inversion and reformulation of received codes, being those linguistic, visual, geographical, social or architectural ones to name just a few. In many of his works, existing structures have been invested with the exuberant forces of nature, reconfigured with shapes and rhythms of "Tropicality" translated from and into vernacular variations of what has been received as modernity. His practice can take the shape of drawings, collages or films realized to portray a particular architecture or to obtain an optical effect, but also photographs, and most importantly, sculptures. There is never just a particular path of investigation at stake in any single work; they often tend to combine content generated by a contingent passion or research path with the formal solution of an abstract conundrum.

For the steirischer herbst festival, Andrade has identified a site that combines the architectural ruins of modernity (it includes what looks like a ventilation tower in concrete fully disguised by a disused pergola), a little garden where nature flourishes and the appropriation of the site by subcultural behavior. The set is adjacent to a hegemonized social and natural situation: the manicured social space codified as the park of a European town. The artist's intervention extends from an existing, abandoned architectural volume — a derelict pergola attached to what looks like two sealed-off cement blocks, using them metaphorically as the base for a sculptural display. These concrete forms have lost their original function and have become surfaces for regulated advertising and informal flyposting as well as shelters for private activities. Their surfaces have been used for graffiti, their covered volumes probably for occasional gatherings of young people carving a niche for themselves in an abandoned corner of the urban fabric.

The same process of re-appropriation of the rejected architecture is the starting point of Andrade's intervention. Like in a palimpsest, his sculptures complete or expand on the missing part of a partly effaced quasi-building giving it back to its potential users with a renewed functionality. The intervention extends the volumes of the selected structure

incorporating two walls made of perforated metal supported with red frames that intersect the concrete blocks to create a porous semi-interior. This prototype of a patio is designed as a double threshold: on the one side extending from the closed-off cement tower and, on the other, looking towards the potential energy of the neighboring garden. The new surfaces increase the potential for the site users to continue their activities of communication and publication (the graffiti or the illegally posted flyers) and partly amplifies the privacy of this very public space. The see-through walls are in fact metaphorical filters of a pavilion that celebrates the spontaneous occupation of abandoned sites and the re-conversion of modernity's ruin to fit the spontaneously expressed need of a social group.

All the materials used by Andrade are porous and penetrable either completely — the red frames — or through vision — the perforated walls. The frame functions as an empty surface that delimits an area and a point of view (like in the cinematic shot that includes and excludes) while the perforated walls, being positioned parallel to each other subject the passerby to a similar optical effect that creates an illusion of perspective. In this way, the formal solution that composes the sculpture also determines the kind of open space of a social pavilion. Andrade's intention to cover the pergola with vegetation further aims at the cooperation between built environment and nature to design a set of surfaces inspired by a kind of suprematism purged from its spiritual tension towards purity, in which space is abstracted, codified and offered to the viewers.

The work poses some interesting problems around the issue of publicness and publica-tion. The debates around public art and its function in opposition to the closed space of the museum have always revolved around the notion of site or social specificity, participa-tion and the shared ownership of a communal space. In Andrade's work, this tradition is pushed in a different direction for two reasons. On the one side there is the recogni-tion and encouragement, by a certain social group, of the privatization (i.e., the occupation of a site by members of the public for their private use) of an abandoned public space. On the other hand, there is the inverted necessity that results in that very space being used by the same users to publicly assert their existence: the architectural surfaces of the blocks are turned into a publication device through the fly-posting and graffiti activities. It is precisely this tension between privacy and publicness that Andrade's intervention attempts to address and make resonate. This act locates the work in a self-reflexive stance that, beyond offering the sculpture to a particular social user, demands to all members of the community to take a position on the meaning and regulation of the notion of what is "public" in its politi-cal and social manifestations.

In this respect, the commission seems to be only the beginning of the work that needs to be fully used, modified and responded to by the current site users in order for it to be subsequently read by the general public. The artist collaboration with the users and with the natural element (the vegetation that from the park reaches out to cover the patio) make the work an experimental social patio that will be complete once it is fully vernacular-ized, following its temporary existence in the public sphere. Rather than positing itself as a solution, Andrade's work throws into the public realm a problem, giving voice to some

unresolved issues already present in the city that have concentrated in the chosen site. The notion of monument investigated here is not one celebrating a victory or a communal result that needs to enter collective memory; on the contrary the intervention de-monumentalizes the notion of public space by interrogating how the rhetoric of public-ness might not be shared by the majority of the social community.

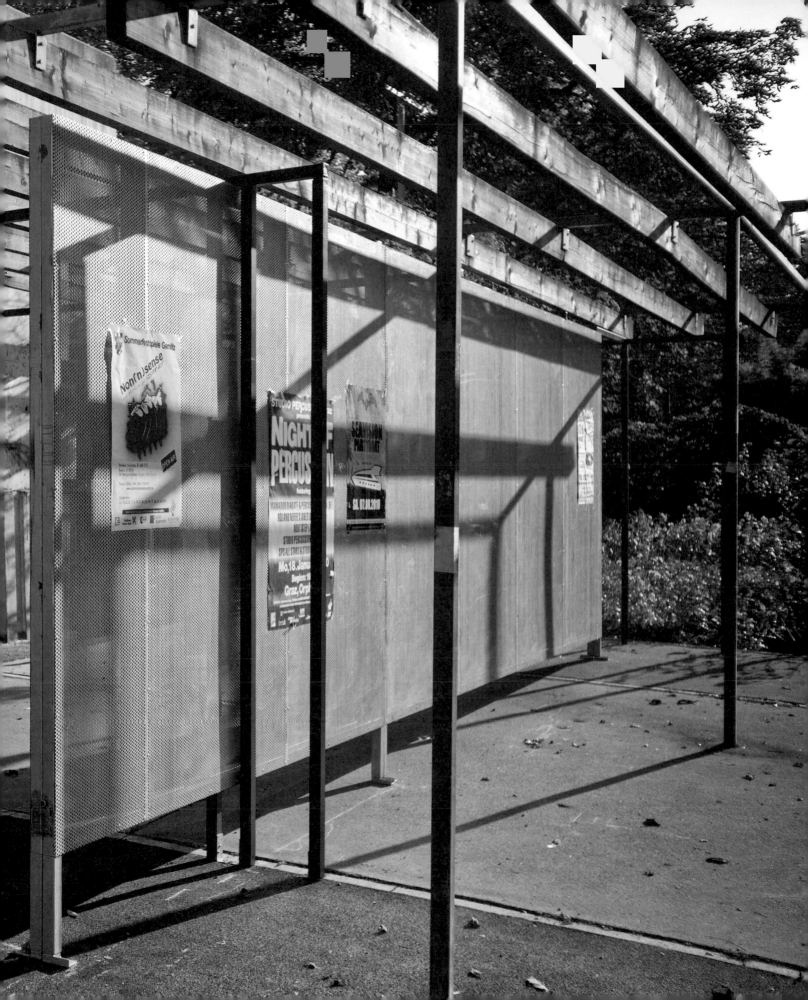

# Kader Attia
# The Myth of Order #1

**Information screens at Jakominiplatz and inside the tramways**

## Kobena Mercer
## Lost Boundaries

A line cuts through a town square and divides public space in two. As a result of this action a boundary has been created and yet the material in which the line is drawn is ephemeral and vulnerable to decay. Documented in a video loop exhibited on trams throughout the city, Kader Attia's boundary marking evokes the foundational political act, which is to establish a frontier in a space previously open to everyone, and yet by virtue of his chosen material — couscous grains — his gesture introduces a transitory element that reveals the public sphere to be as potentially poetical as it is political.

The couscous has a precarious existence because it might be blown away by the wind or eaten by birds — it is constantly at risk of disappearing, becoming invisible.
In this sense it acts as a metonym for the immigrant presence in the city of Graz for the cracked wheat is a signifier of cultural difference and not just an arbitrary volatile substance. In *Untitled (Ghardaia)* (2009), couscous was used as a medium of post-colonial translation when Attia constructed

a model of the Mahgreb architecture that Le Corbusier encountered in the 1930s on cross-cultural journeys that led him to his modernist ideals. Where architecture features prominently in Attia's work, its role in disciplining public space was investigated in *Rochers Carres* (2008), where concrete blocks on the Algerian coastline forbid migrant journeys but have the contrary effect of stimulating desire for the "other place" hidden from view. Migrants are permanently crossing borders in the global economy and yet what makes their journeys political, Attia's work reveals, is precisely the disciplinary control of space that results in the immigrant's condition of public invisibility.

In conversations in the Griesplatz area of Graz, a site associated with Turkish and Somalian immigrants, the artist asked strangers where they were headed in their personal aspirations. Among the responses — "My plan for the future is to finish my studies and to go to the UK and find a job" — it is a split between utopia and monument that sets immigrants apart. The restless drive towards utopian possibilities

is offset by the inability to monumentalize the pain of loss and separation that uproots any migrant from past attachments and belonging. Whereas monuments are always fixed into a given place, someone who is perpetually on the move is locked into the spacelessness that exists between borders — in Euclidean geometry a borderline that separates two or more areas is taken to have no spatial properties of its own. But does such fugitive dispossession not also entail invisibility as a strategy for the best chances of survival? The illegal immigrant, above all, must be a virtuoso performer who adapts to her surroundings and blends in — not to attract the attention of an audience but on the contrary, to pass unnoticed when moving through public spaces, to disappear into the crowd, and thus remain unseen.

Where Attia creates a double scene of inscription — the couscous boundary only exists permanently as an archival or memorial trace — it is crucial to observe how the city's public transport network acts as the medium of exhibition. Art is public not just because it is placed outdoors rather than indoors but to the extent it reflects on the conditions of open circulation that constitute the public sphere as a site of sociability among strangers. As literary scholar Michael Warner points out, the verb "to publish" took off in eighteenth century print culture with the routine appearance of daily and weekly newspapers that were addressed to anonymous readerships by virtue of their mass circulation. Taking the view that, "a public is a relation among strangers," Warner suggests that modernity entails a kind of stranger sociability in which "an environment of strangerhood is the necessary premise of some of our most prized ways of being," for, "a nation or public or market in which everyone would be known personally would be no nation or public or market at all."[1] In view of Attia's insights into the double-sided invisibility ghosting the immigrant, his art also reveals two kinds of publicness.

On the one hand, just as the creation of wealth would be impossible without immigrant labor (which is hidden from view, like domestic labor in the private sphere) so the social worlds of modernity could not possibly function without the normative environment of stranger sociability. Equations between the categories of the immigrant and the ancient idea of the stranger as a wandering outsider or exotic "other" are thus intelligible, on the other hand, as anti-modern reactions to a public sphere in which one's freedom is lived as an impersonal relation among strangers. The democratic potential of the multitudes brought together by the modern public sphere is precisely what is cut off by ideological equivalences between nations and families. When stranger sociability is domesticated in this way, the immigrant must be kept out of the boundaries that enclose publicness within the arbitrary limits of the nation-state. Where Doris Salcedo explored such political aspects of boundary maintenance in her *Shibboleth* (2007), drilling a crack into the floor of the gallery to evoke the ancient test of membership and belonging that once separated friend and enemy, Kader Attia's focus on the porosity of boundaries that are always vulnerable to historical decay adds an awareness of the public sphere's ambiguous condition of strangerhood, which thus links the identities of the immigrant and the neighbor. With his interest in sculptural voids and installations that point to missing elements, Attia embraces emptiness not as a negative space of lack but as an absence that

enables critical potentialities. The condition of public invisibility surrounding the precarious lives of illegal immigrants in Europe today is thus a locus of antagonism that nonetheless opens public space into a site of poetic world making.

1    Michael Warner, *Publics and Counterpublics* (New York: Zone Books, 2002): 74, 76.

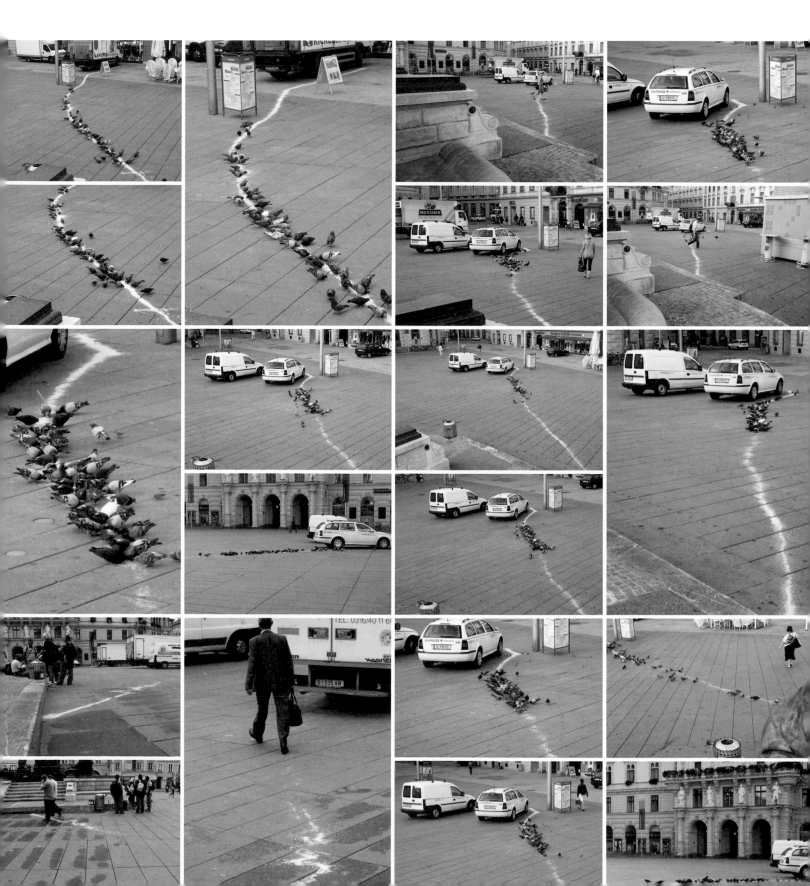

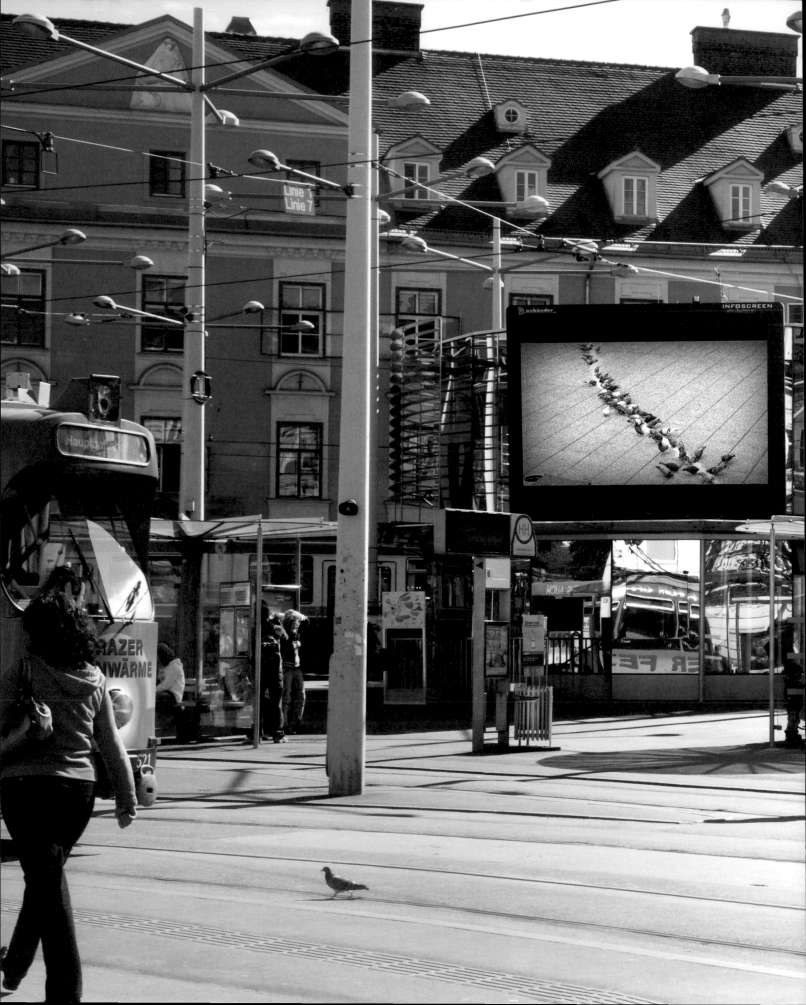

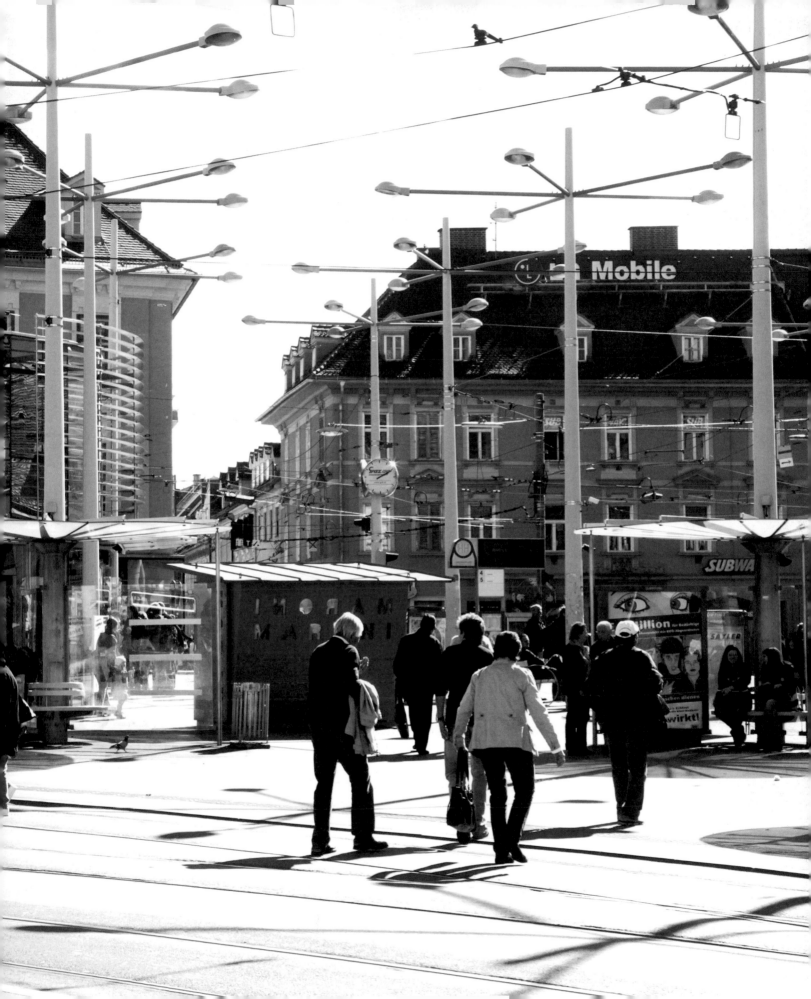

# Angela Ferreira
# Cape Sonnets

**Volksgarten**

**Jürgen Bock**
**Cape Sonnets — Purities and Ambiguities in Different Modernities**

*It was Europe that made Primitivism chic.*
Manthia Diawara commenting on the time-consuming vaporettos in Venice during the opening days of the 2007 Biennale di Venezia.

Angela Ferreira's *Cape Sonnets* is a work that has a range of references that need to be taken into account when 'reading' it: they include allusions to Mozambican vernacular architecture from the 1970s; sonnets written in Afrikaans by the Austrian/South African poet Peter Blum during the early years of the Apartheid in the 1950s; and Angela Ferreira herself. Ferreira is an artist born in colonial Mozambique, whose artistic and political thinking is marked by her formation in the fiery atmosphere of the last years of Apartheid in the 1980s.

The notion of many geographies, histories, and modernities come to mind when trying to decipher Ferreira's installations, often comprising sculptures, documentary photographs, drawings and collages combined with video and audio. Her "inverted" view from the South considers established discourses on art, sculpture and modernity

as fixed western concepts from the North. A North that initially took (or stole) artifacts from Africa to fill its cabinets of curiosities and subsequently to satisfy its avant-garde ambitions, seeking new forms in painting and sculpture via fragmentation derived from "primitivism." These high-art renderings were then reintroduced to the South's "Heart of Darkness." Given this to-and-fro movement during the colonial era, which instigated complex Africanities in Europe and European-ities in Africa, it seems ironic that African modern (and contemporary) art is sometimes accused of being derivative, a move that seems to be borne out of the need to defend modern western myths of originality and authenticity in the arts and beyond.

Angela Ferreira (born 1958) spent the first years of her life in Maputo, now the capital of Mozambique. Then known as Lourenço Marques, it was the center of a Portuguese Overseas Province — at the time the country on the edge of the European continent avoided using the term "colony" directly and was on the brink of bloody liberation wars. Ferreira studied fine art in Cape Town during

the height of the Apartheid struggle and this political moment was decisive in her formation. She invented a place for herself, a virtual geographical site between continents, between the western (art) discourse and the history of her upbringing and education, and a personal scrutiny of their use beyond defined western values and territories, beyond the value systems taken to distant shores by western colonizers. This skeptical scrutiny soon became a leitmotiv for most of her work. From her African perspective, she realized how western standards from the past are used to measure, understand and construct the present outside the West. This led her to deconstruct these parameters and reintroduce them within the context of a different, non-western subjective relevance, within a western sculptural practice through which she conveys other stories that normally remain untold. She uses the art vocabulary of the West and confirms it as the predominant language in art, while at the same time undermining it and taking it apart, unveiling its inherent contradictions through quotations and derivations. Ferreira's abstract forms are, for example, intended to appear as quotations of abstractions, creating sculptures not for the sake of their abstractness but to quote the notion of abstractness and the discourses that accompany it. Thus, she questions the relevance of modern art practices from a non-western perspective. Her perspective is that of an Africa that seeks not to be empowered by the West but to be acknowledged as a neighbor, a neighbor with its own questions and its own pasts that are intertwined with that of western Modernity, creating its own modernities, histories, and notions of the *Jetztzeit*.

The artistic practice of Soviet constructivists, such as Gustav Klucis, is an important point of reference for Ferreira. Klucis was after a merging of the cultural, social, and political in the 1920s, dismissing bourgeois artistic romanticism. His *Screen-Tribune-Kiosks* proposals were based on aesthetically challenging constructivist artworks, proposed as a means of changing societies, reflecting technological achievements in communication. His was an art that at the same time also had a "function": as bookshelves, as stages for orators and as a base for screening films and transmitting sound. In 2008 Ferreira appropriated some of Klucis's drawings from the 1920s, rendering them as a series of towers that evoke the utopian moment of "European" Russian constructivism. They also refer to the history of another utopian moment, another modernity: the enthusiasm of "everything is possible" in post-independence Mozambique. This country invited Jean-Luc Godard in the 1970s to advise on the creation of its first television station. An outstanding vision for a recently created nation, although Godard's response in the form of a film project entitled *The Birth (of an image) of a Nation* was never realized. And it was the icon of the 1960s US protest movement, Bob Dylan, who in 1975 celebrated the "lovely people living free" in his song "Mozambique."

An image of a transmission tower, probably erected in Mozambique in that seminal decade, has inspired Ferreira's work on monuments and utopias. As an artist she operates between Europe and Africa, between ideas of purity of expression associated with defined geographical areas and an assumed ambiguity, which is essential for the creation of an "other" modernism. Working from this perspective, she has erected a reconstruction of the African tower, topped by a loudspeaker, in the middle of a park in Graz. The "monument" broadcasts the Afrikaans *Cape*

*Sonnets* by the Austrian/South African poet Peter Blum (1925–1990). Blum moved to South Africa from Vienna with his Jewish parents in 1935, before the *Anschluss*. In the 1950s he wrote sonnets in Afrikaans slang spoken by the so-called Cape Colored in which Blum satirized and ridiculed local and political events and phenomena. Ferreira's work transmits translations of this colloquial Afrikaans into the slangs of various international languages spoken among the local community of Graz. One of the sonnets in Graz explicitly closes the circle with regard to the monument and its content. In "Talking about Monuments" Blum ironically described this kind of public art in South Africa dedicated to figures such as ("thumbless") Afduim-Murray, Hofmeyr ("wit paunch an"), Jan van Ribbeeck ("s dressed up like a Jintleman in his plus fours"), Cecil John Rhodes ("points everyday to de race course") and also Queen Victoria in front of Parliament house, described by Blum as "ol' Miss Victoria wit' her tiny little melon."

Peter Blum's Afrikaans versions were rejected by the Apartheid regime, which insisted on an idea of a clean and pure language. This, together with the sonnets' ironic tone, may have been one of the reasons why his application for South African citizenship was turned down. He left the country in 1960 and spent the rest of his life in Britain, bitter about the experience and explicitly forbidding any publication of his poetry in South Africa, a firm position, which is not unknown in Austria.

Ferreira's practice reveals a double-sidedness in Graz: she does not pretend to know the city, or Austria, and their local and national characteristics. However, she seeks to gain access to Graz's "glocal" aspects in order to be able to use the notion of monument and utopias there as a vehicle. She does so not only to negotiate issues around codification and de-codification of African-European and European-African relationships, but also to achieve a broader understanding of our world beyond them.

### 1. DIE MILJENÊR SE KOMBUIS

'n Pellie van my, wat da' wêk as kok,
het my vandag laat inloer innie huis
vannie ou miljenêr, sy baas. Kombuis?
Jy sou gasê het dis die Duncan-dok!

Tsaaina en messegoed tot anie nok,
Fridzidêrs volgaprop met piekfyn vleis,
eiers, vrugta en groentes oppie ys,
en die jele karkas van 'n soort bok.

Toe sê hy, „Ennie kjeller's die ena kroeg —
whisky en brannewyn, dzien en muskedil."
Toe sê ek, „Wragtie, dié baas is gaseën!

Ga' hy nou patie skop? Daa's oorganoeg
om twintag ouens 'n week lank te laat smul."
„Nei," sê hy, „Die baas eet altyd alleen."

45

---

### 1. DIE KÜCHE DES MILLIONÄRS

Mein Kumpel, der arbeitet dort als Koch,
ließ mich heut' sehn seines Chefs Haus,
das des alten Millionärs. Sieht so 'ne Küche aus?
Man könnt' meinen 's wär' das Duncan Dock!

Geschirr und Besteck so wie im Barock,
Eiskästen voll mit Fleisch zu exklusivem Preis,
Eiern, Obst und Gemüse auf Eis,
und irgend'nem ausgebeinten Bock.

Da sagt er, „Im Keller gibt's 'ne ries'ge Bar –
Whiskey und Cognac, Gin und Port."
Da sag ich, „Alter, dieser Chef hat's fein!

Schmeißt er grad 'ne Party? Das reicht sogar
dass zwanzig Leut' 'ne Woche feiern dort."
„Nein", sagt er, „Der Chef isst immer allein."

### 1. DA MILYINAIRS KIETSEN

My brah, da chef, who cooks roast, stews an' stock
Tuned me today to come tseck out da place
Where his Larney meneer da milyinair stays
Wid a kietsen det looks like da Duncan Dock

Chaina an' cutlery you jus' koeren knock
Da Fridzadair's stuffed full of meat — so nice
Wit eggs, fruit an' vedz posing on ice
An' a carcass dat looks like a whole springbok

Den he tune me, "De cellar's like one messive bar
Whiskey, brandy, gin, muscadel"
I tune him "Dis larney's so lucky — he can't even moan?

He can mos ghoi a party – here's anuff by far
'bout twenty ohwens — jol for a week like hell."
"Naai man", he tunes, "Dis larny eats alone"

### 2. OOR MONNEMENTE GEPRAAT

Wat spog jul so met julle monnement?
Hy's groot ma' lielak, en hy staan so kaal
da' op sy koppie. Wie't vir hom betaal —
al daai graniet en marmer en sement?

O ja, hy's groter as 'n sirkustent —
ma' waa's die pêd, die mooi nooi innie saal?
die lekka *clowns*, die leeus in hul kraal?
Nei, daa's g'n spôts nie vir jou Kaapse kjend!

Hier het ons stetjoes, elkeen soos 'n mens:
ou Afduim-Murray, Hofmeyr met sy pens;
hier's Jan van Riebeeck, bakgat aangetrek

in sy *plus-fours*; Cecil Rhodes wat jou wys
wa' die reisiesbaan lê; en vorie Paalmint-hys
ou Mies Victôria met ha' klein spanspek.

46

### 3. SLAAIKRAPPERY

Hoekom smaail jy so? soos 'n kat wat 'n vis
gegaps het? Watse leuen het jy verdig
wat my kan raak? Mooi glad van aangesig
ma' skelm innie derms — dis wat jy is!

Met jou jeupswaaiery en rok van sis —
hy ken jou soort. Jy kannie onheil stig
al têre jy. — Hy was uit. — Ek draai my rug . . .
Wat sê jy da'? *„Where ignorance is bliss"!*

Dan is dit jy! Ek het juis so 'n spesmaas
gehad! Jou lae luis! Jou stuk rooi-aas!
Jou vuil djantoe, jou Satansgoed, jou dief!

Jy gaan mos ook met enige seiler saam!
Jou lyfie stink nog erger as jou naam —
en — en die Jere Dzesus het jy ook nie lief!

47

## 2. GESPRÄCH ÜBER MONUMENTE

Warum prahlst du so mit deinem Monument?
Es ist groß aber hässlich, und steht so schlicht
auf'm Hügel. Wer hat bezahlt für die G'schicht' –
den ganzen Granit, Marmor und Zement?

Oh ja, es ist höher als ein Zirkuszelt-Firmament –
aber wo sind das Pferd, das hübsche Mädl im
Rampenlicht,
die lieben *Clowns*, die Löwen unter Aufsicht?
Nein, einem Kind vom Kap ist hier kein Platz
vergönnt.

Hier sind uns're Statuen, jede für'n richt'gen Mann:
der alte Murray Ohnedaumen, Hofmeyr mit Wampe
dran;
hier ist Jan van Riebeeck in eleganter Fasson

in seiner *Pluderhose*; Cecil Rhodes der red't
in Richtung Rennbahn; und vor dem Parlament steht
die alte Viktoria mit ihrer kleinen Melon'.

## 2. TALKING 'BOUT MONUMENTS

Why yous brag so about your monument?
So beeg an' ugly and soema naked
What do you tink dey did pay for it —
All dat granite, marble an' cement?

Oh Yes, he's beega dan a circus tent —
But no horse wit dat kwaai tserry on his back'
De lekker *clowns* and lions in dere shack
Naai, here's no sports for your Kaapse klong, my frem

Here we got statues each one true to life
Thumbless Murray, Hofmeyer wit paunch an' no wife
An' Jan van Riebeeck's dressed up like a Jintleman

In his *Plus Fours* Cecil John Rhodes points everyday
To de race course; an' in front of Pahlament's way
Is ol' Miss Victoria wit' her tiny little melon

# Andrea Fraser
# You Are Here

A Project by Andrea Fraser for Utopia and Monument II in collaboration
with sozYAH (Sabine Haring and Anja Eder), Center for Social Research,
Institute for Sociology, University of Graz.
Information Design by Wolfgang Gosch and Georg Liebergesell.

- Large map: sign board at Tummelplatz
- 9 smaller maps: sign boards at the exhibition sites
- All maps published in the exhibition guide available for free at the
  "dummy salesman" at all exhibition sites and at various locations in Graz.

## Andrea Fraser

Combining sociological research with techniques of urban mapping and information design, *You Are Here* consists of nine graphic representations of *Utopia and Monument II* project sites, presented on sign boards at each of the exhibition's locations throughout the city. A tenth map providing an overview of the project can be found in the exhibition pavilion at Tummelplatz. All ten of these maps are also reproduced in the exhibition guide.

Taking the form of public maps, which typically mark the viewer's location with a symbol indicating "you are here," *You Are Here* attempts to represent the viewer's location, not in the space of the city as a built environment, but in the networks of social and institutional relationships that visitors enter as they intentionally or unintentionally encounter art works in public space. *You Are Here* interprets and represents aspects of these relationships as they are suggested by the urban sites, the art works, and the biographies of the artists.

Using available data as well as data generated by research specifically for the project by collaborating sociologists, *You Are Here* reflects on *Utopia and Monument II*-exhibition sites a as places of encounter of social agents and institutions as well as of cultural phenomenon. Like most public art, viewers of *Utopia and Monument II*-projects include people who just happen upon the art works while using the city as well as those who intentionally seek them out. Unintentional viewers may thus find themselves entering into relations specific to the art field, such as competitive struggles among artists. Intentional viewers may be led to unfamiliar areas of the city, and thus find themselves entering into sites of urban struggles. All viewers will find themselves addressed not only by the artists, but also by the exhibition's private and public patrons, who attempt to reach new customers and constituents through the activities they sponsor. Project sites may thus become implicit fields of political conflict and market competition. As an exhibition featuring artists from four

continents, viewers of projects of *Utopia and Monument II* will also find themselves entering into global networks that extend far beyond the project sites.

The leitmotif of steirischer herbst 2010, "Masters, Tricksters, Bricoleurs: Virtuosity as a Strategy for Art and Survival," specifies that virtuosity "does not necessarily manifest itself as mastery." Rather, virtuosity can be "rendered democratic and thus becomes the art of collaboration, interaction, creative combination of discourses and contexts." For *Utopia and Monument II*, therefore, it is appropriate that *You Are Here* does not have a single author, but was rather the product of collaboration between artists, designers, and researchers, each with their own areas of expertise and each giving over a degree of mastery to the others. Collaborators addition-

ally to the above mentioned include Reinhard Braun, Sabine Breitwieser, Max Lechler and Annika Strassmair. I am grateful to everyone who contributed to this project for the hard work that made it possible.

*You Are Here* was inspired by a proposal originally conceived in 2000 for "Arte Cidade," a program of urban interventions in São Paulo, Brazil. The 2000 proposal, which was never realized, was initially adapted for *Utopia and Monument II* and then further transformed in the process of production by the specific conditions of the exhibition, the project sites, and the available data. Although the adapted proposal for *You Are Here* no longer reflects the content of the completed maps, is printed below as a record of the development of the project.

The project maps *You Are Here* by Andrea Fraser are based on sources from different provenances, as stated, and are therefore subject to change.

**Andrea Fraser**
**You Are Here — A Proposal for *Utopia and Monument*, steirischer herbst, Graz**

Combining institutional analysis with techniques of urban mapping, *You are Here* will consist of graphic representations of *Utopia and Monument* project sites in the space of — not the city as a built environment but instead — networks of institutional relations that constitute the social field of the exhibition itself.

Visitors to *Utopia and Monument*, like visitors to any event produced by a complex organization, will traverse not only the physical spaces of the city and its architecture in the process of viewing. They also will enter into and traverse a social space constituted by the relations of all the many institutions and agents participating in the project. While this social space can be conceived in terms of specific, discrete organizational entities (individual sponsors, museums, etc.), it can also be conceived more broadly in terms of social fields.

## Institutional Mapping

The proposed "institutional mapping" is influenced by Pierre Bourdieu's theory of social fields. Bourdieu describes social fields as relatively autonomous social universes. Their autonomy (that is, their existence as recognizable social worlds) is relative to the degree to which they can impose their own logic on the agents, institutions, products and practices that exist within them. However, this logic and its imposition is not conceived as the mechanistic effect of a structure, but rather as the result of dynamics of struggle. Fields, for Bourdieu, are never simply empirically or substantively given. Fields are always fields of struggle over the definitions of the

boundaries of fields; over the entrance requirements of "membership"; and over the logic that the field imposes on its occupants. This logic can also be understood as a principle of hierarchization. Following a market metaphor (itself imposed, in a sense, by the historical dominance of economic logic), Bourdieu describes these principles of hierarchization in terms of the distribution and composition of different forms of capital. His concept of capital is inseparable from that of fields.

In the context of *Utopia and Monument* as an exhibition, as well as of steirischer herbst as a festival for which it has been developed, one can identify the intersection of three basic social fields. The curator, artists, catalog writers, and other participating art professionals all belong primarily to the cultural field, a field structured according to the distribution of cultural capital in the form of specific, recognized and valorized competencies. The project's private and corporate sponsors belong primarily to the economic field, structured according to the distribution of financial capital. Finally, the project's city, state and federal sponsors are located primarily within the political field, structured according to the distribution of social capital in the form of networks of relations of mutual recognition among associates and constituents. Finally, all three of these fields can be located within the field of power, which Bourdieu describes as the field of struggle over the hierarchization of these dominant forms of capital.

These fields will be the orienting coordinates of an institutional mapping of a complex cultural event: its cardinal points. The terrain

of *Utopia and Monument* itself would be represented as composed of various subfields. While these subfields are potentially infinite in number, primary subfields would include artistic and academic fields. Subfield in the artistic field may be delineated by nationality or organized around artistic, intellectual and political orientation. Within the economic field of the exhibition's private sponsors, one could identify subfields of national and international capital; of primary, secondary and tertiary sectors; of specific industries and markets within a given sector; and so forth down to specific companies within a given industry.

In the graphic representations produced for the project, the scale of each field and subfield and the location of individual or institutional participants will be determined by the magnitude of its resources in specific capital relative to other positions, other subfields, and finally other fields. Of course, much of this will be speculative. Quantitative measurement of cultural capital, for example, is problematic, and the "conversion rate" that would allow comparison of economic, cultural and social capital is itself an object of continual struggle. However, it will be interesting to try.

We could begin with financial capital, which is easiest to quantify. We could begin with the budget of *Utopia and Monument* and the relative "investments" of its public, private and foundation sponsors. These relative investments would then be represented in relation to the overall outlays of these organizations for cultural sponsorship. These outlays would then be represented in relation to the overall assets of these organizations. These assets would then be represented in relation to the total magnitude of the sectors to which they belong within national and international economic fields.

The cultural capital invested in *Utopia and Monument* could be "measured" in a number of different ways. With regard to the exhibition as a whole, a first step would be to represent the exhibition in relation to similar curatorial projects within the field of exhibitions, nationally and internationally. This could be broken down in terms of budget, press coverage, number of visitors of past editions, as well as of the professional recognition achieved by the organizer. With regard to individual projects within the exhibition, one could begin with the biographies of the participating artists. One could compare the number of books and articles published, exhibitions organized or participated in, lectures given, grants received, etc. These indices of overall professional recognition could then be represented comparatively and would vary at each project site. They would also be represented together as the total cultural capital invested in the exhibition. Of course, a representation of the project *You are Here* would also be included.

Finally, the distributions of social capital invested in the exhibition would be mapped. The contributions of city, state and federal agencies may take the form of financial subsidies, administrative or in-kind support. However, it could be argued that regardless of the form of support, such investments are both drawn from, and made to yield, a profit in social capital for public servants and their bureaucratic and constituent base. Because social capital so often accrues with informal exchanges, it may be the most difficult to represent quantitatively. How does one measure the social debt accumulated in everyday relations between colleagues and acquaintances? How does one measure the recognition that defines authority within a professional or political group? It may be only

within the field of institutional constituencies that one would find measurements: voters, contributors to political parties, members and clients of organizations who can be mobilized to defend the defenders of their interests, etc.

These are the primary fields and subfields that an institutional mapping of *Utopia and Monument* would aim to represent. As complicated as this may already be, these fields would not be represented in isolation, as autonomous in their dynamics and structure. Rather, the primary goal of such a mapping would be to represent the relationship between them and to indicate the effects of their intersections — the exhibition being an instance of just such an intersection.

On one level, the potential politics of such intersections are evident: between the cultural and economic field, the instrumentalization of art for public relations and marketing goals; between the economic and political field, corruption and graft; between the political and the cultural field, the instrumentalization of art for propaganda purposes or according to social service needs. An attempt should be made to indicate such potential effects where clear questions appear.

On another level, the conjunction of the different forms of capital invested in an event like *Utopia and Monument* produces effects in what Bourdieu called a symbolic register. Bourdieu defines symbolic capital as the form any kind of capital takes when it is recognized (that is, misrecognized) as legitimate. In these terms, such complex events function as sites of conversion in which the various forms of capital invested in them are exchanged for another form of capital. The economic capital and social capital invested

by sponsors are converted into cultural capital. The cultural capital invested by participants is converted into economic capital in future sales and commissions or, for organizers, into social capital to invest in future projects. In addition, such conversion may itself generate symbolic capital as its own specific yield: a profit in legitimacy that results from the recognition of a specific form of capital under the guise of another — that is, its misrecognition as a "universal" value detached from the logic of its particular field.

The intersections that produce symbolic profit may also produce symbolic violence. Struggles over conversion rates that characterize the field of power can also be called struggles "to impose the dominant principle of domination." As such, they not only produce effects within the individual fields but outside of those fields as well, on the publics they address as potential investors, consumers, clients, constituents, and audiences. If the "properly social magic of institutions" lies in their power to constitute anything as a legitimate interest (an investment that will produce benefits within the economy of that institution), their social logic, like a Ponzi scheme, dictates drawing ever wider circles of investors into their fields of exchange. It is at the nodal point of these circles that institutional mapping would locate its reader, indicating, at their point of reading, *You Are Here*.

## Presentational Forms

*You are Here* will have two manifestations: one will be at the project sites, the other in the publications of *Utopia and Monument*. Its primary form in both manifestations will be graphic presentations of the institutional mapping outlined above. Ten maps will be

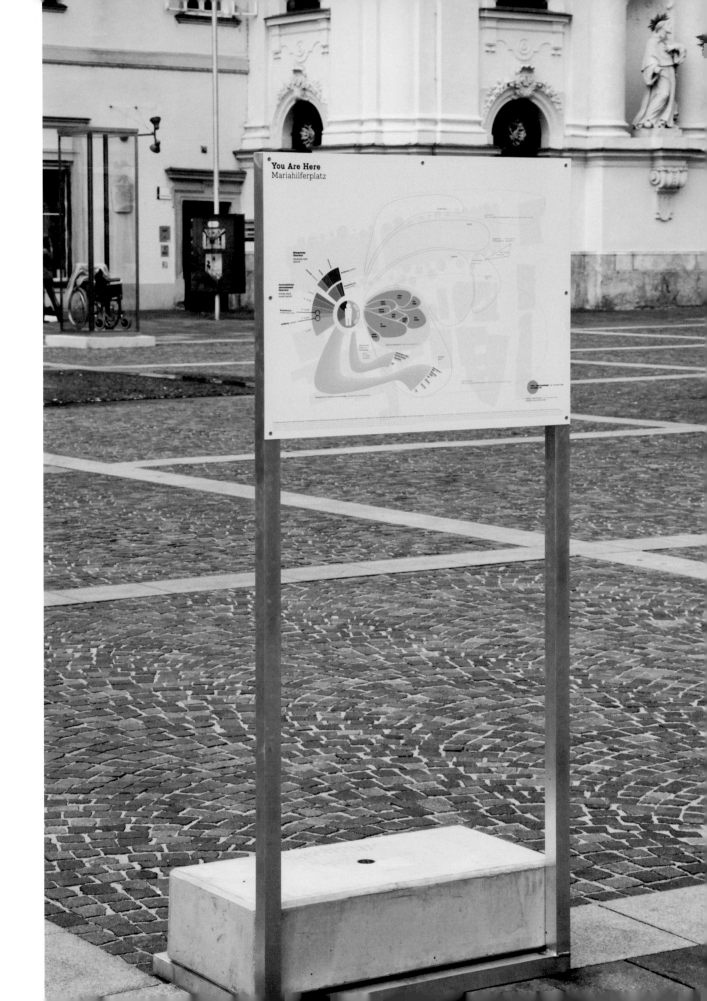

produced: one for each project site. The largest, most complete map will be presented at Tummelplatz, where the exhibition pavilion will be installed. The maps presented at the other project sites will be more focused, according to characteristics suggested by the specific sites (the artists presenting, other institutions in the vicinity, urban conditions, etc.).

How will the graphic representations be composed? What kinds of topographic or cartographic strategies will be employed? I imagine full color, with a different primary color representing economic, cultural and social capital and the fields in which they predominate. The colors would mix where the fields overlapped, with hue linked to composition of capital and value to quantity. As the boundaries of fields and subfields are never fixed but always at stake in struggles within fields, linear outlines should be avoided. Individual participants would be indicated by name; institutional participants and sponsors by logo. Fragments of slogans or statements might also be incorporated at different points. Although it would be too complicated to try to represent trajectory over time, it would be important to find a way to indicate dynamics:

lines of force, contested borders, areas of competition, etc. A legend or key should be included. Maps could be bilingual but text should be kept to a minimum.

## Project Realization

The leitmotif of steirischer herbst 2010, "Masters, Tricksters, Bricoleurs: Virtuosity as a Strategy for Art and Survival," specifies that virtuosity "does not necessarily manifest itself as mastery." Rather, virtuosity can be "rendered democratic and thus becomes the art of collaboration, interaction, creative combination of discourses and contexts." For *Utopia and Monument*, therefore, I propose to step back from the assumed mastery of artistic authorship. Instead of a template for an artwork authored and owned by me, this proposal should function as a script to be directed and staged by the exhibition staff and performed by experts in appropriate fields — sociologist who will conduct the research for the project and designers who will create the graphic and physical manifestations. These experts should be credited as the authors of "You Are Here: A project based on a proposal by Andrea Fraser."

**Sabine Haring, Anja Eder**
***You Are Here*, a project for *Utopia and Monument II*, based on a proposal by Andrea Fraser and produced for the steirischer herbst 2010 in co-operation with the sozYAH working group, the Center for Social Research, Department of Sociology and University of Graz**

Our encounter, which was to lead to a fruitful interdisciplinary collaboration, began with the US-American artist Andrea Fraser, known primarily for her performance and installation work, and her critique of institutions, on the one hand, and the French sociologist Pierre Bourdieu, whose work now ranks among the classics of sociology, on the other. Following Bourdieu, within the framework of *Utopia and Monument II*, Fraser conceived the project *You Are Here* for the steirischer herbst. This project sees the city as a social space: in other words, as interrelationships of actors, institutions and organizations in which artistic representations are embedded. Her ultimate aim was to represent (or visualize for the visitor) in ten "urban mappings" the manifold interrelations that constructed the stage on which everyone involved in *Utopia and Monument II* was operating "by referring to the various foci of the individual exhibition projects."

The central question was how to transform Fraser's concept into concrete research. This is where we two sociologists came in. Together with Sabine Breitwieser, Reinhard Braun and Maximilian Lechler, we started by conceiving this "translation process" theoretically. We then implemented it empirically, applying a variety of methodological approaches.

At the theoretical level, we felt indebted (in the sense intended in Andrea Fraser's statement of principles) to Pierre Bourdieu, who distinguishes the fundamental types of capital, namely: economic, social and cultural capital. Bourdieu describes capital as a "metaphor for a social power," which is equated with the finite quantity of "social energy" registered at a certain point in time on the basis of "objective indicators." Ultimately, symbolic capital is the form assumed by one of these types of capital when it is grasped with perception categories that recognize their "specific logic." Capitals exist in an "objectified form": as money, titles, reputations and institutionally protected authority, as well as in "incorporated form," i.e., in the way they manifest themselves. Bourdieu grasps the social world as a hierarchically structured, multi-dimensional space, as it were. Horizontally, the differentiation is entered in social fields. Vertically it is integrated into a socially recognized scale of ranks and prestige, where the principle underlying the representation of multi-dimensional space in each field is repeated. Social fields, however, do not function without socially predisposed actors who "invest in the game and behave like responsible actors." Social fields such as the economic, religious, cultural and political fields serving as a "sub-field" of the cultural ones, determine the habitus which, in turn, helps to define the fields. Bourdieu speaks of the "ontological complicity" between the habitus and the field on which admission to the game and becoming its prisoner are based: "To think in terms of fields means to think relationally." According to Joseph Jurt, a field represents a configuration of objective relations between positions that captivate the actors.

While we were developing empirical measuring instruments on the basis of Fraser's and Bourdieu's concepts, we found ourselves faced with the following "problems": Firstly, how is it possible to meaningfully narrow down and characterize the fields to be investigated? Secondly, which actors are acting in which specific way in this field, and which factors can be used to determine their positions. Thirdly, what are the limits to comparing the positions of the participant actors? Once this translation process was completed — after consulting experts from the art scene — the research object was narrowed down to the artists and catalogue authors participating in *Utopia and Monument II* and to certain people involved in the projects. Analysis of their positions in the field proceeded from the assumption of their being equipped with social capital (based on the exhibition and media presence, as well as on the social networks), cultural capital (based on education and training), and economic capital (based on the capital available within *Utopia and Monument II*) and interrelated by virtue of their having prepared the "urban mappings." At a meso-macro-level, the economic capital was included in the analysis (focusing on the state and country-wide subsidization, as well as on sponsoring by private companies) of the steirischer herbst along with the related political interconnections as a "sub-field" of the cultural field.

We see our project as an art-sociological contribution that analyzes the reciprocal relationships between actors, institutions and organizations, examines the artists and project-workers participating in *Utopia and Monument II* in relation to selected networks of interdependence, and makes the results available to people working in the field of "urban mapping." Art, sociology and graphic design, all coming from their respective fields, merge transdisciplinarily in *You Are Here*.

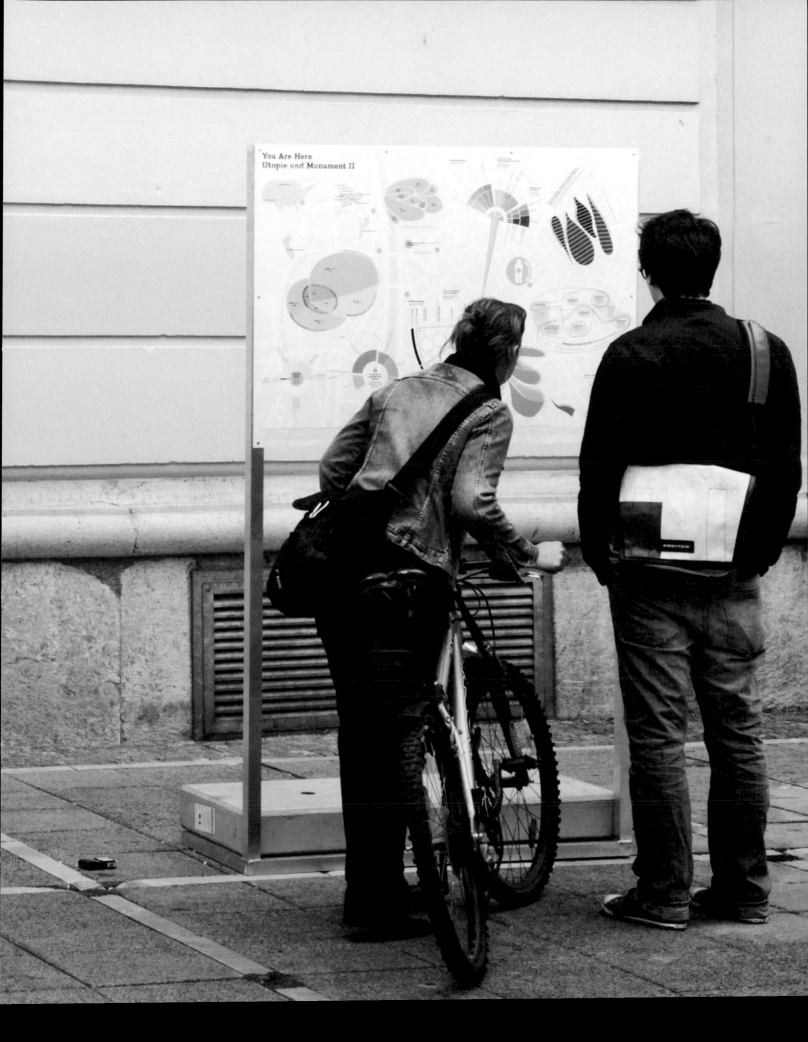

You Are Here
Utopie und Monument II

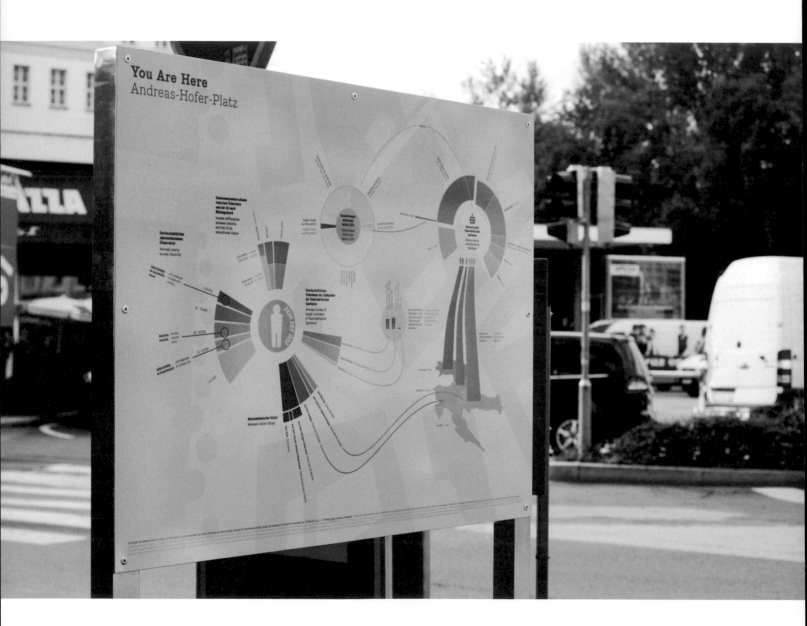

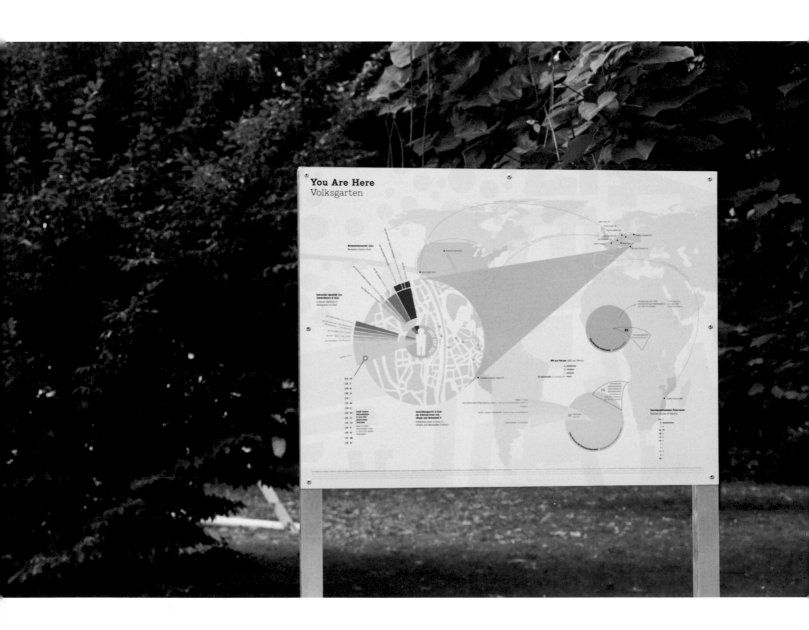

# Isa Genzken
# Clothesline (Dedicated to Michael Jackson)

**Mariahilferplatz**

**Brigitte Franzen**
**Polylogical Places between Art and the Everyday**

When Isa Genzken taught art at the Städelschule in Frankfurt in the early 1990s, she was an advocate of precise conceptual sculpture with a certain strictness of form. Her minimal concrete sculptures embodied this approach. Those who knew her work only fleetingly, were rather surprised when, a few years later, she named Joseph Beuys as an important influence.

The works that Isa Genzken designed in and for public space, like those she did for interiors, too, were rich in variety: ranging from the poetic to the latently critical. At times, they were even aggressive in content. Genzken's work *ABC* was representative of the concrete sculptures she created in the 1980s. Done for the *Skulptur Projekte 1987* exhibition and displayed on the "plateau" of Münster university library, it revealed a new, humorous trait and represented a striking departure from her earlier, strict but colorful wooden sculptures, such as those belonging to the *Hyperbolos* series. *ABC* was the very first work that Isa Genzken realized outdoors. It was an ephemeral yet very solid concrete sculpture, standing several meters high. Its two window-shaped cut-outs framed the sky above Münster. It was preceded by a test series in the form of collages and drawings in which Genzken, with the aid of her contemporaneous plaster building sculptures — such as the *Turm* (tower") and the *Institut* ("institute") — was able to examine how large formations (in connection with average urban architectural works, particularly in a smallish town like Münster, characterized by dense post-war building development) might function as a new public architectural sculpture. The inhabitants of Münster showed her little gratitude for her commitment. After the 1987 exhibition had drawn to a close, the curators and the artist made several attempts to secure her work a permanent place in Münster. Isa Genzken offered the town *ABC* as a gift, but no-one showed any interest in it. On the contrary, people spared neither arguments nor money to be rid of the work as quickly as possible. Looking back, theirs was an outright mistake.

At the time, Isa Genzken was working on two sculptures on the outskirts: *ABC* and, a year later, the *Ring* in Rotterdam. They had a

common motif: floating. It was a remarkable element, related to the site where the sculptures were realized. People generally viewed a sculpture in public space as something that stood on the ground. Genzken, however, played with their apparent weightlessness. *ABC*'s two central columns floated a few centimetres above the ground. The *Ring*, designed for Rotterdam, was supposed to have been positioned above the roofs, near a church in the city center. With this work, Genzken was inspired by a halo on an architectural sculpture.

Genzken continued to experiment with the terrain of the urban public space by testing the principle of over-dimensionality, which proved decisive for the compositions she did in the late 1980s. These involved objects in space, which people initially found impossible to read as typical sculptures. The series of sculptures that she did in the form of flowers, and especially the over-dimensional roses that appeared in urban spaces as singular objects, may also be considered as a step, taken by the artist, towards the deco materials that were to become so important to her later on. Each and every one of these *Roses*, whether at the Leipzig Fair or at the Mori-Tower in Tokyo, looks like a lonely plastic flower that has mutated (as a result of growth hormones) to an undreamed-of size. Isa Genzken, with her artistic position, has again avoided being pigeonholed by art critics and historians: for she was not concerned with the art of appropriation, as she successfully propagated shortly before in the USA. Rather it is the beautiful and the aesthetic in each and every object that she tracks down, ironizes and criticizes, before setting it free again.

In 1991, during her time in Frankfurt, she did a design (never realized) that envisioned spanning a "laundry line" between two high-rise buildings. This proposal effortlessly combined a liking for this kind of architecture with a critique of the hermetics of its prestigious and economic use. A laundry line stretching between the Commerzbank and the Deutscher Bank alluded to the proverbial "laundering" of money, confronting, in a sense, the remoteness of this economic staging with a degree of Sicilian street culture, rendering the interior visible on the outside. Content-wise, it was an extension of her active interest in architecture and, above all, in high-rise buildings, which she would pursue again in *New Buildings for Berlin* (2001–2002) ten years later. Conceptually related to this work is her project *Two Lines*, which she executed that same year for the *Crossroads* exhibition, staged at the University of Toronto campus. There, she linked the roofs of three halls of student dormitories with a nylon rope. The resulting forms recall the outlines of T-shirts — a symbol of leisure and youth culture.

One of the striking features of Genzken's work over the past ten years has been its ever-greater complexity and diversity of content, combined with the artist's constant precision in the treatment of the form and materials. In her series *Empire/Vampire*, *Who Kills Death*, which she began in 2001, she often combined a formal baroque-like departure from minimal art with a response to the events of 9/11. This approach was already apparent in her collage books *I Love New York*, and *Crazy City*, dated 1996. Her works from this time on employ decorative materials: toys, glasses, and other bits and pieces from the one-euro shops and the field of design; they remain identifiable as such in her arrangements, and are even overdrawn; they also reveal a certain impertinence, of course, which is nowadays obscured by

familiarization and all the countless epigones. At this point, an artist who had hitherto been identified with insider content began to work on themes that were intelligible to all. Her transitional works are still basically series that one might describe as art-immanent: with high-rise prototypes, such as her *New Buildings for Berlin* (2001–2002), (80 cm-high tower groups, 2002, at the *documenta XI*) and *Soziale Fassaden* (2002–2003), whose titles lend the pictures both an objective and an emotional quality.

Until this time, Isa Genzken had evidently always used the "right" material, which had, it seems, received the stamp of approval of her fellow artists. She has now moved on from wood to concrete and, in her most recent works, to a mix of materials: in so doing, she has traversed the material history of sculpture in the shortest time imaginable. Now, in *Empire/Vampire*, some of her display cases seem like a combination of shop-window décor, which is collecting dust in front of nightclubs, and the arbitrary, oddly assorted remains of an all-night binge. High trash, which — in this configuration — seems unusually barefaced and young: the plastic champagne glasses, mirror backing foil and action figures, often doused in silver lacquer, was not grouped together in order to throw a certain story in the face of the observer — as in the case of the Young British Artists — but was basically a swansong to human culture. First of all, the material created the meaning, which already assumed form. With regard to their meaning, the form and its content were already enshrined in their own process, and Genzken had appropriated them for spontaneous assembly.

Genzken's turn towards partly cheap and partly expensive, 'un-artistic' material seems

quite an obvious step, but one that ends where the content of the game continues to develop. Isa Genzken recognized the exemplary nature of this step: anchoring new content in materials. However, she found a different history in sculpture to that in painting, and consequently did not develop any works that, for example, engaged in a debate with the notorious bronze sculptures in our inner cities. She was interested in the materials and three-dimensional forms that provide the stuff out of which the everyday aesthetics of our cities are composed in shop windows: a sphere of visuality which the avant-garde seemed to be avoiding in its rear-guard battle with photography, the cinema, and media art: the effects. She originally developed the "semi-finished products," appropriated from the field of decoration, so that she could engage in cheap showmanship in the real world. The plastic soldiers and squeaky dolphins were also taken from the field of youth and children's culture by classifying them once and for all as exaggerated effects and viewing them, on the whole, as completely anti-high-culture.

With the next step, Genzken found herself back in public space, since, as far as her sensitive montages were concerned, she fell between all categories. Her objects were neither massive enough to survive at their location, nor defined by a peformative form or a presence in time. And although they can survive permanently only in protected spaces, she placed them out in the open. For *Skulptur Projekte Münster 2007* she created arrangements of deckchairs, sun-shades, children's dolls, designer furniture, and other toys in urban space. Looking back, she could not have chosen a better place than the forecourt of the Überwasserkirche in Münster for her work-group, whose content was directed

against violence against children. The objects arranged there could have been found (as is now the case in Graz) in any old household. And thanks to their maximum remoteness from arty materials, they put their finger on the real issue again: on the transformation from the dictated monument to subjective artistic expression. The latter, however, makes a statement on fissures within society and culture. There are still very deep rifts between the current, general acceptance of democratic rules now prevailing in politics and the acceptance of a similar degree of "polyphony" in art and culture. An attitude that follows research into consumers' wishes, and can be localized with the launch of private television in Germany, is more indicative of the existence of parallel sweet-tooth cultures than of a broad discussion on cultural forms and formats. To describe Genzken as a provocateur in, and taking on, the public domain would be to falsify and oversimplify the facts, since it would exclude her highly poetic and popular works such as her Roses (from the early 1990s on) and *Full Moon* (1997).

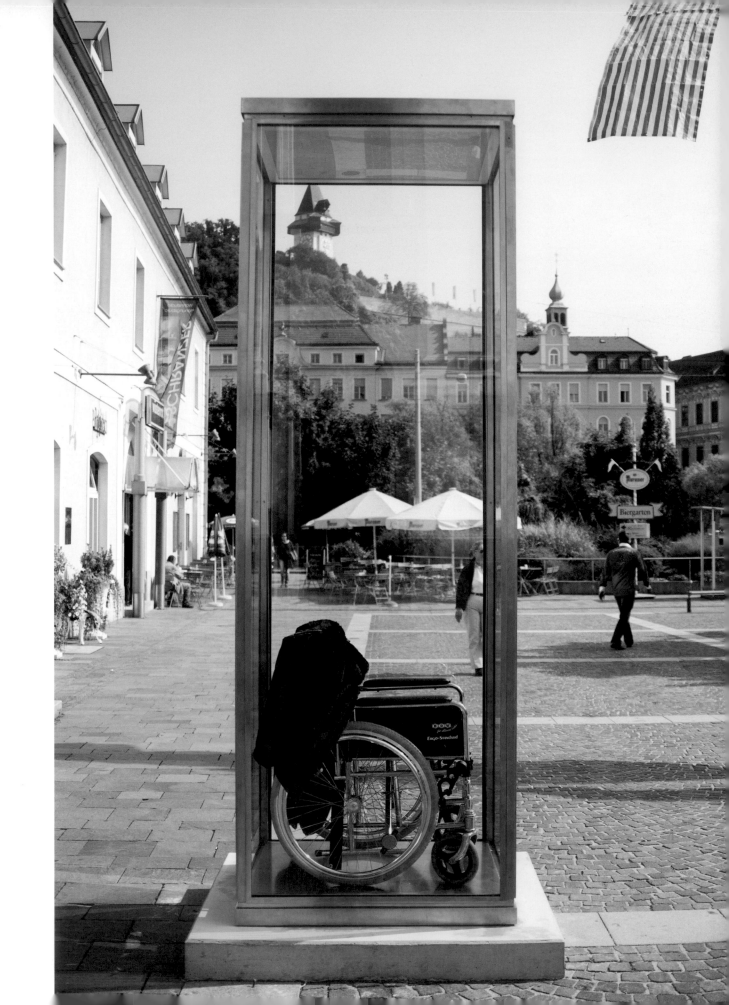

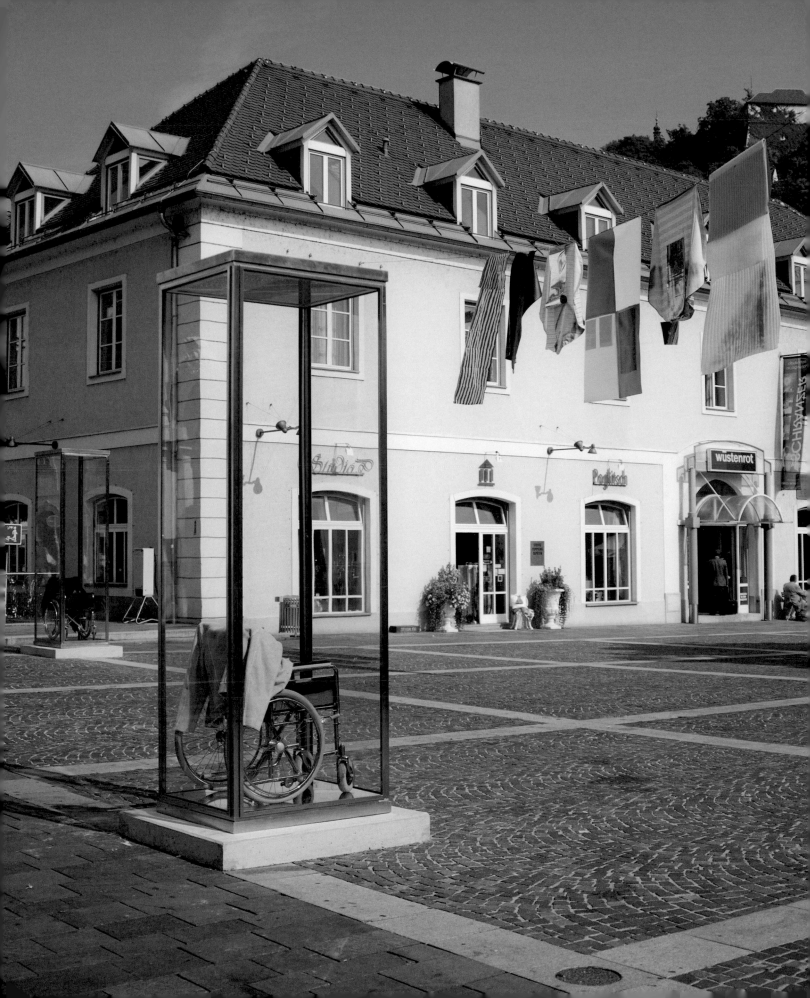

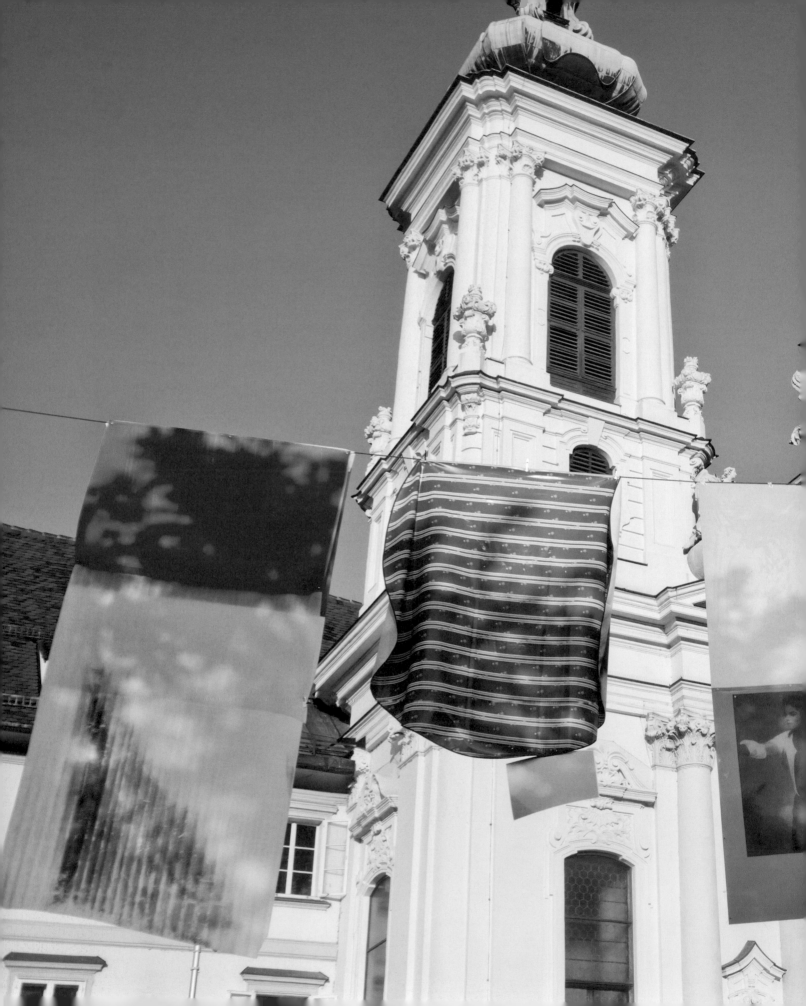

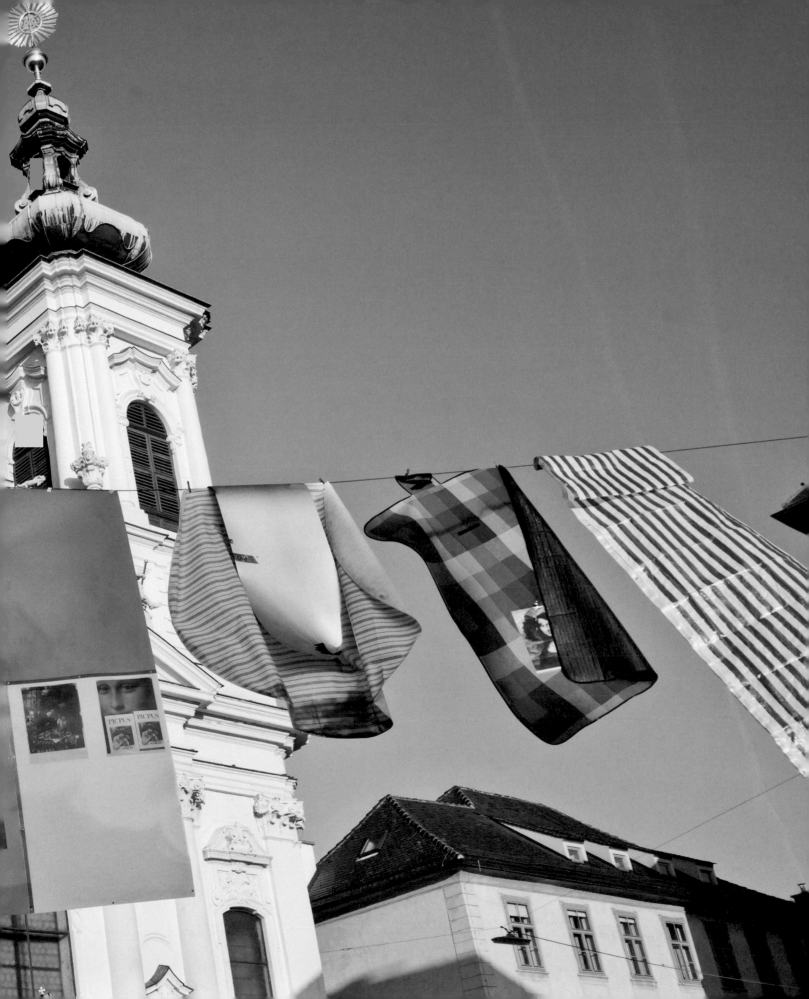

# John Knight
# Lange Tage der Freizeit (Long Days of Leisure)

**Herrengasse**

**André Rottmann**
**Evacuating the Site — John Knight's Virtuosity**

John Knight must be considered one of the most influential and yet elusive figures in site-specific art and institutional critique. The artist, who lives in Los Angeles but always works *in situ*, produces his works exclusively on commission; at a far remove from criteria of stylistic consistency, his works employ morphologies and materials that can hardly be assigned to traditional aesthetic registers or conventions of medium-specificity. His approach is instead defined by the use of readymades that already carry hybrid associations by virtue of their use-value as well as their symbolic meanings, commercially or politically charged imagery, and aspects of architectural and urban design in which iconic significance is a salient feature. Yet Knight's anti-idealist practice not only illustrates that an engagement with these parameters is imperative in postmodern art in general; his projects subject these phenomena structuring the order of visibility that shapes our everyday lives to a critical revision of their authoritative ambitions at the respective sites of their production *and* exhibition.

What emerges as Knight's central interest is the attempt to challenge the definition of what constitutes an object of aesthetic experience as well as the systems of belief and institutional agreements that support its appearance and its material as much as its ideational value. As Benjamin H. D. Buchloh has emphasized, Knight's works focus in particular on the continuity, even identity, between artistic production and strategies of advertisement.[1] Knight's method is accordingly characterized by "semiological inversions," i.e., procedures that recode the meanings associated with an object, image, or site; his dialectical montages place the emphasis precisely on the *empty* space of negation between discrete elements; rather than making unequivocal statements, they achieve a maximum "indeterminacy of traditionally fixed associations."[2]

Consequently, sculpture can exist in Knight's art only as a montage of negations.[3] Interventions in a public or institutional space enable him to examine its laws precisely by refusing to offer spectacular monumentality.[4] Such a work accordingly reveals itself to be a critical

intervention only in the beholder's reflection on the question of what exactly is being marked here in the mode of negativity.[5] Inherent to works of institutional critique — which, as Knight puts it, are committed to a self-reflective mode of critique[6] — is thus the paradoxical attempt to render visible what is invisible in the visible.[7] In this respect, the project Knight has now realized in Graz is paradigmatic of his praxis, which often operates with a remarkable economy of means: rather than "furnishing"[8] a site under the banner of art in the public space, as is so often done, he quite to the contrary evacuates it in order to link, in a critical-reflective act, structures of meaning in the life-world to art-specific knowledge.

During a visit to the site, Knight not only noticed that flagpoles installed at regular intervals along both sides of Herrengasse fly streamers. Come fall, too, banners would announce the steirischer herbst festival. It seemed striking to Knight that both the museums and stores along this shopping mile and the Catholic Church would advertise, in unison, their extended opening hours. Since the late 1970s, the irreversible collapse of the distinction between an advanced aesthetic praxis and the regime of consumerism, which has led art institutions to believe themselves compelled to employ advertising strategies similar to those of businesses dealing in goods, images, and services, has repeatedly been a subject in Knight's works — in his *Logotypes* (1982), for instance, in which he applied marketing imagery to ligatures of his initials, aggressively advertising "JK" as a brand.[9]

The Church's decision to follow the "secular" sector's example in advertising its extended hours is especially remarkable in light of the

fact that the diocese had rejected Knight's initial project proposal — to refrain from ringing all church bells for the duration of the festival — as destructive of Graz's religious as well as urban culture. The banners on Herrengasse, by contrast, unreservedly acknowledge the alliance that art, commerce, and the Church enter into for the purpose of a wholesale colonization of the part of everyday life once called leisure, a part that is entirely committed to the creation of value in the "new spirit of capitalism," which erases the boundaries between the public and private spheres.[10] Knight's response consists in an intervention entitled *Lange Tage der Freizeit* (*Long Days of Leisure*), in which the flagpoles on the left-hand side of Herrengasse remain empty; on the right, the streamers continue to flutter in the wind. The result is an anti-monument that, by force of negation — in the absence of any sculptural materiality in the classical sense and without the traditional phenomenological address to the beholder — exhibits the impossibility of a collective experience of public space.[11] Instead of furnishing Graz with a new landmark, as the marketing strategies associated with the festival would have him do, Knight seeks to create a "place of *non-identity*," as he puts it in the accompanying concept paper. Yet the work as such is by no means an empty gesture of refusal. What it allows to emerge, rather, is precisely what is invisible in the visible

On the one hand, the banners flying on the right-hand side of Herrengasse retain their function as advertising signage; the evacuation of the opposite side of the street in fact even emphasizes this function. On the other hand, however, they become readymades, being elevated to the status of a dynamic sculptural form comparable to the ones employed in the

early works of Hans Haacke, including *Blaues Segel* (1965). The public sculpture is thus revealed to be a banal advertising medium, while the flags are elevated to the status of monuments. At the same time, the evacuated flagpoles look like post-minimalist sculpture, inevitably recalling the obsolete productivist pathos of works such as Walter de Maria's *Lightning Field* (1977). Far removed from the escapism of Land Art, they strike the beholder as the unmistakable sign of crisis in a culturalized economy that might have run out of things to advertise.

Like Daniel Buren's *Les Couleurs: Sculptures* (1975–1977) — flags bearing the artist's notorious stripe-pattern motif were flown from poles mounted atop museums and department stores in Paris, where they could be seen through telescopes installed at touristic vantage points — Knight's flags are symbolic no longer of heroic triumph; oscillating between aesthetic sign and functional object, they signal the irrevocable degradation of sculptural monumentality to mere decoration.[12] Knight's streamers lack even the obtrusive signature of the individual artistic subject that cover Buren's in their entirety. And unlike the banners, say, in Haacke's Munich installation *Die Fahne hoch!* (1991), they are no longer suitable as a medium of political agitation.[13] Nor do they appear as parodies of this tradition that also carry connotations of painting (as in more recent works by the collective Reena Spaulings and the duo Claire Fontaine). And yet the confrontation of an advertising message with, as Knight puts it, a *"gap in the urban topology"* must certainly not be read as a manifesto of resignation.

In fact, Knight's counter-sculpture *Lange Tage der Freizeit* turns out to be a gesture that,

rather than marking a site of opposition outside the conditions that engender it in the first place, renders the work, under the conditions of the contemporary culture industry, the stage for a form of virtuosity of the sort Paolo Virno has described as an "activity without end product."[14] Virtuosic labor occupies a prominent position in the post-Fordist economy, as it draws primarily on communicative skills and requires the presence of spectators in order to achieve realization. As a consequence of the rise of services — in the guise of social interaction, bureaucracy, and "public relations" — to the status of key productive forces, Virno writes, virtuosity can develop a potential of disobedience that is capable of challenging the foundations of a dominant regime of control rather than merely its visible effects.[15] Seen in this perspective, Knight's work enables a reflectivity inherent to negation to replace the ultimately affirmative acts of transgression that were characteristic even of the art of the avant-gardes; a reflectivity that aims not at the desolate conventions of sculptural production but instead at the "matrices of institutional frameworks and their procedures, […] a bureaucratic sphere of legal contracts and administrative negotiations"[16] that conditions the creation of any work of advanced art — especially in regimented public space.

A literary character may serve as an allegorical model here: "Bartleby, the Scrivener" (1853), whom Herman Melville has respond to any attempt on the part of his employer at a law office on Wall Street to give him a task with the phrase, "I would prefer not to."[17] In his essay on Melville's novella, Gilles Deleuze has analyzed Bartleby's reply as the expression of a "logic of preference" that undermines the dominant language: "The formula *I prefer not*

*to* excludes all alternatives, and devours what it claims to conserve no less than it distances itself from everything else [...] it hollows out a zone of indetermination."[18]

In the same way, John Knight, by attempting "to articulate a *non*-dominating thought"

in the medium of sculpture, has created a truly virtuosic anti-monument for Graz that counters the imperative of communication issued by the new spirit of capitalism with a complex formula: "JK" would prefer not to.

Translated from the German by Gerrit Jackson

1   Cf. Buchloh, Benjamin H.D.: "Knight's Moves. Situating the Art/Object" [1986], in *Neo-Avantgarde and Culture Industry. Essays on European and American Art from 1955 to 1975*, Cambridge, Mass. / London 2001, 285–304, here pp. 286–87.
2   Cf. Alberro, Alexander: "Meaning at the Margins. The Semiological Inversions of John Knight," in John C. Welchman (ed.), *Institutional Critique And After*, Zurich 2006, 56–83, here p. 72.
3   Cf. Buchloh, Benjamin H. D.: "Knight's Negations," in *John Knight. 87°*, exh. cat., Storm King Art Center, Mountainville, NY 2001, 4–14, here p. 7.
4   See also Pelzer, Birgit: "The Irresistible Appeal of Utility," in *John Knight. Campagne*, exh. cat., Encore ... Bruxelles, Brussels 1996, 7–36, here p. 14.
5   Cf. Rebentisch, Juliane: *Ästhetik der Installation*, Frankfurt am Main 2003, 268–70.
6   John Knight in conversation with the author at the Academy of Fine Arts Vienna, May 31, 2010.
7   Rebentisch (n. 5), 269.
8   See Axel John Wieder: "Stadtmöblierung," in *skulptur projekte münster 07*, exh. cat., Landesmuseum für Kunst und Kulturgeschichte Münster, Brigitte Franzen, Kasper König, Carina Plath (eds.), Cologne 2007, 460–61.
9   See Buchloh (n. 1), 294–99; Rorimer, Anne: "John Knight. Designating the Site," in *John Knight. Treize Travaux*, exh. cat., Le Nouveau Musée, Villeurbanne / Witte de With. Centre for Contemporary Art, Rotterdam, Dijon 1990, 13–14.
10  See Luc Boltanski, Ève Chiapello: *The New Spirit of Capitalism*, trans. Gregory Elliott, London, New York 2005, 154–56.
11  See Buchloh (n. 3), 7.
12  See Buchloh, Benjamin H.D.: "Daniel Buren's Les Couleurs / Les Formes" [1981], in *Neo-Avantgarde and Culture Industry. Essays on European and American Art from 1955 to 1975*, Cambridge, Mass./London 2001, 119–39, here pp. 125–26 and 137–38.
13  See *Hans Haacke. Wirklich. Werke 1959–2006*, exh. cat., Deichtorhallen, Hamburg / Akademie der bildenden Künste, Berlin, Robert Fleck, Matthias Flügge (eds.), Düsseldorf 2006, 204–205.
14  See Paolo Virno: *The Grammar of the Multitude. For an Analysis of Contemporary Forms of Life*, New York 2004, 52ff.
15  See ibid., 69–70.
16  Cf. Buchloh (n. 3), 7.
17  Melville, Herman: "Bartleby, the Scrivener. A Story of Wall-Street," in *Putnam's Monthly* 2/11 (November), 546–57, and 12 (December 1853), 609–15, passim.
18  Deleuze, Gilles: "Bartleby; or, The Formula," in *Essays Critical and Clinical*, trans. Daniel W. Smith and Michael A. Greco, London 1998, 73.

## John Knight
## Lange Tage der Freizeit [...]

*To have repudiated with utmost vehemence
the political significance of theocracy is the
cardinal merit of Bloch's "Spirit of Utopia."*
Walter Benjamin *Theologico-Political
Fragments*

As the Solemnized bear witness to the
decimation of the four levels of meaning,
while sanctimoniously protecting their
"Liturgical Symbols," echoes of the Eleven
Mühlhausen Articles are seen impishly
dangling along the Herrenstrasse…

What remains to be said about such latter-
day hypocrisy would be of no further import,
*if* it weren't for the uncanny similarity of
duplicity that appears to exist in the manner
with which culture production is authorized
and disseminated. Through a process of
selective amnesia, entire histories of class
critical analyses are ignored, thus any consid-
eration of, or more accurately, sincere regard
for, the integration of the individual social
[sic] subject and *leisure* production to occur
within the time and place of work itself, is nil.

That such a history should remain aloof, rather
than contingent upon cultural production, is
deeply problematic, to say the least. No less
so, is the reckless means by which culture is
disseminated with absolute piety through the
same aforementioned vulgar advertising
strategies, *Lange Nacht der Museen* …

Therefore, in my humble opinion, the task at
hand is to offer for the time of the exhibition,
*Utopia and Monument II*: Virtuosity, a place of
*non*-identity, so as to attempt to articulate a
*non*-dominating thought in a way that might
not be immediately subsumed under the
subject's ideology, by the presence of a *not
so subtle*, asymmetrical use of the existing
advertising tropes that can be found parading
down the Herrenstrasse. In particular, to
"empty" the apparatuses on the entire left
side of the mall of their identity, while at the
same time allowing the standards on the right
side their full affect, in an effort to create
a *gap* in the urban topology.

June 2010

Removing the flags in Herrengasse.

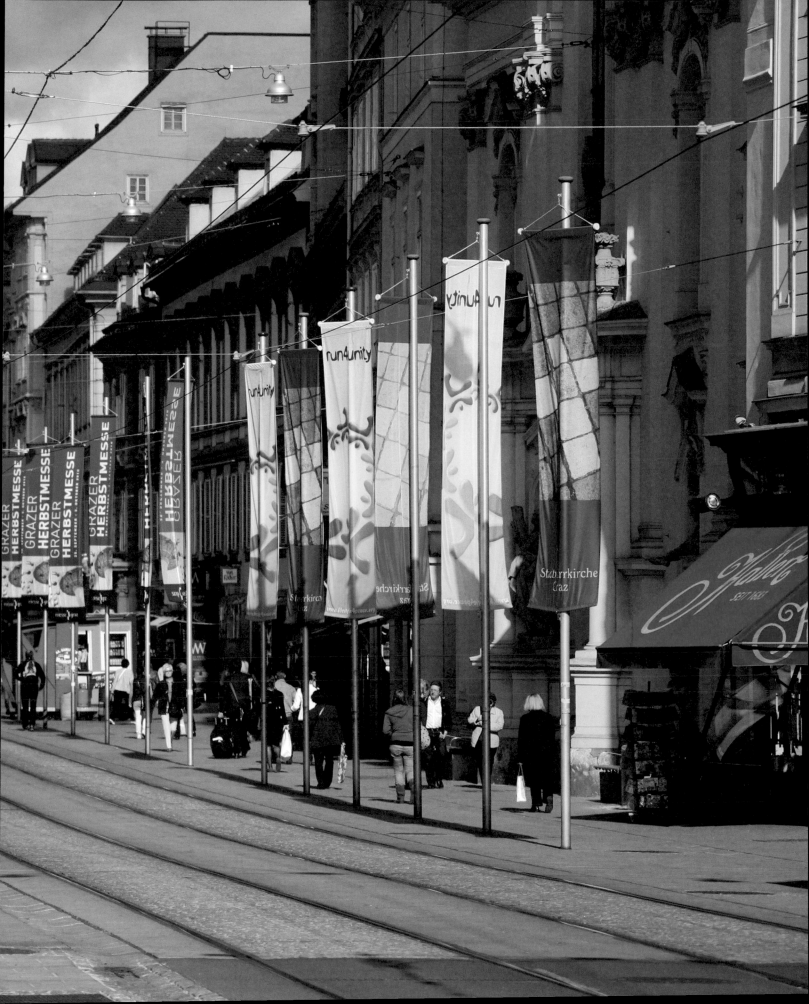

# Jutta Koether
# Demons for Ladies, Gentlemen and Children

**Tramway station Südtiroler Platz, sales booth Hauptplatz**

**David Joselit**
**Truculent Monuments**

### Hey You!

Ever since European easel painting was liberated from the altarpiece, works on canvas have acquired the special mobility of commodities. They can go anywhere the market carries them, and so, like utopias but unlike monuments, whose power is rooted to their site, they exist nowhere in particular.

Jutta Koether is one of a handful of artists to confront the paradox embedded in this exhibition's title — to challenge its contradictory association of utopia and monument. Unlike modernist painting, which is devoted to representing utopias, her works are site-specific, behaving more like failed or humiliated monuments. But these monuments are not passive — Koether's canvases are lively interlocutors who perform flamboyantly for specific audiences.

We are accustomed to believing that paintings either address a general "public" (if their ambition is art-historical or political) and/or an individual "subject" (if their ambition is phenomenological), but these classes of spectator are completely generic: they describe what used to be called "mankind" [sic] or the "humanist subject." The fact that many more precise identity positions have subdivided these generic categories over the past forty years hardly changes the deep structure of a persistent model of spectatorship that, in the end, is addressed to no one in particular, and to anyone and everyone who passes by. Koether on the other hand has specific receivers in mind. *Demons for Ladies, Gentlemen and Children* is really meant for Graz — for those "consumers" on Main Street whose demons, Koether avers, arise both from the legacy of the Third Reich and the city's current, all-consuming cultural enthusiasms. Ladies, Gentlemen and Children of Graz, these demons are for you!

Privatization of public space occurs when a certain group of citizens substitutes its specific interests for those of a "general public" (with the corollary effect of extinguishing the agonistic exchange of opinion, which is the foundation of a genuine public sphere). Utopian (modernist) painting

is thus the perfect expression of such a privatized public sphere: the "universal" subject is discovered in personal consumption of visual stimulus. As a private person, when I regard a beautiful painting, as Kant might instruct, I gain access to shared "public" virtues. But Koether's paintings are singular in their address — like the infamous policeman of Louis Althusser's classic demonstration of interpellation, they cry out, "Hey You!" And indeed, this singular form of address, which might appear to be private because it is directed toward individuals, is in fact precisely the ground of a genuine public which is founded on the agonistic exchange of individual opinions, not on a mild and placid form of consumer affirmation.

Koether's painting in Graz "waits" for a tram alongside its human companions: it will be mounted on the glass side wall of an actual tram shelter, inviting a sidelong glance — a kind of cruising — from those who sit there. But a second enclosed bench — one of two that the city has in reserve for times of construction when temporary stops are needed — will be placed, like a blockade on the sidewalk at a 90-degree angle adjacent to the existing shelter. Here, passersby may sit down and view the painting head on as though they were attending a performance. And yet, by doing so they will obstruct the passage of other pedestrians; they will be misbehaving on the street, attending a demon as though becoming officiants at a black sabbath.

In correspondence with me regarding her project for *Utopia and Monument*, Koether stated something fundamental: "I think the painting should also function as a sign. Something that does not necessarily disrupt traffic but more re-route it to something."

(A monument, after all, typically disrupts traffic, triggering memories as it provokes circumnavigation). I'll be blunt: I think re-routing is a better term for describing the task of art than representing or critiquing. Koether isn't representing the demons she feels haunting Graz; she is calling them into existence in public space and staging an encounter between them and the Damen, Herren und Kinder who pass by. How these demons are handled is up to them.

## Glass

Painting is an art of surfaces, and surfaces stage a paradox: they bring the material and the virtual together on the same plane. (Can this be the source of painting's renewed relevance in a digital era?) It is very possible, as Edouard Manet (or Rembrandt, or Velasquez, or Delacroix) taught us, to see a brushstroke and a negligee at once. Each quantum of paint is simultaneously matter and illusion. Only the literalness of the stupidest followers — or critics — of Clement Greenberg contends that matter can be extracted from an image or that an image may be extracted from matter.

Marcel Duchamp invented a strategy to address this paradox at the outset of twentieth century abstraction, the ingeniousness of which has never been exhausted and the potential of which Koether realizes better than anyone I know of: exchanging painting with glass. Duchamp's *Large Glass* (1915–23) was both a window and a screen of projection: like a lenticular lens it could look opaque from one direction and transparent from another — it can be looked at as well as looked through. Koether embeds materials — often, cheap, Chinese-made products acquired in a place, like Graz, far from China itself —

in liquid glass. Here, the nature of a "medium" is literalized as a substance within which objects are suspended. The glass surface flows beyond its support, spreading and hardening around the canvas like a crust: Koether's surfaces are thus mobile, viscous and detachable. At Graz, she will layer glass upon glass by mounting the painting on the glass wall of the tram stop. In *Demons for Ladies, Gentlemen and Children*, therefore, it's difficult to know where the "painting" ends and where its support begins. Or perhaps I should say that Koether's surfaces fold and ooze themselves into an environment — a monument that is a stop; a sign that "re-routes."

# Paulina Olowska
# Natasza, Workers Canteen and Flowers Onethousandsixhundredseventeen Neons in Warsaw

**Andreas-Hofer-Platz, roof of the gas station/car park**

**David Crowley**
**Reanimating the Future**

Graz has acquired a rather *unmonumental* monument. Paulina Olowska has installed a new, temporary public sculpture above a gas station and café in the city's centre. An assemblage of neon signs, this monument has been fixed on the towering street light which illuminates the steel, concrete and glass pavilion, a low structure on Andreas-Hofer-Platz below. One architectural icon of automotive modernity, a 1965 gas station, has been overwritten with one of the chief scripts of the twentieth-century city: neon advertising.

Olowska's work not only uses the *language* of advertising: these neon monuments are actual advertisements, albeit coming from an unlikely setting. These signs were once fixed on the walls of buildings in Warsaw. Testimonies to the material and symbolic economy of Eastern European socialism, "Natasza" once announced the chain of Soviet gift shops which operated across the Eastern Bloc, whilst the bouquet of flowers was the marker of socialist achievement, awarded on high days in the ritual calendar of socialism. The jaunty cow at one time promoted a workers' café. Together they fuse into an international Esperanto of socialist symbolism.

These neon signs originate in "moment" in the late 1950s when elephants climbed the sides of buildings and flowers grew from the glass panes of department stores in Poland. Drawn in neon — an inert gas animated by electricity — these new graphic signs seemed to be irrepressibly alive. Siegfried Kracauer pointed out their tireless energy: "Once the images begin to emerge one after another, there is nothing left besides their evanescence." In the 1950s, Poland's modern architects and planners sought to tap this animation to compensate for the deadly monumentalism of the Stalin years. An enchanting antidote to monotony, the new neon signs seemed to open up a bright new future where ordinary human needs and pleasures would be met. They are examples of an obscure and perhaps oxymoronic category, that of "socialist advertising."

Unlike the ephemeral billboard which changes its face with unseemly haste, Poland's

socialist advertising seemed to say, "I am here for the long run." But over the decades that followed, the night-time ecology fell into disrepair in cities across the country. In Warsaw, the illuminated globe above Aleje Jerozolimskie (Jerusalem Avenue) stopped turning and Sródmiescie (Downtown) became ródmiescie. After the end of communist rule, Poland's cities — like much of the former East — were over-written with shiny promises of global consumerism. Massive fabric banners covered the street-side elevations of high-rise buildings and inflatable cartoon brands were parked on downtown roofs. Hidden in plain sight, neon was easily overlooked.

In 2006 working with the Foksal Gallery Foundation, Olowska arranged for the restoration of one unseen neon landmark in Warsaw, a volleyball player above Constitution Square, a key location in the socialist cityscape. Reanimated through Olowska's efforts, she pitches her ball — in perfect consecutive illuminated circles — down to the street below. Restoration is usually a conservative enterprise, too often wrapped in nostalgia. But context counts for much. The restitution of socialist-era neon in Poland is a provocation in a culture which — for the most part — has found it difficult to discover virtue in the communist years. Moreover, it is important to stress that Olowska returned the volleyball player to its original setting, the public space of the city square. Being impounded in a museum would have only diminished the *presentness* of this sign. In Constitution Square, the volleyball player has gathered a public to reflect on the abject condition of utopianism today. Olowska's art asks what kind of functions modernity might have in the present.

Olowska has, in fact, been a brilliant archaeologist of soc-modernity (socialist modernity), frequently drawing on major and minor episodes in its history in her paintings and collage works. Interested in images of progress, Olowska has little concern with progression as succession. Different moments and registers of utopianism are often combined in her work to produce a highly subjective exploration of past visions of the future. For instance, her series *Accidental Collages* (2004), shown across Europe in recent years, connects Kasimir Malevich's visual charts used in lectures given in Poland and Germany in 1927, plans and façade drawings for postwar buildings with fashion imagery from the 1960s. Unsettling textures, scales and traces seem to exist side-by-side without one claiming special status or precedence over the others. Adding to this effect, Olowska herself features in this graphic heterotopia. Michel Serres famously announced "the past is not out of date," pointing to the way in which the past is invariably folded into the present, sometimes percolating into our world in unexpected ways. Olowska seems to say something similar and perhaps more provocative when she suggests "the future is not out of date." These are, of course, grand themes but Olowska's work also contains something else often missing from the fanfares of progress. Neon — with it lightness and warmth — points to humour and pleasure. What place has humor in utopia?

So, what are we to make of the arrival of Warsaw's neon signs on a gas station in Graz? Remade from original designs and then exhibited, a bouquet of flowers, the "Natasza" Russian dolls and a cow from a Warsaw canteen proudly offering its milk are strange exiles from a world that no longer exists.

We know a lot about the arrival of capitalist publicity in the "former East," but what might the appearance of socialist advertising tell us about the "former West"? And what is the *presentness* of her illuminated compatriots in Graz? One possibility will be that — in their charm and naiveté — these neon signs can trigger misplaced nostalgia, a confabulation of soc-modernity with Austrian experience.

1    Siegfried Kracauer, „Langeweile" (1924), in: *Das Ornament der Masse. Essays* (Frankfurt/M.: Suhrkamp, 1977): 7.

Apteka Apteka Apteka Apteka Apteka Apteka Apteka Apteka Apteka Apteka Apteka Apteka Apteka Apteka Apteka Apteka Apteka Apteka Apteka Apteka Apteka Apteka Aviotex Alba Alba Alba Alba Art Cukier Art Metalowe Arged Analizy Lecznica Agroma Apteka Apteka Astra Apteka Apteka Apteka Apteka Apis Agata Bar Arget Apteka Agata Pasztecia Agromet Apis Apis Artykuły Mlecz Apteka Apteka Apteka Apteka Apteka Apteka Apteka Wędliny Apteka Alhambra Amatorska Art Spożywcze Artykuły Sportowe Arkady Ambasador Adria Art Pościelowe Apteka Attykwariat Apteka Apteka Apteka Apteka Apteka Apteka Apteka Apteka Aeroflot Apteka Apteka Alba Antylopa Akwarium Agnieszka Agroma Arged Artykuły Pościelowe Astra Apteka Astra Aligator Astra Apteka Agromet Alba Ambasador Apteka Antykwariat Artykuły Motoryzacyjne Apteka Alka Auto Salon Marki Amanda Bombonierka Bar Gruba Kaśka Bar Familijny Bar Kawowy Bar Mleczny Balbinka Bar Baltazar Bar Janosik Baleron Bombonierka Bar Mleczny Bar Mleczny Barbakan Budapeszt Bajka Berlin Bobo Balkancar Biblioteka Biblioteka Biblioteka Biblioteka Biblioteka Bumar Balbinka Bar Łódzki Biuro Turystyki Biblioteka Biblioteka Biblioteka Biblioteka Biblioteka Budopol Bałtkan Turist Bistyp Bar Frykas Bajeczny Bar Oaza Barbara Bar Bartek Bar Piknik Bar Wiktoria Bank Spółdz Biblioteka Bar Wilga Bar Wrocławski Bar Centralny Bar Maciek Bar Zachodni Bar Radek Biblioteka Bar Kawowy Biblioteka Bar Na Rozdrożu Bar Kos Bacutil Bar Pokusa Bar Ikar Bielizna Biuro Zleceń Bar Łódzki Bar Cyranka Beton Stal Beniaminek Bar Zajazd Beata Balbinka Bar Smak Bar Pocztowy Bar Biedronka Bielizniarz Bar Grodzki Biblioteka Bekon Bar Cyganka Bar Praha Biblioteka Bacutil Bank Spółdzielczy Bibliotek Bałkan Tourist Budimex Bank Pko Bonus Bar Frykas Budimex Bucuresti Bank Iniet Gosp Centralna Składnica Harcerska Cepelia Cepelia Cepelia Camargo Camargo Cafe Danusia Camargo Camargo Chemia Gospodarcza Chemia Gospodarcza Cafe Słoneczna Chemia Camargo Camargo Camargo Chemia Gospodarcza Chemia Gospodarcza Chemia Gospodarcza Chinka Celestynka Chodak Chemia Czyst Żywa Wełna Centrala Rybna Cepelia Cepelia Cepelia Cepelia Cepelia Cepelia Cepelia Carl Zeiss Jena Cpn Cukierniczy CHPM Dom Towarowy Smyk Dt Wars Dt Sawa Dt Wola Dt Praga Camargo Centrum Informacji Turystycznej Cepelia Camargo Ciastka Cezas Centr Składni Harc Cafe Danusia Camargo Chłopska Droga Cafe Marie Chemia Chemia Gosp Camargo Camargo Camargo Camargo Ceramika Szkło Centr Księgarnia Rol Cyganeria Cafe Marianna Chłodnia Caf Chełmek Camargo Cpn Cpn Cpn Cpn Cpn Cpn Cepelia Cora Centrala Rybna Caf Cpn Cpn Cpn Cpn Cpn Cpn Chemoinstal Chemoinstal Chemoinstal Ceramika Chemia Gosp Camargo Coktajl Bar Cukierniczy Coktajl Bar Biedro Chemia Gosp Camargo Cepelia Cepelia Cora Cepelia Cafe Basia Centr Skład Harc Cepelia Centrum Wzornictwa Przem Czysta Żywa Wełna Chemia Gospodarcza Cepelia Dom Odzieżowy Dorotka Dzik Drogeria Delikatesy Drogeria Delikatesy Delikatesy Delikatesy Drogeria Drogeria Delikatesy Drogeria Drogeria Dom Sportu Dziewiarstwo Dom Handlowy Dom Mody Damskiej Dom Książki Dom Książki Dom Książki Desa Dom Książki Dom Książki Dom Książki Dom Książki Dom Książki Dom Książki Drogeria Dom Odzieżowy Dom Książki Dom Książki Dom Książki 1001 Drobiazgów Dom Słowa Polskiego Delikatesy Delikatesy Drogeria Drewno Dzianina Dom Kultura Drogeria Dworzec Wa Główna Dom Turysty Dziewiarstwo Dom Mody Ambasad Dom Kultury Dina Dom Kultury Radz Dom Kultury Dziennik Ludowy Dziewiarstwo Delikatesy Dom Książki Dom Książki Delikatesy Drogeria Drogeria Delikatesy Dom Książki Dom Książki Drobiazgów 1001 Drogeria Dziewiarstwo Dziewiarstwo Dziewiarstwo Dom Książki Dom Kultury Radz Dworzec Ostrołęka Delia Delikatesy Delikatesy 1001 Drobiazgów Delikatesy Domus Drogeria Drogeria Drogeria Drogeria Dom Pracy Delia Dom Książki Delikatesy Delikatesy Dom Kultury Dom Książki Dantex Dom Kultury Dworzec Miłask Mazow Delikatesy Drukarnia Emilia Meble Elektra Express Wieczorny Elektroimpex Elektroimpex Elbud Elektrociepłownia Siekierki Elmet Eldom Eldom Elektrownia Kozienice Elkam Lux Eldom Elektrotechnika Emit Eldom Europejski Souvenire Europejska Foto-Optyka Fabryka Tarcz Ściernych Foto-Optyka Foto-Optyka Farby Lakiery Farby Lakiery Farby Lakiery Farby Lakiery Farby Lakiery Foto-Optyka Futra Foto-Optyka Fajki Filatelistyka Foto-Optyka Foto-Optyka Foto-Optyka Farby Foto Fabryka Ołówków Fenik Dom Towarowy Falbet Foton Foto-Optyka Filatelistyka Filatelistyka Fryzjer Fryzjer Futra Futra Fryzjer Fryzjer Rarby Fryzjer Fryzjer Fso Futra Fabryka Armat Mlecz Fantazja Farby Farby Fryzjer Fso Fso Foto Fso Foto-Optyka Filharmonia Narodowa Galanteria Skórzana Gorsety R Gerlach Garmażeria Guziki Gallux Gorsecik Gabinet Kosmet Galanteria Skórz Grodziska Spółdzielnia Inwalidów Galeria Studio Galeria Sztuki Guliwer Gosp Domowe Garmażeria Galanteria Galanteria Sk Galeria Studio Gorsety Gorsety Galeria Zakr Centr Bud Metra Galskór Hydoma Habana Hotel Ursus Hortex Hotel Grand Hotel Vera Hotel Solec Hotel Orbis Hotel Warszawa Hotel Saski Hotel Polonia Hotel Metropol Chemia Gospodarcza Cpn Hotel Mdn Hortex Hotel Forum Herbapol Herbapol Hala Marymoncka Hala Mirowska Hotel Mon Herbapol Hotel Pracownicy Hydomat Hortex Hortex Hotel Hotel Syrena Hotel Mdm Hotel Nowa Praga Hotel Fso Hotel Victoria Hotel Annopol Hotel Leśny Hotel Europejski Hotel Solec Hala Magaz Hala Stalowa Intersigma Instrumenty Muzyczne Ingrom Instytut Przem Organicznego Instytut Przem Gumowego Italia Instytut Reumatologiczny Instytut Szkła Ceramiki Izis Impexmetal Izis Izis Ingrom Izis Intersigma Izis Izys Interpego Instalexport Informatory Informacja Wizualna Inform Informatory Informatory Imb Justyna Jubiler Jubiler Jubiler Jubiler 22 Lipca Wedel Lalka Ludwik Len Loteria Loteria Loteria Loteria Loteria Loteria 22 Lipca Loteria 22 Lipca Lot 22 Lipca 22 Lipca Lecznica Luksus Lecznica Ludwik 22 Lipca Wks Legia Lecznica Lot Lot Leda Dom Mody Leda Loteria Leda Łoś Łaźnia Łaźnia Cent Łaźnia Diana Meble Meble Meble Mięso Melodia Mięso Wędliny Konserwy Mięso Wędliny Mydła Farby Magnolia Mhd Cukierniczy Mięso Meble Meble Mhd Milanówek Młoda Para Meble Mazowszanka Muzeum Sportu Materiały Piśmienne Moda Polska Machinoeksport Moda Polska Ewa Mzk Mzk Mzk Muzeum Sportu i Turystyki Mięso Wędliny Mors Meble Meble Mera Piwefal Mydlarnia Mela Elwro Merkury Mokotowska Mydła Farby Mister Meble Maxim Monika Megadex Miody Miśsk Maz Pkp Miśsk Maz Pks Meble Meble Miejskie Przedsiębiorstwo Transportu Moda Polska Mięso Wędliny Mięso Wędliny Wyszkowskie Fabryki Mebli Małgosia Miejskie Pralnie i Farbiarnie Meble Merazet Merino Magazyny Biurowe Magazyn Mk Marionetka Medica Memonex Maryla Marepol Maryla Mekage Megat Moda Italiana Niespodzianka Nowotko Nabiał Nabiał Warzywa Mięso Naprawa Rtv Naprawa Sprzętu Zmechanizowanego Napoje Słodycze Nowa Praca Niewidomych Naczynia Kuchenne Naprawa Sprzętu Zmechanizowanego Narzędzia Nasiona Napoje Słodycze Nowotko Obuwie Obuwie Obuwie Okrycia Męskie Orno Obuwie Obuwie Obuwie Obuwie Okrycia Męskie Obuwie Obuwie Orbis Orion Orbis Obrabiarki i Narzędzia Obuwie Obuwie Obuwie Obuwie Odzież Sportowa Odzież Włókno Odnowa Odzież Damska Odzież Sportowa Obuwie Orbis Orbis Obuwie Owoce Warzywa Owoce Warzywa Owoce Warzywa Obuwie Orbis Okrycia Orbis Orient Odzież Włókno Orbis Obuwie Obuwie Obuwie Odnowa Ośrodek Kultury Czechosłow Okręgowa Spółdzielnia Mleczarska Orbis Orbis Ośrodek Med Ogrodnik Orbis Orno Orno Orion Odra Pralnia Pko Polmozbyt Polmozbyt Polmozbyt Paged Państwowe Zakł Telekomunikacyj Pko Perspektywy Polityka Polmozbyt Polski Len Pko Piekarnia Wolska Pżb Polmo Polmozbyt Promex Polmozbyt Pzu Pzu Pttk Pzu Polifoto Polifoto Poczta Poczta Pko Pikotka Piotrus Pralnia Par Pzu Polskie Nagrania Pyroflex Pralnia Predom Pralnia Predom Polam Ponar Pawilon Sport Sport Pasmanteria Pawilon Handlowy Papier Predom Porcelana Kryszt Perfumeria Plastuś Pzl Pralnia Pkt Pko Pyroflex Przitbk Pralnia Predom Polifoto Przegląd Sportowy Pewex Pzmot Pko Poczta Pranie Bielizny Poczta Poczta Pkp Pkp Polfa Polfa Pkp Pkp Pkp Pzu Pzu Pzu Pomorin Pyroflex Pyroflex Pyroflex Pyroflex Pyroflex Pyroflex Polifoto Przed Badań Geofizycznych Polfa Polifarb Poczta Pko Pko Pko Pianina Polam Polskie Linie Lotnicze Lot Polena Polam Perfumeria Polam Polmozbyt Polmozbyt Polmozbyt Polmozbyt Polmozbyt Polmozbyt Pewex Pewex Peweks Polifoto Polifoto Polifoto Polifoto Polifoto Polimar Pralnia Pko Powszechny Dom Książki Pollena Pralnia Kosmetyki Piotruś Pan Pasmanteria Pod Skrzydłami Perfumeria Praktyczna Pani Patera Perfumeria Perfumeria Perfumeria Perfumeria Perfumeria Podkomorzanka Plastik Perfumeria Parówka Pralnia Pantera Papier Pekar Papirus Pinokio Pzu Pzu Pzu Polmozbyt Pzu Pko Rotunda Pogotowie Ratunkowe Pogotowie Ratunkowe Ponar Pap Pko Polifoto Polifoto Polmo Pollena Polmozbyt Polmozbyt Pzl Polam Paulinka Polsped Polifoto Perfumeria Pzu Pzu plllot Polfa Ponar Poczta Pko Pod Niedźwiedziem Pawilon Handl Poczta Pks Poczta Perfumeria Papier Perfumeria Perfumeria Pentacon Pbsc Pralnia Pko Pko Pronit Poczta i Dworzec Towarowy Polifoto Poczta Polskie Nagrania Pko Polifoto Polifoto Praktyczna Pani Polifoto Pzu Przedsięb Badań Geofizycz Pijalnia Przy Źródle Pewex Pks Pharmachin Pewex Roxana Restauracja Bar Flis Rolada Restauracja Odra Rękodzieło Ruch Ruch Ruch Ruch Ruch Ruch Ruch Ruch Ruch Ruch Ruch Ruch Ruch Ruch Ruch Ruch Ruch Ruch Ruch Ruch Ruch Ruch Ruch Ruch Ruch Ruch Ruch Ruch Ruch Ruch Ruch Ruch Ruch Ruch Ruch Ruch Ruch Filatelistyka Ryby Ryby Ryby Ryby Rsw Ruch Ruch Ruch Ruch Ruch Ruch Robotron Ruch Ruch Ruch Ruch Ruch Ruch Ruch Rakowiec Róża Luksemburg Ruch Ruch Reklama Ruch Ruch Rzemieślniczy Dom Handl Rolniczy Dom Handl Ruch Ruch Ruch Ruch Rsw Prasa Ruch Rsw Rudka Ruch Ruch Ruch Ruch Ruch Ruch Rolniczy Dom Handlowy Ruch Ruch Ruch Ruch Relax Reion Energetyczny Renata Rumba Ruch Restauracja Ruch Ruch Ruch Ruch Rybex Redom Rzepicha Restauracja Pod Skrzydłami Ruch Restauracja Mangolia Redom Restauracja Mdm Smyk Sport Salon Mody Adam Sprzęt Zmechanizowany Społem Abr Eam Eam Mięso Wędliny Eam Eswajsamhi Bar Eam Eklep Drobiarsko-Jajczarski Sam Krakowski Spożywczy Spożywczy Sam Mazurski Sam Spożywczy Spożywczy Spożywczy Szwajcarska Switezianka Sam Powiśle Sumatra Sezam Społem Spożywczy Szanghaj Sofia Sarenka Sofia Sprzęt Zmechanizowany Spełem Sam Sport Turist Sprzęt Rechabilitac Sport Turystyka Wypoczynek Elektromoc Skala Śródmiejski Ośrodek Sportowy Spożywczy Mleko Sery Spożywczy Sklep Ciastka Torty Spożywczy i Mięso Wędliny Spożywczy Spożywczy Warzywa Spożywczy Syrena Świerczewski Stella Sport Turist Sport Turist Spum Auto Serv Sprzęt Zmechan Sawa Świt Szpilki Skala Serdikal Spożywczy Sam Spożywczy Spożywczy Spożywczy Spożywczy Spożywczy Spożywczy Spożywczy Stocznia Ustka Sprzęt Zmech Sam Sadyba Syrenka Spożywczy Spożywczy Stołówka Sgpis Sklep Spożywczy Spożywczy Stołówka Uniwersyt Służew Nad Dolinką Samosia Sezam Sklep Nocny Spożywczy Spożywczy Straż Pożarna Sklep Mazursk Salamandra Spożywczy Szyldy Spożywczy Spożywczy Złota Rybka Sanatorium Nałęczów Spun Auto Service Syrena Spółdz Dom Handlowy Fenix Sam Syrenka Stomil Sam Stadion Wks Gwardia Sam Sery Społem Straż Pożarna Stołeczne Przed Spożywcze Sklep Spożywczy Spożywczy Sam Sam Sam Sam Sam Sklep Wiejski Sam Szandar Młodych Stolbud Spółdzielnia Spółdz Inwalid Stacja Obsługi Syrena Sport Skala Soutransauto Szecherezda Sp Inw Saturn Sp Świt Teatr Narodowy Tkaniny Dekoracyjne Telimena Tamara Tekstylia Totalizator Sport Tkanina Tor Łyżwiarski Teatr Ateneum Teatr Rozmaitości Teatr Współczesny Teatr Powszechny Teatr Dramatyczny Teatr Buffo Telmet Transpol Torav Teatr Baj Transbud Tkaniny Tkaniny Otex Truskawka Tkaniny Dekoracyjne Techmozbyt Teatr Ateneum Teatr Na Targówku Tokaj Teatr Nowy Trybuna Ludu Tysiąc i 1 Drobiazgów Tramp 1001 Drobiazgów Teatr Syrena Twp Teatr Kwadrat Totalizator Sport ToTo To To Trasa Łazienkowska Teatr Miejski Ubiory U Matysiaków Usługi Jubilenskie Upominki Uniwersum Ubiory Upominki Ubiory Dzieciqce Ubiory Porcelana Urząd Poczty Unitra Unizet Unitra Unitra Upominki Usługi Pralnicze Usługi Pralnicze Usługi Pralnicze Usługi Pralnicze Pralnicze Usługi Usługi Usługi Usługi Usługi Pralnicze Usługi Pralnicze Usługi Usługi Usługi Pralnicze Oczyszczenie Futer Unitra Uniwersum Warel Usługi Krawieckie Uniwersam Grochów Usługi Elektromech Usługi Radiotech Usługi Krawieckie Uroda Usługi Pralnicze Usługi Pralnicze Ubiory Okrycia Usługi Pralnicze Urwis Usługi Pralnicze Uniwersus Uniwersam Ursus Unitra Polkolop Usp Uniwersam Uniwersum Warzywa Owoce Warzywa Owoce Wss Winnica Warel Wnu Wish Wem Vinimpex Waryński Warsowin Wss Społem Spożywczy Wsk Warzywa Owoce Weronika Wędliny Warzywa Warzywa Owoce Przetwory Vis Fabryka Tarcz Ściernych Wojewódzka Spółdzielnia Mleczarska Vis Zakład Narzędzi Vinimpex Wkd Veritas Wss Społem Wenecja Wish Wista Vis Kurczak Kolumna Transportu Sanitarnego Kombinat Instalacji Sanitarnych Węgierski Instytut Kultury Wizytówki Zakłów Przemysłowych Woli Wagons Lits Cook Warta Warmet Warzywa Owoce Warzywa Owoce Warzywa Owoce Warmet Vitropol Wydawnictwo Mon Waryński Waryński Warmet Wfts Vita Medicka Wars Wkd Vinimpex Wish Warzywa Owoce Wedel Warszawskie Huty Szkła Wamel Warszawska Fabryka Mydła Wiejski Dom Handlowy Warszawianka Wenecja Varimex Warzywa Jw Wojskowa Centr Handl Veritas Wedel Wygrodzenie Torowiska Zuch Znak Firowy Zodiak Żywiec Beer Złota Kaczka Znakomite Cukierki Społem Zdrój Zegarki Zwut Zwp Zegarki Radz Zurt Zabawki Zurt Zremb Zakłady Mięsne Zwar Zabawki Zurt Zpbk Zremb Zegarki Nrd Złoty Róg Zakłady Mięsne Zurt Rtv Zurtegarmistr Zwar Zakład Mleczarski Praga Zakład Mleczarski Zdy Przem Cukierniczego 22 Lipca Zremb Zesp Szkół Zaw Zegarek Zoliborzanka Zurt Zodiak Zelos Ziemia Sądecka Zakłady Mebli Artyst Zajazd Nadarzyński Zajazd Napoleoński Zegarki Radzieckie Znp Zdy Przem Turystycznego

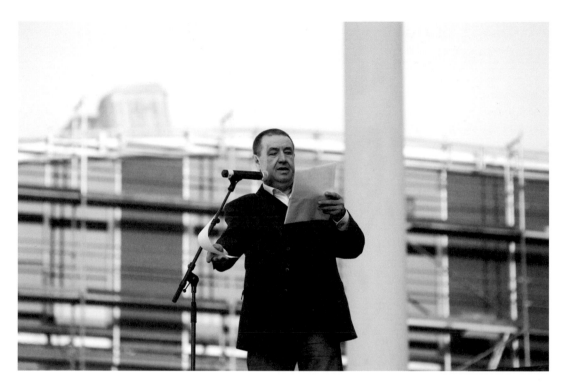

# Michael Schuster
# AUFEINWORT

**Hauptplatz, City Hall**
**Published in daily and weekly newspapers and art magazines:**
**Camera Austria, Graz; Der Standard, Wien; Kleine Zeitung, Graz**

**Reinhard Braun**
**A Political Language Game**

Michael Schuster's contribution to the second part of the exhibition project *Utopia and Monument* is both self-evident and in need of explanation. The lettering "AUFEINWORT" (can I have a word with you), is prominently displayed in one-meter-high letters on the Graz Town Hall balcony facing the main square, which glow in ever-changing colors at night.

Schuster's intervention is simultaneously a textual work, a sculpture, a form of communication and an installation. It has it origins in works for institutional spaces that are translated for their presence in public space. In this space – or rather in this translation – lies the need for an explanation for this work, which nevertheless still distinctly appears to be making a statement. After all, "Can I have a brief word with you?" is a challenge to submit oneself to argumentation, to listen to something, to be taken aside in order to learn something; there is a surplus of information, knowledge, rumors. There is a need for an explanation, for clarification, for adjust-ment/puttingcorrection. But who is talking? Who is taken aside? Who is addressed? How did this need to speak arise in the first

place? And why are these questions being presented to the public?

The façade of Graz Town Hall is certainly a boundary (both representative and satiated with historical vanishing lines) in the space of any city: a façade in which the public sees a reflection of the way it is being governed and administered; a façade that separates the political level from that of the mere everyday and public levels; a façade which, however, equally embodies a surface of projection surface for demands made on politicians (which is why most demonstrations end at the main square, and the town hall becomes the stage for appeals to politicians).

Michael Schuster's sculptural intervention thus marks the boundary between various publics, inter-relating them in a way that reveals their mutual involvement (or the lack of such involvement). With his intervention, Schuster thematizes the question of political communication, political forms of representa-tion that penetrate the public domain and vice versa: forms of presentation of the public that penetrate the political sphere: There are

always slogans, puns, language games, and language as performative "material," all of which have marked the history of political conflicts: On banners and in repetitive chants, the (minority) voice is supposed to assert itself against a hegemonic one; election posters, on the other hand, demonstrate – in a manner seldom convincing – the power of language as political performance.

*AUFEINWORT* translates/transfers the role played by language in debates over politics and the public into an installational-sculptural form, and treats language (and light) as sculptural material, so to speak. Michael Schuster borrows the means for this politicization of the façade of the town hall from both conceptual and minimalist sculptural strategies. Both reference systems permeate collectively Schuster's work, which is characterized by his analytically and reductively processing media-specific elements of art production.

The series of neon cut-out, negative letters started during the past few years exemplarily summarizes this interest in colour, script and sculpture. For instance, the words *"CYAN MAGENTA YELLOW"* (the primary colors of printing technology), appear on a rear-lit black glass surface, with each being written in a different color. (As a result, the relationship between the word and the colour representing it changes constantly). Furthermore, the lettering *"TO WHOM IT MAY CONCERN"* is displayed in these primary colors in an infinite variety of transitions. "Whoever feels concerned" – also an ironic reference to art audiences – is addressed in this work, which constantly changes its appearance, its formal qualities, to apparently constantly suit this audience. The formal reference to serial, minimalist sculpture also alludes to the –

historical – debate on the relationship between the form and its viewer and the generating on of meaning. By this precise interweaving of used material (text or, more precisely, typography, as the basis of text production, light and sculpture) Michael Schuster constantly broadens the scope of the debate to include changes in the bases of artistic production: the transition from analogue to digital printing; the question of text and typography in the age of Web 2.0.; the role of objects, which must be classed as classified as sculpture within the de-limited "operating system" of art, whose contexts have multiplied and can certainly no longer be reduced to formal questions.

In view of the obviousness of the linguistic conjuration, it is these levels in Schuster's work that demand explanation. The change in scale of the script – which corresponds to the size of the balcony's balustrade – as well as its profile and illumination, are measures related to this debate on the bases of art production and thus any reconsideration of the production possibilities open to art in public spaces. If the work addresses the public, it does so not only in the form of a request by seeking "to have a brief word" in a dialogue, but also by presenting the means with which art addresses the public: "to whom it may concern."

One thing is certain: the choice of this specific place lies in its central role in representing the political realm on behalf of urban public space; this is a role that is in danger of disappearing in the face of touristic interpretations of inner cities. In the 1970s, Michel Foucault formulated the basic question of the meaning of the local charac-ter of criticism, that of frequently disquali-fied, illegitimate and incoherent kind of

knowledge, and of how this form of knowledge could be brought into play in certified, authorized, public discourse.[1] It doesn't seem to be far-fetched to understand the lettering "AUFEINWORT" in the terms of the relationship between official and unofficial speech *at a specific place*, and to allow speech, debate and conflict as fundamental aspects of all public-political dimension. Do we feel addressed anyway, to speak for ourselves? In a certain way the work questions who actually talks to whom, what-about, and what is being said about whom. Is it also politics that takes us aside "for a brief word", to persuade us of a (political) reality? Should "we" rather not take politics [Vielleicht sollte man hier – wegen des Gegensatztes "we" and "them" –"politicians" schreiben, oder?] aside, to convince "themit" of "our" reality? The town hall with its main square certainly seems to be an appropriate place for raising these questions, and for posing these questions as public questions. What, then, is "our" share in the "word", in talking about our society? What role does art play in any case in questioning public space in this way? Does Michael Schuster's work identify a vacuum, a lack of involvement in this debate? Is art characterized by seizing such gaps and in rendering them visible? Whatever the case may be *AUFEINWORT* invites us to consider these and other questions as being public and publicly relevant.

The fact that this work was a sensitive issue within this complex of questions on the relationship between art, the public and politics, finally became apparent when permission was refused to realize his works in situ. Objections were raised: ostensibly it was a question of preserving historical building fabric, despite the fact that it had still been possible, in 2009, to put Dolores Zinny and Juan Maidagan's work on the same façade using the same constructional elements. One of the reasons given for opposing this action was that the Town Hall would, on principle, no longer be available for artistic interventions of this kind in the future. As a result, any discourse on the critical questioning and re-assignment of this central urban location within urban public space was will be blocked in the long run. This obviously also prevented prevents the very debate on art, public space and politics that Michael Schuster had sought to initiate with his work. Michael Schuster decided to continue by presenting his work via inserts in daily newspapers and weekly magazines – thus pretending the work to be realized in situ. as an advertisement-cum-montage in daily and weekly newspapers – as if it had already been realized. The illustrations thus confront urban reality (in the same way as the original intervention *in situ* had done) with its pitiful depoliticization as a space of consumption and entertainment that excludes the politicizing positions of the speaker, of all things. It does so by increasingly suppressing questions about the share of public speaking and about degrees of involvement in the construction of public space. *AUFEINWORT* could have at least invited people to consider these – and other – questions as being both public and publicly relevant.

---

1    Michel Foucault, *In Verteidigung der Gesellschaft* (Frankfurt/M: Surhkamp, 2001): 21.

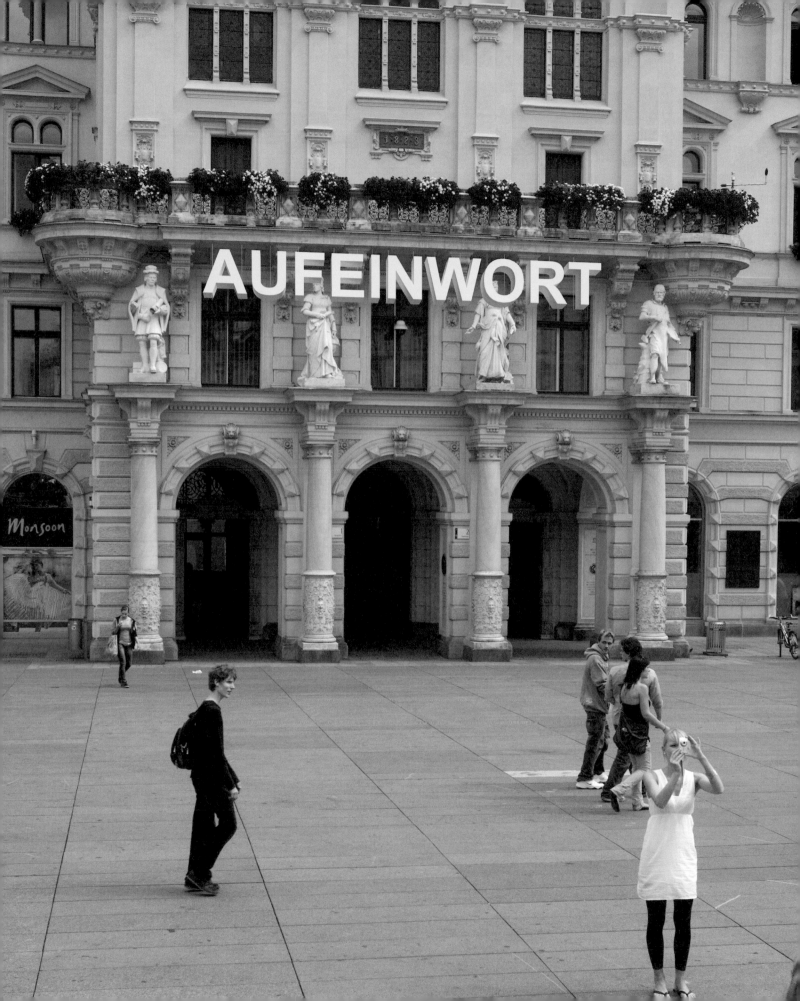

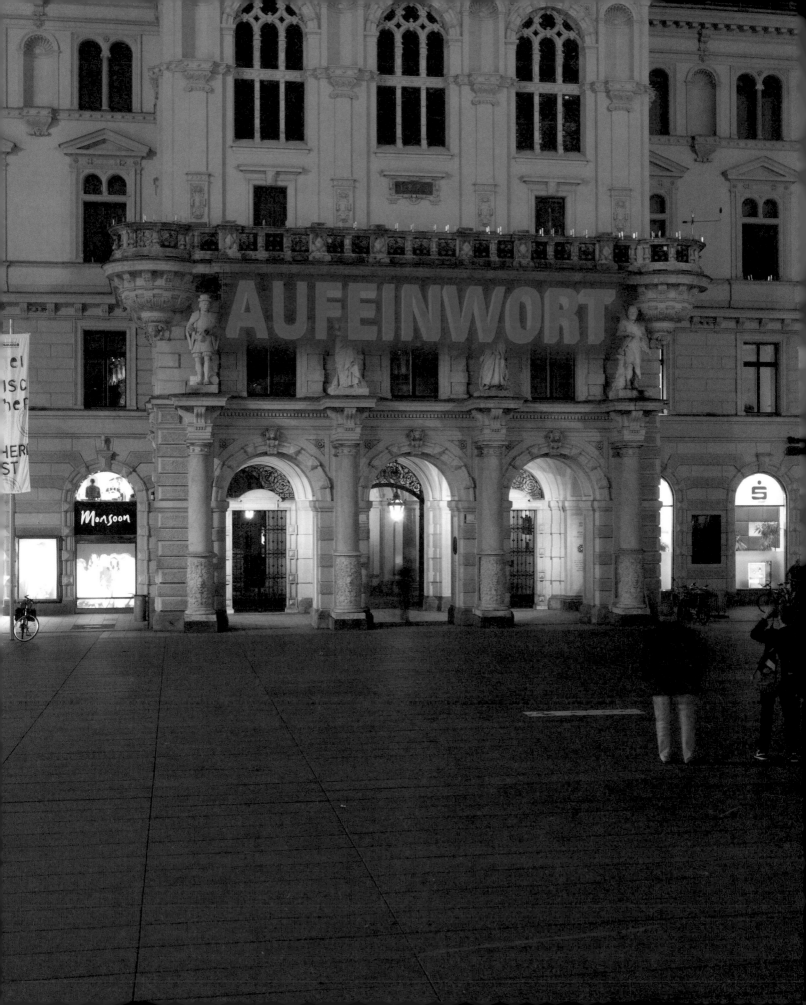

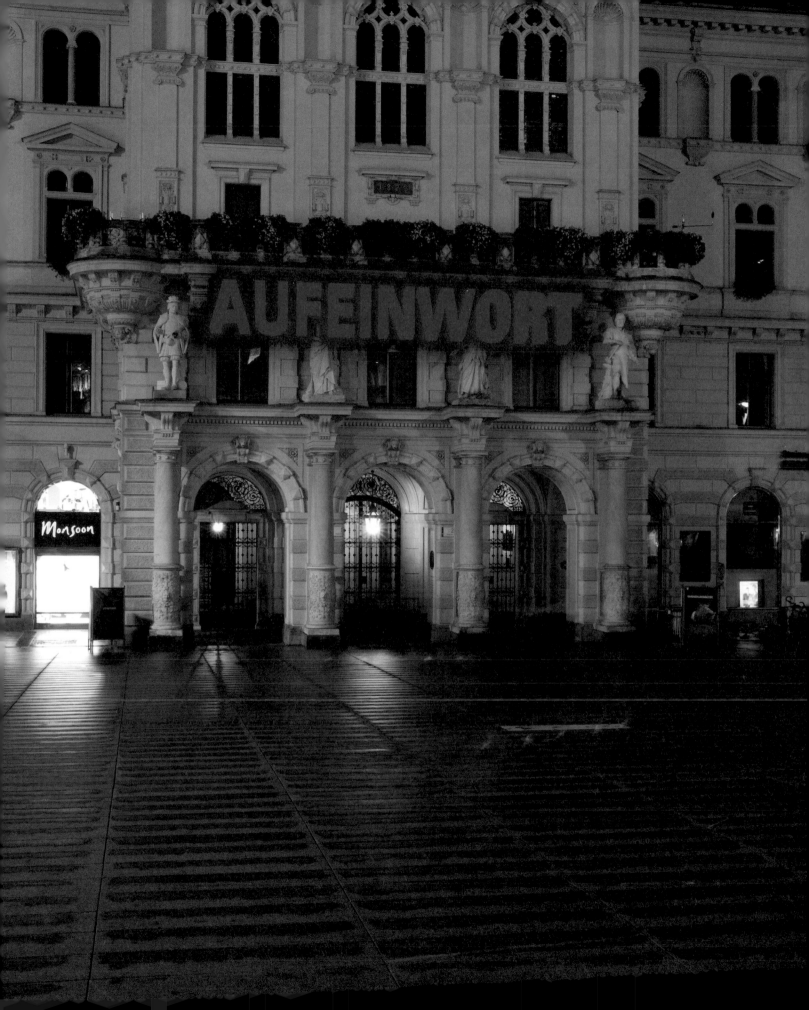

# List of Works

(Measurements in centimetres are expressed here in inches, height precedes width precedes depth)

## WORKS EXHIBITED AND PRODUCED IN 2009

### Lara Almarcegui

**Hidden Terrain with Abandoned Allotments, 2009**
Study on wastelands and allotments
Double-page insert in the daily newspaper *Kleine Zeitung*
Text by Lara Almarcegui and Anna Wood
Translation from German into English by Richard Watts
7 colour photographs by Lara Almarcegui
Graphic design based on the regular layout of *Kleine Zeitung*, executed by Atelier Neubacher, Graz
15 3/4 x 10 3/4 in.

Körösistraße 30
Kleine Zeitung, 25 September 2009, Graz

### Nairy Baghramian

**Construction Helper, 2009**
Two-part sculpture
Outdoor part ("stand"): varnished steel, concrete (core), steel chain
Element 1: 39 3/8 x 9 1/8 x 65 in.
Element 2: 32 1/2 x 9 1/8 x 72 3/4 in.
Inside part ("platform"): casted rubber
55 1/8 x 70 7/8 in.
Production: interzone, Berlin

Tram station "Südtirolerplatz" and lobby
Kunsthaus Graz

### Ayse Erkmen

**Pleasant Corners, 2009**
10 installations
Aluminium composite boards, varnished in different colors
Production: eeza, Graz

Signal green, 181 1/8 x 23 5/8 in.
Burggasse, Dom, street pole

Luminous yellow, 98 1/2 x 23 5/8 in.
Esperantoplatz, street lamppost

Chartreuse, 126 x 23 5/8 in.

Jakominiplatz, overhead line mast

Heather violet, 94 1/2 x 63 in.
Karmeliterplatz, street sign

Sun yellow, 94 1/2 x 145 5/8 in.
Künstlerhaus Burgring, ventilation of basement garage

Distant blue, 59 x 59 in.
Mariahilferplatz, plant pot

Telemagenta, 110 1/4 x 27 5/8 in.
Schlossbergplatz, lamppost

Light blue, 94 1/2 x 74 3/4in.
Schlossberg, Clock Tower, staircase

Sulfur yellow, 100 3/8 x 47 1/4 in.
Südtirolerplatz, Weikhartuhr

Melon yellow, 98 3/8 x 59 in.
Volksgarten, lamppost

### Kooperative für Darstellungspolitik (Jesko Fezer, Anita Kaspar, Andreas Müller)

**Pavilion, 2009**
Multifunctional installation
Metal scaffolding of standard elements, timber girder construction, yellow wooden formwork sheets, red and green inkjet print
Integration of various municipal facilities such as lamppost, park bench, coffee shop and toilets at bath, public library
Lower construction: 405 1/2 x 267 3/4 x 110 1/4 in.
Superstructure/pavilion: 385 3/4 x 236 1/4 x 98 1/4 in.

*Art and public space. An exhibition as unfinished collage:*
Exhibition, arranged and composed in images and texts by Sabine Breitwieser, in cooperation with Reinhard Braun
Editorial work by Edith Hochegger
Graphic concept by Studio Matthias Görlich (Matthias Görlich, Miriam Rösch)

Printed on the inner surface of the pavilion walls
Print: Repro Team GmbH

Reading zone and website at the adjacent public library:
Reference library with publications on the exhibition topic and the artists
Internet terminal with links to http://off site.kulturserver-graz.at/ and numerous other websites to relevant projects on art and public space
Production: eeza, Graz

Platz der Freiwilligen Schützen / Bad zur Sonne

### David Maljkovic

**Untitled, 2009**
Installation
Construction board, steel, concrete, print on aluminium
Illustration: photo montage of the site Pfauengarten with images of the memorial site for Yugoslavian partisans designed by Vojin Baki at Petrova Gora, Croatia
Construction board: 163 3/4 x 163 3/4 in.
Image: 78 3/4 x 157 1/2 in.
Production: Porr GmbH

Karmeliterplatz/Pfauengarten

### Heather & Ivan Morison

**Du vergisst Dinge, 2009 (You forget things)**
Mail art
Edition of 2000 postcards, die stamping on cardboard
Postcard: 5 3/8 x 5 3/8 in.
Envelope: 5 1/2 x 5 1/2 in.
Production: The Oak Diestamping and Engraving Co Ltd, Birmingham/GB

Mailing to 1800 contacts of steirischer herbst database and 200 contacts provided by Sabine Breitwieser, all selected by chance

**Nils Norman**

**Public Workplace Playground Sculpture for Graz, 2009**
Installation
OSB-boards, industrial pipe, wooden structure, roof planted with agaves, oil barrel, stovepipe
Installation on an empty concrete platform
944 7/8 x 1394 3/4 x 1732 3/8 in.
Production: eeza, Graz

Volksgarten

**Andreas Siekmann**

**Trickle Down. The Public Space in the Age of Its Privatization, 2007/2009**
Four-part installation
Sphere-shaped sculpture of compressed fibreglass elements (city mascots), painted
149 5/8 x 149 5/8 x 149 5/8 in.

Skip compactor, metal, spray-painted
96 7/8 x 98 3/8 x 289 3/8 in.
Banner, textile, printed
2185 x 27 1/2 in.
Glossary and interview by Alice Creischer and Andreas Siekmann with Werner Rügemer as handout on the site and download from the website of steirischer herbst
Production banner: eeza, Graz
Sculptures produced for *skulptur projekte münster '07*
Sculptures: collection of the artist, courtesy Galerie Barbara Weiss, Berlin

Landhaushof, Herrengasse 16

**Michael Zinganel**

**The City Speaks! A Fictitious Dialogue, 2009**
Discursive city tour published in the exhibition guide
Text, drawings and city maps

Text by Michael Zinganel
Drawings and maps by Barbara Heier
Offset print
7 7/8 x 3 7/8 in., 52 pages, staple-binding
German and English edition
Print run of 2000 in German and 2000 in English

Available for free at the "dummy salesman" at all exhibition sites and at various locations in Graz.
Exhibition guide enclosed in the catalogue

**Dolores Zinny & Juan Maidagan**

**Curtain Call for Graz, 2009**
Installation
Construction of steel girders, satin drapery in the colours beige, gold, grey, black, silver, white, sewed and strengthened
472 1/2 x 393 3/4 x 39 3/8 in.
Production: eeza, Graz

Hauptplatz 1, City Hall, portico

## WORKS EXHIBITED AND PRODUCED IN 2010

**Armando Andrade Tudela**

**Project for Pergola, 2010**
Installation
2 "walls," galvanized punched metal plate
252 x 78 3/4 x 3 1/4 in. each
2 "frames," steel profile, varnished red
295 1/4 x 78 3/4 x 1 1/8 in. each
Production: Hermann Schapek, Graz

Roseggergarten, Pergola

**Kader Attia**

**The Myth of Order #1, 2010**
Intervention with Couscous
Video screening
4 videos, colour, 25 sec each
Recording, editing: Katja Heiden
Kindly supported by Infoscreen Austria Gesellschaft für Stadtinformationsanlagen GmbH, Wien

Information screens at Jakominiplatz and in the tramways

**Angela Ferreira**

**Cape Sonnets, 2010**
Sound sculpture
Steel base plate, tower construction made from raw round timber, loudspeakers, sound system
Base plate: 78 3/4 x 78 3/4 in.
Tower construction: 299 1/4 x 59 x 59 in.
Broadcast of one of six lyrics of Peter Blum's *Cape Sonnets* (born 1925 in Triest,1937 emigration to South Africa, died 1990 in London).
Translation from a Afrikaans into English by Marji Geldenhuys (ZA)
Translation from English into German by Andreas Schachermayr
Speakers: Basil Appollis, Joachim Bernauer and Marji Geldenhuys
Lyrics advisor: John Mateer
Radiographic technique: 6 CDs 15 min each, WAV 24 bits, 44.1 KHz
Production of the sculpture: eeza, Graz
Thanks to Basil Appolis, Alexandra Baudouin, Jürgen Bock, Marji Geldenhuys, Paul Grendon, Prof. J.C. Kannemeyer, John Mateer, Roger Meintjes, Prof. Gerrit

Olivier, Louisa Sherman, Prof. Wium van Zyl, as well as Peter Blum for his work crossing languages, cultures and politics.

Volksgarten, daily at every full hour between 10 a.m. and 6 p.m.

**Andrea Fraser**

**You Are Here, 2010**
Maps at the sites of the works of the exhibition
Large map: sign board at Tummelplatz
33 1/8 x 46 3/4 in.
9 smaller maps: smaller sign boards at Andreas-Hofer-Platz, Jakominiplatz, Hauptplatz, Herrengasse, Mariahilferplatz, Pfauengarten, Roseggergarten, Südtirolerplatz, Tummelplatz
23 3/8 x 33 1/8 in. each
Information design (maps) by Wolfgang Gosch and Georg Liebergesell
Production sign boards: eeza, Graz

All exhibition project sites

**Exhibition Guide, 2010**
Offset print
7 7/8 x 3 7/8 in., 47 pages, staple-binding
German and English edition
Print run of 4000 in German and 2000 in
    English
Graphic design by Susi Klocker
Production management by Nina Krick

Available for free at the "dummy salesman"
    at all exhibition sites and at various
    locations in Graz.
Exhibition guide enclosed in the catalogue.

**sozYAH (Sabine Haring, Anja Eder)
Center for Social Research, Depart-
ment of Sociology, University of Graz**

Research Report You Are Here, 2010
Interdisciplinary research project based on a
    proposal by Andrea Fraser
87 pages, German and English edition.

German abstract available at the exhibition
    pavilion at Tummelplatz and as download
    on the website of steirischer herbst:
    www.steirischerherbst.at/2010/UM_en

**Isa Genzken**

**Clothesline (Dedicated to Michael
Jackson), 2010**
Multi-part installation
2 display cases
Stainless steel, glass, concrete base
116 1/8 x 30 3/8 x 30 3/8 in. each
2 wheelchairs cut to fit in the display cases
Blue perlon rope stretched over the square
    from two buildings, six suspended objects
Pegs, laminated photographs, PE-foil, PE-
    canvas, picnic rug, waxed tablecloth,
    spray-painted
Measurements variable
Production: Isa Genzken
Collection of the artist, courtesy Galerie
    Buchholz, Berlin-Köln

Mariahilferplatz

**John Knight**

**Lange Tage der Freizeit, 2010
(Long days of leisure)**
A work in situ

Herrengasse, 46 flagpoles

**Jutta Koether**

**Demons for Ladies, Gentlemen and
Children, 2010**
Multi-part installation
Existing and temporary tramway shelter,
    acrylic on canvas, various materials, epoxy
    resin
Tramway shelter: 98 3/8 x 157 1/2 x 47 1/4
    in. each
Acryl painting: 35 3/8 x 78 3/4 in.
Sales booth #15, Hauptplatz, side window,
    acrylic on canvas, various materials, epoxy
    resin
Side window: 23 5/8 x 55 1/8 in.
Acryl painting: 23 5/8 x 31 1/2 in.
Temporary tramway shelter kindly provided
    by Ankünder, Graz

Tramway stop "Südtirolerplatz"
Hauptplatz, sales booth #15

**Kooperative für Darstellungspolitik
(Jesko Fezer, Anita Kaspar, Andreas
Müller)**

Pavilion, 2010
Timber girder construction, yellow wooden
    formwork sheets, red and green inkjet
    print
519 3/4 x 433 1/8 x 98 3/8 in.
Container 8'
80 3/4 x 82 3/4 x 95 3/4 in.
Production: eeza, Graz

**IZK, Institute for Contemporary Art,
University of Technology Graz
Course students "Designing specialized
subjects" and "Art and the public
sphere."**

Raumtraum, 2010
(Space dream)
Artistic and spatiale interventions at the
    pavilion
Participants: Kathrin Bart, Peter Rudolf,
    Franz Baumann, Johanna Doris Binder,
    Theresa Götzfried, Andrea Kalcher,
    Alexander Kampits, Sarah Kandlhofer,
    Stefan Kral, Georges Majer, Pia Pöllauer,
    Emmy Anna Rauscher, Martina Ribic,
    Andreas Rogala, Paul Rossi, Carina Stabel,
    Lisa Thrainer, Elisabeth Maria Weber,
    Mario Weisböck, Karl Zrunek and Lisa
    Zvetolec
Project assistants: Claudia Genger, Lisa
    Obermayer and Maurice Rigaud
Project management: Ruby Sircar

Presentation of the works of the students:
    30 Sept., 7 and 14 Oct., at 5 p.m.
Course on Utopia and Monument II:
    11–23 Oct.
Further information: www.izk.tugraz.at

**Installations and projects**

Lisa Obermayer and Maurice Rigaud
Blao, 2010
Three-part performance

Mario Weisböck
Bitte Kunst einwerfen!, 2010
(Post art please!)
Display case, acrylic glass, yellow wooden
    formwork sheets
Kindly supported by Acrylstudio Wien

Johanna Binder, Alexander Kampits, Andreas
    Rogala, Carina Stabel and Elisabeth
    Weber
[gelbsucht], 2010
([jaundice])
Signage, yellow wooden formwork sheets

Claudia Genger
Lesbar, 2010
Graphic design on yellow wooden formwork
    sheets

Pia Pöllauer, Emmy Rauscher and Karl
Zrunek
Joy Drops, 2010
Book bags, PVC-balloons

Georges Majer
King Size Bed, 2010
Yellow wooden formwork sheets, pneumatic
element

Kathrin Bart, Andrea Kalcher and Sarah
Kandlhofer
Seat islands, 2010
Truck-canvas, polystyrene
Kindly supported by Reststofftechnik GmbH,
Henndorf and Sattler AG, Graz

Peter Baumann and Lisa Thrainer
Skinsideout, 2010
Seats, yellow wooden formwork sheets

Stefan Kral, Martina Ribic and Lisa Zvetolec
Tacked, 2010
Performance, graphic intervention

Theresa Götzfried and Paul Rossi
Da, 2010
Marking

Tummelplatz

**Paulina Olowska**

**Natasza, Workers Canteen and Flowers,
2010**
Installation
Three reconstructed neon signs from
Warszawa
„Babushkas:" store chain "Natasza," Aleje
Jerozolimskie, Warszawa, about 1970
51 1/8 x 78 3/4 in.
"Cow": milk bar "Bambino," 21 Krucza Ulica,
Warszawa, about 1960
78 3/4 x 149 5/8 in.
"Bouquet of flowers:" flower shop, Aleje
Jerozolimskie, Warszawa, 1950s/60s
55 1/8 x 98 3/8, two parts
Production: Reklama, Warszawa/Poland

**Onethousandsixhundredseventeen
Neons in Warszawa, 2010**
Performance, 23 September 2010, 6 p.m.
Reading of the complete list of neon signs
produced by the company "Reklama" in
the 1960s in Warszawa.
Public Rezitation: Ryszard Kałowski
In collaboration with the Polish Culture
Institute, Wien

Andreas-Hofer-Platz, roof of the gas
station/car park

**Michael Schuster**

**AUFEINWORT, 2010**
Installation (unrealized)
Polystyrene, LED-lighting, black painted
wooden construction
39 3/8 x 390 1/8 in.
Hauptplatz, city hall
Published during the exhibition duration in:
*Camera Austria*, art magazine, Graz
*Der Standard*, daily newspaper, Wien
*Kleine Zeitung*, daily newspaper, Graz
Kindly supported by *Kleine Zeitung* GmbH &
Co KG, Graz and *Der Standard* Verlags-
gesellschaft m.b.H., Wien

**Signage 2009 and 2010**
"Dummy salesmen"
Aluminium, plastics, printed site map
23 5/8 x 15 3/4 in.
Display for exhibition guide, available for
free
Graphic design by Susi Klocker, Wien
Production: Signum Siebdruck, St. Veit a.d.
Glan

# Short Biographies and Bibliographies of the Artists

**Lara Almarcegui**
1972 Zaragoza/E – Rotterdam/NL

Solo exhibitions
*Lara Almarcegui*, Secession, Wien/A, 2010
*Guide to Ruined Buildings in the Netherlands
   XIX-XXI Century*, Ellen de Bruijne
   Projects, Amsterdam/NL, 2008
*Bilbao Wastelands*, Cabineta, Sala Rekalde,
   Bilbao/E, 2008
*Colocation # Lara Almarcegui*, La Box,
   Bourges/F, 2008
*Lara Almarcegui*, Galería Pepe Cobo,
   Madrid/E, 2008
*Construction Materials of the Exhibition
   Room*, CAC, Malaga/E, 2007
*Lara Almarcegui*, FRAC Bourgogne, Dijon/F,
   2004
*Lara Almrcegui*, INDEX The Swedish Art
   Foundation, Stockholm/S, 2003.

Group exhibitions
3rd Moscow Biennial of Contemporary Art,
   Moskwa/RUS, 2009
*Utopia and Monument I*, steirischer herbst,
   Graz/A 2009
*Radical Nature*, Barbican Art Center,
   London/GB, 2009
2nd Athens Biennial 2009, Athen/GR, 2009
*Monument to Transformation*, Tranzit,
   Praha/CZ, 2009
7th Gwangju Biennale, Gwangju/ROK, 2008
*Estratos*, PAC Murcia, Murcia/E, 2008
8th Sharjah Art Biennial, Sharjah/UAE, 2007
BIACS 2, Sevilla/E, 2006
27. Bienal de São Paulo, São Paolo/BR, 2006.

Publications
Llorca, Pablo, "Lara Almarcegui," *Artforum*,
   New York/USA, 02/2009
*Guide to the Ruins in the Netherlands*, Rotter-
   dam/NL, 2008
*L'art, le territoire, espace public, urbaine*,
   Lyon/F, 2008
*Guide to Al Khan. An empty village in the city
   of Sharjah*, Sharjah/UAE, 2007
*Design and Landscape for People*, London/GB,
   2007
Kastner, J./Lippard, L.R./Maathai, W., *Land
   Art. A Cultural Ecology Handbook*,
   London/GB, 2006
*Guide of Wastelands São Paulo*, São Paolo/BR,
   2006
*Terrains Vagues de Amsterdam*, Lyon/F, 2002.

**Armando Andrade Tudela**
1976 Lima/PE – Berlin/D

Solo exhibitions
*ahir, demà*, MACBA, Barcelona/E, 2010
*Hier, Aujourd'hui, Demain, Aujourd'hui,
   Demain, Hier, Demain, Hier, Aujourd'hui*,
   FRAC Bourgogne, Dijon/F, 2010
*Torcida*, DAAD Galerie, Berlin/D, 2009
*Gamblers Die Broke*, Frankfurter Kunstverein,
   Frankfurt a.M/D, Kunsthalle Basel,
   Basel/CH, 2008
*Les Signaux de l'âme*, Annet Gelink Gallery,
   Amsterdam/NL, 2007
*Inka Snow*, Carl Freedman Gallery,
   London/GB, 2006
*Camión*, Carl Freedman Gallery, London/GB,
   2004.

Group exhibitions
*Utopia and Monument II*, steirischer herbst,
   Graz/A, 2010;
*Modernologies*, MACBA, Barcelona/E, 2009,
   Muzeum Sztuki Nowoczesnej w Warsza-
   wie, Warszawa/PL, 2010
*Yellow and Green*, MMK, Frankfurt a.M/D,
   2009
*Open Plan Living*, Helena Rubinstein Pavillon,
   Tel Aviv/IL, 2008
*Building, Dwelling, Thinking*, Laura Barlett
   Gallery, London/GB, 2008
*Autour de Max Bill*, Centre culturel suisse,
   Paris/F, 2008
9th Biennale de Lyon 2007, Lyon/F, 2007
27. Bienal de São Paulo, São Paolo/BR, 2006
*Tropical Abstraction*, Stedelijk Museum
   Bureau, Amsterdam/NL, 2005.

Publications
*ahir, demà*, Barcelona/E, 2010
Manacorda, Francesco, "Armando Andrade
   Tudela," *Kaleidoscope*, Milano/I, 5/2010;
*Modernologies*, Barcelona/E, 2009
*How to live together*, São Paolo/BR, 2006
*Inka Snow*, London/GB, 2006
Fox, Dan, "Armando Andrade Tudela," *Frieze*,
   London/GB, 102/2006
*Camión*, London/GB, 2004
Godfrey, Mark, "Andrade Tudela," *Frieze*,
   London/GB, 85/2004.

**Kader Attia**
1970 Dugny/F – Algier/AL, Berlin/D

Solo exhibitions
*Kasbah*, CCC, Tours/F, 2009;
*Po(l)etical*, Galerie Krinzinger, Wien/A, 2009;
*Signs of Reappropriation*, Acca Gallery of The
   Savannah College of Art and Design,
   Atlanta/USA, 2008;
*Black & White: Signs of Time*, Centro de Arte
   Contemporaneo Huarte, Huarte/E, 2008;
*Kader Attia: New Work*, Henry Art Gallery,
   Faye G. Allen Center for the Visual Arts,
   University of Washington, Seattle/USA,
   2008;
*Momentum 9: Kader Attia*, ICA, Boston/USA,
   2007;
*Square Dreams*, BALTIC Center for Contem-
   porary Art, Newcastle/GB, 2007;
*Kader Attia*, MAC Lyon, Lyon/F, 2006.

Group exhibitions
17th Biennale of Sydney, Sydney/AUS, 2010;
*Dreamlands*, MNAC, Centre Pompidou,
   Paris/F, 2010;
*Geo-graphics, A Map of Art Practices in
   Africa, Past and Present*, Palais des Beaux
   Arts, Bruxelles/B, 2010;
10th Havana Biennial, Havana/CU, 2009;
*La Force de l'art 02*, La Nef du Grand Palais,
   Paris/F, 2009;
*Time out of Joint : Recall and Evocation in
   Recent Art*, The Kitchen, New York/USA,
   2009;
*Notre Histoire*, Palais de Tokyo, Paris/F, 2006;
50. Biennale di Venezia, Venezia/I, 2003.

Publications
Banai, Nuit, „Kader Attia," *Artforum*, New
   York/USA, 09/2009;
Altman, Anna, „Never quite filling the Void :
   Kader Attia," *Art in America*, New
   York/USA, 07/2009;
Briegleb, Till, „10 Vorurteile über Kunst und
   Islam und was davon zu halten ist," *Art*,
   Hamburg/D, 12/2008;
*Signs of Reappropriation*, Atlanta/USA, 2008;
Ackermann, Tim, „Das Vokabular des
   Vandalismus," *die Tageszeitung*, Berlin/D,
   01/04/2008;
*Kader Attia*, Lyon/F – Grenoble/F, 2006;
*Notre Histoire*, Paris/F, 2006;
*Ateliers 1997-2002 – Collectif*, Paris/F, 2005.

**Nairy Baghramian**
1971 Isfahan/IR – Berlin/D

Solo exhibitions
*Nairy Baghramian and Phyllida Barlow*,
  Serpentine Gallery, London/GB, 2010
*La lampe dans l'horologe* (with Janette
  Laverrière), 5th Berlin Biennale, Schinkel
  Pavillon, Berlin/D, 2008
*Ein semiotisches Haus, das nie gebaut wurde*,
  Neuer Aachener Kunstverein, Aachen/D,
  2008;
*The Walker's Day Off*, Staatliche Kunsthalle
  Baden-Baden, Baden-Baden/D, 2008;
*Everlasting layers of ideas, images, feelings, …*,
  Kunstverein Nürnberg, Nürnberg/D, 2007;
*Es ist ausser Haus*, Kunsthalle Basel,
  Basel/CH, 2006
*Die Geister mögen das Flanieren*, Galerie
  Christian Nagel, Köln/D, 2005;
*voluptuous panic*, Galerie Christian Nagel,
  Berlin/D, 2004.

Group exhibitions
*Yesterday's Tomorrows*, Musée d'art contem-
  porain de Montréal, Montréal/CDN, 2010;
*Utopia and Monument I*, steirischer herbst,
  Graz/A, 2009;
*Gespinst*, Museum Abteiberg, Mönchenglad-
  bach/D, 2009
*Entre deux actes – Loge de comédienne*,
  Kunsthalle Baden-Baden, Baden-Baden/D,
  2009;
*Pop-Up!*, Ludwig Forum für Internationale
  Kunst, Aachen/D, 2009
*Looking is Political*, Bergen Kunsthall,
  Bergen/N, 2009
*Marc Camille Chaimowicz "…In the Cherished
  Company of Others…,"* De Appel, Amster-
  dam/NL, Museum of Modern Art,
  Oostende/NL, 2008
*Draw a Straight Line and Follow It*, Tate
  Modern, London/GB, 2008
sculpture projects münster 07, Münster/D,
  2007.

Publications
Lorch, Catrin, "Nairy Baghramian," *Artforum*,
  New York/USA, 01/2009
*Entre deux actes – Loge de comédienne*,
  Baden-Baden/D, 2009
Rottmann, André, "The 5th Berlin Biennial,"
  *Artforum*, New York/USA, 06/2008
*The Walker's Day Off. Nairy Baghramian*,
  Baden-Baden/D, 2008
Rebentisch, Juliane, "Eine Reaktion auf
  Sebastian Egenhofer," *Texte zur Kunst*,
  Berlin/D, 72/2008
Hermes, Manfred, "Nairy Baghramian," *Frieze*,
  London/GB, 107/2007
*Who is in the house?*, Basel/CH, 2006
Ilka Becker, "Nairy Baghramian," *Texte zur
  Kunst*, Berlin/D, 59/2005.

**Ayse Erkmen**
1949 Istanbul/TR – Istanbul/TR, Berlin/D

Solo exhibitions
*Bluish*, Kunstverein Freiburg, Freiburg/D,
  2009
*Hausgenossen*, K21, Düsseldorf/D, 2009
*Weggefährten*, Hamburger Bahnhof, Berlin/D,
  2008
*Ayse Erkmen. Ups and Downs*, Yapi Kredi Art
  Gallery, Istanbul/TR, 2008
*Awesome*, Physics Room, Christchurch/NZ,
  2006
*Busy Colours*, SculptureCenter, Long
  Island/USA, 2005
*soaked*, Schirn Kunsthalle, Frankfurt a.M/D,
  2004
*Kuckuck*, Kunstmuseum, St. Gallen/CH, 2003
*Kein gutes Zeichen*, Secession, Wien/A, 2002.

Group exhibitions
*Utopia and Monument I*, steirischer herbst,
  Graz/A, 2009;
*Beyond These Walls*, South London Art
  Gallery, London/GB, 2009
9th Sharjah Biennial, Sharjah/UAE, 2009
*All-Inclusive. A Tourist World*, Schirn
  Kunsthalle, Frankfurt a.M/D, 2008
*Above-the-Fold*, Museum für Gegenwarts-
  kunst, Basel/CH, 2008
Folkestone Triennial 2008, Folkestone/GB,
  2008
*World Tale, Mixed Narrations*, Hacettepe
  University Art Museum, Ankara/TR, 2008
2nd Berlin Biennial, Berlin/D, 2001
La Biennale de Montréal 2000,
  Montréal/CDN, 2000
Skulptur. Projekte in Münster 1997,
  Münster/D, 1997
4th International Istanbul Biennial,
  Istanbul/TR, 1995.

Publications
*Hausgenossen*, Düsseldorf/D, 2009
*Weggefährten*, Berlin/D, 2008
*U2 Alexanderplatz 2006*, Berlin/D, 2006
*Kein gutes Zeichen*, Wien/A, 2002
*Shipped Ships*, Frankfurt a.M/D, 2001
*Hier da und Dort*, Singen/D, 2000
*Echolot*, Kassel/D, 1998
*Zuspiel*, Frankfurt a.M/D, 1996
Loreck, Hanne, "Verräumlichungen. Zu Ayse
  Erkmens neuen Arbeiten," *Texte zur
  Kunst*, Berlin/D, 16/1994.

**Angela Ferreira**
1958 Maputo/MOC – Lissabon/P

Solo exhibitions
*Double Lecture*, Carpe Diem, Lissabon/P,
  2010
*Werdmuller Centre and other Works*, Michael
  Stevenson Gallery, Cape Town/ZA, 2010;

*BNU*, Filomena Soares Gallery, Lissabon/P,
  2009
*Hortas na Auto-Estrada*, Museum of Neo-
  Realism, Vila Franca de Xira/P, 2009
*Hard Rain Show*, Museu Colecção Berardo,
  CCB, Lissabon/P, La Criée, Rennes/F, 2008
*For Mozambique*, Michael Stevenson Gallery,
  Cape Town/ZA, 2008
*Maison Tropicale*, 52. Biennale di Venezia,
  Portugal Pavilion, Venezia/I, 2007
*Random Walk*, Filomena Soares Gallery,
  Lissabon/P, 2005.

Group exhibitions
*Utopia and Monument II*, steirischer herbst,
  Graz/A, 2010;
*The Great Divide*, Art Gallery of New South
  Wales, Sidney/AUS, 2009
*Modernologies*, MACBA, Barcelona/E, 2009,
  Muzeum Sztuki Nowoczesnej w Warsza-
  wie, Warszawa/PL, 2010
*Maputo: A Tale of One City – Africa in Oslo
  Festival*, Oslo Museum, IKM, Oslo/N, 2009;
28. Bienal de São Paulo, São Paulo/BR, 2008
*Meridian House*, Frieze, Sculpture Park,
  London/GB, 2008
*Peripheral Vision – Collective Memory*,
  Museion, Bozen/I, 2008
*Front of House*, Parasol unit, London/GB,
  2008
6th International Istanbul Biennial,
  Istanbul/TR, 1999.

Publications
*Hard Rain Show*, Lisboa/P, 2008
*Maison Tropicale*, Lisboa/P, 2007
*Afterlife*, Cape Town/ZA, 2007
*Angela Ferreira. Em Sítio Algum / No Place at
  All*, Lisboa/P, 2003
*Zip Zap Circus School*, Cape Town/ZA, 2003
*In the Meantime*, Amsterdam/NL, 2001
House Maputo: an intimate portrait,
  Oporto/P, 1999
Williamson, Sue, *Resistance Art in South
  Africa*, New York/USA, 1990.

**Andrea Fraser**
1965 Billings, Montana/USA – Los
Angeles/USA

Solo exhibitions
*Andrea Fraser: Boxed Set*, Carpenter Center
  Gallery, Harvard University,
  Cambridge/USA, 2010
*Projection*, Galerie Christian Nagel, Berlin/D,
  2008
*Official Welcome*, performance, MOCA, Los
  Angeles/USA, Dia: Chelsea, New
  York/USA, MUMOK, Wien/A, 2005
*Andrea Fraser. Works: 1984 to 2003*,
  Kunstverein Hamburg, Hamburg/D, 2003
Dunkers Kulturhus, Helsingborg/S;

*An Introduction to the Sprengel Museum*,
Sprengel Museum, Hannover/D, 1998
*Inaugural Speech*, performance, InSITE97,
San Diego/Tijuana/MEX, 1997
*Ein Projekt in zwei Phasen / Project in Two
Phases*, Generali Foundation, Wien/A, 1995
*A Society of Taste*, Kunstverein München,
München/D, 1993
*May I Help You?*, with Allan McCollum,
American Fine Arts, Co., New York/USA,
1991
*Museum Highlights: A Gallery Talk*, perfor-
mance, Philadelphia Museum of Art,
Philadelphia/USA, 1989.

Group exhibitions
*Utopia and Monument II*, steirischer herbst,
Graz/A, 2010;
*Modernologies*, MACBA, Barcelona/E, 2009,
Muzeum Sztuki Nowoczesnej w Warsza-
wie, Warszawa/PL, 2010
*That was Then...This is Now*, P.S.1 Contempo-
rary Art Center, New York/USA, 2008
*Our Literal Speed*, ZKM, Karlsruhe/D, 2008
*The World as a Stage*, Tate Modern,
London/GB, 2007
*Why Pictures Now*, MUMOK, Wien/A, 2006
*Life, Once More*, Witte de With, Rotter-
dam/NL, 2005
*Big Bang*, MNAM, Centre Pompidou, Paris/F,
2005
*Body Display*, Secession, Wien/A, 2004
*The Museum as Muse: Artists Reflect*, MoMA,
New York/USA, 1999;
45. Biennale di Venezia, Austrian Pavilion,
Venezia/I, 1993.

Publications
Fraser, Andra, "Procedural Matters,"
*Artforum*, New York/USA, 06/2008
Fraser, Andrea, "Psychoanalyse oder Sozio-
analyse," *Texte zur Kunst*, Berlin/D,
68/2007;
Fraser, Andrea, "From the Critique of Institu-
tions to an Institution of Critique,"
*Artforum*, New York/USA, 07/2005
*Museum Highlights: The Writings of Andrea
Fraser*, Cambridge/USA, 2005
*Exhibition: New Video Work by Andrea
Fraser*, Vancouver/CDN, 2004
*Andrea Fraser. Works: 1984 to 2003*,
Hamburg/Köln/D, 2003
*Report / Bericht*, Wien/A, 1995
*Eine Gesellschaft des Geschmacks*,
München/D, 1993
Fraser, Andrea, *Woman 1/Madonna and Child
1506-1967*, New York/USA, 1984.

## Isa Genzken
1948 Bad Oldeslohe/D – Berlin/D

Solo exhibitions
*Isa Genzken: Open Sesame!*, Whitechapel Art
Gallery, London/GB, Museum Ludwig,
Köln/D, 2009
*Oil*, 52. Biennale di Venezia, German Pavilion,
Venezia/I, 2007
*Isa Genzken*, Secession, Wien/A, 2006
*Kinder filmen*, Galerie Daniel Buchholz,
Köln/D, 2005
*Empire Vampire*, Lenbachhaus, München/D,
2004
*Isa Genzken*, Kunsthalle Zürich, Zürich/CH,
2003
*MetLife. Isa Genzken*, Generali Foundation,
Wien/A, 1996
*Isa Genzken*, Kunsthalle Bremen, Bremen/D,
1993
*Everybody needs at least one window*, Palais
des Beaux Arts, Bruxelles/B, 1993,
Portikus, Frankfurt a.M/D, Renaissance
Society, Chicago/USA, et al., 1992.

Group exhibitions
*Utopia and Monument II*, steirischer herbst,
Graz/A, 2010;
*Modernologies*, MACBA, Barcelona/E, 2009,
Muzeum Sztuki Nowoczesnej w Warsza-
wie, Warszawa/PL, 2010
skulptur projekte münster 07, Münster/D,
2007
*Birds in a Park*, Galerie Daniel Buchholz,
Köln/D, 2007
50. Biennale di Venezia, Venezia/I, 2003
Documenta11, Kassel/D, 2002
7th International Istanbul Biennial,
Istanbul/TR, 2001
45. Biennale di Venezia, Venezia/I, 1993
documenta IX, Kassel/D, 1992
documenta 7, Kassel/D, 1982.

Publications
*Isa Genzken. Sesam, öffne dich! / Open,
Sesame!*, Köln/D–London/GB, 2009
*Isa Genzken. Ground Zero*, London/GB, 2008
*Oil*, Köln/D, 2007
*Isa Genzken*, Köln/D, 2006
*Isa Genzken*, London/GB, 2006
*Isa Genzken*, Innsbruck–Wien/A, 2006
*Isa Genzken. I Love New York, Crazy City*,
Zürich/CH, 2006
Buchloh, Benjamin, "All Things Being Equal:
Isa Genzken," *Artforum*, New York/USA,
09/2005
*Isa Genzken*, Köln/D, 2003
*Artists Imagine Architecture*, Boston/USA,
2002
*MetLife. Isa Genzken*, Wien/A, 1996

*Isa Genzken. Jeder braucht mindestens ein
Fenster / Everyone needs at least one
window*, Bruxelles/B–Chicago/USA–
Frankfurt a.M/D–München/D, 1992.

## IZK
Institut für Zeitgenössische Kunst, TU
Graz/A
The Institute for Contemporary Art, Depart-
ment for Architecture, University of
Technology Graz, researches interfaces
between contemporary artistic, design and
architectural practices. The students are
asked to gather new artistic, media and
spatial experiences, implementing those
into projects and exhibitions. The
institute focuses on how to work with and
in public space. The results have been
shown in various urban and rural settings:
in Graz, Bad Radkersburg/Gornja Radgona
and Lunz am See, as well as in exhibition
spaces such as Kunsthaus Muerz.
The IZK's current team is: Hans Kupelwieser
(Director), Annemarie Dreibholz, Nicole
Pruckermayr, Ruby Sircar, Claudia Genger,
Christian Hoffelner, Jasna Kuljuh, Lisa
Obermayer and Maurice Rigaud.

## Jutta Koether
1958 Köln/D – New York/USA

Solo exhibitions
*Trio: Lynda Benglis/Jo Baer/Jutta Koether*,
Van Abbemuseum, Eindhoven/NL, 2009
*Lux Interior*, Reena Spaulings Fine Art, New
York/USA, 2009
*New Yorker Fenster*, Galerie Daniel Buchholz,
Köln/D, 2008
*JXXXA Leibhaftige Malerei*, Sutton Lane,
Paris/F, 2008
*Änderungen aller Art*, Kunsthalle Bern,
Bern/CH, 2007
*Fantasia Colonia*, Kölnischer Kunstverein,
Köln/D, 2006
*I Is Had Gone*, Thomas Erben Gallery, New
York/USA, 2005
*Massen. Malerei und Versammlung*, Generali
Foundation, Wien/A, 1991.

Group exhibitions
*Utopia and Monument II*, steirischer herbst,
Graz/A, 2010;
*See This Sound*, Lentos, Linz/A, 2010
*Sonic Youth etc.: Sensational Fix*, Kunsthalle
Düsseldorf, Düsseldorf/D, et al., 2009
*Nothing is exciting. Nothing is sexy. Nothing
is not embarrassing*, MUMOK, Wien/A,
2008

*If I Can't Dance, I Don't Want To Be Part of Your Revolution Part II*, MoCA, Antwerpen/NL, 2007
*Bastard Creature*, Palais de Tokyo, Paris/F, 2007
*Whitney Biennial 2006*, Whitney Museum, New York/USA, 2006
*Vom Horror der Kunst*, Grazer Kunstverein, Graz/A, 2003.

Publications
Koether, Jutta, "Interview with Martin Kippenberger," in: *Martin Kippenberger. The Problem Perspective*, New York/USA, 2009, first publication in: *Martin Kippenberger. I Had a Vision*, San Francisco/USA, 1991
Koether, Jutta, "Von Manischem Materialismus," *Texte zur Kunst*, Berlin/D, 70/2008
*Jutta Koether*, Bern/CH–Köln/D, 2006
Koether, Jutta, *Desire Is War*, Köln/D–New York/USA, 2003
Koether, Jutta, *Kairos. Texte zur Kunst und Musik*, Berlin/D, 1996
*The Use of Pleasure. Die Neunziger*, Wien/A, 1994
*100% Malerei. Niemand ist eine Frau*, Köln/D, 1992
*Inside Job*, Graz/A, 1992
*koether: massen*, Wien/A, 1991
*The Köln Show*, Köln/D, 1990
*20 Minuten*, Köln/D, 1989
„f," Graz/A, 1987.

## John Knight
1945 Los Angeles/USA – Los Angeles/USA

Solo exhibitions
*Works in Situ, A Work in Situ*, Galerie Rüdiger Schöttle, München/D, 2008
*Cold Cuts*, EACC, Castelló/E, 2008
*John Knight*, Storm King Art Center, Mountainville, New York/USA, 2000
*John Knight*, American Fine Arts, Co., New York/USA, 2004
*John Knight*, Galerie Roger Pailhas, Marseille/F, 2002
*Bienvenido*, MCASD, San Diego/La Jolla/USA, 1990
*Enkele Werken*, Witte de With, Rotterdam/NL, 1990
*Treize Travaux*, Le Nouveau Musée, Villeurbanne/F, 1989.

Group exhibitions
*Utopia and Monument II*, steirischer herbst, Graz/A, 2010;
*How Many Billboards?*, MAK Center, Los Angeles/USA, 2010

*Modernologies*, MACBA, Barcelona/E, 2009, Muzeum Sztuki Nowoczesnej w Warszawie, Warszawa/PL, 2010
*...Concept Has Never Meant Horse.*, Generali Foundation, Wien/A, 2006
*Los Angeles 1955-1985: Naissance d'une capitale artistique*, MNAM, Centre Pompidou, Paris/F, 2006
*1965-1975: Reconsidering the Object of Art*, MOCA, Los Angeles/USA, 1995
*De Campagne / The Campaign*, Stroom Den Haag, Den Haag/NL, 1993
*Treize à la douzaine*, Palais des Beaux-Arts, Bruxelles/B, 1991
documenta 7, Kassel/D, 1982.

Publications
*In Vivo*, Albuquerque/USA, 2009
Sanders, Jay, "Jay Sanders reads John Knight," *Parkett*, Zürich/CH, 86/2009
*Modernologies*, Barcelona/E, 2009
Buchloh, Benjamin, "Counter-Propaganda," *Texte zur Kunst*, Berlin/D, 70/2008
*Cold Cuts*, Castelló/E, 2008
*L'emprise du Lieu*, Reims/F, 2007
Buchloh, Benjamin, "Who's afraid of JK," *Texte zur Kunst*, Berlin/D, 59/2005
*87°*, New York/USA, 2001
Buchloh, Benjamin, "Knight's Moves: Situating the Art/Object," in: *Neo-Avantgarde and Culture Industry*, Cambridge/USA, 2001
Rorimer, Anne, *New Art in the 60s and 70s: Redefining Reality*, London/GB, 2001
*De Campagne / The Campaign*, Bruxelles/B, 1996
*Treize Travaux*, Dijon/F, 1989
*Leetsoi*, Albuquerque/USA, 1988.

## Kooperative für Darstellungspolitik
Jesko Fezer, Anita Kaspar, Andreas Müller – Berlin/D

Solo exhibitions
*advocate / educate*, hfg ulm, Ulm/D, 2009.

Group exhibitions and related projects
*Utopia and Monument II*, steirischer herbst, Graz/A, 2010;
*Berlin Documentary Forum 1*, Haus der Kulturen der Welt, Berlin/D, 2010
*Utopia and Monument I*, steirischer herbst, Graz/A, 2009;
*An Atlas of Radical Cartography*, whitespace, Zürich/CH, 2010, Künstlerhaus Stuttgart/D, 2009
*In the Desert of Modernity. Colonial Planning and After*, Haus der Kulturen der Welt, Berlin/D, 2008

*Soziale Diagramme. Planning Reconsidered*, Künstlerhaus Stuttgart, Stuttgart/D, 2008;
*traurig sicher, im training*, Grazer Kunstverein, Graz/A, 2006
*Project Migration*, Kölnischer Kunstverein, Köln/D, 2005
*Now and Ten Years Ago*, KW, Berlin/D, 2005.

Publications
*An Atlas of Radical Cartography*, Los Angeles/USA, 2009
Miller, Daniel, "In the Desert of Modernity," *Frieze*, London/GB, 19/2008
Krasny, Elke, "Das Labor europäischer Modernefantasien," *Dérive*, Wien/A, 32/2008;
*Projekt Migration*, Köln/D, 2005
*Jetzt und zehn Jahre davor*, Berlin/D, 2005
*An Architektur. Produktion und Gebrauch gebauter Umwelt*, Berlin/D, 2002/2008.

## David Maljkovic
1973 Rijeka/HR – Zagreb/HR

Solo exhibitions
*David Maljkovic*, Sprüth Magers, Berlin/D, 2009;
*Out of Projection*, MNCARS, Madrid/E, 2009
*After the Fair*, Galerie Georg Kargl, Wien/A, Fondazione Morra Greco, Napoli/I, 2009
*Nothing Disappears Without a Trace*, ARCO, Madrid/E, 2009
*Retired Compositions*, Metro Pictures, New York/USA, 2009
*Scene for New Heritage Trilogy*, P.S.1 Contemporary Art Center, New York/USA, 2007;
*Almost Here*, Kunstverein Hamburg, Hamburg/D, 2007
*Scene for New Heritage*, Van Abbemuseum, Eindhoven/NL, 2005.

Group exhibitions
*Les Promesses du Passé*, MNAM, Centre Pompidou, Paris/F, 2010
Glasgow International Festival of Visual Art's Projects 2010, Glasgow/GB, 2010;
*Utopia and Monument I*, steirischer herbst, Graz/A, 2009;
*Modernologies*, MACBA, Barcelona/E, 2009, Muzeum Sztuki Nowoczesnej w Warszawie, Warszawa/PL, 2010
*Modern Ruins*, Kate MacGarry, London/GB, 2009
11th International Istanbul Biennial, Istanbul/TR, 2009
*Places to be*, Annet Gelink Gallery, Amsterdam/NL, 2009
5th Berlin Biennale, Berlin/D, 2008

*Eyes Wide Open*, Stedelijk Museum CS, Amsterdam/NL, 2008
*Magellanic Cloud*, MNAM, Centre Pompidou, Paris/F, 2007.

Publications
*The Art of Tomorrow*, London/GB, 2010
*Transitory Objects*, Köln/D, 2009
*Lost Review*, London/GB, 2008
Cerizza, Luca, "David Maljkovic," *Frieze*, London/GB, 110/2007
*David Maljkovic. Almost Here*, Hamburg/D, 2007
*Ground Lost*, Graz/A, 2007
*Magellanic Cloud*, Paris/F, 2007
*Again for Tomorrow*, London/GB, 2006
Heingartner, Douglas, "Mercury in retrograde," *Frieze*, London/GB, 100/2006
*Painting for everyday use*, Zagreb/HR, 2002.

## Heather & Ivan Morison
1973 Desborough/GB and 1974 Nottingham/GB – Brighton/GB

Solo exhibitions
*The Shape of Things to Come*, Situations, Bristol/GB, 2009
*I hate her. I hate her.*, Danielle Arnaud Contemporary Art, New York/USA, 2009
*The Land of Cockaigne*, Bloomberg Space, London/GB, 2007
*And so it goes*, 52. Biennale di Venezia, Wales Pavilion, Venezia/I, 2007
*Drowned Worlds*, Camden Arts Centre, London/GB, 2006
*Heather & Ivan Morison do not understand it*, IPS, Birmingham/GB, 2004
*Heather & Ivan Morison are spellbound*, Shrewsbury Museum & Art Gallery, Shrewsbury/GB, 2004.

Group exhibitions
*Utopia and Monument I*, steirischer herbst, Graz/A, 2009;
*Mythologies*, Haunch of Venison, London/GB, 2009
*Radical Nature*, Barbican Art Gallery, London/GB, 2009
*Paraisos Indomitos – Untamed Paradises*, MoCA, Vigo/E, 2008
*This Is The Gallery and The Gallery Is Many Things*, Eastside Projects, Birmingham/GB, 2008
Folkestone Triennial 2008, Folkestone/GB, 2008
British Art Show 6, Newcastle/Nottingham/Bristol/GB, 2006
Guanzhou Triennial, Guanzhou/RC, 2005

*Tempered Ground*, Danielle Arnaud Contemporary Art, London/GB, Museum of Garden History, London/GB, 2004;
*The Art of the Garden*, Tate Britain, London/GB, 2004.

Publications
*Falling Into Place by Heather & Ivan Morison*, Derry/GB, 2009
*Radical Nature*, London/GB, 2009
*Mythologies*, London/GB, 2009
*Paraìsos indomitos – Untamed Paradises*, Vigo/E, 2008
*Folkestone Triennial: Tales of Time and Space*, Folkestone/GB, 2008
*Tatton Park Biennal 2008*, Tatton Park/GB, 2008
*Thin Cities*, London/GB, 2008
*Beck's Futures 2006*, London/GB, 2006
*The Starry Messenger: Visions of the Universe*, Warwickshire/GB, 2006.

## Nils Norman
1966 Kent/GB – London/GB

Solo exhibitions
*Dave Hullfish Bailey & Nils Norman: Surrounded by Squares*, Raven Row, London/GB, 2009
*The University of Trash*, SculptureCenter, Long Island/USA, 2009
*You have been misinformed*, Reena Spaulings Fine Art, New York/USA, 2008
*A Mystery Thing*, Vilma Gold, London/GB, 2007
*Degenerate Cologne*, Galerie Christian Nagel, Köln/D, 2006
*The Homerton Playscape Multiple Struggle Niche*, City Projects, London/GB, 2005;
*Everything in the future will necessarily come. Corporate fairytales and other sculptural maneuvers*, Galerie für Landschaftskunst, Hamburg/D, 2004
*The Geocruiser*, University of Cambridge Botanic Garden, Institute of Visual Culture, Cambridge/GB, 2001.

Group exhibitions
*Utopia and the Everyday. Between Art and Education*, Centre d´Art Contemporain, Genève/CH, 2010
*Utopia and Monument I*, steirischer herbst, Graz/A, 2009
*Street Art, Street Life*, BxMA, New York/USA, 2009
*International '08*, Liverpool Biennial, Liverpool/GB, 2008

*STARSHIP various sketches for leaving the room*, Ludlow 38 Kunstverein, München/D, Goethe Institut, New York/USA, 2008
Folkestone Triennial 2008, Folkestone/GB, 2008
*How To Cook A Wolf – Terrible Video*, Kunsthalle Zürich, Zürich/CH, 2008
*The Happiness of Objects*, SculptureCenter, Long Island/USA, 2007
50. Biennale di Venezia, Venezia/I, 2003.

Publications
Graw, Isabelle, "Von hier aus. Über Köln-Mythen, Fremdbestimmung und Rückzugs- und Ausstiegsszenarien angesichts der gestiegenen Bedeutung von Leben," *Texte zur Kunst*, Berlin/D, 63/2006
*Make Your Own Life: Artists In & Out of Cologne*, Minneapolis/USA, 2006
Claydon, P./Cranwell, K./Norman, N., *An Architecture of Play. A survey of London´s adventure Playgrounds*, London/GB, 2004
Demos, T.J., "The Cruel Dialectic: On the Work of Nils Norman," *Grey Room*, Cambridge/USA, 13/2004
*Homeland*, New York/USA, 2003
*An Unofficial Statement*, Genève/CH, 2003
*The Contemporary Picturesque*, London/GB, 2000
Verwoert, Jan, "Nils Norman," *Springerin*, Wien/A, 04/2000.

## Paulina Olowska
1976 Gdansk/PL – Raba Nizna/PL

Solo exhibitions
*Accidental Collages*, Tramway, Glasgow/GB, 2010
*Shadow with a Sneak*, Pinakothek der Moderne, München/D, 2009
*Attention à la Peinture*, Galerie Daniel Buchholz, Köln/D, 2008
*Salty Water / What of Salty Water*, with Bonnie Camplin, Portikus, Frankfurt a.M/D, 2007
*Noël sur le balcon / Hold the Color*, with Lucy McKenzie, Sammlung Goetz, München/D, 2007
*Metamorphosis*, Museum Abteiberg, Mönchengladbach/D, 2005
*Metaloplastyka*, Galerie Daniel Buchholz, Köln/D, 2005
*She had to Reject the Idea of a House as a Metaphor*, Kunstverein Braunschweig, Braunschweig/D, 2004.

Group exhibitions
*Utopia and Monument II*, steirischer herbst, Graz/A, 2010;
*Early Years*, KW, Berlin/D, 2010
*Modernologies*, MACBA, Barcelona/E, 2009, Muzeum Sztuki Nowoczesnej w Warszawie, Warszawa/PL, 2010
*modern modern*, Chelsea Art Museum, New York/USA, 2009,
*Head-Wig (Portrait of an exhibition)*, Camden Arts Center, London/GB, 2009
5th Berlin Biennale, Berlin/D, 2008
*The Subversive Charme of the Bourgeoisie*, Van Abbemuseum, Eindhoven/NL, 2006
9th International Istanbul Biennial, Istanbul/TR, 2005
50. Biennale di Venezia, Venezia/I, 2003.

Publications
Decker, Julia/Liebs, Holger, "Ich kann Ihnen die Handlung Seite für Seite erzählen: Ein Interview mit Paulina Olowska," *Süddeutsche Zeitung Magazin*, München/D, 46/2009;
*Modernologies*, Barcelona/E, 2009
*Le Nuage Magellan*, Paris/F, 2007
*Salty Water / What of Salty Water*, Frankfurt a.M/D, 2007
*Noël sur le balcon / Hold the Color*, München/D, 2007
*Metamorphosis*, Frankfurt a.M/D, 2005
*Alphabet*, Köln/D, 2005
*Sie musste die Idee eines Hauses als Metapher verwerfen*, Köln/D, 2004.

## Michael Schuster
1956 Graz/A

Solo exhibitions
*For Your Information*, Neue Galerie, Graz/A, 2008
*Der Kurator*, Galerie Bleich Rossi, Graz/A, 2004
*Drombeg*, Camera Austria, Graz/A, 2002
*Fotografie als Spiegel*, Neue Galerie, Graz/A, 2000
*Dialektstudie I und II*, Neue Galerie, Graz/A, 1999, Galerie im Taxispalais, Innsbruck/A, 2000
*Schuster / Schneider*, Galerie & Edition Artelier, Graz/A, 1999
*K.C.C.P. in USA*, Galerie & Edition Artelier, Frankfurt a.M/D, Neue Galerie, Graz/A, MUMOK, Wien/A, 1993
*5 x SM 144-18*, Neue Galerie, Graz/A, 1990.

Group exhibitions
*Utopia and Monument II*, steirischer herbst, Graz/A, 2010;
*Medium Religion*, ZKM, Karlsruhe/D, 2008
BIACS 3, Sevilla/E, 2008
*Reading Back And Forth*, Stadtmuseum Graz, Graz/A, 2007
*Shandyismus. Autorschaft als Genre*, Secession, Wien/A, 2007
*Simultan*, Museum der Moderne, Salzburg/A, 2005, Fotomuseum Winterthur, Winterthur/CH, 2006
*Postmedia Condition*, Neue Galerie, Graz/A, 2005, ARCO, Madrid/E, 2006
*Occupying Space*, Haus der Kunst, München/D, Nederlands Fotomuseum, Rotterdam/NL, MSU, Zagreb/HR, 2005.

Publications
*Medium Religion*, Karlsruhe/D, 2008
*Shandyismus. Autorschaft als Genre*, Wien/A, 2007
*Simultan. Zwei Sammlungen Österreichischer Fotografie*, Salzburg/A, 2005
Draxler, Helmut, "Michael Schuster. Die Quadratur des Kreises," *Camera Austria*, Graz/A, 81/2003
*M_ARS – Kunst und Krieg*, Graz/A, 2003
*Variable Stücke. Strukturen. Referenzen. Algorithmen*, Innsbruck/A, 2002
*Re-Play. Anfänge internationaler Medienkunst in Österreich*, Wien/A, 2000
Brunner, Norbert/Schuster, Michael, *Dokumentarische Dialektstudie vom Fersental bis Garmisch-Partenkirchen*, Graz/A, 1982.

## Andreas Siekmann
1961 Hamm/D – Berlin/D

Solo exhibitions
*Verhandlungen unter Zeitdruck. Aus: Faustpfand, Treuhand und die unsichtbare Hand*, Städtische Museen Jena, Jena/D, 2010, Galerie Barbara Weiss, Berlin/D, 2008
*From: Limited Liability Company*, Gustav Lübcke-Museum, Hamm/D, 2010;
*Collateral in Hand, Treuhand, and the Invisible Hand*, Heidelberger Kunstverein, Heidelberg/D, 2006
*Max Mueller Bhavan*, Goethe-Institut, 11th Triennale India, New Delhi/IND, 2005
*The Exclusive Power. On the Policy of the Exclusive Fourth*, Salzburger Kunstverein, Salzburg/A, 2002

*Hier baut die Firma Petit à Petit...*, Statements, Art Basel, Basel/CH, 2001
*Limited Liability Company, 1996-1999*, Portikus, Frankfurt a.M/D, 1999
*Square of Permanent Reorganization*, Neuer Aachener Kunstverein, Aachen/D, 1997.

Group exhibitions
*Utopia and Monument I*, steirischer herbst, Graz/A, 2009;
*Modernologies*, MACBA, Barcelona/E, 2009, Muzeum Sztuki Nowoczesnej w Warszawie, Warszawa/PL, 2010
*Islands + Ghettos*, Kunstverein Heidelberg, Heidelberg/D, 2009
*The Way Things Are...*, Centrum Sztuki Współczesnej, Torun/PL, 2008
*Shrinking Cities*, 1st Moscow Biennale Architecture, Moskwa/RUS, 2008
documenta 12, Kassel/D, 2007
skulptur projekte münster 07, Münster/D, 2007
50. Biennale di Venezia, Venezia/I, 2003
documenta 11, Kassel/D, 2002
*Hier ist dort 2*, Secession, Wien/A, 2002.

Curated exhibition projects and publications (with Alice Creischer et al.)
*Principio Potosi*, MNCARS, Madrid/E, 2010
*Half Jacket – Half Human*, after the butcher, Berlin/D, 2007
*Ex-Argentina*, Museum Ludwig Köln, Köln/D, 2004, Goethe-Institut, Buenos Aires/AR, 2003
*Violence is at the Margin of All Things*, Generali Foundation, Wien/A, 2002
*Messe 2ok. ÖkonoMiese machen*, Köln/D, Amsterdam/NL, 1995.

Publications
Creischer, Alice/Siekmann, Andreas, "Als ob es tausend Stäbe gäbe und hinter tausend Stäben keine Welt," *Texte zur Kunst*, Berlin/D, 74/2009
*The Way Things Are...*, Torun/PL, 2008
*Dresden Postplatz*, Berlin/D, 2006
Siekmann, Andreas, "Collateral in Hand, Treuhand, and the Invisible Hand," in: *Shrinking Cities, Vol. 2*, Ostfildern-Ruit/D, 2005
*Hier ist dort 2*, Wien/A, 2002
*Wir fahren für Bakunin*, Köln/D, 2002
*Aus: Gesellschaft mit beschränkter Haftung*, Frankfurt a.M/D, 1999
*Platz der permanenten Neugestaltung*, Aachen/D, 1997.

**Michael Zinganel**
1960 Bad Radkersburg/A – Wien/A

Solo exhibitions
*Saison Opening*, kunstraum lakeside, Klagenfurt/A, 2005
*Stadt und Gewalt*, Haus der Architektur München, München/D, 2005
*Akte Langenhagen. Ein Projekt zur Spurensicherung in Kunst und Verbrechen*, Kunstverein Langenhagen, Langenhagen/D, 2004
*Michael Zinganel – Real Crime*, pro qm, Berlin/D, 2004
*Michael Zinganel*, Secession, Wien/A, 1998
*Michael Zinganel – Videoinstallationen*, Museum Abteiberg, Mönchengladbach/D, 1991;
*QWERTYUIOPASDFGHJKLZXCVBNM*, Grazer Kunstverein, Graz/A, 1991.

Group exhibitions and interdisciplinary projects
*Utopia and Monument I*, steirischer herbst, Graz/A 2009;
*Crossing Munich. Sites, representations and debates about migration in Munich*, Ludwig-Maximilians-Universität München, München/D, 2009
*Panic Room Karlsplatz or Tactics of Every Day Avoidance*, guided tour, Wien/A, 2008
*TOP of Experience. Art in Adventure Worlds*, symposium, conceptual design and architecture, with Peter Spillmann, Kunsthalle Luzern, Luzern/CH, 2007
*Real Crime Tour / Real Crime Walk*, guided tour, Wien/A, 2001–2006
*Crime City. Social Spread, Vandalism, Crime and the Culture of Metropolis*, discourse-performance, steirischer herbst, Graz/A, 2005
*Shrinking Cities*, GfZK, Leipzig/D, 2004/05
*Sex & Space II*, with Marion von Osten, Forum Stadtpark, Graz/A, 1997;
*Pension Stadtpark*, Forum Stadtpark, Graz/A, 1996.

Publications
Zinganel, Michael, "Crime does pay! The Structure-Building Power of Crime for Urban Planning and Urban Experience," in: *Open City*, Amsterdam/NL, 2009
Zinganel, Michael, "Vor lauter Thema verschwindet die Stadt! Stadtwanderungen zwischen Bildungsauftrag und widerständigen Lesarten," in: *Urbanografien*, Berlin/D, 2008
Zinganel, Michael, "Landscapes of Power," in: *Power and Space*, Zürich/CH, 2008
Zinganel, Michael, "Tourism, Shopping, Security, 3 Definitions," in: *skulptur projekte münster 07*, Münster/D, 2007
Albers, H./Sagadin, M./Zinganel, M., *Saison Opening*, Wien/A, 2006
Marschik, M./Müllner, R./Spitaler, G./Zinganel, M., *Das Stadion. Architektur, Politik, Ökonomie*, Wien/A, 2005
Zinganel, Michael, *Real Crime. Architektur, Stadt und Verbrechen*, Wien/A, 2003.

**Dolores Zinny & Juan Maidagan**
1968/1957 Rosario/AR – Berlin/D

Solo exhibitions
*Compartment – Das Abteil*, MMK Zollamt, Frankfurt a.M/D, 2009
*Instead of Heaven, Architecture*, Galerie Sabine Knust, München/D, 2009
*La Costa. El Ataque  Lo Mismo*, Sala Rekalde, Bilbao/E, 2007
*I have no revelations to offer you*, Galerie Sabine Knust, München/D, 2005
*Garden Concluded*, Museum für Gegenwartskunst, Siegen/D, 2004
*Semantic Gap*, Lund Konsthall, Lund/S, 2004
*Such a Good Cover*, DAAD Galerie, Berlin/D, 2003
*Untitled*, The Showroom, London/GB, 2003.

Group exhibitions
*Utopia and Monument I*, steirischer herbst, Graz/A, 2009;
7th Gwangju Biennial, Gwangju/ROK, 2008
5th Berlin Biennale, Berlin/D, 2008
*Exile of the Imaginary*, Generali Foundation, Wien/A, 2007
BIACS 2, Sevilla/E, 2006
10th Art Forum Berlin, Berlin/D, 2005
50. Biennale di Venezia, Venezia/I, 2003
*ForwArt a choice*, Bibliothèque Royale, Bruxelles/B, 2002
*Inside Space*, MIT List Visual Arts Center, Cambridge/USA, 2001.

Publications
*Compartment – Das Abteil*, Frankfurt a.M/D, 2010
*Monographic Book*, Bilbao/E, 2007
*Exil des Imaginären*, Wien/A, 2007
*The Unhomely*, Sevilla/E, 2006
*D.Zinny & J. Maidagan*, Lund/S, 2004
Gaensheimer, Susanne, "Understanding the work of D Z & JM," in: *The Showroom Annual 2003/04*, London/GB, 2004
*ForwArt a choice*, Bruxelles/B, 2003
*Fresh Cream*, London/GB, 2000.

**sozYAH**
Sabine Haring, Anja Eder – Graz/A

sozYAH is a research team formed at the Centrum für Sozialforschung of the Department of Sociology at University of Graz, in order to undertake a socio-scientific analysis for the project *You Are Here*, outlined and proposed by Andrea Fraser for the steirischer herbst 2010 festival's particular exhibition *Utopia and Monument II*.

# Short Biographies and Bibliographies of the Authors

**Jürgen Bock**
(born in 1962, lives in Lisboa, Portugal) is Director of the School of Visual Arts Maumaus in Lisboa and works as curator, publisher and writer. Exhibitions he has curated include the *CCB Project Room* in Lisbon 2000/2001, *From: Limited Liability Company* at the 2005 Triennial of India, New Delhi, and *Angela Ferreira, Maison Tropicale* for the Portuguese Pavilion, Biennale di Venezia (2007). He is the editor of the publication *From Work to Text – Dialogues on Practice and Criticism in Contemporary Art* (2002) and produced the artist's book *TITANIC's wake* by Allan Sekula (2003). In 2008 he produced the documentary film *Maison Tropciale*, directed by Manthia Diawara.

**Reinhard Braun**
is author and curator. Currently he is curator for Visual Arts at steirischer herbst festival, before he was curator and editor at Camera Austria, Graz. Since 1991 essays and exhibition projects in the field of practises of media art and photography with the focus on cultural implications of visual media. Last curatorial projects were *Common Affairs* (Graz: steirischer herbst, 2008), *Then the work takes place* (with Maren Lübbke-Tidow, Graz: Camera Austria, 2009), *talk talk. Das Interview als künstlerische Praxis* (with Marc Ries and Hildegard Fraueneder, HGB Leipzig; Kunstverein Medienturm, Graz; Galerie 5020 Salzburg, 2009/2010) and *Milk Drop Coronet* (with Maren Lübbke-Tidow, Camera Austria, Graz, 2010).

**Sabine Breitwieser**
is currently an independent curator, author and lecturer, lives in Vienna, Austria. In October she will start her new post as Chief Curator for Media and Performance Art at The Museum of Modern Art in New York. She is Secretary and Treasurer of CIMAM – the International Committee of ICOM (International Council of Museums) for Museums and Collections of Modern Art. From 1988 until 2007 she was the (Founding) Director and Curator of the Generali Foundation in Vienna for which she has built the institution, the program and an important collection published in the volumes *Exhibitions 1989-2007* (2008) and in *Occupying Space* (2003). She has curated numerous projects and edited as many publications on artists such as Dan Graham, Hans Haacke, Theresa Hak Kyung Cha, Andrea Fraser, Mary Kelly, Edward Krasi ski, Gordon Matta-Clark, Gustav Metzger, Adrian Piper, Martha Rosler, Allan Sekula. Her most important thematic projects are *Designs for the Real World*, *double life*, *RE-PLAY*, *vivencias/life experience* or *White Cube/Black Box*. Recent projects – additionally to *Utopia and Monument* for the steirischer herbst – are *Modernologies* presented at MACBA (2009) in Barcelona and at the Museum of Modern Art in Warsaw (2010), and *Which Life?*, in the frame of the "curatorial project" at the Academy of Fine Arts Vienna.

**Juli Carson**
is Associate Professor in the Studio Art Department at the University of California where she teaches Critical and Curatorial practice in Contemporary Art and directs the University Art Gallery. She was Curator of *Exile of the Imaginary: Politics, Aesthetics, Love* (Vienna: Generali Foundation, 2007). She also curated the archival exhibition accompanying Mary Kelly's *Post-Partum Document* (Vienna: Generali Foundation, 1998). Her essays on conceptualism and psychoanalysis have been published in *Art Journal*, *Documents*, *October*, *Texte zur Kunst* and *X-Tra*, as well as in numerous critical anthologies. She is currently completing her forthcoming book, *The Conceptual Unconscious: A Poetics of Critique*.

**Alice Creischer**
(born in 1960, lives in Berlin, Germany) studied philosophy and literature at the university and fine arts at the Kunstakademie, both located in Düsseldorf and works as conceptual artist. From 1997 till 1998 she was Guest Lecturer at the Kunstakademie München. Since the 1990s she participated in several group projects, many of them in collaboration with Andreas Siekmann, with whom she curated the exhibitions *Violence on the Margin of All Things* (Vienna: Generali Foundation, 2002) and *Ex-Argentina* (Cologne: Ludwig Museum, 2004). In 2006 she was awarded by the Norwegian Edward-Munch-Prize for Contemporary Art. She published essays in *Springerin*, *Texte zur Kunst* and *ANYP*.

**David Crowley**
studied in Poland during the 1980s and developed a strong interest in the cultural history of Eastern Europe under communist rule. He teaches at the Royal College of Art, London, where he is also the head of a new department of Critical Writing in Art and Design. He writes art and design criticism and curates exhibitions. In 2008 he was the co-curator of *Cold War Modern: Design 1945-1970* (London: Victoria and Albert Museum, 2008; Rovereto: MART, 2009; Vilnius: National Gallery, 2009). He is currently curating an exhibition on the life and work of Roman Cieslewicz (London, 2010) and another show on the connections of experimental art to music in Eastern Europe in the 1960s (Warsaw: National Museum, summer, 2011).

**T. J. Demos**
is an art critic and teaches in the Department of Art History, University College London. He writes widely about modern and contemporary art and is the author of *The Exiles of Marcel Duchamp* (2007). He is Co-curator of *Uneven Geographies: Art and Globalisation* (Nottingham Contemporary, 2010) and was Director of *Zones of Conflict: Rethinking Contemporary Art During Global Crisis*, comprising both an international group exhibition at Pratt Manhattan Gallery in New York, and a series of research workshops in London (in partnership with Iniva, Tate Modern, Tate Britain, and UCL's Centre for the Study of Contemporary Art, of which he is a founding member). During 2009–2010, he is a Fellow at the Flemish Academic Centre for Science and the Arts (VLAC) in Brussels, working on a new book on contemporary art and migration during global crisis.

**Diedrich Diederichsen**
(born in 1957, lives in Berlin and Vienna) is
cultural scientist, critic, journalist, curator,
author, professor and pop theorist. From
1985 till 1990 he was chief editor of the
music magazine *Spex*. From 1998 till 2006
he was professor at the Merz Akademie in
Stuttgart. Additionally he was lecturer at
many other academic institutions. Since
2006 he is professor at the Institute for Art
and Culture Sciences of the Academy of Fine
Arts Vienna. Focal points of his research are
pop music as a model of contemporary
culture, net cultures and entertainment
architecture, and neo formalisms. Latest
publications are *Über den Mehrwert (in der
Kunst)* (2008), *Kritik des Auges* (2008) and
*Eigenblutdoping – Selbstverwertung,
Künstlerromantik, Partizipation* (2008).

**Claire Doherty**
is director of "Situations" and senior
research fellow in Fine Art at University of
the West of England. Over the past she has
investigated new models of curatorial
practice beyond conventional exhibition
models at a range of institutions such as
Ikon Gallery in Birmingham, Spike Island in
Bristol and FACT in Liverpool. She initiated
"Situations" in 2003 as a new model of
commissioning and research programme
within a university context. From 2008 till
2009 she was curatorial director of the *One
Day Sculpture* series in New Zealand. In 2008
she got the Paul Hamlyn Breakthrough Fund
Award. She lectures and publishes widely on
curatorial issues and is editor of such as
*Situation* (2009) and *From Studio to Situation*
(2004).

**Silvia Eiblmayr**
is an art historian, lector, author and curator.
From 1999 till 2008 she was director of
Galerie im Taxispalais/Galerie des Landes
Tirol in Innsbruck, Austria. She lectured at
various national and international academic
institutions. She is advisory board member
of Kontakt, the collection of Erste Group
Bank, university council member of the
Academy of Fine Arts Vienna and Advisory
Board Member for photography of federal
ministry of art, culture and education
(BMUKK). In 2000 she received the Aby-
Warburg-Foundation's Hans-Reimer-Award.
In 2009, with Valie Export, she was commis-
sioner of the Austrian Pavilion at the 53th
Venice Biennial. She is author and editor of
numerous essays and publications, such as
*Die Frau als Bild* (1993).

**Brigitte Franzen**
is an art and cultural scientist and since
2009 she is director of Ludwig Forum für
Internationale Kunst in Aachen. From 2005
till 2009 she was head of the contemporary
collection at the Westfälisches Landesmu-
seum in Münster. In 2007 together with
Kasper König she curated the exhibition
*skulptur projekte münster 07*. In 2005 she
founded the "Skulptur Projekte Archive,"
which for the first time was exhibited in
2007. Since 1993 she has curated numerous
exhibition projects about art in 20th and
21st century. She is editor and author of
several publications about contemporary art,
such as *Wem gehört die Stadt?* (2009),
*Mikrolandschaften / Microlandscapes* (2006)
and *Landschaftstheorie* (2005).

**Christine Frisinghelli**
is an cultural scientist, curator, senior editor
and chief editor of the *Camera Austria
International* magazine and since 2003 she
directs the exhibition program of Camera
Austria, Graz. In addition she is editor of the
publication series *Edition Camera Austria*.
From 1975 till 1995 she was co-curator (with
Manfred Willmann) of the photography
program of Forum Stadtpark, Graz, which she
directed as vice chair from 1987 till 1995.
From 1996 till 1999 she was artistic director
of steirischer herbst festival. Since 2001
she's the curator of the Pierre Bourdieu
photography archive as well as co-editor and
co-curator (with Franz Schultheis) of the
publication and internationally presented
exhibition *Pierre Bourdieu: In Algeria.
Testimonies of Uprootin*.

**Martin Fritz**
(born in 1963, lives in Vienna, Austria) is
curator, consultant and publicist. From 1996
till 1998 he was director of operations and
director of program planning for the reopen-
ing of P.S.1 Contemporary Art Center in New
York, from 1998 till 2000 executive director
of the Expo 2000's art project *In Between*
in Hannover and from 2000 till 2002 chief
coordinator of the European art biennial
Manifesta 4 (Frankfurt a.M., 2002). Most
recently he directed the Festival der
Regionen in Upper Austria from 2004 till
2009. Current publications are in artist-
and exhibition catalogues, online media
and journals.

**Emiliano Gandolfi**
(born in 1975, lives in Rotterdam, Nether-
lands) works as assistant lecturer, architect
and curator. He is co-founder of "Cohabita-
tion Strategies" and the cooperative platform
"REbiennale." He was co-curator of the
11th International Architecture Exhibition
(Biennale di Venezia, 2008), the International
Architecture Biennial Rotterdam (2007) and
curator at the Netherlands Architecture
Institute in Rotterdam. Over the past years
he has been involved in a wide range of
projects, exhibitions and conferences that
dealt with methodologies and interventions
for urban transformation. He is currently
guest teacher at the National University of
the Arts in Taiwan, TU Delft in The Nether-
lands and advisor for the Curry Stone
Design Prize.

**Søren Grammel**
(born in 1971, lives in Graz, Austria) is a
cultural scientist, curator and since 2005
he is director of Grazer Kunstverein. In 2001
he curated the 9th edition of the Videonale
Bonn and several exhibitions at Münchner
Kunstverein. The *Frieze* magazine awarded
the exhibition *Die Blaue Blume* at Grazer
Kunstverein with the label Best Themed
Shows 2007. Most recently he was curator-
in-residence at the Academy of Fine Arts
Vienna. He published *Ausstellungsautor-
schaft: Die Konstruktion der auktorialen
Position des Kurators bei Harald Szeemann*
(2005). He is editor of a multiplicity of
publications such as *Andreas Fogarasi:
Information* (2008) and *Gesammelte
Drucksache* (2005).

**Simone Hain**
(born in 1956, lives in Graz, Austria) is a
historian for architecture and urban
planning, appraiser, publicist, curator and
teaches as professor and director at the
Institute of Urban and Architectural History
at the University of Technology Graz. In the
1990s she was member of the federal state
monument protection board of Berlin and
director of the field of study for newer
construction and planning history at the
Leibniz Institut für Regionalentwicklung und
Strukturplanung in Erkner. From 2005 till
2006 she was Gropius chair holder for the
history of modern architecture at the
Bauhaus-Universität Weimar. In 2003 she
curated (with Hartmut Frank) the ifa exhibi-
tion *Zwei deutsche Architekturen 1949–1989*.
She is author of *Wolfgang Hänsch –
Architekt der Dresdner Moderne* (2009), *Zwei
deutsche Architekturen 1949-1989* (2004)
and *Reise nach Moskau* (1995).

**David Joselit**
is Carnegie Professor of the History of Art at Yale University where he served as department chair from 2006 till 2009. He is author of *Infinite Regress: Marcel Duchamp 1910-1941* (1998), *American Art Since 1945* (2003), and *Feedback: Television Against Democracy* (2007). He is an editor of the journal *October* and writes regularly on contemporary art and culture.

**Veronica Kaup-Hasler**
is director of the Graz based arts festival steirischer herbst since 2006. Previous positions include dramatic adviser at Basle Theatre (1993–1995), and for the Wiener Festwochen (1995–2001), from 1998 on as artistic collaborator of theatre director Luc Bondy. Other work included lecturing in professor Erich Wonder's master classes at the Academy of Fine Art Vienna (1998–2001) and the artistic directorship of biennial Festival Theaterformen in Hannover and Braunschweig (2001–2004). In addition, she is active in international juries and since 2008 member of the Council of the University of Music and Performing Arts Vienna.

**Francesco Manacorda**
(born in 1974, lives in London and Turin) is a critic, curator and currently artistic director of Artissima, the international fair of contemporary art in Turin, Italy. He completed an MA in curating contemporary art at the Royal College of Art, London. Between 2007 and 2009 he was curator at the Barbican Art Gallery, London, where he realised the exhibitions *Martian Museum of Terrestrial Art* (2008) and *Radical Nature* (2009). He has written extensively for *Domus*, *Flash Art Italia*, *Flash Art International*, *Frieze*, *Metropolis M*, *Piktogram*, *Untitled*, and *Art Review*.

**Doreen Mende**
(born in 1976, lives in Berlin, Germany), PhD, author and curator, is founding member of the publication series *DISPLAYER* of the program Exhibition Design and Curatorial Practice at State University of Art and Design / ZKM Karlsruhe, and of the project/space "General Public" in Berlin. She currently undertakes journeys to the Middle East as practice-part of her ongoing curatorial research in the think tank PhD project "Curatorial/Knowledge" at the Goldsmiths College, University of London.

**Kobena Mercer**
writes and teaches about the visual arts from the black diaspora. He is the editor of the series *Annotating Art's Histories*, including titles including *Cosmopolitan Modernisms* (2005), *Discrepant Abstraction* (2006), *Pop Art and Vernacular Cultures* (2007) and *Exiles, Diasporas & Strangers* (2008). He taught at Princeton University and at New York University and is the first recipient of the 2006 by the Clark Art Institute awarded Clark Prize for Excellence in Arts Writing.

**André Rottmann**
is an art historian and critic based in Berlin. Since 2005 he is the editor in chief of the quarterly journal *Texte zur Kunst* in which he also publishes essays, interviews and reviews. His writings on contemporary art, particularly focusing on the history and legacy of conceptualism, institutional critique and site-specificity, frequently also appear in *Artforum International* and in exhibition catalogues (on artists such as Nairy Baghramian, Jan Timme, and Christian Philipp Müller). He currently is researching for a book on the history and aesthetics of Institutional Critique.

**Werner Rügemer**
was until 1989 editor of the educational journal "Demokratische Erziehung" and has been working as freelance writer, consultant, guide, and lecturer. He is a member of the Association of German writers (VS) and the International Association Antonio Gramsci, in the advisory board of attac and is chairman of Business Crime Control (BCC). He is the author of *Cross-Border-Leasing – Ein Lehrstück zur globalen Enteignung der Städte* (2009), „*Heuschrecken*" *im öffentlichen Raum: Public Private Partnership – Anatomie eines globalen Finanzinstruments* (2008) and *Colonia Corrupta* (2002). In 2008 he was awarded the Cologne Karls-Prize for engaged literature and journalism.

**Andreas Siekmann**
deals in his work with the burning issues of commercialization and privatization of urban space. With his scale models, videos and installations in public space he subjects the existing social hierarchies of power to an ironical mordant critic. Simultaneously he searches for alternatives and ways out of the current process of transformation of social market economy into a system of neo-liberalism impressed by the effects of globalization.

**Ruby Sircar**
(born in 1975, lives in Graz, Austria) is an assistant lecturer, scientist and artist. Currently she is research associate at the Institute for Contemporary Art, faculty for architecture, Graz University of Technology, and research coordinator for the initiative "Minderheiten Wien" (minorities Vienna). She was research fellow at the theory department of the Jan van Eyck Academy Maastricht and holds a PhD in Contemporary Art Theory and Post-Colonial Studies. Her research covers cultural and migrational translation and difference, spatial, sonic and media architecture as knowledge production.

**Beate Söntgen**
(born in 1963, lives in Düsseldorf, Germany), is a professor, publicist and curator. She teaches art history at the Ruhr-University of Bochum. Before she was professor for contemporary art at the University of Basel. She also worked as independent critic for the FAZ Feuilleton and as a curator. She published several books about modern and contemporary art and art theory. Actually she works on a publication about *Interieur. Von der Zugänglichkeit des Bildes in Barock und Moderne.*

**sozYAH**
is a research team formed at the Centrum für Sozialforschung of the Department of Sociology at University of Graz, in order to undertake a socio-scientific analysis for the project *You Are Here*, outlined and proposed by Andrea Fraser for the steirischer herbst 2010 festival's particular exhibition *Utopia and Monument II.*

**Sabine Haring**
(born in 1970, lives in Graz, Austria) is a sociologist, historian and assistant professor at the Department of Sociology of the University of Graz. From 1999 till 2005 she was scientific collaborator in the SFB "Moderne – Wien und Zentraleuropa um 1900" at the University of Graz. Her main research fields are historical and political sociology, sociology of religions, sociological theory and Central European history of the 19th and 20th century. She is author of *Verheißung und Erlösung* (2008) and co-editor of *Das Gesicht des Krieges* (2008).

**Anja Eder**
(born in 1984, lives in Graz, Austria) is a sociologist working in different research projects in the field of applied research, mainly for the association IG Soziologie Graz. Since 2008 she has been specializing on the sociology of mobility, road traffic and public space dealing with the mobility and city and regional planning concept "Shared Space."

# Colophon

## Utopia and Monument I
### On the Validity of Art between Privatization and Public Sphere

### Exhibition
Artistic director: Veronica Kaup-Hasler
Curator steirischer herbst: Reinhard Braun
Curator Utopia and Monument I:
Sabine Breitwieser
Managing Director: Martin Walitza
Production managers: Christine Sbaschnigg,
Annika Strassmair, Dominik Jutz
Production assistant: Roland Gfrerer
Exhibition graphic design: Susanne Klocker,
Wien
Lenders: Galerie Barbara Weiss
Exhibition installation: eeza, Graz (Erkmen,
Siekmann, Zinny Maidagan, Baghramian,
Pavilion, Norman); Porr, Graz (Maljkovic)
Technician: eeza, Graz

Public relations: Andreas R. Peternell
Press: Heide Oberegger
Fundraising: Christine Conrad-Eybesfeld
Art education: Regina Novak, Markus Boxler

Special Thanks to
All authors, artists and lenders

Hermann Candussi
Frido Hütter
Bettina Leidl
Hermann Schapek
Andrea Schliecker, London
Walter Titz
Galerie Barbara Weiss, Berlin
Dr. Gerhard Wohlfart

Stadtbibliothek Graz
Amt der Steiermärkischen Landesregierung-
Flächenmanagement
Stadt Graz:
-Abteilung für Grünraum und Gewässer
-Liegenschaftsverwaltung
-Straßenamt
-Feuerpolizei
-Stadtplanung
-Stadtvermessungsamt
-Bau- und Anlagenbehörde
ASVKGrazer-Altstadtsachverständigenkom-
mission
Energie Graz GmbH
APCOA Parking Austria GmbH

Patrons

Festival sponsor

Project sponsors

Project partner

## Utopia and Monument II
### On the Virtuosity and the Public Sphere

### Exhibition
Artistic director: Veronica Kaup-Hasler
Curator steirischer herbst: Reinhard Braun
Curator Utopia and Monument II:
Sabine Breitwieser
Managing Director: Artemis Vakianis
Production manager: Annika Strassmair
Curatorial assistance: Maximilian Lechler
Exhibition graphic design: Susanne Klocker,
Wien
Lenders: Galerie Daniel Buchholz
Exhibition installation: Ankünder, Graz
(Koether); eeza, Graz (Pavillion, Ferreira,
Genzken); Hermann Schapek, Graz (Andrade
Tudela); Reklama, Warschau (Olowska); Stadt
Graz Wirtschaftsbetriebe, Wilbeton (Fraser)

Technician: eeza, Graz; Hermann Schapek, Graz;
Public relations: Andreas R. Peternell
Press: Heide Oberegger
Fundraising: Christine Conrad-Eybesfeld
Art education: Regina Novak, Markus Boxler

Special Thanks to
Alle KünstlerInnen, AutorInnen und Leihge-
berInnen / all authors, artists and lenders,

Galerie Daniel Buchholz, Köln/Berlin
Galerie David Zwirner, New York
Büro Dr. Wolfgang Leitner
Hans Kupelwieser/IZK, TU Graz
Alexandra Föderl-Schmidt und Andrea
Schurian, Der Standard, Wien

Walter Titz, Kleine Zeitung, Graz
Livia Immervoll, Verkaufsstand Nr. 15
Stadt Graz:
-Abteilung für Grünraum und Gewässer
-Liegenschaftsverwaltung
-Straßenamt
-Bau- und Anlagenbehörde
Wirtschaftsbetriebe Stadt Graz
ASFINAG AUTOBAHN SERVICE GMBH
ASVK Grazer Altstadtsachverständigenkom-
mision
BOE GEBÄUDEMANAGEMENT Gesellschaft
m.b.H.
ACOTON Projektmanagement & Bauträger
Ges.m.b.H.

Patrons

Festival sponsor

Project sponsors

Project partner

**"Utopia and Monument I + II" has been made possible through special funding from the Cultural department of the Province of Styria as well as the Austrian Federal Ministry for Education, Arts and Culture.**

## Publication

This publication has been published on the occasion of the steirische herbst festival
*Utopia and Monument I + II* in Graz (24.9.–18.10.2009 and 24.09–02.11.2010).

Edited by
Sabine Breitwieser and steirischer herbst

Sackstraße 17
A-8010 Graz
T: +43 316 823007
F: +43 316 823007-77
www.steirischerherbst.at

Head of production: Nina Krick
Graphic design: Susanne Klocker, Wien
English copy editor: Charlotte Eckler,
pp. 10–33 Peter Blakeney & Christine Schöffler
Translations: Robin Benson (e),
Thomas Raab (dt)
Printed by: Grasl Druck & Neue Medien
GmbH, Bad Vöslau
Paper: Claro Bulk 130 g
Print Run: 800 deutsch / 550 english

Cover: Dolores Zinny & Juan Maidagan,
*Curtain Call for Graz*, 2009
© Dolores Zinny & Juan Maidagan; photo /
photo: Yashar Dehagani

Photo Credits:
© Lara Almarcegui; photo: courtesy of the
artist, p. 53, p. 54, p. 55, p. 56–57.
© Nairy Bagrahmian, photo: Wolfgang Silveri
p. 61; photo: Werner Kaligofsky, p. 62–63,
p. 64–65.
© Ayse Erkmen, photo: Wolfgang Silveri,
p. 69, p. 70, p. 71, p. 72 oben, p. 73;
photo: Werner Kaligofsky, p. 72 unten.
© Aalvar Aalto, photo: V&A Images, Victoria
and Albert Museum, p. 75.
© David Maljkovic, photo: Werner Kaligofsky,
p. 77; photo: Wolfgang Silveri, p. 78–79.
© Heather & Ivan Morison, photo: courtesy
of the artists, p. 83, p. 84, p. 85.

© Nils Norman, photo: Werner Kaligofsky,
p. 90–91, photo: Wolfgang Silveri,
p. 89, p. 92, p. 93.
© Andreas Siekmann, photo: Wolfgang
Silveri,
p. 97, photo: Werner Kaligofsky,
p. 98–99, p. 100–101, p. 102, p. 103.
© Dolores Zinny & Juan Maidagan, photo:
Werner Kaligofsky, p. 107, p. 108–109, p. 110,
p. 111.
© Michael Zinganel, photo: Wolfgang Silveri,
p. 114, photo: Maximilian Lechler, p. 115.
© Kooperative fur Darstellungspolitik, photo:
Werner Kaligofsky, p. 119, p. 120–121, p.
122–123, p. 124–125, photo: Wolfgang Silveri,
p. 130–131, p. 132–133, p. 134, p. 135.
© Yashar Dehagani, p. 126.
© Armando Andrade Tudela, photo: Wolfgang
Silveri: p. 139, p. 140–141, p. 142–143.
© Kader Attia, Film Stills: courtesy of the
artist, p. 147, photo: Wolfgang Silveri,
p. 146, p. 148–149.
© Angela Ferreira, photo: courtesy of the
artist, p. 153, p. 154, photo: Wolfgang Silveri:
p. 155, p. 156–157.
© Andrea Fraser, photo: Wolfgang Silveri,
p. 163, p. 167, p. 168, p. 169.
© Isa Genzken, photo: Wolfgang Silveri,
p. 173, p. 174, p. 175, p. 176–177.
© John Knight, photo: Wolfgang Silveri,
p. 183, p. 184–185.
© Jutta Koether, photo: Wolfgang Silveri,
p. 189, p. 190–191, p. 192–193.
© Paulina Olowska, photo: courtesy of the
artist, photo: Wolfgang Silveri,
p. 197, p. 198–199, p. 201.
© Michael Schuster: photo: Wolfgang Silveri,
p. 205, p. 206, p. 207, Fotomontage: Auner
http://www.auner.net

This work is subject to copyright.
All rights are reserved, whether the whole or
part of the material is concerned, specifi-
cally those of translation, reprinting, re-use
of illustrations, broadcasting, reproduction
by photocopying machines or similar means,
and storage in data banks.

Product Liability: The publisher can give no
guarantee for all the information contained
in this book. The use of registered names,
trademarks, etc. in this publication does not
imply, even in the absence of a specific
statement, that such names are exempt from
the relevant protective laws and regulations
and therefore free for general use.

© 2011 steirischer herbst festival gmbh
© 2011 Springer-Verlag/Wien
Printed in Austria

SpringerWienNewYork is part of
Springer Science+Business Media
springer.at

Printed on acid-free and chlorine-free
bleached paper
SPIN: 80062441

With 118 colored Figures

Library of Congress Control Number
applied for

ISBN 978-3-7091-0772-0
SpringerWienNewYork